Zen
in the fifties

interaction in art
between
east and west

Waanders Uitgevers, Zwolle

cobra museum voor moderne kunst *amstelveen*

Contents

Introduction

The strong predilection in the Western world for the Far East did not suddenly come about in the nineteen-fifties. The tendency was already present at the end of the nineteenth century, when Oriental mysticism was felt to be an interesting alternative for the matter-of-factness of the Western world. New movements, like Theosophy, enjoyed popularity in those days. Japonisme, which had already emerged in the eighteen-sixties, initially derived only from the formal characteristics of Japanese woodcuts. But around the turn of the century a touch of Oriental mysticism served to enhance it further.

This was followed by a fifty-year period in which interest in the East ebbed somewhat, but in the nineteen-fifties the passion for that part of the world was rekindled. However, the type of interest had altered over the years, and in the two decades following the Second World War, the appeal of Zen Buddhism gradually became greater. Today, with the end of the twentieth century in sight, yet another revival in interest for the East can be observed, but now adapted to present-day needs. The present study focuses primarily on the fifties – the period in which I believe the foundations were laid for this fascination in its contemporary form.

In the visual arts of the Western world in the nineteen-fifties there was a distinct preference for painting based on direct emotional experience. A number of artists were aiming not at individualistic art (in the sense of something highly subjective), but believed that by expressing their personal experience they could produce art of a universal nature.

Immediately after the Second World War confusion prevailed. It was a period in which questions arose as to Man's existence and the nature of reality. Various artists not only sought answers to these questions in Western culture, but also opened their minds to views from non-Western cultures. Consequently, many works of art from that period call forth associations, to a greater or lesser extent, with works from cultures outside Europe. One wonders what the artists found in those remote cultures.

It is also interesting to note that at that time a number of artists in Japan and China were producing works which resembled those of their contemporaries in the West. This observation inspired me to seek greater clarity concerning the connections and contrasts between modern art in the West and its counterpart in the Far East. As there was no source from which my questions could be answered, I conducted extensive research, which concentrated to an increasing extent on the affinity with Zen and the Zen arts.

The focus of my research has been to elucidate the complexity of the observed affinity of artists with Zen and the Zen arts in the fifties, and to reveal

the relation with Japonisme. My studies led to a demystification of the subject I originally selected, namely 'the influence of Zen'.

I have opted for a wide-reaching approach, with a view to demonstrating the implications of interest in Zen and the Zen arts. Various important centres of modern art in the fifties, such as Paris, New York, Munich and the Kansai district of Japan, will therefore be reviewed. I began my preliminary studies in the Netherlands, and continued the research in the above centres, conducting interviews with experts (art historians and artists, who, preferably, had been active in the art world in the fifties) and research at libraries, archives and museum collections in those places. Japanese art has been studied, as has Western art, from a Western viewpoint, since it is impossible for a Western art historian to consider the works from a Japanese point of view.

The consequences of Western artists' interest in Zen have already been contemplated by various critics and scholars, both during and after the fifties. I came across several observations from the second half of the nineteen-fifties (for instance by Alfred Barr Jr. and Michel Ragon) on the great popularity of Zen. On the whole they were very general in content and were not corroborated with examples. In subsequent decades attention for the influence of the Far East on Western modern art waned. Reference to the subject was restricted almost exclusively to monographs of artists. The scant enthusiasm to study the scope and nature of modern artists' interest in the Far East is probably due to the fact that influences from the East are hard to *prove*. There is an interesting exception: an essay by Manfred Schneckenburger in the catalogue *Weltkulturen und moderne Kunst. Die Begegnung der europäischen Kunst und Musik im 19. und 20. Jahrhunderts mit Asien, Afrika, Ozeanien, Afro- und Indo-Amerika* written in 1972. A section of several pages, entitled 'Zen-Buddhismus, Tuschmalerei und Moderne Kunst' in Schneckenburger's essay can be seen as one of the first serious attempts to catalogue twentieth century artists with an interest in Oriental calligraphy and Zen. In recent years, interest among art historians in the relationship between views from the Far East and modern art has increased slightly, as is apparent from several publications, such as David Clarke's thesis *The Influence of Oriental Thought on Postwar American Painting and Sculpture*, dating from 1988, and the exhibition *The Trans Parant Thread* which was held in 1990 in Hampstead, amongst other places. My study of the relevant literature revealed that preconceived opinions on the influence of the Far East are frequently adopted as the basis for a study. That was especially true of the catalogue for the above-mentioned 1990 exhibition.

The arrangement of the present treatise requires some further explanation. In order to acquaint the reader with the rudiments of Zen, its characteristics and those of Zen art are described in the first chapter, in particular the features for which they were known in the Western world of the fifties. This is followed by a short background to the then prevailing fascination in the West for the Far East, with particular reference to Wassily Kandinsky's work in the first decade of the twentieth century. That, after all, marked a turning point in thought on Japanese art.

The aforementioned centres of modern art are reviewed in four case studies, with each study featuring a different country, but pursuing an identical course. The development in interest in Japanese art is outlined, from the latter decades of the nineteenth century to around 1960, followed by a discussion of a small selection of artists. The affinity to which I refer was evident among artists who were producing abstract work, and so I have limited my research to that group.

The works in question have been divided into three categories, which I have termed 'art of the calligraphic gesture', 'art of the empty field' and 'living art'. The artists were selected as being the most prominent representatives of the three different categories. Apart from their affinity with Zen, the importance of the role they played in the world of art was also a criterion. The artists are dealt with in two different ways. To start with each individual's specific connection with Japan is discussed, and then a number of aspects of Zen and the Zen arts are compared with the selected artists' views, working methods and work. Five aspects have been chosen as being the most notable of a larger number of parallels I examined.

Since the individual case studies are not suitable for comparison, the different artists and artistic centres will only be compared and contrasted in the concluding section. The main objective of both the case studies and the concluding observations has been to provide insight into the complex nature of the subject, and, in view of the scholarly nature of the research, a detached approach has been taken in the interpretation. The difficulty, and sometimes impossibility of interpretation in the field of study I have chosen, was revealed by my examination of the information I had collected.

I discovered that there were more centres of art and artists in the fifties meriting study. I shall, therefore, be continuing my research in the years to come. In addition, Japanese artists who live in Western countries also form an interesting group for further study – a group for which there was no room in the present research.

There is every indication that the interest of artists in Zen continued to grow for several years after 1960. I hope that my study into the interest in Zen in the fifties will serve as a basis for research into subsequent decades.

The specific use of a few terms in this thesis requires some explanation. I have opted for the more general word 'work', instead of the customary designations 'drawing' and 'painting'. It is hard to say of a remarkable number of works by the artists in question whether they are 'drawings' or 'paintings'. Some artists even tried to erase the boundaries between drawing, painting and writing. When the outward appearance of the works no longer occasions their unequivocal classification as drawings or paintings, I believe it is better to apply a neutral term like 'work'. I have occasionally relaxed this procedure, to avoid repetition.

The use of the word 'calligraphic' and the sequence in which some names are written require some explanation. In the context of this study calligraphic refers only to a formal characteristic – that of 'expressive line'. Japanese names have been written in the Western order, so first names before family names, rather than the customary sequence used in Japan, of family name first.

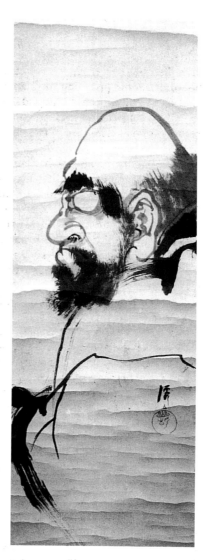

1. Unidentified seal, 'Daruma' (i.e. Bodhidharma), 19th century (?), ink on paper,
128 (including calligraphy above) x 29.5 cm.
Collection Tom Lenders, Amsterdam

Zen and the Zen arts

The Indian monk Bodhidharma, who travelled to China in around 520, is seen as the first patriarch of Zen Buddhism (ill. 1).[1] He called his sect in China 'Ch'an', based on the word *Dhyana* (meaning meditation in Sanskrit). Many Taoists[2], who discovered similarities between Ch'an and their own views, became interested and proceeded to influence the development of that religious sect's beliefs. Not only were ideas from Taoism incorporated in Ch'an, but also some Confucian tenets.

At the end of the twelfth century monks who had studied in China succeeded in introducing Ch'an in Japan, after several unsuccessful attempts in previous centuries. It was primarily the Samurai and Shōguns who supported the views to start with.[3] In Japan Ch'an was termed 'Zen' – a word derived on the one hand from the Chinese Ch'an, and on the other hand from the Japanese verb *Zazen* (meaning to sit or to meditate). Zen monasteries became centres of teaching and in that way Zen exercised influence on Japanese culture. The fact that the ruling class expressed an interest in Zen enabled the movement to acquire greater importance than in China.[4]

Opinions differ as to the exact extent of Zen's influence on Japanese culture. Daisetz T. Suzuki, who has written a great deal on Zen and to whom frequent references will be found in the coming chapters, believes that Zen has played an important part in shaping Japanese culture. A fact which he is sometimes accused of exaggerating. However, the philosopher Ryosuke Ohashi, who is conducting research into the role of Zen in Japanese culture, tends to agree with Suzuki. Ohashi believes that many Japanese underestimate its influence, since they are inclined to see the flowers and not the roots. Moreover, he compares Zen with an explosion which sets things in motion, but is not itself visible.[5]

Zen is, in fact, almost impossible to characterize. Suzuki wrote that just when you imagine you are catching a glimpse of it, it disappears. And by writing or talking about it, it escapes you even more.[6] Nevertheless, Suzuki did make an attempt to describe Zen. He even tried to explain it for Westerners. He was immersed in the subject for many years, but he never became a Zen Master. That does not mean that his books present an incorrect picture of Zen. Literature research and interviews with Japanese experts, who were involved with Zen as Masters or researchers, have revealed that Suzuki's views do not differ greatly from other people's. Although Zen is not a clearly defined

doctrine, and everyone is entitled to his or her own view, the various interpretations studied prove to coincide in essence.

Over the centuries Zen has been divided into several 'main schools'. The most important schools in Japan are *Rinzai* and *Sōtō*.[7] A significant difference between the two is that *Rinzai* considers the arts an important aspect in the practice of Zen, whilst *Sōtō* focuses entirely on meditation. 'Suzuki Zen' is one of the many interpretations of *Rinzai* Zen and was of particular importance for my research, since artists in the West largely acquired their idea of Zen from his books. The characteristics I describe are also primarily based on Suzuki's texts.

An important characteristic of Zen is the practice of *Zazen*, and the state of *Satori* (Enlightenment) which is achieved as a result. Contrary to the claims of many other Buddhist movements, Enlightenment can be attained according to Zen without help from higher powers, by means of inner discipline and concentration.

As Suzuki explains, purely logical thought and dualistic thought are felt to be obstacles in the process leading to Enlightenment. Exclusion and limitation (features of dualist thought) restrict freedom and unity.[8] Consequently, dogmas are also rejected and there is no holy book to guide believers. This makes it difficult to define Zen according to clear characteristics.[9] In Suzuki's view it cannot in fact be defined as a religion or a philosophy.[10] Everything in Zen focuses on here and now. *Satori,* which means 'insight into the true being', is only possible to obtain by intensely felt and practical, personal experiences. The experience of concrete things from everyday life is particularly important. So we do not have to look far: "we are like those who die of hunger while sitting beside the rice bag".[11]

Irrationality and paradoxical thought are the only tools with which to gain insight into the true existence, since being cannot be penetrated by cerebral means. The *Koan*, an irrational question, is a way of learning to transcend rational experience. An example of which is "what is the sound of one hand clapping?".[12] Suzuki believes that Zen is both difficult and easy to understand: "Hard because to understand it, is not to understand it; easy because not to understand it, is to understand it".[13]

Once *Satori* has been obtained, the world is experienced from a new, fresh point of view, as well as in its 'wholeness'.[14] So *Satori* can be seen as an attitude or outlook. Suzuki is of the opinion that the emphasis on the intuitive nature of this outlook does not mean that Man should be equal to the animals: "The animals do not know anything about exerting themselves in order to improve their conditions or to progress in the way to higher virtues".[15] This pursuit of new insight does not mean that Zen only centres on the mind. *Satori* can only be attained by a combination of an active body and an active mind. So an important goal of meditation is the harmonious unity of mind and body.

The feeling of unity with Nature is very important in Zen. This primarily amounts to an awareness that Man himself is also part of Nature. According to Suzuki, that does not mean that Man is expected to revert to being 'primitive': "Going back to Nature, therefore, does not mean going back to the natural life of primitive and prehistoric peoples. It means a life of freedom and emancipation".[16]

The role of the Zen Master on the path towards enlightenment is limited, since he has nothing to teach his pupils.[17] Everyone must teach himself, from his own inner being. Accordingly, Zen believes in Man's inner purity and goodness. It shows the way, but Zen Masters warn that we should not take the pointing finger to be the moon itself: "A finger is needed to point at the moon, but what a calamity it would be if one took the finger for the moon".[18] Nor is it allowed to imitate the Master. Just think of the way a Zen Master, who always raised a finger in reply, chopped off the finger of a pupil who imitated him. That pupil is said to have achieved *Satori* immediately afterwards.[19] Where there is no creative originality, there can be no Zen. So Suzuki's books on Zen should be fingers pointing at the moon. They themselves do not provide insight into the moon, i.e. Zen.

The Zen arts: Sumi-e and Shō

Zen unites the religious and the secular. And that has consequences for the Zen arts. Not only are the arts practised in traditional forms, like poetry and painting, but also, preferably, by way of everyday activities like writing (*Shōdō*), tea-making (*Sadō*), flower arranging (*Kadō*), self-defence (*Judō*), archery (*Kyudō*) and swordsmanship (*Kendō*).[20] The necessary physical component of these arts obviates the antithesis between mind and body.

The outcome of the great popularity of these Zen arts was that various aspects of Zen were to play a part in the daily lives of many Japanese people, albeit unconsciously.[21] In China, on the other hand, where Ch'an was mainly linked to painting, calligraphy and poetry, the Ch'an arts were practised primarily by intellectuals.[22] Yet awareness of the philosophy of Zen was limited to an elite group in Japan, as was the case in China.

It is striking how close the ties are between *Rinzai* Zen and art. In many religions art is considered merely to be an illustration of the far more important spiritual aspect. However, the Zen arts are seen as a means in the quest for *Satori*. There is, accordingly, a specific connection in *Rinzai* Zen between art and meditation. Heinrich Dumoulin described this connection as follows: "The Zen arts are inspired by meditation and the meditation experiences manifest themselves in the arts".[23] Zen wants us to make ourselves free and untrammelled, and sees the practice of art as a way of attaining the awakening and liberation of the self.[24] Yet the self may not be something we cling to or become poisoned by. Zen wants us to get in touch with the 'inner workings of our being', without seeking refuge in the 'self' or resorting to anything external or superadded.[25]

Before describing some of the characteristics of Zen painting, *Sumi-e*, I should first like to sketch briefly the history of its introduction and development in Japan.

In the second half of the sixth century Buddhism was introduced into Japan from China. Until then Japan had not had a religion, only a cult which originated in animism and which was termed *Shinto* (meaning the way of the gods, or *Kami*/spirits) to distinguish it from Buddhism. In that period Buddhist painting was also adopted from China, which led to the oldest known paintings in

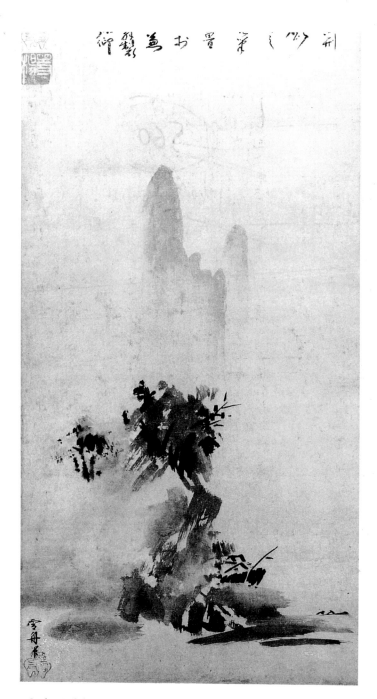

2. Sesshū, 'Haboku sansui zu' (Landscape in splashed ink), 1495, ink on paper, 148.6 x 32.7 cm. The Tokyo National Museum, Tokyo

3. Hakuin, 'Bodhidharma', 18th century, ink on paper
From: L.Hajek, A.Hoffmeister, *Chinesische Malerei der Gegenwart*, Prague, 1959
4. Sengai, 'Daruma', circa 1800, ink on paper, 17 x 6cm.
Idemitsu Museum of Arts, Tokyo
5. Nantembō, 'Bō' (Staff), early 20th century, ink on paper, 148.6 x 44.5 cm.
The translation reads: "If you can answer forty whacks! If you can't answer forty whacks!"
Pulverer Collection, Germany

Japan. It was not until several centuries later, in the ninth century, that a typically Japanese style of painting developed. This painting, called *Yamato-e*, was influenced by literature and was poetic in mood. The artists tried to evoke emotions in the viewer. Since then the expression of emotion has been an important characteristic of Japanese painting.

At the end of the twelfth century the Japanese not only took with them Ch'an from China, but also monochrome ink painting as practised by the Ch'an monks. The Japanese called the style *Sumi-e* (ink painting), and the Chinese ink paintings were both collected and copied in Japan. During the fourteenth century, starting in the Muromachi period (1333-1573), a more Japanese style of Zen painting evolved. Emotions were given expression in the paintings. The best known artist of that time was Tōyō Sesshū (1420-1506), who, having spent two years in China, developed a highly expressive style in which he 'threw' the ink on the paper (ill. 2).This technique was termed *Haboku* (splashed ink) and Sesshū combined the results with strong brush-strokes. Many painters were to continue in this style.

Since the sixteenth century the most famous Zen painters have been Ekahu Hakuin (1685-1768), whose powerful brushwork made his technique even more expressive than that of Sesshū (ill. 3)[26], Gibon Sengai (1750-1838), whose style was primarily poetical, but at the same time caricatural (ill. 4) and Nakahara Nantembō (1839-1925), whose work was the peak of the expressive technique (ill. 5). He wrote in his autobiography that the painter himself, with his whole body, was the paintbrush.[27]

It is impossible to specify characteristics which are applicable to all Zen painting, since styles vary. However, there are a number of recurring aspects. Shin'ichi Hisamatsu formulated seven characteristics of 'Zen Aesthetics' in his book *Zen and the Fine Arts*: Asymmetry, Simplicity, Naturalness, Tranquillity, Freedom of Attachment, Subtle Profundity and Austere Sublimity.[28] With respect to asymmetry, naturalness and freedom of attachment, he notes a preference for the irregular and seemingly unfinished.[29] In addition to the characteristics which Hisamatsu lists, we might add that the figures are placed in the composition in such a way that no element can be moved without disturbing the entire composition.[30] That is partly due to the fact that the empty spaces in the paintings are just as important as the painted figures.[31]

Suzuki describes the style and technique of *Sumi-e* in his *Essays* as follows:

> "The inspiration is to be transferred on to the paper in the quickest possible time. The lines are to be drawn as swiftly as possible and the fewest in number, only the absolutely necessary ones being indicated. No deliberation is allowed, no erasing, no repetition, no retouching, no remodelling". (...) The Master lets his brush move "without his conscious efforts. If any logic or reflection comes between brush and paper, the whole effect is spoiled. (...) There is no chiaroscuro, no perspective in it. Indeed, they are not needed in *Sumi-e*, which makes no pretension to realism. It attempts to make the spirit of any object move on the paper. Thus each brush-stroke must beat with the pulsation of a living being. It must be living too (...) the rhythm of its living breath vibrates in them".[32]

As regards what this type of painting aims to express, he added:

"However faithfully a painter may try to remind us of an object of nature as it is, the result can never do justice to it (...) The *Sumi-e* artist thus reasons: why not altogether abandon such an attempt? Let us instead create living objects out of our own imagination. As long as we all belong to the same universe, our creations may show some correspondence to what we call objects of nature. But this is not an essential element of our work. The work has its own merit apart from resemblance. In each brush-stroke is there not something distinctly individual? The spirit of each artist is moving there. His birds are his own creation. This is the attitude of a *Sumi-e* painter towards his art, and I wish to state that this attitude is that of Zen towards life (...): The creative spirit moves everywhere, and there is a work of creation whether in life or in art".[33]

And Suzuki writes regarding the absence of colour:

"It is thus natural that *Sumi-e* avoid colouring of any kind, for it reminds us of an object of nature, and *Sumi-e* makes no claim to be a reproduction, perfect or imperfect. In this respect *Sumi-e* is like calligraphy".[34]

Finally, a few words about the Zen art of calligraphy, *Shōdō* (ill. 6).[35] It is not only the characters that count in this art form. The writing process is at least as important. The use of the entire body is emphasized, the mind is focused on here and now, and a sense of oneness with the painting materials comes about.[36] In that respect the artist has a strong affinity with the methods of the *Sumi-e* painter. And the formal aspects of *Shō* also coincide with those of *Sumi-e*. The unity between the painted character and the paper, so the relationship between form and residual form, is of particular importance in the *Shō* work of art. The brush-strokes resemble those in the ink paintings, in their highly expressive nature. In addition, the *Kanji* (derived from Chinese characters) in *Shō* and the figures in *Sumi-e* are both depictions of reality which, in the course of time, have acquired an almost abstract character.

Aspects of Zen and the Zen arts

When I compared some of the characteristics of Zen and the related Zen arts, as described by Suzuki and several other writers, with the work, views or methods of Western artists and Japanese artists with a Western orientation from the nineteen-fifties, I discovered some connections. I selected five striking parallels and proceeded to examine them in more detail with respect to Zen. In fact, these aspects relate to the beliefs of Zen, as well as the method of the Master involved in the Zen arts, and the formal features of the Zen arts.

Emptiness and nothingness

In the Zen belief the concepts of emptiness and nothingness do not refer to an absence of something, but are 'complete' in themselves. It means that empty is also full, and nothing is something (ill. 7). In Zen negations are often applied, as there is no rational way of saying what Zen is, only what it is not. The *Sutras*[37] of *Sūnyatā* (emptiness) are the most esteemed among the Buddhist Sutras of Perfect Wisdom. The Prajnaparamita-Hridaya is used as the daily

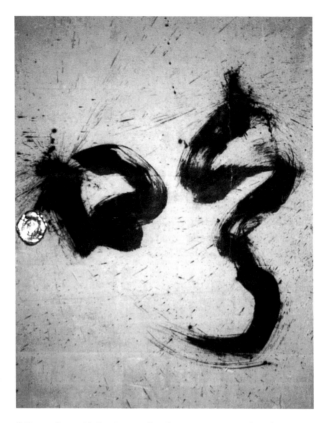

6. Nantembō, Untitled, Kaisei temple, ink on paper screen, early 20th century
Kaiseiji, Nishinomiya

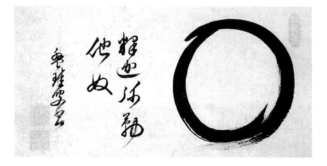

7. Bankei, 'Enso' (Circle), 17th century, ink on paper, 28.6 x 54 cm.

Sutra. Suzuki worded it as follows:

"Thus, Sāriputra, all things have the character of emptiness, they have no beginning, no end, they are faultless and not faultless, they are not perfect and not imperfect. Therefore O Sāriputra, here in this emptiness there is no form, no perception, no name, no concepts, no knowledge. No eye, no ear, no nose, no tongue, no body, no mind. No form, no sound, no smell, no taste, no touch, no object... There is no knowledge, no ignorance, no destruction of ignorance...".[38]

The great significance of emptiness and nothingness in Zen is reflected in the descriptions of *Mu* (meaning emptiness and nothingness) as "pure experience, the very foundation of our being and thought" and "always with us and in us (...), is our life itself".[39] Nothingness can also be found in the emphasis Zen places on 'detachment'.[40] The feeling of oneness with matter is an essential stage in the striving towards the gradual transcending of every relationship, whereby the state of total detachment or freedom is reached. There is a legend of a famous archery Master which tells that when the Master had passed through the stage of becoming one with his bow and arrow and had ultimately reached the highest level, in response to the question whether he wished to teach shooting with a bow and arrow, he asked: "What is a bow and arrow?"[41] Although emptiness and nothingness are also important aspects in other movements of Buddhism, they are greatly emphasized in Zen, and are an essential component of the Zen arts.

Moreover, emptiness plays an important part in the Zen arts, as a formal aspect. Take, for example, the central role played by the large empty spaces in *Sumi-e*, like the favourite subject of *Enso* (ill. 7) and the expanses of emptiness in

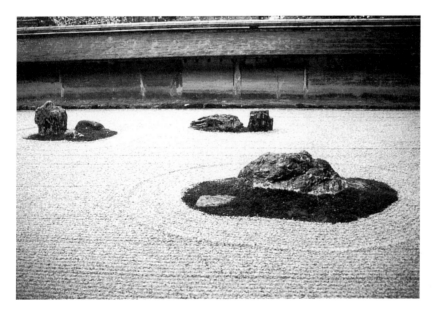

8. Ryoanji Zen garden, Kyoto

Zen gardens (ill. 8). These empty spaces are never lifelessly empty: the suggestion of mist (ill. 2) and the texture of Japanese paper, or the raked gravel give the empty spaces an ambience of activeness. The difficult nature of creating high quality emptiness is apparent from the following comment by the painter Ikeno Taigado (1723-1776): "The places in a painting in which there is absolutely nothing are the most difficult".[42] In addition, emptiness and nothingness are also essential to the Zen Master's mental state in his working process (*Mushin* = No-Mind).

Dynamism

An expert in the field of Zen remarked during an interview: "Zen is doing, the becoming one with dynamism. The way of expression is not important".[43] This attitude is the result of Zen's world view. The world is seen as a dynamic and constantly changing whole.

In a Zen Master's working method dynamism is especially apparent in arts such as *Kendō*, and in *Sumi-e* and *Shō* it can be clearly observed in the spontaneous use of the brush.[44] Suzuki wrote with respect to the necessary attitude during work: "Life itself must be grasped in the midst of its flow; to stop it for examination and analysis is to kill it, leaving its cold corpse to be embraced".[45]

It may not be a noncommittal spontaneity on the individual's behalf, but one which is only attained after a disciplined learning process, in which the unity of subject and object has to be attained. The ensuing spontaneity is then one of Nature itself.

In the end results of the Zen Master's painting and writing, the spontaneously painted lines are primarily what give the work a dynamic expression. The empty parts emanate a 'quiet dynamism'.[46]

Indefinite and surrounding space

The Japanese word *Ma* means both time and space, and is mainly interpreted as 'interval'.[47] This term is not only used for a time interval, as in the pause between two notes of music, but the space between two brush-strokes is also experienced as *Ma*.

The traditional Japanese artist also sees space as 'surrounding', meaning that during his work he is aware of the space around him. In that way he differs from the academic Western painter, who, under the influence of principles of perspective, is only aware of the space in front of him, and envisages it as receding. Kitaro Nishida described the traditional Japanese way of suggesting space as follows: "the space in art from the Far East is not the space facing the self, but the space in which the self is situated".[48] This difference would seem to be reflected in the terms 'observation' with respect to Western artists, and 'participation' with respect to Japanese artists.[49]

In *Sumi-e* the experience of the surrounding space can be perceived in the suggestion of an indefinite space. That means that there is not by any means a clearly receding space, but that the space in the work is also part of the space in which the viewer is situated. The absence of a horizon means that the suggestion of space can also be interpreted as an infinite space. Space in *Sumi-e* and *Shō* can also be found in the important part played by the residual forms, or *Ma*.

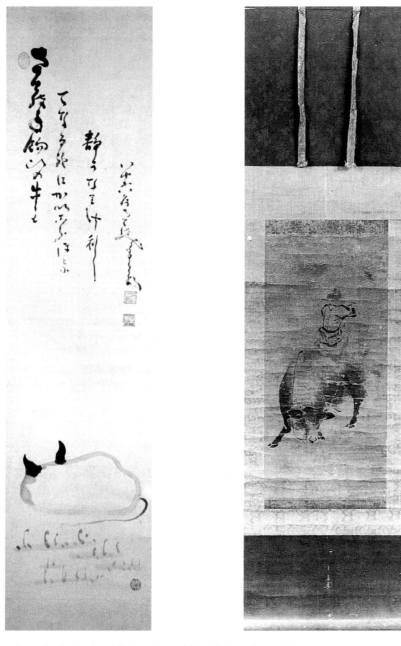

9. Nantembō, *Sumi-e* of an old bull grazing, probably referring to the tamed ox,
picture no.5 of 'The Ox and its Herdsman', 1925, ink on paper, 130.5 x 33 cm.
Pulverer Collection, Germany

10. Anonymous, *Sumi-e* of a man sitting on the back of an ox,
picture no.6 of 'The Ox and its Herdsman', 15th century (?), ink on paper, 122 x 34 cm.
Collection Tom Lenders, Amsterdam (photo: Fotostudio Peter Bersch Cuijk)

Direct experience of here and now

Unlike many religions, including Christianity, in which the present is linked with the past and the future, Zen focuses entirely on here and now. Consequently, during meditation, the concentration centres on the respiration and on the awareness of 'now'.[50] The importance of here and now is visualized in the well-known series of pictures of the parable of the 'Ox and its Herdsman' illustrating the process towards *Satori*. The first picture and the last are almost the same, and depict a man walking. The eight intervening pictures show the man taming an ox (ills. 9 and 10) and a completely empty frame symbolizes the stage when *Satori* is attained. When that happens, insight becomes more acute and experience more intense. So after *Satori* has been reached, its seems as though nothing has changed – except that the walking man is now aware of here and now.

Suzuki believes that pure experience of being is the basis of our existence and thought. He quotes as an example of pure experience the answers of a Zen Master to a pupil's questions. The latter asked how the Master pursued truth. To which the Master replied: "When I am hungry I eat; when tired I sleep". When the pupil countered that everyone does that, the Master explained: "When they eat they do not eat, but are thinking of various other things, thereby allowing themselves to be disturbed; when they sleep they do not sleep, but dream of a thousand and one things. This is why they are not like myself".[51]

Suzuki stresses the focus on the concrete things of everyday life, commenting that Zen attaches inexpressibly great significance even in holding up a finger or in saying a 'good morning' to a friend casually met in the street.[52] Shin'ichi Hisamatsu relates the interest within Zen in the commonplace with the aims of art:

> "When in the raising of a hand or in a single step something of Zen is present, that Zen content seems to me to possess a very specific, artistic quality. A narrow conception of art might not accept that such manifestations contain anything artistic, but to me it seems that they possess an artistic quality that ordinarily cannot be seen. In fact, in such vital workings of Zen, I believe that something not merely artistic but also beyond art is involved, something toward which art should aim as its goal".[53]

Suzuki is even of the opinion that every 'Zenist' is an artist, as he makes a work of art of his life.[54]

The focus on here and now, instead of on the future, also produces 'purposelessness'. In a well-known anecdote from Zen literature, the story is told of three men who asked someone why he was standing on top of a mountain. That person replied: "I am just standing here".

The immediate experience of here and now in the Zen Master's working method, can be perceived in his concentration.

Nondualism and the universal

From a theoretical point of view, Zen comprises the entire universe, and does not wish to tie itself down to the rule of antithesis.[55] Zen prefers nondualism, which is the opposite to the traditional Western way of thinking, based on 'discrimination'. This means that Western Man is primarily oriented towards estab-

lishing his own identity and that of other people and things, doing so by seeking differences. Zen advises a unification of antitheses, by means of nondualistic thought.[56] In that way, contact can come about with 'the universal', characterized by the fact that it is 'one', something and nothing at the same time. The universal is not considered to be 'something divine', but rather a universal basis of everything that is present in everything.

The Zen Master tries, during his work, to feel at one with his materials, and thus obtain a more universal expression. The resulting pieces should also characterize a nondualism. That means that a fragment can seem both full and empty, that dynamism is at the same time rest, form can also be formless, and so on.

The foregoing outline of some of the characteristics of Zen will now be followed by a historical sketch of the view of the East which has existed in the West, after which the affinity with Zen of Western and Western-oriented Japanese artists in the fifties will be described, in the form of case studies.

Notes

1 There is a feeling that this genesis of Zen was 'invented' a few centuries later.

2 Taoism is one of the three main doctrines of ancient China, together with Confucianism and Buddhism. Tao, or Tau, means 'way'. Man must adapt to the path the universe takes. Its world view is dynamic, since everything is seen as constantly changing.

3 Zen was welcomed there because its directness and practical nature (which will be discussed in the chapter) appealed greatly to the minds of the *Shōgun* (literally supreme commander) and *Samurai* (warriors). VOS, 1964, p. 107.

4 In the 9th century, during the T'ang dynasty (618-906) the weakened government in China had decided to put an end to the prosperity of the temples. Buddhist monasteries, temples and art objects were destroyed. And so Buddhism, including the Ch'an movement, never again flourished as it had in the early T'ang period. However, the Ch'an sect was able to survive because its practice did not need temples or writings. FONTEIN, 1970, p. xvii.

5 Interview with Ryosuke OHASHI in Kyoto on 9 November 1993.
The emeritus professor Dr. F. Vos, and professor E. Zürcher from Leiden commented

in VOS, 1964, p. 194: "We can go so far as to say that the lives and behaviour of *all* Japanese are influenced by Zen".

However, I must note here how difficult it is to prove the extent to which this entails Zen influence or whether Zen tied in well with Japanese culture at some stage, and derived its success from that.

6 SUZUKI, 1991 (1949/1934), pp. 43 and 46.

7 *Rinzai* Zen is the Japanese name for *Lin Ch'i* Zen, of the Master Huai Jang (677-744). *Sōtō* Zen is the name given in Japan to the Chinese *Ts'ao Tung* Zen of the Master Hsing Sze (?-740). The names *Lin Ch'i* and *Ts'ao Tung* indicate the regions where the Masters originally worked. Amongst others, VOS, 1964, p. 25. In 1191 the Japanese priest Eisai (1141-1215) introduced the first-mentioned sect in Japan, and Dōgen (1200-1253) founded the first monastery of the last-mentioned sect in 1244 in Japan.

8 SUZUKI, 1991 (1949/1934), p. 67.

9 Some adherents of Zen are of the opinion that the characteristics of Zen can be summed up in four concise maxims, which, it is told, Bodhidharma himself voiced: 'A direct reference to Man's heart (= spirit, inner self)', 'Acquisition of a Buddha- nature by contemplating one's own nature', 'A separate teaching outside the (traditional) doctrine' and 'No reliance on (canonical) texts'. VOS, 1964, p. 29.

10 According to SUZUKI, 1991 (1949/1934), pp. 39, 62 and 72, the existence of God is not denied in Zen, but not confirmed either. Nor is life after death mentioned. For that reason Zen is not a religion. Philosophy is based on thought. Zen believes that reason stands in the way of pure experience.

11 SUZUKI, 1991 (1949/1934), p. 73.

12 The '*Sōtō*' sect rejects the use of the *Koan*.

13 SUZUKI, 1991 (1949/1934), p. 76

14 SUZUKI, 1991 (1949/1934), pp. 96 and 61.

15 SUZUKI, 1991 (1949/1934), p. 86.

16 SUZUKI, 1993 (1938/1927), p. 375. With respect to this aspect of Zen, Suzuki's essay 'The Role of Nature in Zen Buddhism' of 1953 (published in SUZUKI, 1955, pp. 176-206) is especially interesting. Suzuki states that Western Man believes in the antithesis between Man and Nature. A few quotes: "There is nothing in Man that does not belong in Nature" (p. 178), "To treat Nature as something irrational and in opposition to human 'rationality' is a purely Western idea..." (p. 181), "no distinction between the *en-soi* and *pour-soi* [terms used by Sartre]" (p. 197) and "...our task is now to make Man retreat, as it were, into himself and see what he finds in the depths of his being" (p. 183).

17 Zen Masters spontaneously reply to questions by monks as to who or what Buddha is with an irrational answer, like: "Three pounds of flax" (SUZUKI, 1991 (1949/1934), p. 77), or ask a counter-question, are silent or react physically, for instance by grabbing the monk by the nose.

18 SUZUKI, 1991 (1949/1934), p. 74.

19 SUZUKI, 1991 (1949/1934), p. 72.

20 *Dō* means 'way'. See, amongst others, DUMOULIN, 1989 (1976), p. 82. Judō literally means 'the yielding way', implying that it is a sport of defence in which the strength of the attacker is used to bring him down. See also the chapter 'The Zen arts in France'.

21 DUMOULIN, 1989 (1976), p. 84. An example of one of Zen's unconscious influences is a preference for emptiness and dynamism. Since several aspects, such as simplicity, purity and a connection with matter, are also elements of Shinto, it is not always easy to distinguish between the influence exerted by these two.

22 Interview with Ryosuke OHASHI in Kyoto on 9 November 1993.

23 "Die Zen-Künste sind von der Meditation beseelt, die Meditationserfahrungen offenbaren sich in den Künsten". Dumoulin in WALDENFELS, 1980, pp. 15 and 16.

24 Interview with Ryosuke OHASHI in Kyoto on 9 November 1993.

25 SUZUKI, 1991 (1949/1934), pp. 41, 43, 44 and 64.

26 For more information please refer to the thesis by DREESMANN ,1988, on this artist.

27 ADDISS, 1989, p. 192.

28 HISAMATSU, 1971, pp. 30-40.

29 Ibid.. YANAGI, 1972, pp. 119 and 121, refers to Okakaru: "The love of the irregular is a sign of the basic quest for freedom" and makes a connection with modern art: "A conspicuous trend in modern art movements is the pursuit of deformation, discarding the conventional form, as an expression of man's quest for freedom".

30 BAKER, 1986 (1984), p. 10.

31 Interview with Midori SANO in Tokyo on 25 October 1993. See the aspect 'emptiness and nothingness'.

32 SUZUKI, 1970 (1934), p. 351.

33 SUZUKI, 1970 (1934), p. 352.

34 SUZUKI, 1979 (1934), p. 353.

35 *Shō* has two variants – one concentrates entirely on the formal side of calligraphy, the other, *Shōdō*, is based on the views of Zen. Throughout the thesis the word *Shō* is used synonymously with *Shōdō*.

36 OMORI and TERAYAMA, 1990 (1983), p. 89.

37 Sutras are dogmatic explanations in Buddhist literature which often take the form of a dialogue. Since Zen rejects all dogmas, the use of Sutras can only be seen as inconsistent. The quotation of Sutras reflects Zen's' Buddhist origins.

38 SUZUKI, 1935, p. 30. Suzuki quotes this Sutra in several books he has written. Sāriputra was a pupil of Buddha.

39 SUZUKI, 1935, and SUZUKI, 1991 (1949/1934), p. 60. KADOWAKI formulated it as: "'Mu' is not something 'above people', but it is here and now, in the mind and in the body". Interview with Kakichi KADOWAKI in Tokyo on 26 October 1993.

40 In the stories about Zen Masters some Masters are, for instance, mentioned who tore up Sutras, burned a Buddha figure, or even gave the following advice: "If you meet Buddha, kill him".

41 Interview with Y. IWATA in Leiden on 24 May 1995.

42 He adds: "The addition of this suggestion in the viewer's mind is the actual *Mu* of the painting – the *Mu* which is the premiss of Satori". VOS, 1964, p. 147.

43 Interview with Kakichi KADOWAKI in Tokyo on 26 October 1993.

44 An example of the dynamic working method of the Zen Master is that of Nantembō. In 1916 Nantembō made a painting of two by over seven metres in front of an audience in the Kaisei-ji temple. He began by pulling up his robe, taking his brush in both hands and plunging it in a bowl of ink, he then got some-one to squeeze it out a little, took a deep breath and uttered a cry as he moved the brush over the paper with a sweeping gesture. As he applied his forceful brush-stroke the drops of ink splashed the faces of his audience. And, placing his final stroke, he suddenly kicked the brush and the ink flew in all directions, even staining the temple ceiling. ADDISS, 1989, p. 192.

45 SUZUKI, 1991 (1949/1934), pp. 75 and 132.

46 The emphasis on movement which is typical for Zen painting, rather than on the depiction of an image, is described in ROWLAND, 1954, p. 100, as a feeling which portrays the constant process of change.

Readers are referred with regard to 'quiet dynamism' to the aspect of 'emptiness and nothingness'.

YANAGI, 1972, p. 148, wrote regarding the connection between movement and rest: "an object ought to show motion in stability and stability in motion".

47 James Valentine, in his essay 'Dance Space, Time and Organization' in HENDRY, 1986, pp. 111-128 and p. 119, provides an interesting description of *Ma* as 'The Pause': "One may at the same time appreciate transient phenomena and yet wish to make them, or one's experience of them, last as long as possible".

48 Nishida in OHASHI, 1990, p. 137. Hajime SHIMOYAMA confirmed this in an interview on 10 October 1993 in Shizuoka-shi with the comment that space for the Western artist exists primarily in front of him, whereas for the Japanese artist space is around him.

49 With reference to that difference, I should like to mention Augustin Berque's essay 'The Sense of Nature' in HENDRY, 1986, pp. 100-108. Berque states, amongst other things (p. 103): "...the opposition between subject and object, between self and non-self, appears only at a certain level, while at another level both terms merge". The surroundings are, in his opinion, even more important than the subject, a phenomenon which he calls 'contextualism'. He contrasts with that the Western approach: "This culture less easily assimilates itself to nature because, fundamentally, the subject's spontaneous self-definition, or particularity, acts in opposition to the definition, or naturalness, of its environment".

A comparable view can be found in Jane M. Bachnik's essay 'Time, Space and Person in Japanese Relationships' in Ibid., pp. 49-75. This essay ends with the following comment: "In conclusion, it should be greatly significant to us that the Japanese perspective on social life focuses on the relationship *between* what we in the West have most often perceived as dichotomies".

50 Interview with Klaus RIESENHUBER in Tokyo on 22 November 1993.

51 SUZUKI, 1991 (1949/1934), p. 86.

52 SUZUKI, 1991 (1949/1934), pp. 83, 45 and 34.

53 HISAMATSU, 1971, p. 12.

54 SUZUKI, 1993 (1938/1927), p. 17.

55 SUZUKI, 1991 (1949/1934), p. 124.

56 See note 49, in which this quest is termed a typically Japanese characteristic.

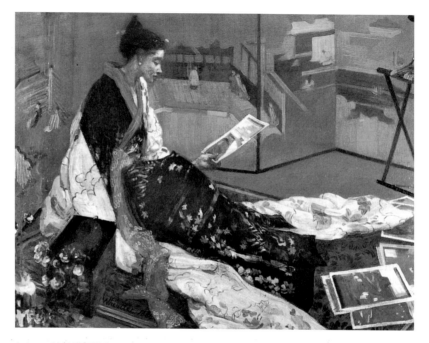

11. James McNeill Whistler, 'Caprice in Purple and Gold: The Golden Screen', 1864, oil on wood panel, 50.1 x 68.5 cm.
Courtesy of the Freer Gallery of Art, Smithsonian Institution, Washington D.C., no.F04.75a

West looks East
A short history

For many centuries people in the Western world were aware that there were cultures in the East with a different view of the world. They were not felt to be inferior, but wise and cryptic (on account of the views which were puzzling to Westerners). In the Bible, for instance, Matthew (2:1-12) refers to the arrival of the 'wise men from the East' to the place of Jesus' birth. However, we should bear in mind that over the centuries the geographical tenor of the 'East' shifted from the Middle to the Far East.

Yet in the West little effort was made, until the nineteenth century, to study the beliefs from the East seriously. Any publications there were, were read only in a small circle.[1] Moreover, the picture the Western texts gave of the Orient was rather a reflection of the prevailing Western culture than an objective portrayal of the East. This will still prove to apply to some extent in the twentieth century.[2] In the eighteenth century people's ideas about the East were primarily coloured by the French translation of *A thousand and one nights*. At the start of the nineteenth century interest grew among German intellectuals for wisdom from India, in particular. Friedrich Schlegel (1772-1829), the theoretical founder of the Romantic view of art and life, published *Über die Sprache und Weisheit der Inder* in 1808. The works of famous philosophers like Goethe, Novalis, Schopenhauer and Nietzsche also contained references to Indian Hinduism and Buddhism. In America a similar interest could be observed among Transcendentalists like Emerson and Thoreau. Their inspiration came partly from translations of Indian literature and partly by way of German philosophy. The Russian Helena Blavatsky (1831-1891) who lived in America and who was especially interested in Indian Buddhism, founded the Theosophical Society in 1875, with Henry Steel Olcott (1832-1907). One of their objectives was to unite East and West.[3]

In the twentieth century the holy books of Hinduism – the *Vedas*, *Upanishads* and *Bhagavad Gita* – continued to be held in esteem by various intellectuals and artists. At the start of this century important literature from China, such as the *I Ching* and the *Tao Te Ching* by Lao Tzu (a leading exponent of Taoism) was also published in the West.[4]

The surprisingly great enthusiasm for and admiration of the Buddhist religion and philosophy in the years preceding the First World War can be explained to some extent by declining church attendance and a yearning for 'Eastern wisdom'. It is especially true to say that this need for a new view of life and the world coincided with the emergence of countless idealistic and humanitarian movements, including not only Theosophy, as already mentioned, but also the peace movement, animal protection societies, vegetarianism and temperance movements.[5]

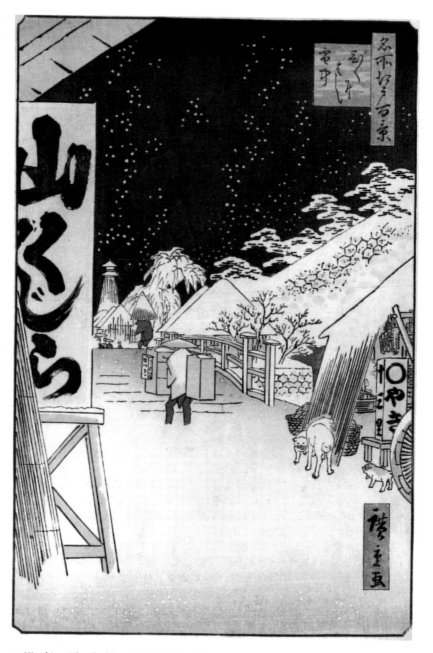

12. Hiroshige, 'Bikunibashi setchū' (The bridge Bikuni under the snow), 1858, woodcut, 35 x 23 cm.
Van Gogh Museum (Vincent van Gogh Stichting), Amsterdam

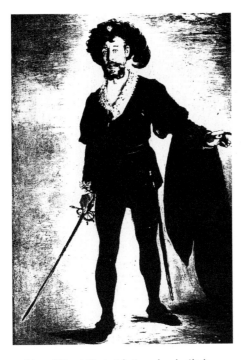

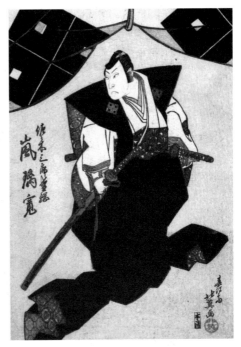

13. Edouard Manet, 'Portrait de Faure dans le rôle de Hamlet' (Portrait of Faure, playing the role of Hamlet), 1877, oil on canvas, 196 x 131 cm. Folkwang Museum, Essen

14. Shunkosai Hokuei, 'Sasaki saburo moritsuna arashi rikan' (The actor Arashi Rikan II playing the role of Sasaki Saburo), circa 1835, woodcut, 37 x 25.5 cm.

From the start of the twenties, the West began to notice the philosophy of Zen Buddhism thanks to the essays published from 1921 onwards by Daisetz T. Suzuki in the English-language magazine *The Eastern Buddhist*.[6] Before discussing Western publications on Zen, I should first like to focus on a different aspect, as the close ties between religion, philosophy and art in Zen produced an overlap with another development.

In the seventeenth century, interest in Japan's material culture had grown in the West. Japanese arts and crafts were especially popular, thanks to the trade by the Dutch VOC (East India Company). Lacquerwork, porcelain and kimonos were particularly favoured. Western knowledge of Japanese culture was very limited until the eighteen-sixties, because very few people had had the opportunity to visit Japan.[7] In 1867 Japan was represented for the first time at the world exhibition held in Paris, after trade had been restored with other countries after more than two centuries. Subsequent world exhibitions provided an even clearer picture of Japanese culture.[8] The great interest in Japan among Parisians at that time led the French art critic Philippe Burty to conceive the term 'Japonisme'.[9]

In the eighteen-sixties the American artist James McNeill Whistler (1834-1903), who was then living in Europe, was one of the first to make a serious

study of Japanese art (ill. 11). In 1863 he started collecting Japanese woodcuts (called *Ukiyo-e*[10]) (ill. 12), kimonos, porcelain and fans, also painting many of these objects. The French artist Felix Bracquemond (1833-1914) actually discovered Japanese art before Whistler did. In 1856 he found the book *Manga* by the Japanese artist Katsushika Hokusai (1760-1849) in the shop of the printer Delâtre. It is a book (from a series with the same title) containing over a hundred sketches of everyday life. These pictures were to be copied and used as a source of inspiration in following decades by various French artists.[11]

Many artists, both in France and in other Western countries, used formal aspects of *Ukiyo-e* to liberate themselves from the traditional concepts of academic painting.[12] In their work, planes of bright colours and flat backgrounds

15. Vincent van Gogh, 'Japonoiserie', 1887, oil on canvas, 55 x 46 cm.
Van Gogh Museum (Vincent van Gogh Stichting), Amsterdam

16. Alfred Kubin, illustration
in *Der Blaue Reiter*, 1912

17. Katsushika Hokusai, print from *Manga*, 1814-78, woodcut

took over from the suggestion of depth. A scant use of shadow also gave their paintings a more decorative character. A diagonal composition was all that was used to suggest depth. A new element was 'cropping'. Edouard Manet (1832-1883) (cf. ills. 13 and 14), several Impressionists, like Claude Monet and Edgar Degas, and Vincent van Gogh were artists who applied these aspects in their paintings. Vincent van Gogh (1853-1890) (ill. 15) acquired an interest in the Japanese arts thanks to both Japanese woodblock prints and Pierre Loti's book *Madame Chrysanthème*. The Japanese influence in his work was very varied.[13]

However, like the previously mentioned artists, Van Gogh was only influenced by the formal features of Japanese art.

Japanese woodcuts were also a source of inspiration for several Symbolists. The French artist Odilon Redon (1840-1916) and the German artist Alfred Kubin (1877-1959) might well have been familiar with the famous book *Manga* (cf. ills. 16 and 17).[14] Moreover, Redon was also interested in Oriental religions. Some of his work from the first decade of the twentieth century contains a Buddha figure (ill. 18).

From the end of the nineteenth century some artists and art lovers began to develop an interest for *Sumi-e* and other Zen arts, and their relationship with the Japanese view of life.[15] And this was the 'overlap' between the two developments which had come about with time: the awareness of 'wisdom from the East' and the interest in material Japanese culture. The work and ideas of the artist Wassily Kandinsky from the early part of the nineteen-tens are a clear example of the changing perception of Japanese art.

Kandinsky: a new perception of Japanese art

At the end of the nineteenth century interest in Japanese art in Munich, as in Paris, consisted mainly of the collection of Japanese woodcuts. Like their French colleagues, the Munich artists were using various formal characteristics of these prints as examples for their own work. The artist Emil Orlik (1870-1932), who was living in Munich at the end of the nineteenth century, was one of the leading collectors of Japanese prints in Germany. He was in Japan from 1900 to 1901, and from 1911 and 1921. His vast collection of *Ukiyo-e* and the knowledge of Japanese art he passed on to other artists meant that Orlik was seen as an important stimulator of Japonisme in the visual arts in Germany.[16]

18. Odilon Redon, 'L'Intelligence fut à moi! Je devins le Buddha' (the spirit came to me, I became a Buddha), 1895, litho, 32 x 22 cm.

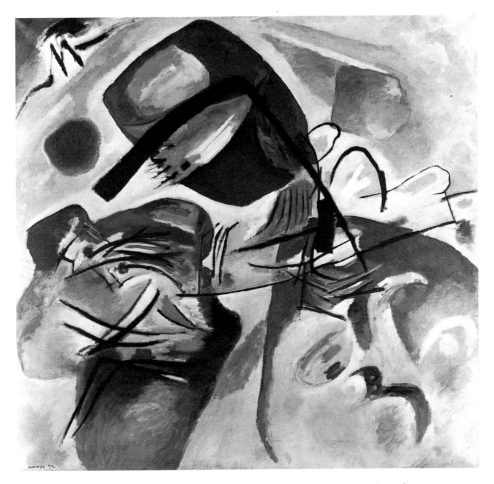

19. Wassily Kandinsky, 'Mit dem schwarzen Bogen' (With the black bow), 1912, oil on canvas, 189 x 198 cm. Collection Centre Georges Pompidou, Paris

Other artists who were living in Munich – Eugen Kirchner (1865-1938) and Hans Schmithals (1878-1969) – also owned large collections of Japanese woodblock prints. And they, like Orlik, adopted some of the formal aspects from works in their collections. From around 1900 onwards Alfred Kubin drew particular inspiration from Hokusai's woodblock prints in *Manga*.[17]

Wassily Kandinsky (1866-1944), who lived from 1908 in Munich, knew both Kubin and Orlik well, for instance from the Neue Künstlervereinigung. He was particularly interested in Japanese prints in the period at the turn of the century, but his interest would seem to have taken a different course following an exhibition of Japanese ink paintings (ill. 19).

In the summer of 1909 an exhibition entitled 'Japan und Ostasien in der Kunst' was held in Munich. It featured paintings, woodblock prints and sculpture, as well as crafts and books. Museums in Berlin and Cologne and a num-

ber of private individuals had lent parts of their collections for the exhibition.[18] It was the first large retrospective of Japanese art in Europe. Prior to that there had only been small exhibitions in various museums.[19] The Munich exhibition attracted a great many visitors, even from outside Germany. Ulrich Weisner, the present chief curator of the Museum of East Asian Art in Cologne, confirmed the importance of the exhibition, as implied in the catalogue. He maintains that it can be considered as a milestone, since it promoted awareness of Japanese art in Europe.[20]

Wassily Kandinsky was one of the many visitors. He described his personal impressions in an article for the Russian magazine *Apollon*.[21] He started the article, entitled 'Letter from Munich', with a description of the artistic climate in that city. Paintings in exhibitions seemed to him to be for ever the same, and he regarded them in their entirety as a chronic wilderness. He expressed his hope that the Neue Künstlervereinigung (in which he was personally involved) would be able to change the situation. In the latter part of his 'Letter' he described the impression the 'Japan und Ostasien in der Kunst' exhibition had made on him.

Since this reaction was an important source in the research into the significance of Japanese art for Kandinsky, the passage in which he formulated his personal opinion is quoted here in full:

"Here (...) one finds landscapes of tremendous variety and abstraction in the use of form and colour, subservient to the feeling of rhythm which is the pure expression of a unique, fully artistic temperament. Again and again; so much of what belongs to Western art becomes clear when one sees the infinite variety of the works from the East, which are nonetheless subordinated to and united by the same fundamental 'tone'! It is precisely this general 'inner tone' that is lacking in the West. Indeed, it cannot be helped: we have turned away, for reasons obscure to us, from the internal to the external. And yet, perhaps we Westerners shall not, after all, have to wait too long before that same inner sound, so strangely silenced, reawakens within us and, sounding forth our innermost depths, involuntarily reveals its affinity with the East – just as in the very heart of all peoples – in the now darkest depths of the spirit, there shall resound one universal sound, albeit at present inaudible to us – the sound of the spirit of man".[22]

As yet, Peg Weiss would seem to be the only one to have paid attention to Kandinsky's 'Letter' in a publication. Weiss believes that the article demonstrates that the exhibition had made a great impression of Kandinsky. Nevertheless, she does not examine any possible influence of the exhibition on his work.[23]

Rose Long and Will Grohmann, both of whom have conducted considerable research into Kandinsky's early work and theories, make no mention in their biographies of his enthusiastic reaction to the Japanese exhibition. However, Long does frequently refer to the year 1909 as a point at which his work changed radically, but does not look for significant impressions he experienced in 1909.[24] Grohmann suggests in his biography associations with Zen Buddhism, without any reference to the exhibition or any other occasion on which Kandinsky might have become acquainted with Zen.[25]

Cäcilie Graf-Pfaff wrote an article in the *Münchener Jahrbuch der Bildenden Kunst* as a follow-up to the exhibition. She formulated some of the characteristics of the works on display. Her comments "...the pure, spiritually induced, artistic impression..." and "the mere interiority, of which form is a pervasive thought (...) for everything has a soul..." display remarkable similarities with Kandinsky's personal reaction.[26] Graf advised readers to change their attitude:

> "That world of art (...) will come closer and its magic will touch us more and more if we try to immerse ourselves in that distance (...) and free ourselves from the artistic pursuits of our time which are directed solely at the fleetingly decorative effect".[27]

The attitude she hoped the reader would develop is comparable with the characteristics Kandinsky described in his 'Letter' as being desirable for Western Man. So far there is no specific evidence that he acquired information from publications, connoisseurs or collectors regarding other people's ideas of the exhibited works or the motivations of Japanese artists.

In his book *Über das Geistige in der Kunst* Kandinsky described his theory of the *Innere Klang* (inner sound), which he felt was missing in the art of his time.[28] Although the book was not published until 1912, it is unlikely that the exhibition of art from Japan and the Far East generated the idea of the *Innere Klang*. According to Armin Zweite and Jessica Boissel, amongst others, he is thought to have completed the text for the book in the autumn of 1909, after a few years of work on it.[29] So we can assume that he was already interested in the idea of *das Geistige* prior to his visit to the Japanese exhibition. However, his reaction to it suggests that it constituted for him the expression, in practice, of what he was involved with, in theory, at that time.

Kandinsky's own woodblock prints with which he illustrated his book (ill. 20) are from 1911 and called 'Vignette'.[30] That means that Kandinsky had not made them when he was completing his text in 1909 – so the woodcuts certainly date from after the exhibition.[31]

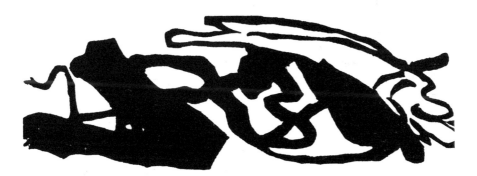

20. Wassily Kandinsky, illustration in *Über das Geistige in der Kunst*, 1911, woodcut

21. Illustration in *Der Blaue Reiter* of Japanese ink painting

Some months after his first book he published the Almanac *Der Blaue Reiter*, together with the artist Franz Marc (1880-1916). The Almanac contained illustrations of work from different cultures. Between the texts there are, in all, seven examples of Japanese work (ill. 21).[32] The texts did not refer specifically to the Japanese drawings, but several remarks by Kandinsky would seem to refer to their simplicity and abstraction, for example:

"...the abstract life of objective forms that have been reduced to a minimum – hence the noticeable predominance of abstract elements – reveals in the surest way the inner sound of the picture".[33]

Kandinsky's woodblock prints in his book *Über das Geistige in der Kunst* exhibit striking similarities as regards line and dynamism with the Japanese illustrations in *Der Blaue Reiter*. He concluded the former book with the pronouncement that the era of great spirituality had begun.[34] In his first 'Letter from Munich' he had announced this era as one of the 'inner sound', characterized by what 'will prove to be an element related to the East'.

Will Grohmann seems to have been alone in associating Kandinsky's focus on interiority and the blurring of the distinction between body and spirit with the 'inner' Man in Zen.[35] Moreover he associates Kandinsky's ideas on Man's identity, the universe and the inner heaven, with Zen Buddhism. Grohmann believes that the 'sensory contemplations' which are inborn in people from the Far East, fitted better in Kandinsky's world than the inborn thought processes of Westerners. However, he is of the opinion that the connections with Oriental art emerge most clearly during Kandinsky's Bauhaus period.[36]

Kandinsky's emphasis on spiritual freedom, which he believed was just as important in art as in life[37], is comparable with the quest in Zen Buddhism for freedom of spirit. Daisetz T. Suzuki writes that Enlightenment, the highest goal of Zen, means emancipation or freedom, and that Man must realize that he is also free within.[38] When *Satori* is reached, Suzuki believes that paintings are made 'which vibrate in spiritual rhythm'.[39] Art is felt only to be possible when there is absolute freedom, because without that freedom there cannot be creativity.[40] According to Sixten Ringbom freedom is one of the most important characteristics of the era of Great Spirituality which Kandinsky expected – an unlimited freedom which will enable us to perceive the inner sound of things.[41]

Although no precise moment can be indicated when Kandinsky began his efforts to depict the *Innere Klang* in his visual art, 1909 is the year mentioned in almost all the literature studied – the year in which he started his 'Improvisations'.[42] Since he was still painting many 'traditional' townscapes of Murnau in that year too, it is likely that he began his experiments halfway through the year (coinciding with the exhibition of Japanese and Oriental art).

Between 1909 and 1914 he painted 35 works entitled 'Improvisations'. His own description of these works reads as follows: "Primarily unconscious, largely sudden expressions of processes of the character within, so impressions of the 'inner nature'. I call them 'Improvisations'".[43] This description is remarkably similar to his description of the Japanese works at the exhibition in Munich. The word 'sudden' is somewhat unusual in Western art history. In Zen Buddhism, and in the Japanese *Rinzai* sect in particular, the most important goal is the 'sudden' attainment of *Satori*. The creation and contemplation of Japanese ink paintings serve as a means to achieve this Enlightenment, and once it has been reached, the painting process and the paintings continue to play a role as exercises. This spiritual goal of painting, rather than the Western, formal goal, was probably what Kandinsky observed in the Japanese paintings, calling it *Innere Klang*.

The literature I studied in my research regularly makes a connection between Kandinsky and the East, by way of Theosophy. Long, and more especially Ringbom describe his interest in the Theosophical Society. They suggest that Kandinsky primarily encountered Theosophy through Rudolf Steiner, who lived in Munich and had been the leader of the German Theosophists since 1902. Steiner believed that the next society would be a mixture of East and West.[44]

Jean Cassou believes that Kandinsky's Asian origins explain why he was 'different'. His family had moved from the east of Siberia to Moscow.[45] In the *Bayerische Kurier* a critic described Kandinsky in 1914 as the embodiment of the Asian mind, expressing the hope that this Asiatic 'disintegration' would be repulsed by Europe.[46] However, it is impossible to state categorically that his interest in the 'Far East' could partly have been explained by his own origins.

Kandinsky, like the nineteenth century 'Japonistes', integrated various aspects of the Japanese woodcut in his work, though admittedly in his own way. According to Hans Roethel he was applying several technical aspects of the Japanese woodcut around 1903 in his own polychrome woodblock prints.[47] However, he does not specify when Kandinsky first encountered Japanese prints. Emil Orlik, who travelled to Japan in 1901 to learn the woodcut technique, had an exhibition at the Berliner Sezession with Kandinsky. And that might have been Kandinsky's first encounter with Japanese prints.[48]

Striking features of Japanese woodblock prints are the dominating black lines and the autonomous expression of colour and line. Several Post-Impressionists, like Vincent van Gogh, used only the black contours of Japanese prints in their paintings. Kandinsky's striking black lines, which were not tied to the fields of colour, have more in common with the lines the Japanese placed independently and expressively in the colour fields of the woodcuts and in the sketches preceding the actual woodcut.[49] Kandinsky also

saw the combination of merging slabs of colour with contrasting expressive black lines used in the ink paintings at the Munich exhibition. There were works on display by Sesshū, for instance, and by his pupil Sesson (1450-1506). Sesshū had developed the *Haboku* technique in Japan. Paintings in that technique look as if they are built up of 'stains' which contrast sharply with the forceful lines, plus the fact that an undefinable space comes about. Kandinsky's technique, particularly in his abstract watercolours, resembles that of *Haboku*. His work also had a comparable indefinable or 'atmospheric' space. He probably first used 'paint stains' in his first abstract watercolour dating from 1910.[50]

In this section I have applied both formal and theoretical analogies to take stock of what I surmised was the Japanese influence in Kandinsky's 'early' work. This survey does not aim to demonstrate that the Japanese source was his prime inspiration, but merely to draw attention to the fact that Kandinsky's interest in Japanese art differed from that of the nineteenth century 'Japonistes'.

The Zen arts did not only appeal to artists. The popularity of *The Book of Tea* by Kakuzo Okakura which was published in America in 1906 and appeared twenty years later in a French translation, confirms that the Zen arts were growing in popular appeal.

The number of publications on Zen and the Zen arts increased considerably in the course of the twentieth century. In 1922, a year after Suzuki's first publications on the subject, Arthur Waley's *Zen Buddhism and Its Relation to Art* and Ernst Grosse's *Die ostasiatische Tuschmalerei* were published. In the thirties important publications on Eastern religions followed, by Rudolf Otto in Germany and Ananda Coomaraswamy in America. However, their work tended to focus more on the religions of India. Suzuki's first series of essays on Zen was published in book form in 1927, by the publishers Luzac and Company in London. And in subsequent years many other books by this Japanese scholar were distributed via the English capital. From 1949 onwards his books were also published in New York, but the books from London were available in America as well. German and French translations of a number of works were published in 1939 and 1941, respectively. In the fifties not only were Suzuki's works an important source of information on Zen in various Western countries, but also Eugen Herrigel's 1948 publication *Zen in der Kunst des Bogenschießens*. This book also appeared in English and French translations in the early fifties.[51]

As the following chapters will reveal, Zen's popularity was growing in the fifties, in the United States of America, France and Germany. Although my research has focused on those countries, plus Japan, other countries also prove to have displayed an interest in Zen. In the Netherlands, for instance, the founding of the 'Zengroep Nederland' was announced in 1960.[52]

Notes

1 The Venetian merchant Marco Polo (1254-1324) was the first important European writer to describe the Far East (though lately doubts have arisen as to whether he actually visited China himself). A researcher of note in the period around 1700 was Gottfried Wilhelm von Leibniz (1646-1716). He was interested in what in those days, according to DAWSON, 1973 (1964), p. 384, was considered to be 'the natural religion' of the Chinese. Leibniz wrote that he felt it to be almost essential that Chinese missionaries be sent to the West to teach the goals and practices of natural theology.

In 1716 Engelbert Kaempfer, a doctor, published a book in High German on the history of Japan. He had lived in that country between 1690 and 1692. In 1727 the book was published in English as *History of Japan*. According to VERSLUIS, 1993, p. 17, it was the first publication mentioning Zen in a Western language. However, Kaempfer's book was only known within a small circle.

2 SAID, 1979 (1978), describes in detail in his book how the West's picture of the Orient was determined and adapted, as changes took place in Western culture. With this he wishes to point out how subjective our view is of the Eastern world.

3 An important aim of the Theosophical Society was to stimulate the comparative study of religions, philosophies and sciences.

4 The *I-Ching* ('Book of Changes'), containing oracles with philosophical explanations, which had, for many centuries, formed the basis for cosmological speculations, is described by VOS, 1964, p. 43, as the most impenetrable text of the Chinese literature.

5 VOS, 1964, p. 225. Vos even describes that passion as a 'frequently fanatical and unrealistic' longing for Oriental wisdom. Within the framework of my research, an additional interesting comment by Vos is also worth quoting: "If Zen had been known here [in the Western world of that time], it would not have been fitting for the times". And that remark will be confirmed by the history of Zen's introduction in America. See the chapter entitled 'The unity between West and East: American artists and Zen'.

The interest in the spiritual in the period between 1900 and 1915 is described in the catalogue *Okkultismus und Avantgarde*, FRANKFURT 1995.

6 See note 1 for an example of an eighteenth century publication mentioning Zen. I have recently concluded that the book *The Religion of the Samurai* by Nukariya Kaiten, which was published back in 1913 in London, should be seen as the first publication on Zen in the West.

7 The Dutch were the only Westerners who were allowed to trade with Japan, from the island Deshima, and so many Japanese goods, including lacquerwork, kimonos and porcelain, were imported via the Netherlands.

8 Catalogue *Le Livre des expositions universelles*, PARIS 1983, pp. 297-304.

9 G.P. Weisberg writes, in the catalogue *Japonisme*, CLEVELAND 1975, pp. xi and 15: "'Japonisme' was first used by the art critic Philippe Burty, 'to designate a new field of study – artistic, historic and ethnographic'...".

10 *Ukiyo-e* means 'pictures of the fleeting world', i.e. 'genre paintings'. There is a difference between *Nikuhitsu Ukiyo-e* (hand-painted genre paintings) and *Ukiyo-e Hanga*, the prints. VOS, 1964, p. 150. The word *Ukiyo-e* when used in Western writings on art history refers to the latter group. And so it should be interpreted as such with respect to Whistler, and to descriptions in the texts that follow.

11 Catalogue *Japonisme*, CLEVELAND 1975, p. 22. French artists who used *Manga* as a source of inspiration included Edgar Degas and Paul Gauguin.

12 WICHMANN, 1981 (1980), p. 9. See also the chapter 'The Zen arts in France'.

13 WICHMANN, 1981 (1980), pp. 40-44, wrote that Van Gogh attempted to imitate, amongst other things, the angular lines in varying thicknesses in Hokusai's woodcuts, by using reed pens on Japanese paper, and making a self-portrait following the example of portraits of Japanese monks. Van Gogh also copied several Japanese woodcuts in oils (ill. 15).

Gerald Needham wrote in the catalogue *Japonisme*, CLEVELAND 1975, p. 128: "His Japonisme was consequently more extensive and more complex than that of any other artist of the period".

14 WICHMANN, 1981 (1980), p. 269 made that suggestion.

Gerald Needham remarked in the catalogue *Japonisme*, CLEVELAND 1975, p. 129, that Redon was the only French artist who was inspired by the 'horrifyingly grotesque', which was felt to be an important element in Japanese art.

See also the introductions to the following chapters on American, French and German art in the fifties.

15 See the next chapters.

16 WICHMANN, 1981 (1980), p. 234, is of the opinion that Orlik played an important part in the great interest in Germany for Japanese woodcuts, thanks to his large 'Ukiyo-e' collection. In addition, his practical studies into the 'Ukiyo-e' technique are also felt to have generated considerable interest.

17 See p. 32.

18 The exhibition 'Japan und Ostasien in der Kunst', which was held in the exhibition centre beside the Glaspalast was organized at the initiative of the artists Oskar and Cäcilie Graf-Pfaff, and Prince Rupprecht von Beieren, a collector of Oriental art. One of the contributors and a collector of Oriental art, A. Fischer, lent part of his collection. In an article written in 1909, entitled 'Die Münchener Ausstellung Ostasiatischer Kunst', he reviews the exhibits and provides information on the owners of the collections. Neither the catalogue nor the articles on the exhibition make mention of when the exhibition actually began and ended. They refer to 'the summer of 1909'.

The exhibition catalogue listed all 1276 exhibits, and contained several articles by various authors, including Cäcilie Graf-Pfaff and the Japanese professor T. Uno. The articles traced the history of Japanese art.

19 In her foreword to the catalogue, Cäcilie Graf suggests that this was the reason why Europeans knew so little about Japanese art. Thanks, amongst others, to the French Impressionists, the Japanese woodcut had, in her opinion, meanwhile become more widely known. She also observed that in the applied arts (Jugendstil and Art Nouveau) Japanese decorative elements had been in use for several decades. However, she maintained that there was little awareness among Europeans of Japanese art and culture, and painting in particular. Catalogue *Japan und Ostasien in der Kunst*, MUNICH 1909, pp. 7-10.

20 In an interview in Cologne on 5 December 1990, Ulrich WEISNER recounted the great importance of the exhibition. In 1909, the year of the exhibition, Adolf Fischer, one of the participating collectors, founded the Museum of Oriental Art in Cologne.

21 The monthly magazine *Apollon* was edited by Sergei Makovsky. The first issue was published in October 1909. *Apollon* was primarily a literary magazine. Each number contained a literary almanac (including poetry, essays and short plays). In addition, each number contained large sections on art and music, and long reviews and discussions of exhibitions. A number of foreign correspondents discussed exhibitions in various West European cities. Kandinsky was the correspondent for Munich, writing five articles entitled 'Letter from Munich' (pis'mo iz Miunkhena).

22 KANDINSKY, 1909, p. 20. Kandinsky's 'Letter from Munich' of 3 October 1909 in the magazine *Apollon*, pp. 19 and 20, was translated from Russian for this research by S. Thorn-Leeson.

23 Weiss in 'Kandinsky. Begegnungen und Wandlungen' in the catalogue *Kandinsky und München*, MUNICH 1982, p. 65. Armin Zweite only mentions in his 'Vorwort' in this catalogue the existence of the 'Letters' to illustrate Kandinsky's appreciation of French artists. He concludes his list of the French artists in question (Ibid., p. 10) with "... and exhibitions of East Asian art".

In the publication of Kandinsky's entire written oeuvre, the editors Kenneth Lindsay and Peter Vergo wrote commentaries to the various series of publications. The explanatory text accompanying 'Letters from Munich' makes no mention of the fragment relating to the exhibition 'Japan und Ostasien in der Kunst' in 1909. So the following comment on his 'Letter' on the exhibition of Eastern art in 1910 is all the more remarkable: "Kandinsky's detailed account, in the last 'letter' of the large summer exhibition of Eastern art held in Munich in 1910 is (...) valuable, especially for his remarks concerning the 'inner life' of ancient art (...)". That exhibition comprised mainly Persian art. LINDSAY and VERGO, 1982, p. 55.

24 LONG, 1980, pp. IX, 10, 88 and 101.

25 GROHMANN, 1958, p. 84

26 "...Die echte seelisch bewegte künstlerische Impression..." and "Gerade die Innerlichkeit, der die Form durchdringende Gedanke ist (...) den alles hat ja eine Seele..." GRAF-PFAFF, 1909, p. 109. In her article 'Aus der Gestaltenfeld der Kunst Ostasiens' in the catalogue *Japan und Ostasien in der Kunst*, MUNICH 1909, p. 102, she also makes a comparable remark: "Das kleinste Blatt, ein Blütenzweig, eine Welle, war von einem inneren Sinn beseelt".

27 "Jene Kunstwelt (...) wird uns näher kommen und ihr Zauber uns mehr und mehr ergreifen, wenn wir versuchen, in (...) jener Ferne

unterzutauchen und uns frei zu machen von den auf flüchtig decorative Wirkung allein abzielenden Kunststrebungen unserer Zeit". GRAF-PFAFF, 1909, p. 125.

28 This chapter would be unnecessarily long if Kandinsky's ideas of the 'Innere Klang' were to be dealt with. More information on his theories can be found in his book *Über das Geistige in der Kunst*.

29 Zweite in the catalogue *Kandinsky und München*, MUNICH 1982, p. 172, and Boissel in 'München und Murnau 1908-1914' in the catalogue *Kandinsky*, PARIS 1984, p. 72. In his foreword to the second edition of *Über das Geistige in der Kunst* Kandinsky mentioned that he had written the book in 1910. Later that proved to have been 'revised', not 'written'.

30 ROETHEL, 1970, explanations accompanying 'Vignette'.

31 Sadly the literature I studied on *Über das Geistige in der Kunst* did not discuss the illustrations. That refers in particular to the extensive papers by LONG, WEISS, GROHMANN and RINGBOM.

32 The editors of the 1965 reissue of *Der Blaue Reiter* almanac added to the explanation of the Japanese illustrations, the remark that they could have been European copies. One of the woodcuts is thought to have been made in 1818 after a drawing by Korin (1658-1716). Two works are assumed to be original sketches by Hokusai.

33 "... [die] auf das Minimale reduzierten gegenständlichen Formen und also das auffallende Vorwiegen der abstrakten Einheiten entblößt am sichersten den inneren Klang des Bildes". KANDINSKY, 1965 (1912), p. 155.

34 KANDINSKY, 1973 (1912), p. 143, writes in the final sentence of his book: "... daß dieser Geist in der Malerei im organischen direkten Zusammenhang mit dem schon begonnen Neubau des neuen geistigen Reiches steht (...) da dieser Geist die Seele ist der Epoche des großen Geistigen".

35 GROHMANN, 1958, p. 84.

36 GROHMANN, 1958, p. 158.

37 MEYERS, 1957, p. 208.

38 SUZUKI, 1959 (1949/1934), p. 6.

39 SUZUKI, 1959 (1949/1934), p. 22.

40 SUZUKI, 1959 (1949/1934), p. 44.

41 RINGBOM, 1970, p. 115.

42 According to Werner HAFTMANN, 1954, p. 94, the important shift in Kandinsky's work started around 1900, under the influence of Jugendstil and Post-Impressionism. In both of those movements some Japanese influence is in evidence.

43 "Hauptsächlich unbewußte, größtenteils plötzlich entstandene Ausdrücke der Vorgänge inneren Charakters, also Eindrücke von der 'inneren Natur'. Diese Art nenne ich '*Improvisationen*'". KANDINSKY, 1973 (1912), p. 142.

44 LONG, 1980, pp. 16, 27 and 28. In 1909 Steiner gave a series of lectures entitled 'Der Orient im Lichten des Okzidents' (The East in the light of the West). Long maintains that Kandinsky did not acquire the texts of the lectures until 1911. Ibid., p. 27. Long states that Kandinsky received the text in March 1911 from E. Dresler.

45 Cassou in 'Kandinsky in France' in the catalogue *Kandinsky 1866-1944*, NEW YORK 1962, p. 27.

46 Article in *Bayerische Kurier* of 23.1. 1914, quoted by Zweite in the catalogue *Kandinsky und München*, MUNICH 1982, p. 141.

47 ROETHEL, 1970, p. XXIII, is referring to the merging of tones within the slabs of colour. This was a typically Japanese technique.

48 ROETHEL, 1970, p. XXIII.

49 Comparison of the preliminary study of 'Improvisation 7' with Hokusai's woodblock print 'The Wave', reveals some striking similarities. They might be coincidence, but Kandinsky certainly knew the Hokusai print. It was one in the series '36 views of mount Fuji'. Individual prints from the series, as well as the entire series, bound and in book form, were on display at the exhibition 'Japan und Ostasien in der Kunst'. Moreover, many artists were already familiar with the '36 views of mount Fuji' series even before the exhibition.

50 Nowhere, in any of his publications, did he write about the use of 'paint stains'. Gilbert Lascault, in 'Autour de la Vache (1910)' in the catalogue *Kandinsky*, PARIS 1984, p. 30, commented that the artist did use the word 'stain' in many titles, for example 'Black Stain 1' of 1912, 'Red Stain' of 1913 and 'Painting with three Stains' of 1914. Lascault did not use this observation to draw a comparison with the Japanese painting technique, but to highlight the similarity with the 'Tachistes' in the nineteen-fifties.

51 This essay was published in Germany in 1936, in the magazine *Nippon*, and in 1948 in book form. See the chapter 'Release through Zen and German art'. In 1953 French and English translations were published.

52 See Appendix 3.

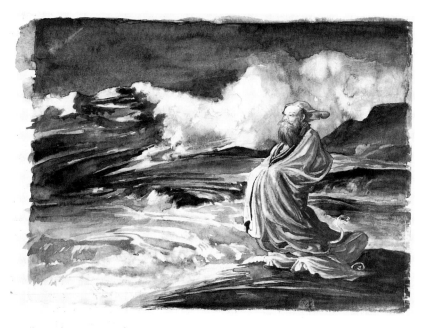

22. John La Farge, 'A Rishi Calling up a Storm, Japanese Folklore', 1897, watercolour on paper, 33 x 40 cm. The Cleveland Museum of Art, Cleveland, Ohio. Purchased from the JH Wade Fund, 1939.267

23. Hokusai, print from *Manga*, 1814-78, woodcut

The unity between West and East
American artists and Zen

The painting style and methods of the American Abstract Expressionists from the late forties and the fifties call forth associations with *Shō* and *Sumi-e*. The directness, the importance of the physical element and the calligraphic gestures present in the Action Painters' works are specifically elements which lead one to reflect on a possible connection with *Shō*.[1] And at the same time the meditative empty expanses in the Colour-field Paintings and in *Sumi-e* also elicit comparisons.

In the fifties there was indeed an interest in Zen and the Zen arts in America. Although artists like Jackson Pollock and Willem de Kooning play a prominent part in almost all research into the art of their day, other artists prove to have been more important as regards the Japanese interest. A dozen different artists who had an affinity with Zen will be mentioned in the course of this chapter. However, three in particular will receive special emphasis. They had a pronounced interest in Zen, worked in a different style, and also played a considerable part in the art of the fifties. An important pioneer in the focus on Zen was Mark Tobey, who had spent a month in a Zen monastery in Japan back in 1935. His work can be described as 'art of the calligraphic gesture'. The artist and composer John Cage, who was involved, amongst other things, in 'living art', was not only interested in Zen, but also discussed it with a great many people. The third artist who will be playing a leading part in this chapter is Ad Reinhardt. His interest in philosophies from the Far East also affected his visual works, which count as examples of 'art of the empty field'. Franz Kline will also be discussed briefly. Compared with the other three painters he had little affinity with Zen, but in a sense was closer to nineteenth century Japonisme. Moreover, if we are to appreciate the affinity with Zen in the fifties, we must take up the thread in the nineteenth century, with the then prevailing interest in Japan.

In 1856 the artist John La Farge (1835-1910), who lived in New York, began collecting Japanese art. His own paintings from 1864 onwards were inspired both by Japanese woodblock prints (cf. ills. 22 and 23), and by Japanese ink paintings, gold screens and porcelain.[2] Towards the end of the nineteenth century various American artists were painting 'Japonistic' work (ill. 24)[3], influenced by French Japonisme, La Farge's work and that of the Japanese prints which were available in America.

At that time, too, a number of scholars in Boston developed a fascination with Japan. The philosopher Ernest Fenollosa (1853-1908), who had assembled a large collection of art objects in Japan, became an important focus for American artists in the late nineteenth and the twentieth century who were

24. William Merritt Chase, 'Hide and Seek', 1888, oil on canvas, 70.1 x 91.1 cm.
The Phillips Collection, Washington D.C.

interested in Zen painting.[4] When he was returning to America in 1890 the emperor of Japan instructed him to bring Japanese culture to the notice of the Americans, in the same way as he had pointed out the importance of their traditional art to the Japanese during his stay.[5] The request coincided with Fenollosa's own goal: the unity between East and West.[6] The strategy he selected was that of 'art education'. It entailed organizing exhibitions of Japanese art and acquainting the American public with a form of aesthetics, which, he believed, could become universal. His ideas on 'art education' were converted into a practical method by Arthur Wesley Dow (1857-1922)[7], who published it in 1899, calling it *Composition, A Series of Exercises Selected From a New System of Art Education*. The illustrations, apart from Japanese woodcuts, also included work by Sesshū. Thanks to Dow's book, of which thirteen editions were published before 1931, many Americans became acquainted with the principles of Japanese painting.[8]

The attempts to reform American painting in this way had some remarkable successes. L.W. Chisolm demonstrates in his biography of Fenollosa how great the influence of Japanese art was on education around 1900: "... the influence of Japanese art began to be discernible in the exhibitions of drawings of

25. Georgia O'Keeffe, 'Blue Lines no.10', 1916, watercolour on paper, 63.3 x 48.1 cm.

public school children" and "in the minds of many educators Japanese art stood for liberation from colorless pencil drawing". [9] It is hard to say exactly just how great an impact Fenollosa and Dow had. The consequences of reforms in the teaching of drawing in primary education are hard to research, but the drawing classes every artist had at primary school could be termed an 'unconscious legacy'.

Several artists reacted directly to Fenollosa's and Dow's work.[10] In 1914 Georgia O'Keeffe (1887-1986), whose work was to spark off Mark Tobey's interest at a later stage, studied with Dow. In 1903 Dow had been appointed director of Fine Art in Teachers' College Department of Columbia University. O'Keeffe had read Fenollosa's life work *Epochs of Chinese and Japanese Art*, and hoped to learn more from Dow about his views. She began experimenting with the Japanese *Sumi-e* technique around that time. In 1916 she made 'Blue Lines' (ill. 25), a watercolour in a series of works comprising only some spots or lines, writing about it: "there were probably 5 or 6 paintings of it with black watercolor before I got to this painting with blue watercolor that seemed right".[11] Fenollosa's love of the expressive Japanese line probably inspired her to make several works of this kind.

In around 1916 O'Keeffe came in contact with Alfred Stieglitz and his artist friends who ran the avant-garde 291 gallery and published the magazines *Camera Work* and *291*. Even before these artists had met O'Keeffe, they had an interest for the Far East. However, it was primarily for Japanese woodcuts, continuing the interest which had existed at the end of the nineteenth century. Stieglitz was apparently especially fascinated by the Japanese aesthetics of simplicity, abstraction, evocative empty spaces and vertical formats.[12] The Japanese influence in a number of works by his friends Max Weber, Arthur Dove [13] and John Marin[14], resembles in some respects that in Stieglitz's own work. Furthermore, Weber, like O'Keeffe, was not only an admirer of Fenollosa's work, but was also one of Dow's pupils.

Mark Tobey, John Cage and Ad Reinhardt

Mark Tobey (1890-1967)

In the period between 1910 and 1930 the artist Mark Tobey often lived and worked in New York. He felt an affinity with the artists in the Stieglitz Circle, and his work of that period bears a resemblance to that of O'Keeffe, and a little later also to that of Marin.[15] In some literature it is suggested that Tobey acquired his interest in the Far East independently, but Eliza Rathbone's conclusion would seem to be more justified, in view of the Fenollosa-Dow-O'Keeffe line. She writes: "In his discovery of Oriental techniques and aesthetics, he found what other American artists had discovered in New York not many years before".[16] However, his interest in the Far East became more profound than that of his colleagues, in particular through his idealism and his travels to the Orient. Tobey shared Fenollosa's opinion that the encounter between the Far East and the West could take place in America. Its geographical location made it particularly suitable in that respect.

In around 1918 Tobey had become interested in Baha'i. One of the objectives of this religion, which originated in the Middle East, was the meeting of East and West .[17] And that became an important goal for Tobey. In his opinion, the theory of Baha'i was that Man would gradually come to understand the coherence of the world and the unity of mankind.[18]

Tobey spent two years, from 1931 to 1933, at Dartington Hall in Devon, England, teaching at that progressive school-cum-cultural centre. There he met the writers Arthur Waley and Aldous Huxley, and the potter Bernard Leach, all of whom had the common ideal of uniting East and West. Nine years before Tobey arrived in Devon, Waley had published the book *Zen Buddhism and Its Relation to Art*, in which he described the relationship in Zen between 'one' and 'many', and between the subjective and objective aspects of life.[19] Such aspects may well have appealed to Tobey, in that they coincided with the beliefs of Baha'i. Waley particularly emphasized the connection between Zen and art, believing that Zen helped to give insight into the psychological conditions under which art was produced. He felt that such insight was not supplied by any other source.[20]

No doubt Waley's observation appealed to Tobey, as an artist, arousing his interest in Zen too. Leach, who had been engrossed in Japanese culture for

26. Mark Tobey, 'Broadway', 1936, tempera on masonite board, 65 x 48,7 cm.

27. Mark Tobey, 'New York', 1944, tempera on paperboard, 83.7 x 53.2 cm.
Gift of the Avalon Foundation, ©1996 Board of Trustees, National Gallery of Art, Washington D.C.

28. Mark Tobey, 'Shadow Spirits of the Forest', 1961, tempera on paper, 48.4 x 63.2 cm.
Kunstsammlung Nordrhein-Westfalen, Düsseldorf

many years, invited Tobey to accompany him to Shanghai, and on to Japan. The trip was sponsored by Dorothy Elmhirst, the founder of Dartington Hall.[21] Leach and Tobey travelled to Shanghai in 1934, staying with the Chinese artist Teng Kuei and his family. Tobey had become friendly with Kuei in 1922, when they were both living in Seattle. From him Tobey had learnt Oriental brush techniques, and at a later stage he was to say that he had then discovered the difference between mass and the living line, whereby what had been a tree became an energetic rhythm.[22] Kuei had also explained to him that the artist should seek the expression which is closely connected with his personal experience, which in turn should lead him to transcend himself, and leave Nature to do the work.[23] With that Kuei probably meant that the rational intent should make way for the apparently more natural action, which comes from practice and experience. In Zen a similar view can be found. Daisetz T. Suzuki explains that in Zen the personal experience is essential, yet warns against a fixation with the self, since to adhere to the self as a refuge cannot lead to Enlightenment.[24]

Tobey and Leach travelled independently to Japan from Shanghai. Tobey spent a month in a Zen monastery, some fifty kilometres outside Kyoto, learning about calligraphy, Japanese painting and Zen. He claims that he only really knew what painting was after his stay in Japan.[25] Tobey called the dynamic lines used in calligraphy and ink painting and which he had practised regularly at the Zen monastery, 'moving lines' – so, mobile, alive and animated.[26] Inspired by his Zen studies, he experienced the use of the brush as a feeling of mental liberation.[27]

Tobey's works which were inspired by these moving lines are invariably termed 'White Writings' in the relevant literature (ills. 26, 27 and 28).[28] They comprise a great many layers of white lines, which are not straight but 'moving', as in the Japanese examples which he admired. Tobey developed this style in 1935, shortly after he returned from Japan. In the nineteen-forties his work tended to become abstract. With their close web of lines, the works seem almost to have a completely white surface. Among the many white lines, the occasional black line can often be found too (ill. 27 and 28). They are integrated in the white web in the same way as the ink lines in *Shō* en *Sumi-e* are absorbed in the white paper.

Publications on Tobey frequently suggest that there was a connection between the geographical location of Seattle, where he lived for a number of

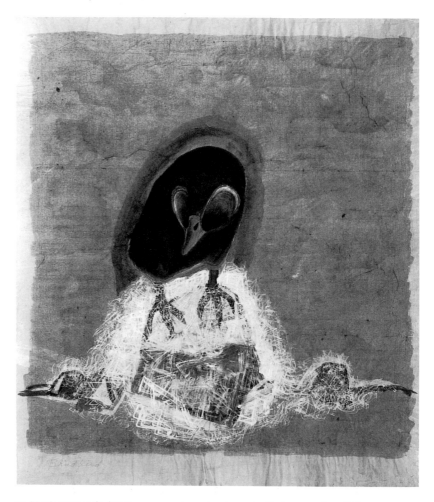

29. Morris Graves, 'Blind Bird', 1940, gouache, watercolour on mulberry paper, 76.5 x 68.6 cm. The Museum of Modern Art, New York. (Photograph ©1996 The Museum of Modern Art, New York)

years, and his interest in the Far East. However, my research has shown that his periods in New York, Devon and Japan, and his friendship with Teng Kuei, were of more consequence in that respect.[29]

During his time in Seattle Tobey was an important inspiration for various artists who were living on the North West coast.[30] The artist Morris Graves (b. 1910) who lived in Seattle and was a friend of Tobey's, was most impressed with Tobey's drawings of birds which were on display at the end of 1934 (a few months after his stay in Japan) at a solo exhibition in the Seattle Art Museum. Tobey had painted the works, which were inspired by the Japanese *Sumi-e*, in San Francisco in the previous months. Graves was sufficiently inspired by Tobey's paintings to start painting birds himself (ill. 29) and the subject was to continue to fascinate him in the decades that followed. However, he had been interested in Japanese culture for quite some time. Back in 1928 he had made his first trip to Japan, commenting afterwards: "In Japan I at once had the feeling that this was the right way to do everything".[31]

A few years later he began using a Japanese brush to paint on thin rice paper, sometimes using gilded backgrounds (customary in Japanese screens).[32] He often painted his works on the floor, occasionally using a broom as a paintbrush, hitting it against the paper as a therapeutic release.[33] The use of painting with a view to achieving inner equilibrium was probably not something Graves had only observed with Japanese artists. As his work became progressively more expressive in the nineteen-forties, the ideas of the Surrealists and Psychoanalysts had already reached America – and they too confirmed the awareness of the liberating effect of painting.

At the end of the thirties Graves regularly visited a Zen Buddhist temple in Seattle, where he met Dorothy Schumacher, who spoke to him about Zen and about Ernest Fenollosa. He also discussed Zen at length with his friend John Cage, who will be dealt with later in this chapter. Cage wrote about Graves in his book *Silence*, as well as in various catalogues and books.[34]

Under the influence of Zen, Graves arrived at his theory of the 'Inner Eye', with which he referred to the state of awareness in which the artist attains a view of his own, by way of the meditative act of painting.[35] He says, specifically with regard to his own painting: "I paint to rest from the phenomena of the external world – to pronounce it – and to make notations of its essences with which to verify the inner eye".[36]

Graves' and Tobey's first solo exhibitions in New York were held in the Willard Gallery, in 1942 and 1944 respectively.[37] Thereafter they often exhibited at that gallery, as did a striking number of Zen-oriented artists: Richard Pousette-Dart, Ralph Rosenborg, Richard Lippold, John Ferren, Rudolf Ray and the French artist André Masson.[38] Marian Willard, the gallery's owner, wrote in 1944 that she tried to achieve "a kinship among men and the realization of the oneness of mankind...".[39] Eight years later she wrote to Graves: "After 15 years of searching for spiritual content in painting and becoming known for it (...) I look more to the East for synthesis and Zen to study for our own expression of universal truths".[40] However, New York art critics paid little attention to the Willard Gallery artists.[41]

Daisetz T. Suzuki and his contact with artists in New York

The interest of Fenollosa (and such adherents as O'Keeffe) and Tobey was not the only channel for the focus on the Far East. Interest was also generated by Zen Masters – the first Japanese to take the philosophy of Zen to the United States – who travelled there at the end of the nineteenth century.[42] The symposium 'World Parliament of Religions' formed the first, short introduction for Americans to Japanese Zen Buddhism in America. The symposium was organized for the world exhibition, held in 1893 in Chicago. The Japanese Zen Master Soen Shaku (1859-1919) spoke there on Zen Buddhism. However, the initial introduction did not have far-reaching consequences. The Open Court Publishing Company did ask Shaku to send a translator to America within the framework of publishing books on Buddhism. In 1897 Shaku sent his pupil Teitaro Suzuki (1870-1966), whose Buddhist name was Daisetz (great simplicity) to the Publishing Company in LaSalle. There Suzuki translated a great many books into English and started writing about Zen himself, in a way which was to make it more accessible for Westerners. In 1906 Suzuki went on a tour of America, and returned to Japan via Europe. In Japan he wrote his *Essays in Zen Buddhism*, which were published as articles from 1921 and in book form in 1927. Three editions of the book followed in rapid succession, greatly enhancing Suzuki's reputation in England. Waley and Huxley, who both refer to Suzuki in their books, indirectly put Tobey in touch with Suzuki's work.[43]

On account of this success Suzuki travelled to England in 1936 for a lecture tour. Alan Watts, a young Englishman, went on to publish a great deal on Zen Buddhism after he had met Suzuki.[44]

In America interest in Japan waned after the drama of Pearl Harbour in 1941. The first important attempt to redress the image of Japanese culture was made in the book *The Chrysanthemum and the Sword*, published in 1946. Its author Ruth Benedict explains for Americans some of the traditional Japanese rules of conduct. Although the American attitude to the Japanese was still not particularly positive at the end of the nineteen-forties, Suzuki nevertheless returned there in 1949 and, after some travelling and lecturing in the country, settled in New York the following year. There he was invited to give a series of courses at Columbia University as a visiting lecturer.[45]

Philip Yampolsky, professor of East-Asian Studies at Columbia, attended several of the courses in the early fifties, and remembers that it was Suzuki's special charisma that particularly drew people to him.[46] Mary Farkas, the lady Master of the First Zen Institute in New York, not only followed the courses, but also knew Suzuki personally. According to her, most of the people attending the classes were 'arty' (artists and devotees of art) and psychologists, in particular psychoanalysts. The subject matter was often very difficult, but in one-to-one talks and, more especially, thanks to his many books, Suzuki succeeded in disseminating the ideas of Zen, over the entire world even.[47] The artists who attended the lectures included John Cage, Ad Reinhardt, Philip Guston and Abram Lassow. And the gallery owner Betty Parsons was also present.

Suzuki wrote and spoke of all the aspects of Zen, including its philosophy of life, and its application in art. It is hard to assess exactly what influence

Suzuki had in engendering the interest of artists in Zen. The art historian Dore Ashton believed that their knowledge of Zen was slight, "but an artist needed only to see a few phrases by Dr. Suzuki to be stimulated".[48] In the nineteen-fifties, the period in which Suzuki was lecturing in New York, interest in Zen did at least increase, especially among artists. The scholar Rick Fields even referred to a 'trend' and a 'Zenboom'.[49] Fields' opinion of the importance of Suzuki's lectures was that "at these seminars the seeds of the so-called 'Zenboom' of the late fifties were sown".[50] Suzuki's renown is also reflected in the fact that the *New Yorker*, which was one of New York's leading cultural magazines in the fifties, contained an extensive biography of Suzuki in its issue of 31 August 1957; added to which he was interviewed on television.

Several artists, including Tobey, were sceptical in their comments on the Zenboom of the late fifties. Tobey was irritated by the tremendous superficiality in the use of Zen elements during the Zen rage.[51] Nancy Wilson Ross, who wrote several books on Zen and introduced Tobey to the gallery-owner Marian Willard, noted in 1958 that the rage had also spread to the general public. She describes a cocktail party at which "everyone present had been talking about Zen".[52] Not only artists, psychologists and students expressed an interest, but a racing driver also recounted that Herrigel's book *Zen in the Art of Archery* had permanently changed his style of driving. According to Ross, Zen had meanwhile become an adjective for everything, varying from painting styles to personality types, from verse forms to states of awareness. Words like *Koan* and *Satori* were apparently being bandied about everywhere.[53] The extent of the popularity of Zen terminology in the fifties is demonstrated, for instance, by a remark by Philip Guston: "Sometimes I think of the Zen *Koan*. I know very little about Zen, but I think somehow I am undergoing the *Koan*".[54]

30. Barnett Newman, Untitled, 1945, ink on paper,
27.5 x 18.7 cm.
Collection Anthony d'Offay, London

Specifically, the Americans' affinity with Zen in the twentieth century, was to some extent related to the role that Transcendentalism had played in American culture since the nineteenth century. Leading Transcendentalists like Henry David Thoreau, Ralph Waldo Emerson and Walt Whitman were especially interested in the Buddhism and Hinduism of India.[55] According to David Anfam, an expert in the field of Abstract Expressionism, the influence of the Transcendentalists was still evident in the views of the American avant-garde painters of the forties and fifties.[56] The artist Barnett Newman, for instance, visited the homes of Emerson and Thoreau during his honeymoon (ill. 30 from a series which are evocative of *Sumi-e*).[57] The emphasis Emerson, Thoreau and Whitman placed on the pursuit of 'wholeness' instead of dualism, and their focus on 'pure experience', bears resemblances to the philosophy of Zen. When Suzuki tried to explain Zen to Westerners in his books, he used these parallels.[58] In addition, he is thought to have derived the described characteristics of *Satori* from the American philosopher William James' description of the 'religious experience' in a general sense, when attempting to make his books accessible to Westerners.[59]

Van Meter Ames observes in his book *Zen and American Thought*: "Japanese Zen is pouring the Orient into America. An unexpected result is a new perspective on our own thinkers, showing how much more than local they are, although quite American".[60] Another reason for Zen's appeal to many artists, psychologists and philosophers in America was, according to Ames, the similarity between the American quest for independence and Zen in the union of the high and the here in the human. Ames compares this to the American struggle for freedom: "the Zen feeling that each person must make of life what he can is akin to the Declaration of Independence (...) with the conviction that every human being has the unalienable rights of life, liberty and the pursuit of happiness".[61] Suzuki's success, in a historical perspective, is comparable in Ames's opinion with that of the missionaries who took Buddhism from China to Japan all those centuries ago.[62]

Although Suzuki stimulated interest in Zen, he was not its sole generator. Zen painting, calligraphy, martial arts and books of *Haiku* (seventeen-syllable poems influenced by Zen) were also available sources in the fifties. Dore Ashton wrote in that respect: "Interest in Zen on the part of visual artists and writers was as much directed to style as to content. The abbreviated, fragmented forms of Zen writings and the immediacy of brush painting influenced by Zen attracted them".[63]

Although several exhibitions of Japanese art were held in America during the fifties, literature was particularly important in the interest in Zen among the artists I have been studying. They were especially conversant in the fifties with Daisetz T. Suzuki's books, the book *Zen in the Art of Archery* by Eugen Herrigel and Arthur Waley's *Zen Buddhism and Its Relation to Art*.[64]

The psychoanalyst Carl Gustav Jung also bridged the cultures of East and West. Many American artists were interested in his ideas. In 1949 Jung observed in his foreword to Suzuki's *An Introduction to Zen Buddhism* that Zen and psychoanalysis had a common objective: to 'cure' the mind and make the

human being 'whole' again.[65] Many psychoanalysts after Jung, Erich Fromm in particular, became engrossed in Zen. In January 1955 Martha Jaeger, also a psychoanalyst, held a lecture for artists at The Club. It was entitled 'Zen and the Art of Psycho-Analysis' and was introduced by the artist John Cage, for whom Zen also held a fascination.[66]

John Cage (1912-1992) and The Club

John Cage, the composer and visual artist, followed Daisetz T. Suzuki's courses from 1952 onwards. Prior to that he had attended Suzuki's lectures at Columbia University, and had had private talks with the Japanese teacher (ill. 31).[67] At that time Cage was having emotional problems in his private life and with respect to the function of art in society. The study of Zen Buddhism rather than psychoanalysis (as had been recommended) proved to be therapeutic:

> "I got involved in Oriental thought out of necessity. I was very disconcerted both personally and as an artist in the middle forties. (...) I saw that all the composers were writing in different ways, that almost no one of them, nor among the listeners, could understand what I was doing (...) so that anything like communication as a raison d'être for art was not possible. I determined to find other reasons. (...) I found that the flavor of Zen Buddhism appealed to me more than any other".[68]

Back in 1936, at the time he was teaching at Cornish School in Seattle, a lecture by Nancy Wilson Ross sparked off Cage's fascination with Zen. She spoke on the topic 'Dada and Zen Buddhism', pointing to the similarities in philosophical foundations. Cage's reaction to her explanation was: "very impressive, it drew a parallel for me with its insistence on experience and the irrational rather than on logic and understanding".[69]

31. Daisetz T.Suzuki in conversation with John Cage

32. John Cage, 'Water Music', 1952

© 1960 by Henmar Press, publication with permission of C.F.Peters, Frankfurt/M.

Cage began applying the ideas propounded in Zen in his music (ills. 32 and 33). He experimented with 'shaking up' the public, by turning them into active participants rather than passive listeners. From Suzuki he learned that the task of art was to 'wake people up'. And, under the influence of those views, Cage formulated his aim for art: "waking up to the very life we're living".[70] In 1952 he got the pianist David Tudor to perform the work '4'33"', which entailed Tudor sitting motionless at the piano for 4 minutes and 33 seconds, without playing a note. The sounds of unrest in the audience constituted the contents of the work. It was 'framed' by Tudor's opening the lid of the piano at the start of the piece, and closing it again after 4 minutes and 33 seconds.

According to Cage, Western Man had built his ego into a wall which did not even contain a door for communication between the inside and the outside world. Suzuki had taught him to break down that wall and open himself to all possibilities, both internal and external.[71] In addition, he learned the difference between Western and Eastern thought from Suzuki. In the West, people think in opposites, in the East in a cohesive whole. Moreover, in the West the principle of cause and effect is applied. In the East, an infinite number of causes and effects are assumed to exist, with everything automatically being interwoven. That made the traditional Western compositional frameworks superfluous, in Cage's opinion. Such frameworks are based in a centre, which is typically Western. Unlike in Zen, in which everyone is a centre, and in which, consequently, there is a multitude of equivalent centres.[72] John Ippolito, the curator of the Solomon Guggenheim Museum and involved in the exhibition 'Rolywholyover John Cage' in the Spring of 1994, is of the opinion that Cage's interest in Zen related primarily to 'the denial of traditional relationships'. That signified 'no meaning, no direction, no cause and effect'. The *I-Ching*, which Cage frequently used to help him in performing his events, and the disciplined way in which he occupied himself with his hobbies, such as chess and the study and consumption of mushrooms, were said to be comparable for him to the role played by the Zen arts for Zen Masters. They were a means of attaining 'direct experience' or of 'interpenetration without obstruction', the goal of Zen.[73]

Cage used everyday objects and sounds to remove the boundary between life and art, reminiscent of the integration of the two in Zen Buddhism. In 1952 Cage performed his Untitled Event at Black Mountain College in North Carolina, assisted by several artists and many branches of the media. At the event Robert Rauschenberg's 'White Paintings' [74] were hung, Merce Cunningham danced between the public, David Tudor played the piano, the poets Charles Olsen and Mary Richards read poetry aloud, Cage gave a talk, and slides and films were shown. All the activities took place simultaneously. Cage allowed each artist the freedom to do what he or she thought fit, within certain time margins. That, and the fact that no recordings were made, meant that the relevant literature contains differing descriptions of the Event. Cage wanted the viewer to compose his 'own work' from the available information, using all his senses.[75]

Earlier in this text the Transcendentalists were mentioned, in particular with reference to their affinity with Buddhism.[76] Cage greatly admired the Transcendentalist Thoreau, and was himself even described as 'the new

33. John Cage, 'Music for piano 2', 1953
© 1960 by Henmar Press, publication with permission of C.F.Peters, Frankfurt/M.

Thoreau'.[77] In 1973 Cage wrote: "No greater American has lived than Thoreau. Other great men have vision, Thoreau had none. Each day his eyes and ears were open and empty to see and hear the world we lived in".[78]

For many painters in New York Cage played an important part in the fifties. From 1949 onwards he held several lectures at The Club in New York; it was a venue for the Abstract Expressionists [79] and an important place for the exchange

of ideas. According to Dore Ashton, the artists tried to develop a philosophy there which reflected their own experience of life. They were more concerned about what to paint and the pursuit of new values than how to paint.[80] Cage advised the audience in his first lecture to read the books of Alan Watts, whose enthusiasm for Zen Buddhism had been fired by Suzuki.[81] Cage also recommended the books of Arthur Waley and Ananda Coomaraswamy. The latter's work *The Transformation of Nature in Art* was published in 1934.[82] In it he compares the religions and art of the East on the one hand with the contemporary Western world, and on the other hand with the Christian mystic, Meister Eckhart (1260-1327). In the bibliography he refers to Waley, Suzuki and Okakura, amongst others.[83] The popularity of that book among various artists in the late fifties encouraged the further effectuation of Fenollosa's ideal: the reconciliation of East and West.[84] Cage believed that the Oriental way of thinking had become almost as accessible as that of the European thanks to Coomaraswamy.[85] Artists like Mark Tobey and Ad Reinhardt had apparently also read Coomaraswamy's book.[86]

Dore Ashton and the art critic Calvin Tomkins, who were personally acquainted with a great many artists, are both of the opinion that the artists in The Club were interested in Cage's ideas. In that context Ashton mentions in particular Cage's idea of the event itself, of organic silence and the fullness of nothing, believing that these aspects helped to disseminate beliefs of Zen Buddhism in the work of many artists in New York.[87] The elements listed by Ashton had been explained by Cage to visitors to The Club during his 'Lecture on Something' and 'Lecture on Nothing'.[88] Although artists clearly were interested in Cage's views, there is no unequivocal proof of Ashton's claim that Cage's ideas were to be found in many artists' works.

David Clarke maintains that Cage, as a translator of the Oriental concepts for American avant-garde artists, helped with his writings to undermine the role the West had attributed to rational thought in the creative process.[89] The part played by Cage should not be overestimated. The nineteenth century Symbolists, the Dadaists and Surrealists, had already sown the seeds of doubt regarding the role of reason in art. Cage's greatest influence would seem to have been on the public's idea of the artist's attitude. James Brooks, a regular visitor to The Club, commented in 1965: "Zen came in pretty strong to The Club and a good many members were very receptive to it because it emphasized the pure confrontation of things rather than intellectualization (...) there was the deep felt need to confront things in a purer way, without bias, or as innocently as could be done". He believed that 'innocence' and 'purity' were important concepts at that time: "...to make a real attempt to see things or to experience them simply. So Zen did take quite a hold, or rather we had a great many talks about it. (...) I think it affected us all in our general attitude, whether we thought that we accepted it or not (...)".[90] For the New York artists, who felt rather desperate about life, the acceptance of uncertainty as something natural (which Cage claims to have learnt from Zen philosophy[91]), and the positive focus of Zen's outlook on life, were undoubtedly interesting subjects for discussion. But it is difficult, perhaps impossible to demonstrate to what extent Cage succeeded in changing their attitude.

34. Alcopley, 'Composition', 1961, black paint, 194 x 104 cm.
Stedelijk Museum, Amsterdam

35. Robert Motherwell, 'Blue with China ink. Homage to John Cage', 1946, mixed media
Private collection

36. Robert Motherwell, 'Composition', serigraphy and collage, undated, 61.1 x 50.9 cm.
Stedelijk Museum, Amsterdam

Some of the artists who regularly visited The Club and expressed an interest for Zen's beliefs were Theodoros Stamos, Robert Motherwell, David Smith, Philip Pavia, John Ferren, Alcopley and Abram Lassaw.[92] Alcopley (b. 1910) (ill. 34) who was born in Germany and had been working as an artist in America since 1937, was particularly interested in Japanese calligraphy. He spent some time in Paris, from 1952 to 1957, where he contacted like-minded artists. In 1955 he organized with Pierre Alechinsky and the Japanese calligrapher Morita an exhibition of modern Japanese calligraphy which travelled round Europe.[93] A number of Alcopley's works reflect his interest in the expressive character of Japanese calligraphy, although he was not in fact especially engrossed in the philosophy of Zen.

John Cage, who was acquainted with various visual artists, appears to have discussed his interest in Zen with some of them already several years before he gave his lectures at The Club. In 1946 Robert Motherwell (1915-1991) entitled one of his paintings 'Homage to John Cage'(ill. 35). At the centre of this painting there are small brush drawings resembling *Sumi-e* and *Shō*. Towards the end of the forties Motherwell's work evolved from a collage style to a style comprising occasional forms which resemble expressive Japanese brush-strokes. His statement that his work forms the solution of the inner antitheses between the conscious and the unconscious is indicative of his quest for synthesis.[94] Towards the end of the fifties Motherwell's works show the uniting of the individual and the universal, or, in other words, his interest in psychoanalysis and Zen (ill. 36).[95]

Existentialism was also a frequent topic of discussion at The Club. For artists, who had not studied either Existentialism or Zen in depth, there appeared to be several striking resemblances between the two. The French Existentionalist Jean Paul Sartre refers to transcendence as 'self-surpassing'. At first sight that striving would seem to resemble the goal of Zen. Both movements had an aversion to the 'over-intellectual' and sought 'concrete' experience. Moreover, both movements emphasized individual responsibility and intuition. Sartre criticized analytical and logical mind-sets, as does Zen. The listed aspects of the two philosophies greatly appealed to the artists of The Club.[96]

Within the framework of this research, it is interesting to see what the main differences were between these two 'philosophical systems'. Existentialism rejected any mysticism, whilst Zen emphasizes 'mysticism' in the sense of the mystery of life itself, like the shining of the sun, et cetera. The 'ideal unity' which Zen pursues, is not found in Sartre's views, though it is in those of the German Existentialist Heidegger (who related to the Far East at the end of the fifties).[97] 'Nothingness' in Zen is not contrasted with 'Being', unlike in Sartre's approach to nothingness.[98] According to Cage, Sartre's view is typically Western in its opposition of being and not-being, as a game of intellectual categories.[99] Moreover, the preference for the 'experience of being' in Zen contrasts with the Cartesian 'Cogito ergo sum' of Sartre. His emphasis on the individual decision, 'you are what you decide' probably appealed less to the aforementioned Club members, who wanted to transcend individuality, than the ideas of Zen.[100] Although The Club organized lectures and panels on Friday evenings, at which

topics such as the views of Heidegger, Sartre, Hitler, Marx, Dada, Futurism and Zen were discussed, the intellectual level of the discussions should not be overestimated.[101]

In the same period that The Club was an important rendezvous, many artists met in North Carolina, at Black Mountain College, an institute of artistic research and debate. There, from around 1949, the ideas of Jung, Dada, the *I-Ching* and Zen Buddhism were also discussed.[102] However, the discussions did not take place on appointed evenings, but mainly at mealtimes. Not surprisingly, Cage described the dining-room as the most important place in the building.[103] Since Black Mountain College was primarily an institute for artistic experiments, the ideas were also put into practice. For instance, the poet Charles Olson performed Nō plays with his students.[104] John Cage lectured on Zen and Suzuki, read aloud the Huang Po Doctrine of the Universal Mind [105] and also performed the Untitled Event mentioned earlier, assisted by Olson, amongst others.

The artist Franz Kline (1910-1962) (ill. 37), a frequenter of The Club, undoubtedly belonged to Cage's audience. In addition, like Cage he too worked in the summer of 1952 at Black Mountain College. There Kline witnessed the Untitled Event. However, there is no evidence of any connection between his first sketches, dating from 1949, which resembled calligraphic characters from the Far East and Cage's call to artists to seek inspiration in Zen.[106] Only Alan Watts' claim in his autobiography that he introduced Kline to Zen, suggests there might have been a connection between Kline's work and Zen (and so Suzuki via Watts).[107] The fact that Kline was identified in some circles with Zen can be deduced from a special issue of the *Chicago Review* on Zen, published in 1958. It contained articles by Suzuki and Watts, amongst others. A work by Kline was included between the articles, as an example of an artist who was influenced by Zen.[108]

However, my research showed that Kline was not interested in Zen, though he had been interested in the style of the dialogues in the Zen literature with which artists were conversant in the fifties.[109] A journalist quoted Kline in 1958 in *Time*, to illustrate the view that the Abstract Expressionists were holding discussions along the lines of Zen Masters, in other words in riddles. In reply to the question what he was trying to express, Kline answered: "When I was young, I was 19. Does that answer your question?".[110] Cage wrote concerning his 'Lecture on Nothing' that in reply to the questions at the end of the lecture, he gave one of the six answers he had prepared beforehand, regardless of the question. This was intended to reflect his commitment to Zen.[111] It is quite possible that Kline was present.

Kline's interest in Japan was primarily formal in nature. He was an enthusiastic devotee and collector of *Ukiyo-e* and books on the subject (ill. 38).[112] One of his colleagues at The Club had even nicknamed him *Ukiyo-e*.[113] Kline's paintings were characterized by a strong contrast between black and white. The lines are expressive in character, but also severe and taut. And that is more reminiscent of *Ukiyo-e* than of the more flowing lines with irregular contours of *Sumi-e* and *Shō*.

37. Franz Kline, 'Accent Grave', 1955, oil on canvas, 191 x 131.6 cm.
The Cleveland Museum of Art, Cleveland, Ohio, Anonymous Gift, 1967.3

38. Kunisada (Toyokuni III), 'Taimen' (Meeting),
1830's, woodcut, 38.6 x 26.6 cm.
Van Gogh Museum (Vincent van Gogh Stichting),
Amsterdam

However, the researched interviews with Kline only referred, concerning the influence from Japan, to 'the relationship with Japanese calligraphy', which he nearly always denied.[114] He did express an interest in writing in general, so with 'universal calligraphy': "Everybody likes calligraphy. You don't have to be an artist to like it, or go to Japan. Mine came out of drawing".[115] And at The Club he had said with respect to calligraphy: "Instead of making a sign you can read, you make a sign you can't read".[116] Yet when Kline switched from figurative to abstract work in about 1949, he made preliminary sketches which are far more evocative of calligraphy from the Far East than with writing in general.

Recurring arguments which are used to deny any parallel between Kline's work and work from the Far East are that Kline did not feature a ground with a black figure on it, and that meaning is absent in his work.[117] As we saw in the introductory chapters, *Ukiyo-e*, *Shō* and *Sumi-e* are all characterized by the equivalence of figure and ground. Dow explained that in Japanese art, it is very important to achieve *Notan* (arrangement of the dark and light masses): "To attain an appreciation of Notan, and power to create with it, the following fundamental fact must be understood, namely, that a placing together of masses of dark and light, synthetically related, conveys to the eye an impression of beauty entirely independent of meaning".[118] So *Notan* is determined by the composition and not by observation.[119] The fact that this term did not sink into oblivion in the second half

of the twentieth century is evident, amongst other things, from Tobey's observation in 1962 that *Notan* was probably the most satisfying aspect of a painting.[120]

Although Kline developed a personal style of painting in the fifties, the works, in my opinion, have more in common with *Ukiyo-e* and Japanese calligraphy than most of the literature maintains.[121] That in turn implies that Kline's work also has a lot in common with nineteenth century Japonisme.

The analogy with Oriental calligraphy in some of the paintings by Pollock (ill. 39) and Willem de Kooning should to some extent also be seen as a stage in the development of the expressive use of lines, which process began in the period of nineteenth century Japonisme, gaining particular momentum thanks to Surrealism.[122] The expression in the post-war era was no doubt engendered by the spirit of the times – a period in which there was an intense search to discover the Inner Self.

39. Jackson Pollock, 'Number 15', 1951, mixed media on canvas, 142,2 x 167,7 cm. Museum Ludwig, Cologne, (photo: Rheinisches Bildarchiv, Cologne)

40. Ad Reinhardt, 'Abstract Painting', 1954-59, oil on canvas, 276 x 102 cm.
Museum Ludwig, Cologne, (photo: Rheinisches Bildarchiv, Cologne)

Ad Reinhardt (1913-1967)

Ad Reinhardt (ill. 40) was also a visitor to The Club. He was even one of the organizers. He had been studying Oriental art history since 1944, and taught at Brooklyn College for many years, in particular the subjects Chinese, Japanese and Indian art.[123] In a book review in 1966 in *Art News* he wondered how long we would have to wait for East Asian art to be accorded a worthy place in the 'world art history' of the West.[124] The fact that Zen painting deserved to be included is clear from his qualification that it is: "one of the greatest achievements in art and human history".[125]

In the early fifties he attended Suzuki's lectures at Columbia University and also read his books. He once mentioned that Suzuki and Coomaraswamy were his favourite religious authors.[126] Added to which, he had read the works of Arthur Waley, the writer who was referred to earlier in connection with Tobey.[127] In this period Reinhardt held slide shows, both at The Club and at other locations, in which he presented fragments of combinations of Eastern and Western art. He used them to demonstrate the universality of art and artistry.[128] So the shows formed an important source of information on Oriental art for the artists who attended.[129] Moreover, Reinhardt apparently tried to contrast the 'Sturm und Drang' bombast of the post-war years in New York with the tranquil, independent works of Oriental art.[130]

Reinhardt wrote several articles on art from the Far East in the magazine *Art News*, commenting, for instance, on the fact that Asiatic ink painting is especially notable for "... its timelessness, its clarity, its quietness, its dignity, its negativity...".[131] A quote from that essay about the Buddha figure was used on the announcement of the *Reinhardt* exhibition in Düsseldorf in 1972, to characterize Reinhardt's paintings: "breathless, timeless, styleless, lifeless, deathless, endless".[132]

However, nowhere in his publications on the Far East did Reinhardt make any connection with his own visual work. And that is probably the reason why few writers have ventured to link his work and his interest in Zen Buddhism, in particular.

The art critic Lucy Lippard initially thought that it would be misleading to attribute 'Oriental qualities' to his work, however much Reinhardt might have admired the art and philosophy of the Far East.[133] Later, however, she proves to have changed her mind, believing that in the austerity of the Black Paintings, the perspicacity of his texts and his preference for the *tabula rasa*, she recognizes connections with his interest in Zen and Indian philosophy, and even with Dada.[134] According to another art critic, Barbara Rose, Reinhardt sought in 'high civilizations' an alternative to European Cubism, and derived from Zen painting a mysterious abstract space and an ascetic discipline.[135]

Between 1947 and 1949 Reinhardt was making vertical paintings resembling Eastern scroll paintings (ill. 41). Whereas, owing to their calligraphic character, these early works call up associations with Japanese and Chinese writing, his later monochrome works, with their large planes and barely distinguishable shades of one colour have more in common with the art of Zen Buddhism. From 1950 onwards he was producing paintings of that type, and

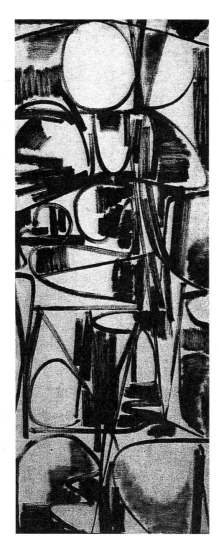

41. Ad Reinhardt, 'Calligraphic Painting',
1949-50, oil on canvas, 127 x 50.8 cm.
Private collection, present location unknown

later began to concentrate on Black Paintings, which after 1960 were only 60 by 60 inches in size (ill. 42). The Black Paintings, too, were characterized by their subtle variations of hue. Reinhardt himself said of these monochrome paintings: "They are a logical development of personal art history and the historic traditions of Eastern and Western pure painting".[136] His ideas on Eastern pure painting can be concluded from his writings on Far Eastern art. In one of his essays he expressed an admiration for the timeless universal 'formula' in Asiatic art whereby the absolute essence can be attained.[137] A year later he described the 'formula' of his Black Paintings. It is striking that he uses words like 'pure', 'lightness', 'spaceless' and 'timeless', as they are exactly the same words he used to characterize Zen painting.[138]

42. Ad Reinhardt, 'Abstract Painting', 1960,
oil on canvas, 152.4 x 152.4 cm.
Staatsgalerie, Stuttgart

On 16 August 1967, two weeks before his death, Reinhardt took part in a debate
entitled 'Black', organized by the art magazine *Arts/Canada*. The text was print-
ed in its October issue. Of special interest in the context of my research, is the
combination of two illustrations which accompanied the article. Alongside a
vertical Black Painting by Reinhardt, we find a Japanese calligraphic work, with
the explanatory text "Element of Japanese Calligraphy, emblematic of 'paint-
ing', Anonymous". Possibly this illustration was still selected by Reinhardt, or
in consultation with him. The caption does refer to the anonymous art of which
he was so fond. Reinhardt felt that anonymity was an important characteristic
of pure painting, and that is what appealed to him, for instance in the art of the
Far East.[139]

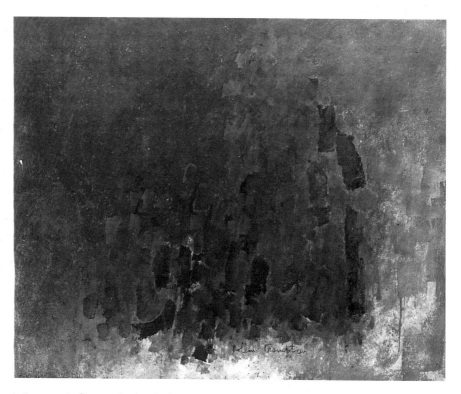

in Crampton, 'no.8', 1952, oil on board, 76.2 x 101.6 cm.
unknown

The artist Rollin Crampton (1886-1976) (ill. 43) was a good friend of Reinhardt's. He lived and worked in Woodstock, and actually began making monochrome paintings before Reinhardt. His works also appear, at first sight, to consist of one colour, but they too are made up of subtle tones. Crampton was inspired by Zen, and was interested in Theosophy and Indian literature as well. He was primarily fascinated by the quest for essentials in Zen, the "getting down to a basic sort of simplicity".[140] Crampton's 'minimal' paintings were a new phenomenon in his day, as the reaction of the art critic Clement Greenberg to Crampton's monochrome paintings in 1951 bears out. He wrote that his immediate reaction was one of irritation, but when he saw Ad Reinhardt's and Yves Klein's monochromes at a later stage, such work had, in his words, become widely accepted.[141]

The art historian Jeffrey Wechsler believes that Reinhardt's step towards monochrome painting was influenced by Crampton.[142] Crampton's works from the late forties were grey monochromes, so subtle variations on grey. And it was only towards the end of the forties that Reinhardt's paintings gradually became monochrome. In 1950 he made his painting with the title 'Grey', which consists of overlapping vertical rectangular strokes, in which the transparent

44. Ad Reinhardt, 'Abstract Painting-Grey', 1950, oil on canvas, 76.2 x 101.6 cm.

shades of colour suggest a 'coloured grey monochrome' (ill. 44). Its style and colour are reminiscent of Crampton's 'coloured grey' paintings. Striking works by Crampton in this style include two large grey monochromes, owned by his friend Sal Sirugo. One of the works is dated on the back: 1944. If that date is correct, it means that the works can be seen as harbingers on the movement of 'empty field art'.[143]

Thomas Merton, another of Reinhardt's friends, was even more engrossed in Zen Buddhism and the Zen arts than Crampton. He was a monk of the Trappist order, and wrote books on Zen. Merton claimed to have been greatly impressed in his meetings with Suzuki.[144] Reinhardt continued a correspondence with Merton until his death. A letter written to him in October 1963 by his friend Merton reveals that Reinhardt did his utmost not to be seen as a 'calligraphic' artist: "I know you are making large calligraphies in secret and that corners of the huge papyrus are lying around and fed to the mice. They should rather be sent down here...".[145]

The 'black humour' cartoons which Reinhardt drew in black ink sometimes elicit associations with anecdotes from Zen literature. He made a cartoon in 1946 representing a man standing in front of an abstract painting, with the text:

"What does this represent?", to which the painting replies "What do you represent?" It is interesting to note that his friend Merton quoted in one of his books the following dialogue between a monk and his master: "Who is the Buddha?" "Who are you?".[146] In that context it is also worth noting that Alfred H. Barr wrote in 1958: "In recent years, some of the painters have been impressed by the Japanese Zen philosophy with its transcendental humour...".[147]

In view of the interest Reinhardt had in Zen and the characteristics his works shared with Zen philosophy, his negative comments on Zen-inspired artists are all the more amazing. He is said to have used the term of abuse 'Neo-Zen-Bohemians' for such artists.[148] Reinhardt was probably referring to artists who, in his view, overemphasized the influence of Zen on their work, and who imitated Zen painting or calligraphy.[149]

Insight into Zen

There are a few specific features of Zen which are also aspects of work by Tobey, Reinhardt and Cage. Often an affinity with Zen is apparent, sometimes inspiration was involved. The aspects which have already been discussed with regard to Zen, are present in the artists in question as part of their 'philosophy' or method, or else they form a formal aspect in an artist's work.

Emptiness and nothingness

In 1958 the art magazine *It is* published an essay by Stanley Breul entitled 'Kill the Buddha'. The following text is quoted from the article in question:
> "Zen is not Zen. Zen begins in Zen: passes through No Zen; ends in neither Zen nor No-Zen. Freedom – from Zen. Freedom (...) through the living logic of endless negations and negation negating negation".[150]

The interpretation of nothingness and emptiness in Zen as a negation can also be recognized in Reinhardt's and Cage's views. Reinhardt regularly used endless series of negations in order to convey his thought on art. The idea of negativity was, in his view, no longer something bad, and he was especially fascinated by the 'negativeness' of black.[151] His remark: "You can only make absolute statements negatively" is comparable with the Zen belief, and the association with that Eastern religion is reinforced by his claim that his work is linked with "a long tradition of negative theology in which the essence of religion, and in my case the essence of art, is protected or the attempt is made to protect it from being pinned down or vulgarized or exploited".[152] In 1952 the catalogue *Contemporary American Painting* published the following text by Ad Reinhardt entitled 'Abstract Art Refuses':
> "It's been said many times in world-art writing that one can find some of painting's meanings by looking not only at what painters do but at what they refuse to do. (...) And today many artists like myself refuse to be involved in some ideas. In painting, for me no fooling-the-eye, no window-hole-in-the-wall, no illusions, no representations, no associations, no distortions, no paint-caricaturings, no cream pictures or drippings, (...) no divine inspiration or daily perspiration, no personality-picturesqueness, no romantic bait, no neo-religious or

neo-architectural hocus-pocus, (...), no experiments, no rules, no anarchy, no anti-intellectualism, no innocence, no irrationalism, no low level of consciousness, no reality-reducing, no life-mirroring, no abstracting from anything, no involvements, no confusing painting with everything that is not painting".[153]

This text presents remarkable analogies with the 'Sūnyatā' (emptiness) Sutra, which was described by Suzuki as a favourite Sutra of the Zen monk, and is quoted in his book *An Introduction to Zen Buddhism*.[154]

Another example of one of Reinhardt's strings of negations can be found in the rules for making a painting which he formulated in 1957. He advises using no texture, no brushwork or calligraphy, no drawing or sketching, no forms, no design, no colours, no light, no space, no time, no size or scale, no movement, no object, no subject and no matter.[155]

In 1953 Cage wrote, in a reaction to an exhibition of Rauschenberg's work at the Stable Gallery in New York:

"To whom No subject No image No taste No object No beauty No talent No technique (no why) No idea No intention No art No feeling No black No white (and) After careful consideration, I have come to the conclusion that there is Nothing in these paintings that could not be changed, that they can be seen in any light and are not destroyed by the action of shadows. Hallelujah! the blind can see again; the water's fine".[156]

When the texts of Reinhardt and Cage are compared, we see that both artists are seeking to put the traditional ideas about art behind them. The difference between the texts is in the tone. Cage inclines towards a shocking nihilism and irony, along the lines of Dada, and Reinhardt argues seriously for purism in painting.[157]

With respect to Cage's nihilism, some explanation is needed on the role of Dada in the fifties. Cage, who was a great admirer and friend of Duchamp, would seem to have been put on a Dada-like track by him, and that tied in with what he had learnt from Zen. Hilton Kramer even went so far as to say, in a recent publication, that there was in fact nothing in Cage's philosophy that had not already been propagated by Duchamp.[158] Several of Cage's projects do indeed have remarkable similarities with works by that artist.[159] As observed earlier, it was Nancy Wilson Ross' lecture in Seattle in 1936 that brought both Dada and Zen to Cage's attention. She believed that Dada had caused a crisis in Western consciousness for the first time.[160] We can conclude from comments by Cage that the positive approach of Zen appealed more to him than the nihilism of Dada. Another important difference between Zen and Dada is that, once Dada has broken with traditions and prejudices, it does not return to the ordinary everyday situation, but opts for the bizarre.[161] Cage was evidently closer to Zen, since he was fascinated by ordinary things. In the framework of this book, it is interesting to note that although the Dadaists could not have been acquainted with Zen, there was some interest in Hinduism, Taoism and, to some extent, Buddhism.[162]

The aspect of emptiness became popular among artists in the Japonisme period. However, in those days it was emptiness as a formal aspect only. An important new development in art was that emptiness in a work did not have to

be subordinate to the figuration. In the course of the twentieth century the awareness grew that emptiness and nothingness could at the same time also be 'full' and 'something'. The three protagonists in this case study were of the opinion that emptiness was indeed no longer the absence of something, but was actually something. Tobey said, with respect to empty space: "It's all loaded with life".[163] Cage had a comparable view, namely that there is no such thing as an empty space or an empty time.[164] In 1949 Cage held his 'Lecture on Something' in The Club, and his 'Lecture on Nothing' a year later.[165] In the former lecture he explained that 'something' and 'nothing' are not each other's opposites. Because everything is constantly changing art much be such that it reminds us of nothing. In that way it will simply fit in and ultimately become nothing.[166] He stated that Western art history was a process of 'nothing towards something', but he believed it would change: "Now we are going from something towards nothing...".[167] Reinhardt's comment on art is akin to that: "When space, matter was 'nothing', art was the making of something out of nothing; now when space, matter are 'something', art is the making of nothing out of something".[168] Reinhardt also gave as two characteristics of 'Art-as-Art' "a special art to paint empty space" and "knowledge of nothingness and the void", after having referred twelve years previously to Zen as the "doctrine of great emptiness".[169] In the diary of his trip to Japan in 1958, another of his comments was "Zen – How to make manifest meaning of empty space in a picture".[170]

That idea is also apparent in the works of the artists who were mentioned. Tobey's White Writings become 'something' because of the multitude of lines, but the close network also gives them the appearance of empty white monochromes. They are comparable with the open expanses in Zen paintings, which seem to be both void and something, for instance mist or an undefined mass. The fields comprising white lines also recall Zen gardens, in which emptiness consists of expanses with the texture of gravel and raked lines. The silences in Cage's compositions also proved to be filled with something, like the sounds of the audience during the performance of '4'33''. During a spell in a soundproof cabin, Cage noticed that a person always hears some sound from his own body. Reinhardt's frequent observation 'form is emptiness' clearly applies to his monochrome works, in which the forms appear to become disembodied.[171] These works seem at first sight to be empty, but prove to consist of a number of rectangles. The observation of his Black Paintings is even described as a 'contemplation of nothing'.[172]

In the working method of the artists in question, the word emptiness is applicable to the absence of thought while they were working – the void was filled with concentration on what they were doing.

It is hard to determine to what extent they were inspired by Zen. Emptiness had also become an important subject of study in the twentieth century in the sciences. It was also seen to be 'filled', comprising 'something' and 'nothing' at the same time – as in Zen.[173] Some of Tobey's observations reveal that he was aware of the analogy between the views of modern physics and Zen.[174] Reinhardt's friend Thomas Merton is thought to have brought the similarities between Einstein's ideas and the beliefs of Zen to Suzuki's attention.[175]

Dynamism

Cage, following Suzuki's recommendations, was of the opinion that the *modus operandi* of Nature should be imitated.[176] Movement was of particular importance in Cage's Untitled Event. The participants performed various acts, and the use of slides, film and sound provided the necessary dynamism. And in the context of working method, the artist's movements in 'living art' are the equivalent of the artwork.

Dynamism was also very important for Tobey. His utterances concerning his expressive works included such comments as: "My work is obviously in a state of constant flux" and "I want vibration in it. Everything that exists, every human being, is a vibration...".[177] He believed that the idea of 'continuum' – something which greatly appealed to him – was typically Oriental. To illustrate that he mentioned his Chinese friend Teng Kuei, who once asked him why Western artists only painted fish that were dead.[178] The most important result of his training in Japan in fact appeared to be related to dynamism, and was, in Tobey's words, the 'Calligraphic Impulse'.[179] It had taught him how to create movement, which, for him, meant the suggestion of the dynamic character of the big city, with which he was so familiar. In his first White Writings, the topic of which was Broadway in New York, Tobey depicted the constant change surrounding him, the perpetual motion of the city, in a way which not only evokes calligraphy, but also the Zen painter's manner of portraying the eternally changing landscape around him. The representation of dynamism is more important for both Tobey and the Zen Masters than the depiction of contours or volumes.[180]

Tobey tried to achieve the effect of movement by applying numerous layers of 'moving lines' on top of one another. If these lines in his abstract works are compared with the calligraphy of the Far East, parallels can be found with the Japanese running style, or cursive script (cf. ills. 28 and 5). That style was greatly favoured in Japan because it was easy to use for *Kana* (the Japanese syllabary phonetic script) and its dynamic style coincided with the Japanese aesthetic feeling.[181]

In 1957 Tobey spent several months painting a series of spontaneous works in the traditional *Sumi-e* technique, using the appropriate materials (ill. 44).[182] The dynamism in these works is even greater than in his White Writings, as was his actual working method. In fact the procedure with the monochromes of white lines can be described as careful rather than dynamic.

Dynamism is less in evidence in Reinhardt's work than in that of Tobey and Cage. Reinhardt proceeded with even greater care than Tobey. Yet his works do contain dynamism, albeit in an unusual form. In a catalogue the term 'subliminal dynamism' is used to describe his work.[183] And that coincides with Reinhardt's own description of Ch'an painting: "equilibrium of tensions – outward actions sacrificed for inner tensions".[184] The fact that dynamism need not necessarily be explosive action, is probably best demonstrated by the *Sumi-e* in which emptiness and nebulous ink stains prevail. The tension these works radiate might be termed 'dynamic silence'. Tobey's White Writings also have the same effect. They are often referred to as having a vibrant effect. Several of Cage's works also emanated the 'tension of silence'. And in that respect I have

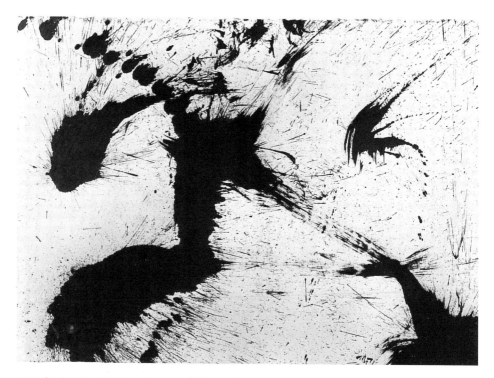

45. Mark Tobey, 'Space Ritual no.1', 1957, sumi ink, 74.3 x 95.1 cm.
Eugene Fuller Memorial Collection, The Seattle Art Museum, Seattle

found terms like 'activity within inactivity' and 'dynamics of silence' referring to those works of Cage's.[185]

In the works I have studied, there is more emphasis on dynamism than on mass, suggesting some affinity with the theory of relativity. The formula $E=mc^2$ leads us to conclude that mass is but a form of energy. Unmoving objects also possess an energy unseen to Man. The reviewed artworks of the fifties would in turn appear to be striving to make visible a comparable invisible energy.

Indefinite and surrounding space

From the end of the nineteenth century the suggestion of infinite, or indefinite space had become increasingly popular among artists. Tobey's White Writings also have the effect of endless depth, produced by the many layers of intersecting lines. Yet, as with many *Sumi-e*, the white web of lines is also compared with a fog in which the viewer is situated. Tobey termed this new three-dimensional effect brought about by the moving lines 'multiple space', for which he claimed he had received his inspiration from Japanese ink paintings.[186] But he would seem to have been inspired by Western sources as well. At first sight, the White Writings would seem to have little in common with Cubism. Yet, having studied the works by John Marin, which were inspired by Cubism, I came to the conclusion that Marin's works, in which space is created by means of many

76

diagonal lines, could well have been one of Tobey's sources of inspiration for his White Writings (cf. ills. 26 and 46).

There were several artists in the fifties in whose work the spatial effect apparently forming part of the space in which the spectator is standing, is even stronger than in Tobey's White Writings (which he started making in the second half of the thirties). In 1958 the artist Philip Pavia called the new approach to space in the fifties 'The Second Space: The American Sense of Space on Space'.[187] Pavia saw Cubism as its starting point, but unlike the approach of the Cubists, for whom it was a matter of the object in space, he believed that in the fifties space was "pushed out into the room".[188] In his opinion, this way of depicting space was one of the points of particular attention of the artists of The Club. He conceived the name Chinese Cubism for the new approach, since the connection between light and space [the suggestion of plasticity] had become progressively less clear.[189] Indeed the three-dimensional effect customary in the painting of the Far East is strongly independent of shadow effect and linear perspective.

In an essay in 1954 Reinhardt compared the 'reverse perspective' in Zen painting with Western perspective which is based on the so-called 'ego-self'.

"The Eastern perspective begins with an awareness of the 'immeasurable vastness' and 'endlessness of things' out there, as things get smaller as they get closer, the viewer ends up by losing (finding?) himself in his own mind".[190]

The forms in his monochromes suggest, alternately, that they came forward to the spectator, so reverse perspective, and recede, the Western effect of depth.

In his events, Cage clearly made use of the surrounding real space in which the artist and the public were situated. In the Untitled Event, the happening took place around and between the spectators. Cage was also fascinated by the relationship between time and space: "More and more we refer to 'spacetime', 'timespace experience'".[191] The Japanese concept of *Ma*, interval, clearly applies to Cage's music, texts and events alike. In the course of the twentieth century awareness of the relationship between time and space grew in the West, with Einstein emphasizing it more than anyone before him in the West. It meant that you could not speak of space without referring to time as well, and vice versa.[192] In the moving, or vibrating space in Reinhardt's and Tobey's works there is also a relationship between time and space.

Direct experience of here and now

In the essay 'Notes on Japan' which was published in 1959 in the art magazine *It is*, Sari Dienes explains the emphasis on the direct experience in Zen. Moreover Dienes advises the artist to remain alert to the experience of things as they are.[193] The essay describes how difficult it is for a Westerner to achieve Japanese 'pure experience'. It proves to be a problem to identify with this Japanese attitude, to transcend the self and learn to open one's eyes, ears, mind and heart. Yet that kind of openness is what is required of the human being if he is to live in reality and desires a kind of contact that is just as natural as breathing.[194]

Cage concentrated in the fifties on 'pure experience', which meant that he strove to become one with the surrounding world.[195] It led to a focus on both

46. John Marin, 'Street Crossing, New York', 1928, watercolour on paper, 66.6 x 55.2 cm.
The Phillips Collection, Washington D.C.

here and now, and on the awakening, or liberating of the self. In the pursuit of oneness with the life that Man leads, art can be of help in its function of 'waking up the very life we're living'. So art should primarily be an action in life, and Zen can help one to enjoy that life.[196] That is why he uses everyday actions and objects in his works.

Direct experience as a means of seeing the world from a different point of view was something Tobey learnt from his experiences in a Zen monastery. His first exercise took the form of a sheet of paper with a large, expressive circle painted on it. He had to take it to his room, hang it on the wall and meditate in front of it. Although he believed he had never entirely fathomed what it meant,

he had a feeling that the painting had taught him a different way of looking at things.[197] Moreover, by sitting on the floor he discovered another world, for example that of the insects, enabling him to experience reality from another angle.[198] The abstract White Writings which Tobey was to make a few years later, reveal his new view of the world. The new view of everyday things can be recognized most clearly in such works as 'Broadway'. In later works he was to depict the dynamism suggested by daily life in the city in abstract terms. So those abstract works can also be seen as expressions of the direct experience of here and now. To feel was more important than to see, in his opinion.[199]

The relationship which exists in Zen between art and meditation is also apparent in Tobey's work, both in mood and in method. He has said about it: "My work is a kind of self-contained contemplation".[200] Wieland Schmied described a visit to Tobey's studio, where he encountered the artist 'in meditative concentration' at his desk.[201] Tobey believed that the Japanese had not only taught him to combine simplicity, directness and profundity, but also the meaning of 'abstraction', concentration and dedication.[202]

Reinhardt is directly the opposite to Cage and Tobey as regards the relationship between art and everyday life. He was of the opinion that art should be elevated above the commonplace.[203] And art's relationship with religion is what raises it above the everyday for Reinhardt. According to Cage and Tobey, and according to the beliefs of Zen, spirituality, art and the commonplace should actually form a whole. For Reinhardt, direct experience was only linked with the transcendence of self, as one of his comments shows: "By being personal, I felt I was more impersonal".[204] Abstract art, in his opinion, could be defined as "Art that is non-objective, transpersonal, transfigurative, transcendent".[205] He believed that pure painting, stripped back to the essence, relates most to the direct experience.[206] With respect to Chinese painters he once wrote that they say 'I experience and therefore I create'.[207] That would seem to have applied to his own working process, in that he never made preliminary sketches.[208] His comment that painting meant meditation and contemplation for him, also indicates an affinity with artists from the Far East.[209] And he had this interest in the relationship between art and meditation in common with Tobey.

The quest of the artists I studied for a 'direct experience' proved not only to apply to their own experience. Cage felt that art, which reflects experience of here and now, can also help the viewer to go beyond his personal limitations, and make a jump into a whole new field of human awareness.[210] Both Cage and Reinhardt wanted the spectator to be free in his interpretation, omitting titles which would refer to something and thus hamper the 'direct experience' of the artwork. Freedom of interpretation was also important for Tobey. He illustrated his point with the example of the *Haiku*. He thought you should allow someone else his own freedom of interpretation, as with the *Haiku* [211] which can be characterized as a moment of intense experience.[212] *Haiku* also had an appeal for Cage, who wrote a piece of music entitled 'Haiku' in 1952, the same year as R.H. Blyth published *Haiku* translated into English.[213]

Direct experience demands great concentration during the work process. In Zen, concentration is connected with strict discipline. Reinhardt also painted

in a very disciplined fashion, in order to achieve extreme purity in his work. And strict discipline is said to have formed the background to Tobey's approach to his painting action.[214]

The focus on here and now is also apparent in Zen, in its propensity for 'meaninglessness' and 'purposelessness'. These aspects are found in the views and works of Cage and Reinhardt too. Cage's 'Lecture on Nothing' dealt with the subject of purposelessness. He believed that art was an aimless game, and that a meaningful meaninglessness is the confirmation of life.[215] And aimlessness is expressed in Reinhardt's quest for *l'art-pour-l'art*. The element of 'repetition' also reflects aimlessness in the works under review. Dow wrote with reference to repetition: "It seems almost instinctive, perhaps derived from the rhythms of breathing and walking or the movement of ripples and rolling waves".[216] Repetition is un-Western, where progression is preferred to repetition: 'stagnation means decline'. That makes it all the more interesting that Tobey's White Writings and Reinhardt's Black Paintings differ so little, and 'progressive development' is out of the question.[217] Reinhardt painted his Black Paintings about two hundred times, with minimal differences in shades and proportions. And in that respect it is significant that he especially appreciated Oriental art for its repetition and uniformity.[218] In Zen the irrational *Koan* was intended to bring about 'Enlightenment' after it had been 'experienced' many times. The Black Painting appears to have had a comparable goal, since Reinhardt viewed monotony as a positive characteristic of Oriental art, the aim being to teach the viewer the right mental attitude, in which there is no understanding or expectation.[219] Cage said on the subject of repetition:

> "In Zen they say, if something is boring after 2 minutes try it for 4. If still boring, try it for 8, 16, 32, and so on. Eventually one discovers that it's not boring at all but very interesting".[220]

The subject of direct experience was discussed in America not only in Suzuki's books. In 1934 the American philosopher and educationalist John Dewey published the book *Art as Experience*. It attracted considerable interest from contemporary artists.[221] According to Dewey, 'experience' is constantly occurring, given that the interaction between a live creature and the conditions surrounding him is part of the process of living.[222] It is interesting to note that in the period Suzuki was working at the Open Publishing Company in LaSalle, he was in touch with Dewey and had acted as Dewey's interpreter during his trip to Japan.[223]

In the same year that Dewey's *Art as Experience* was published, Coomaraswamy's *The Transformation of Nature in Art* also appeared. That writer remarked that 'direct experience' in Zen formed the way to Enlightenment, also highlighting the resemblance between 'experience' in the Zen arts and the experimental and testing methods of modern Western science.[224] The connection Coomaraswamy made between the philosophy of Zen and modern Western science with respect to 'personal experience' also proves to apply to the theory of relativity. As a result of these theories, time and space are no longer considered to be absolute factors, but as subjective experience. Everyone has his own here and now.[225]

Nondualism and the universal

William Seitz wrote in 1953, concerning the work of Tobey and Motherwell, amongst others, that instead of antitheses like rationalism and emotionalism, there was clearly evidence of a new spirit of reintegration in painting since the last war. He felt that the unification of opposites should be the as yet unfulfilled task in the modern world, and unification by means of synthesis the future goal.[226] He believed that elements and principles of Expressionism, Cubism, Dada and Mondrian should be combined, out of a new feeling for humanity, Nature, the immaterial and reality.[227] A comparable remark can be found in Suzuki's writings. On the subject of Zen, he stated that, in conformity with desires in our inner lives, Zen leads us to an area of absoluteness, in which there is no antithesis whatsoever.[228]

In 1958 Reinhardt travelled to various Asian countries. He began his journey through Japan on 1 June, and it lasted five days. He stayed in Kyoto for two days, during which he visited the American artist Ulfert Wilke, who was studying the beliefs of Zen and the Zen arts in a temple there.

On the first day of his trip, Reinhardt immediately recorded eleven characteristics of Zen in his diary. Each point comprised two elements which were more or less conflicting.

"Zen – West? Eleven Elements – Zen Elements?
Whole Value, Vital Poetry, Best in Art – Word?
Mind – Body –> Actor – Scenery –> one
one thing is acted as all things
all things manipulated in one thing

1. asymmetry. (avoidance of geometrical and perfect. "unsaintly saints")	1. symmetry–geometry–perfection–absolute
2. simplicity. (black & white)	2. centrality–frontality–black rectilinearity
3. agedness. (finished before begun)	3. finished when begun?
4. naturalness. (innocence, thoughtlessness, no compulsion)	4. thought–contemplation–meditation
5. latency. (gentleness of warrior) (subdued, but not gloomy light of tearoom) much in little	5. more is less–much in little–latent–twilight
6. unconventionality. (indifference to contradictions. no idea of the holy)	6. conventionality–repetition
7. quietness. (inner)	7. quietness–"holy"–sacred–symbolic

terms–flexible–made include apparent opposite
latency but not symbolic
naturalness–become child–no Zen in child
nameless thing which is not a thing

8. freedom. (absolute freedom)	8. discipline–limits–order–form
9. humor. (paradox–contradiction) (blessedness)	9. humor–detachment
10. sexuality. (orgasm–sadism–masochism)	10. no pleasure or pain? subdued passion joke*

11. joy. (youthfulness) 11. neither joy nor gloom?
 not universe as machine world-weary
 confirmations of single artistic mind?
*why does so much sculpture today look like teeth

not necessarily visible or tangible
stinks of Zen – lacks Zen
West Zen is not East Zen
my Zen – not your Zen Deep but easy
eleven elements of Zen...".[229]

In this text Reinhardt describes the 'unity in opposites' in Zen philosophy. In elements 1, 3, 4, 6, 8, 10 and 11 he contraposes Zen characteristics which contradict one another, showing in this way that opposites can exist side by side in Zen. He no doubt knew that the pursuit of independence from dogmas in Zen is what makes that possible. By placing elements between the opposites which are not in opposition (numbers 2, 5, 7 and 9) Reinhardt would seem to have wanted to interrupt the logic in the list, in order to stress even more the undogmatic nature of Zen.

In the three lines preceding the list of elements, he comments that diversity and unity in Zen coincide. The cryptic first sentence of the text: "Zen-West? Eleven Elements-Zen Elements?" can be interpreted as an open question, as used in Zen.

In the intermezzo between elements 7 and 8 it is striking that Reinhardt, apart from once more emphasizing the unity in opposites, points out that the naturalness which is aimed at in Zen does not mean that Zen is present in a child, but that Zen requires development in awareness. Suzuki had stressed this element of Zen at an earlier stage.[230] Reinhardt uses terms like 'Self-transcendence', 'Risen above...', 'Beyond...' and 'Perfection' in essays on topics like dark and black, indicating a striving to exceed and not a desire for the primitive life.[231]

The closing lines of the text emphasize the elusiveness of Zen and return to the starting question "Zen-West?". Reinhardt concludes that Zen is probably different in the West from in the East. His remark that everyone's Zen is different suggests that he concludes that one cannot pass judgement on what is correctly or incorrectly termed Zen. The final words "Deep but easy" call forth associations for me with Suzuki's words that Zen is both hard and easy to understand.[232]

The short, cryptic lines of Reinhardt's text are reminiscent of the *Haiku*, which is in fact referred to in the second sentence (Vital Poetry). Since Reinhardt had studied the cultures of the Far East long before he travelled to Japan, his other texts in this style may well have been inspired by the *Haiku* as well.

The 'unity in opposition' which characterizes this series of Zen elements, is also an important characteristic of many of Reinhardt's works and utterances. According to Lippard, he sought to blend, amongst other things, purism and impression, subjectivity and objectivity, uniformity and individuality, and colour

and colourlessness.[233] Reinhardt did indeed state that art always conquers dualism. He believed that art was the extremely impersonal way of attaining what was truly personal, most complete control for the purest spontaneity, and the most universal path to the most unique, and vice versa.[234] In '44 Titles for Articles for Artists under 45' he wrote a remark along the lines of a Zen anecdote: "When you say 'yes' you get 44 blows of my swivel-stick; when you say 'no' you get 44 blows of my swivel-stick just the same".[235] It is almost identical to the example Suzuki quoted in one of his books to illustrate the paradoxical statements of the Zen Masters: "If you utter a word I will give you thirty blows; if you utter not a word, just the same, thirty blows on your head".[236]

Cage and Tobey aimed, with their working methods, at a feeling of unity with their materials, which they hoped would help them to surpass the individual. In the formal features of their work, and that of Reinhardt, there is a striking preference for equality of the individual parts of the work. Reinhardt opted for pure juxtaposition in his overall composition, Tobey for extreme overlapping. Although these methods are each other's opposites, it is amazing how similar their effect is on the viewer. Cage chose both equality and simultaneity of elements in his events.

An aspect which has received little attention in the literature of art history on the fifties is the 'religious feeling'. I found indications of such a feeling with Tobey, Graves, Crampton and Reinhardt. It is interesting to see what Dorothy C. Miller wrote in that respect in a catalogue in 1946: "All are concerned not only to utter the unique and spontaneous experience of the artist, but to make that experience embody the moods and intentions of our time (...) The mood is serious, even religious".[237] The interesting thing is that the three protagonists of my research were all familiar with the work of Meister Eckhart, and that that German mystic was also quoted on various occasions in Suzuki's and Coomaraswamy's books. Reinhardt wrote, for instance, about the concept of 'the divine dark', as described by Eckhart, and Cage read several quotations from his work during the Untitled Event.[238] Eckhart's liking for paradox and unity, his use of terms like 'the One' and his advice to descend into the self in the most profound silence are much akin to the philosophy of Zen.[239]

As we have seen, the universal and nondualism in Zen also relate to the interrelationship of all things. In that respect, Zen has some common ground, albeit superficial, with the changing world view of physicists in the wake of Einstein's theories. Their modern view of the world can be described as a complex web of relationships, in which the viewer is an essential element.[240] Coomaraswamy had already noted this similarity in 1934 and expressed the following hope:

"It is just possible that the mathematical development of modern science and certain corresponding tendencies in modern European art on the one hand, and the penetration of Asiatic thought and art into the Western environment on the other, may represent the possibility of a renewed *rapprochement*".[241]

I frequently came across the idea of the 'universal', in the sense of internationalism, in my research. An important reason for the striving for the universal would seem to have been what was felt to be too great a focus on Europe. In 1946 the foreword to a catalogue contained the following observation: "...there is a profound consciousness that the world of art is one world and that it contains the Orient no less than Europe and the Americas".[242] In the same publication Motherwell observed that modern art was related to the ideal of internationalism. He described it as a natural consequence of dealing with reality at a certain level.[243] Tobey wrote in the catalogue in question that there was already an awareness here but

> "only now does the challenge to make the earth one place become so necessarily apparent. Ours is a universal time (...) and the significances of such a time all point to the need for the universalizing of the consciousness and the conscience of man (...) Our ground today is not so much the national or the regional ground as it is the understanding of this single earth (...) The earth has been round for some time now (...) America more than any country is placed geographically to lead in this understanding, and if from past methods of behavior she has constantly looked forward toward Europe, today she must assume her position, Janus-faced, towards Asia, for in not too long a time the waves of the Orient shall wash heavily upon her shores".[244]

Elsewhere Tobey referred to the interest in America for such 'Japonistes' as Toulouse-Lautrec and Gauguin – in order to illustrate the belief that the East Asian influence on American art was not new. He wondered, in surprise, why the influence had been brought in through the back door, instead of direct.[245] In 1951 he observed that the Far East had indeed arrived in America in a direct way: "The Pacific hiatus is closing (...) The snake has seen its own tail".[246] After the quoted remark, made in 1946, on the need for improved contact with the Far East and the conclusion in 1951 that this desire had proved to be fulfilled, he declared eleven years later that the outcome was bound to be art that was neither typically of the West nor of the East: "Today we stand at a time where you have to paint a painting which is neither East nor West".[247]

Cage was also of the opinion that America was the ideal place for a start of a universal art. He observed that the movement caused by a tail-wind from the Orient, and the movement with a head-wind from the Occident, met in America, bringing about an upward stream of "the space, the silence and the nothing that support us".[248]

Reinhardt mainly pursued a timeless universal formula. He believed that the next revolution in art would be the recognition of universal paintings of a "pure land school".[249]

The artists whose work has been examined did not seek individual expression, but they did have their own opinions on the way in which the 'universal' can be expressed. However, transcendence of the subjective did not result in an 'objective' art, since that term is often associated with what is rational. For the artists in question transcendence of the individual was linked to 'direct experience' and 'involvement'.

The various comparisons have exposed and explained the affinity with Zen.[250] However, it is impossible to establish precisely to what extent this affinity influenced the artists' ideas, works and working methods. Accordingly, the art historians I interviewed had differing opinions on the role played by Zen. However, they were largely unanimous on the influence exerted by the Far East, in particular the beliefs of Zen on the ideas and works of Mark Tobey and John Cage, since they actually expressed clear opinions on the subject. Tobey mainly learned from Zen to see his surroundings from a different angle and as something purely dynamic. He was also inspired by formal aspects of *Sumi-e* and *Shō*. Cage tried consciously to integrate aspects of the Zen philosophy in his projects. And for Reinhardt, Zen would seem to have had a stimulating effect, though it is hard to prove. Zen chiefly confirmed Reinhardt in his quest for an exceedingly pure form of painting.

The role played by Zen in the work of a larger group of artists in the fifties in America is a subject on which most disagreement exists. The main cause is not the fact that the pronouncements were made at different times, but rests mainly on differences of opinion. Jeffrey Wechsler attributes a minor influence to Zen. He suggests that it was merely a matter of an affinity for Zen among artists and scholars which came about because they discovered that they had reached the same conclusions, on the late side, as the Zen Masters.[251] David Clarke concluded that American painters and sculptors found, in the 'empty mirror' of Zen, a kaleidoscopic range of possibilities for their art.[252] Some historians have, to my mind, exaggerated the Asiatic influence of the fifties. James J. Sweeney claimed in 1956: "For today, judging by what I have come across not only on the West Coast, but in New York, New Mexico, and even here in Chicago, it is the Oriental (or distantly Oriental) that seems the dominant interest of the younger artist".[253] Recent research by Gail Gelburd and Geri DePaoli resulted in the following reckless conclusion: "The encounter with Asian ideas resulted in new ways of seeing, new ways of being, new conceptions, and new experiences of space, time, form, void, subject and the object".[254]

For Americans who wanted to free themselves of the excessive influence of Europe, the almost logical consequence was an interest in the recently imported philosophy of life of their 'neighbours to the left', the Japanese.[255] The introduction of Zen and the Zen arts proved to come at a time when American artists were ripe for that interest. Zen coincided with their own evolution. Amongst other things, Zen confirmed that personal experience was the gateway to the universal. So Tobey's, Reinhardt's and Cage's interest in Zen was not the result of a desire to flee to a primitive past or a quest for an alternative for modern Western culture, but of a conviction that the time was ripe for a universal art, at a time when West and East were seeking greater *rapprochement*.

Notes

1 As already stated in the Introduction, the term 'work' is used in preference to 'painting' or 'drawing', since the dividing line between those two forms in modern art has become increasingly less clear. In Western art history the drawing has long been a preliminary study for a painting. From around the sixteenth century onwards it became customary to keep these studies, and in that way the drawing became known in that capacity, after which it began to be used as an art form as such, and not necessarily a preliminary sketch. From which time everyone would seem to have been aware of the difference between drawing and painting. Confusion appears to have come about when watercolours were first introduced. Strangely enough, it was agreed to classify the watercolour as a drawing, on account of the 'carrier', i.e. paper. With drawings made in 'mixed techniques' and acrylic paintings done on paper, the difference between a drawing and painting can sometimes be very slight.

In this context I should like to quote HILLIER, 1980, who begins his book *Japanese Drawings of the 18th and 19th Centuries* as follows: "In the West, there is a clear distinction between a drawing and a painting. (...) To the Japanese, all their paintings were drawings, all drawings, paintings". Yet Hillier opts for the word 'drawing', as the title of his book indicates.

The difference between drawing and writing has come about in the course of our cultural history. Writing originated in drawings (stylized characters). And that natural connection has never completely disappeared. We find it, for instance, not only in ancient Egyptian art and in the mediaeval art of the West, but also in modern art and in Art Brut (depictions made by the mentally disturbed and by children).

2 ADAMS, 1985, pp. 449-470. In his publication Adams complains at the lack of interest from art historians in the Japonisme of La Farge and other artists in America.

3 LANCASTER, 1963, chapter 19.
An example of an American Japonist of that period is William Merrit Chase (ill. 24). He was a friend of La Farge, but was primarily inspired by the French Japonistes.

4 This Japanese collection was placed in the Museum of Fine Arts in Boston, and in that way became the largest collection of art from the Far East in the world. Fenollosa worked for several years as the curator of this collection at the museum.

5 FIELDS, 1981, p. 155.

6 FIELDS, 1981, p. 155.

7 Lloyd Goodrich wrote in the catalogue *Georgia O'Keeffe*, NEW YORK 1970, p. 8, about Dow: "Dow was one of the few sophisticated American art educators of the time. He had spent years abroad, had been with Gauguin at Pont Aven, and through the Orientalist Ernest Fenollosa had become an ardent admirer of Japanese and Chinese art. As a teacher of teachers he rejected realism and based his system on the principles of design as he interpreted them in Far Eastern art: flat paintings, simplification, harmony".

8 LANCASTER, 1963, p. 235.

9 CHISOLM, 1963, p. 189.

10 The composition diagrams which Dow included in his book have several remarkable similarities with works by artists five decades later like Ad Reinhardt and Barnett Newman. Research has shown that there was apparently no influence whatsoever, just a common interest, as will be described later in this chapter.

11 O'KEEFFE, 1976, p. 16.

12 Catalogue *Japonism comes to America*, KANSAS CITY 1990, p. 222. That applied, according to Julia Meach, not only to Stieglitz, but also to his fellow photographers, Steichen, Weston and White. The art critic Charles Caffin had a 'helpful relation' with Stieglitz, and supplied contributions for *Camera Work*. He was an admirer of Whistler and La Farge, and welcomed the 'anti-realistic' contribution of Japanese art to American taste. He attempted to stimulate the trend in his book *How to Study Pictures* of 1912, with such remarks as: "The Japanese laugh at our Western art that tried to represent the human form and the forms of nature exactly. Japanese painting has taught our Western artists a good deal; it has a further lesson for all of us, if only in the matter of simplification...". Ibid.

13 COHN, 1985 (1982), p. 10, on Arthur Dove: "He was deeply absorbed in the study of Eastern religious and occult literature". Dove had a copy of *Epochs of Chinese and Japanese Art* by Fenollosa, but was chiefly interested in Theosophy. Dove once told his son that he (Dove) possessed "the soul of a transmigrated Chinaman". Ibid. pp. 11 and 48.

14 REICH, 1970, pp. 38 and 106: "Marin's use of watercolour approximates the medium of Japanese ink paintings" regarding Marin's work

around 1910, and "Marin was assimilating a new influence, perhaps a renewed experience with Japanese art", with respect to his work from 1917 onwards. Ibid. p. 106.

15 More will be said in this chapter, pp. 76-77, on the relationship between the work of Tobey and Marin. For more information on the connection with O'Keeffe's work, readers are referred to specific literature on these two artists.

16 Catalogue *Mark Tobey*, WASHINGTON 1984, p. 21.

17 Interview by William Seitz with Mark Tobey in 1962, TOBEY PAPERS, Archives of American Art.

18 TOBEY, 1955, unpaged.

19 WALEY, 1959 (1922), pp. 15, 21-22.

20 WALEY, 1959 (1922), pp. 15, 21-22.
The books Waley wrote on Zen were later read by various artists in Europe and America, and constituted for the French artist André Masson (see chapter 'The Zen arts in France') a first encounter with Zen.

21 HOFFMAN, 1979, p. 29.

22 SEITZ, 1953, p. 84.
In an interview with Seitz in 1962 Tobey remarked with regard to Teng Kuei: "He was a fingernail artist. He painted all his pictures with his fingernails, which is one of the traditions of Chinese painting". TOBEY PAPERS, Archives of American Art.

23 Catalogue *Mark Tobey*, NEW YORK 1949, unpaged, and TOBEY, 1958, p. 24.

24 SUZUKI, 1991 (1949/1934), p. 43.

25 Tobey in an interview with William Seitz in 1962, TOBEY PAPERS, Archives of American Art.

26 Tobey in an interview with William Seitz in 1962, TOBEY PAPERS, Archives of American Art.

27 SULLIVAN, 1973, pp. 251-252.

28 HOFFMAN, 1979, p. 28, tells that the art critic Clement Greenberg was the first to use the appellation 'White Writings' in 1944 (22 April) in *Nation*. It was also the first time that Greenberg had written about Tobey. After that 'White Writings' was adopted by many other writers as a collective term for Tobey's works comprising white moving lines.

29 Although he first met Asians in Seattle – including Kuei and the dealers who constituted an encounter between East and West at Pike Market – his comments on San Francisco were more positive: "Swerving to the left there is the Orient, although in San Francisco I feel the Orient rolling in with the tides". TOBEY, 1951, p. 229. His comments on Seattle varied tremendously, ranging from "I could smell

the Orient out there" to remarks to his friend Charles Seliger that he primarily felt himself to be a world citizen and that Seattle was merely 'the farthest possible place after his divorce'. Charles SELIGER in an interview in Mount Vernon (NY) on 9 May 1994. That artist corresponded regularly with Tobey from around 1950; they lunched together almost every day when they had neighbouring studios.
Seattle had not initially been Tobey's choice. He had gone there after an offer to work as a lecturer at the Cornish School. PATTERSON, 1969, p. 10.

30 Morris Graves, Kenneth Callahan (b. 1906) and Guy Anderson (b. 1906) were, together with Tobey, the foremost artists of what was called the 'Northwest School'. They were all interested in the Far East.
Publications which attempt to underline the differences between the painting on the West and the East Coasts of America, frequently refer to the collections of Chinese, Japanese and Indian art, the Buddhist temples and large numbers of Chinese and Japanese immigrants in towns on the West Coast. See REXROTH, 1955, p. 59, for instance. Research has shown, however, that there was no less focus on Japan in New York compared with the West Coast, thanks to the presence of people like Suzuki and to the available literature on Buddhism, and Zen in particular, to the magnetism of Fenollosa and Dow from Boston, and Japonisme which was introduced from Europe. This view was confirmed during various interviews, amongst others with Louise BOURGEOIS, in New York on 5 May 1994.

31 KASS, 1983, p. 23, quoting Graves.

32 Wight in the catalogue *Contemporary Calligraphers*, HOUSTON 1956, p. 6.

33 KASS, 1983, p. 66.

34 Cage wrote, for example, 'Series Re Morris Graves' in *The Drawings of Morris Graves*, Boston, 1974.

35 KASS, 1983, p. 19.

36 The catalogue *Americans 1942*, NEW YORK 1942, unpaged. Graves tried to emphasize his theory using the titles he had given his works, for example 'Little Known Bird of the Inner Eye' and 'Dove of the Inner Eye'.
Duncan Philips described Graves' aim as "the revelation of an inner life". This quote from the *Magazine of Art* (1947) 40, was included in KASS, 1983, p. 11. Ray Kass, Ibid., p. 26, would seem to have been convinced that

Graves had succeeded. In his article 'Vision of the Inner Eye' he observed "He has defined space and reality in terms that implicitly unite the goals of his spiritual inquiry with those of his art".

LANCASTER, 1963, p. 244, also makes positive comments on Graves' results. He is particularly enthusiastic about the works with Graves' favourite subject of the bird. He writes about the painting 'Moon Mad Crow in the Surf': "The moon, the sea, the sky have merged in oneness in the bird, and there is no external existence. His concentration is complete; he has attained 'satori'". ROWLAND, 1954, p. 127, who compares several works from both sides of the world, is very negative about the interpretations of the Zen-inspired 'Inner Eye' view. He believes that Graves' works "appear as no more than a decorative and self-conscious improvisation in the Oriental technique".

Having compared Graves' work with Zen painting, I have reached the conclusion that the former does not call forth associations with 'meditation' and certainly not with 'Enlightenment', as Lancaster suggests. The White Writings which Graves used had been borrowed from Tobey. However, the effect of the texture of the white lines was quite different with Tobey. There they have an independent function, rather than the background function as in Graves' work. With their effect of 'infinite space', Tobey's works to my mind have a greater affinity with Zen painting and meditation than do Graves'. Important aspects of Zen painting, such as 'simplicity' and 'elimination of the irrelevant' would seem to apply more to the work of Tobey and Reinhardt than to that of Graves. The remarks on birds in meditation suggest that Graves and Lancaster probably thought that birds symbolized meditation in the paintings by Zen Masters. However, birds in fact epitomized liberation from earthly matters and *joie de vivre* for the Zen Masters. BRINKER, 1987 (1985), p. 128.

37 The art critic Clement Greenberg observed with respect to Tobey's exhibition: "....one of the few original contributions to American painting". ROBERTS, 1960, p. 10.

38 WILLARD GALLERY PAPERS, Archives of American Art. See chapter 'The Zen arts in France' for more information on Masson. Rudolf Ray exhibited several portraits of Suzuki in 1955 in the Willard Gallery. The catalogue *Toward Self Realization*, NEW YORK 1955,

contained several remarks by Ray on Suzuki. The latter attended the opening of the exhibition.

39 Willard in *Direction*, February 1944, WILLARD GALLERY PAPERS, Archives of American Art.

40 KASS, 1983, p. 59.
According to Charles SELIGER in an interview in Mount Vernon on 9 May 1994, Marian Willard studied with Jung and initially had wanted to become a psychoanalyst. However, she decided against it, in view of her lack of communicative skills. It is striking that her interest in the affinity between East and West is comparable with that of Jung.

Seliger tells that her lack of communicative skills was also held against her as a gallery proprietor. Many artists felt she did too little to promote them. That might explain the fact that few art critics and art historians mentioned her gallery.

41 The American art historian Jeffrey Wechsler suggests that this was primarily due to the picture that critics wanted to present of 'typically American' art of the fifties as 'vehement and subjective'. In addition, many critics inclined towards 'local thinking' rather than 'universal thinking'. Jeffrey WECHSLER in an interview in New Brunswick (New Jersey) on 3 May 1994.

42 In 1898 five Japanese Zen monks went to San Francisco, where they founded a temple with several small 'offices' scattered through the West Coast area.

43 See pp. 38 and 46. The role of Suzuki's work in the ideas of Waley and Huxley merits further research, in my opinion.

44 He first published in England about Zen. From 1938 onwards some of his writings were published in New York, where he also held several lectures. I shall return to that later in this chapter.

45 Research at the archives of that university revealed that Suzuki began his courses in 1952. In the Columbiana Library, the historical archives of Columbia University, the dates noted for Suzuki's lectures were 1952 to 1957. The archives contained little information on the content of the courses, since Suzuki was a visiting lecturer.

According to ABE, 1986, p. 223, Suzuki held courses there from September 1950 onwards. In an interview in 1968 with KOSTELANETZ, 1970 (1968), Cage said that he thought he had begun attending the classes in 1949. That is impossible, since Suzuki was teaching at the

University of Claremont in California then. However, there are indications, as we shall see later in this chapter, that Suzuki did give some lectures in New York as early as 1949.

Since Suzuki only went to America in June 1949, having spent his time since 1937 in Japan, any earlier date must be incorrect. In his thesis E.J. Snyder gave 1945 as the year in which Cage began following Suzuki's courses at Columbia University (Kostelanetz used the chronology in that thesis in his book of 1968). BERNLEF/SCHIPPERS, 1967, gave the year as 1946 and DANUSER, 1974, mentioned 1947.

46 Interview with Philip YAMPOLSKY in New York on 15 October 1990.

47 Interview with Mary FARKAS in New York on 16 October 1990.

48 ASHTON, 1964 (1962), p. 105. The artists who were seeking the Self discovered, according to ASHTON, Ibid, the same quest in Zen, though they were not concerned with the differences in meaning. The distinction between the Western and the Eastern view of self will be discussed in the chapter 'The inherent Zen in Japan'.

49 FIELDS, 1981, p. 205.
VOS, 1964, p. 229, gives three factors as occasioning the popularity of Zen: the war with Japan and the subsequent occupation of that country, during which thousands of young men came in contact for long periods of time with Japanese culture; Zen proved or seemed to give an answer to many problems experienced by the postwar 'rebels' against the conventions and ideals of their own culture, and lastly, many people idolized what was new and unknown.

50 FIELDS, 1981, p. 196.

51 Interview with Charles SELIGER, a friend of Tobey's, in Mount Vernon on 9 May 1994. The artist Ad Reinhardt had a similar opinion, as will become evident later in this chapter.

52 ROSS, 1958, pp. 64-65 and 116.

53 ROSS, 1958, p. 116.

54 ASHTON, 1965, p. 66, quotes Guston. I am unaware exactly when the remark was made, but it is clearly a 'product' of the Zen-boom of the fifties.

55 VERSLUIS, 1993, devotes his book to the relationship between Transcendentalism and beliefs in East Asia.
According to Versluis, Ibid., p. 6, the Transcendentalists believed that Christ was not the only way to redemption, but that Hinduism and Buddhism could also be the way. Emerson and Thoreau in particular were interested in Hindu holy books like the *Vedanta* and the *Bhagavad Gita*, the teachings of Confucianism and the beliefs of Buddhism. Ibid., p. 79.

56 Interview with David ANFAM in Washington D.C. on 5 April 1994.

57 Dale McConathy, catalogue *Reinhardt*, EINDHOVEN 1972, p. 11. However no specific relationship with *Sumi-e* has been demonstrated.

58 VERSLUIS, 1993, p. 317. See also the many references to Emerson and Thoreau in SUZUKI 1993 (1938/1927).

59 FIELDS, 1981, p. 205, believes that Suzuki derived the description of the characteristics of *Satori* from William James' mystical experience. Fields is referring to the characteristics "irrationality, intuitive insight, authoritativeness, affirmation, exhilaration and momentariness".
In his essay 'The Psychological Antecedent and the Content of the Zen Experience' Suzuki refers readers to James' book *Varieties of Religious Experience*. That essay was included in SUZUKI, 1963 (1962), p. 194.

60 AMES, 1962, p. 18, forgets that the beliefs of the Transcendentalists were influenced by Buddhism. The ideas of the American Transcendentalists were originally based on the German idealism, and so were not typically American in origin.

61 AMES, 1962, p. 18.

62 AMES, 1962, p. 18.

63 ASHTON, 1964 (1962), p. 107.
In 1952 R.H. Blyth began publishing a series of books with English translations of *Haiku*. It is interesting to note that Blyth was a friend and follower of Suzuki.

64 Reinhardt, Tobey and Cage all prove to have read nearly all these books.

65 FIELDS, 1981, p.205, remarks that Suzuki did not entirely agree with Jung on that point. He criticized the fact that psychoanalysis separates the conscious from the subconscious.

66 An information booklet by Suzuki was on sale there for 50 dollar cents. WILLIAM LITTLEFIELD PAPERS, Archives of American Art.

67 See note 223. Suzuki's charisma was his main attraction, and the same applied to Cage. However, the sculptress Louise Bourgeois, who had met Suzuki and also attended Cage's lectures at The Club, stated in an interview that there was a great difference between Suzuki, with his 'modesty', and Cage with his 'bombastic' behaviour. Louise BOURGEOIS in an interview in New York on 5 May 1994. In this

respect there would seem to be a considerable difference between the concept of 'personality' in the Far East ad in the West (see the chapter 'The inherent Zen in Japan').

68 Cage in an interview with Paul Cummings on 2 May 1974, Archives of American Art.

69 KASS, 1983, p. 28.

70 CAGE, 1967 (1961), p. 95.
YANAGI, 1972, p. 124, wrote of Zen-inspired art: "Creation means making a piece that will lead the viewer to draw beauty out of it for himself".

71 CAGE, CHARLES, 1981 (1976), pp. 56 and 106.

72 CAGE, CHARLES, 1981 (1976), p. 234.

73 Interview with John IPPOLITO in New York on 11 May 1994.

74 Rauschenberg's uniform White Paintings were apparently not inspired by Cage or the beliefs of Zen. My research revealed that Rauschenberg made the first works in that series in the autumn of 1951 at Black Mountain College, a few months before he resided there with Cage. He and Cage first met at an exhibition of Rauschenberg's work at Betty Parsons Gallery in May 1951 (a few White Paintings were on display which at that stage were not entirely uniform in their whiteness). Cage did not see the latter type until 1952. TOMKINS, 1981 (1980), p. 71.
There is nothing to suggest that Rauschenberg was interested in Zen.

75 DUBERMAN, 1974 (1972), p. 46, wrote in that context: "Cage and the Zen masters know events are too full of multiple-sensory inputs and momentary variables even to be reproduced with descriptive exactness". By virtue of the Untitled Event Cage is quite frequently referred to in the relevant literature as the father of living art.

76 See p. 54.

77 Friedman, undated, unpaged, ARTIST FILE JOHN CAGE, MOMA New York.

78 CAGE, 1979, p. 3. Thoreau built a cabin in the wilderness near Walden Pond. He spent a great deal of time meditating there and observing Nature. His principal work is *Walden or Life in the Woods*, which was published in 1854. His independent, anti-authoritarian attitude to life was an inspiration to many people in the second half of the twentieth century.

79 The Club was set up in 1949 by several Abstract Expressionists, including Robert Motherwell and Ad Reinhardt, as a New York equivalent to the Parisian artists' café.

80 ASHTON, 1972, p. 98.

81 WATTS, 1973, p. 84, wrote of his personal dealings with Cage.

82 See also pp. 80 and 83.

83 See the chapters 'West looks East' and 'The Zen arts in France'.

84 It is worth noting that Coomaraswamy, after Okakura, succeeded Fenollosa at the Museum of Fine Arts in Boston.

85 CAGE, CHARLES, 1981 (1976), p. 105.

86 CLARKE, 1988, p. 32. Ad Reinhardt will be discussed later in this chapter.

87 ASHTON, 1972, p. 225. My research has not shown that 'many' artists were involved.

88 Later in this chapter, on p. 74, these lectures will be discussed in more detail.

89 CLARKE, 1988, p. 107.

90 Brooks in an interview with Dorothy Seckler on 12 June 1965, Archives of American Art.

91 MC.EVILLEY, 1992, p. 100.

92 The artist John Ferren (b. 1905) once remarked that he felt a particularly affinity with Cage's striving towards the "super personal, not superman". WILLIAM SEITZ PAPERS, Archives of American Art. Moreover, Ferren refers in his text 'Innocence in Abstract Painting' written in 1958, to the effect of the 'Koan'. FERREN, 1958, p. 12. Little Zen inspiration can be detected in Ferren's painting, which he began in 1930 after having first worked for several years as a sculptor. Stamos' interest in Zen was part of his interest in various non-Western cultures, and is especially apparent in several works in the 'Teahouses' series made between 1950 and 1952.
I have not examined the sculptors David Smith and Abram Lassaw in greater detail, as sculpture is not the focus of my research.

93 More attention will be paid elsewhere in this book to the artists Pierre Alechinsky, p. 113ff., and Morita, p. 201ff.

94 Motherwell quoted in SEITZ, 1983, p. 22.

95 FLAM, 1983, p. 21. In an interview, Ibid. p. 23, Motherwell confirms his affinity with Zen, which, he maintains, primarily emerged in his work in the sixties.

96 ASHTON, 1964 (1962), pp. 103-105.

97 PAVIA, 1958, 1, pp. 2-5, writes regarding to reactions in The Club to Heidegger's beliefs. Although the discussions clarified the philosopher's views on a number of points, the artists in question mostly found Heidegger too intellectual.

98 Much of this comparison is taken from ASHTON, 1964 (1962), pp. 32-41 and 103-112.

99 CAGE, CHARLES, 1981 (1976), p. 92.

100 Interview with John IPPOLITO in New York on 11 May 1994. He made this remark particularly with reference to John Cage.

101 THOMAS HESS PAPERS, Archives of American Art. Hess also mentioned in his notes: "Gertrude Stein, Kropotkin, Paul Goodman's idea of communitas, John Cage's restful silences, Faulkner, Artaud and Baseball".

Literature research and various interviews suggest that the level of the debates should not be overestimated. For many artists the presence of alcohol was of prime importance.

102 HARRIS, 1987, p. 182. According to Harris, Josef Albers, an important leader at the institute, had closer ties with the ideas and aesthetics of the Far East than his remarks suggest. His great interest in the work and ideas of Kandinsky and Itten especially, meant that he was automatically inspired by the Far East. Moreover, Harris comments in her book that Thomas Whitney Surette "who had an immeasurable impact on the arts at the College, reflected the view of the New England transcendentalists".

103 Mary Emma HARRIS during an interview in New York on 2 May 1994.

104 HARRIS, 1987, pp. 160 and 116, added that Olson was greatly influenced by Ezra Pound, who had frequent contact with Fenollosa and was very interested in Japanese literature and theatre.

105 This Ch'an Buddhist text was published in New York in 1949 in an English translation.

106 See above, his 'Lecture on Something' in 1949.

107 WATTS, 1973, p. 88. So far, no definite conclusion can be drawn concerning Watts' role as regards Kline.

108 This theme issue of the *Chicago Revue*, SUZUKI a.o., 1958, included the following articles: 'Beat Zen, Square Zen, and Zen' by Watts, 'Rinzai on Zen' by Suzuki, 'Meditation in the Woods' by Jack Kerouac, 'Zen and the Various Arts' by Shinichi Hisamatsu. The remaining articles on Zen were written by Philip Whalen, Ruth Fuller Sasaki, Ryogen Senzaki, Gary Snyder, Harold E. McCarthy, Akihisa Kondo and Paul Wienpahl. Kline's 'Drawing' was immediately after Suzuki's article. The other illustrations in the theme issue were made by modern Japanese artists: Toko Shinoda (drawings) and Takashi Simmi (1 lithograph).

109 This can be concluded from several interviews from the fifties.

110 Name of journalist unknown, *Time*, 4 August 1958.

111 CAGE, 1967 (1961), foreword. See also note 165 of this chapter.

112 I am unaware of which Japanese prints Kline owned, so we cannot know if Kline was familiar with the print reproduced in this book.

113 WILLIAM LITTLEFIELD PAPERS, Archives of American Art. Littlefield was also a member of The Club and referred to that fact in a letter to Paul Cummings written in 1969. Although he noted the name 'Ukioye', I suspect he was mistaken with the spelling.

114 For example, in the interview with Katherine Kuh, Kline said: "calligraphy has nothing to do with us". KUH, 1962 (1960). p. 144.

115 RODMAN, 1957, p. 109.

116 WILLIAM SEITZ PAPERS, Archives of American Art.

117 One of SANDLER's arguments, 1976, p. 128, for denying a connection is the passive white ground in calligraphy, compared with Kline's active white.

118 DOW, 1899, p. 37. Early on in the same book, p. 7, Dow commented on the subject of 'lines': "They may be frankly left in the finished work, as in Japanese prints and early Italian frescoes. In the making of these lines there is opportunity for great beauty of proportion, and a powerful vital touch, full of personality".

Dow's remarks are not quoted to suggest there was an influence on Kline, but merely to point out the affinity between these quotes and Kline's works, both of which stemmed to some extent from an interest in Japanese woodcuts.

119 Eliza Rathbone in the catalogue *Mark Tobey*, WASHINGTON 1984, p. 22.

120 Eliza Rathbone in the catalogue *Mark Tobey*, WASHINGTON 1984, p. 22.

121 However, the remark by Harry F. GAUGH, 1986, p. 131, that there is no doubt that Kline recognized the Japanese brush drawing on a 17th century dish at Freer Gallery in Washington, is very reckless.

122 See the section 'Kandinsky: a new perception of Japanese art', the text relating to Fenollosa and O'Keeffe in this chapter and the next chapter 'The Zen arts in France', where Surrealism will be discussed in more depth.

Although Jackson Pollock was interested in Kandinsky's and Massons' work (see the chapter entitled 'The Zen arts in France') and

Jung's ideas, we should certainly not underestimate the influence on his work of such non-Western cultures as those of the Mexicans and the Indians.

123 "I taught a lot of art history, especially Chinese, Japanese, and Indian" Reinhardt was to say in an interview with Mary Fuller in 1966. The interview in question was published in *Art Forum* in October 1971 and in ROSE, 1991 (1975), pp. 23-29.

124 "When will the Hindu and Buddhist figurative art of India, Farther India and the Far East of China and Japan begin to take its proper place in world art histories of the West?", quotation by Reinhardt from his essay 'Art versus History', which was published in *Art News* in 1966 and in ROSE, 1991 (1975), pp. 224-227.

125 REINHARDT, 1954, p. 24. In that essay he discusses an exhibition of Ch'an painting at Cleveland Museum of Art.

126 LIPPARD, 1981, p. 176.

127 CLARKE, 1988, p. 50.

128 Irving SANDLER in an interview in New York on 26 April 1994.
 In the REINHARDT PAPERS in the Archives of American Art several lectures are mentioned, including 'Religion and Modern Art', Studio 35, 1952; 'Detachment and Involvement in Eastern and Western Art', Studio 35, 1952; 'Oriental Art – Indian Sculpture and Chinese Painting', Comparative Thought Club, Brooklyn College, 1955; 'Chinese Painting', Art Group, Brooklyn College, 1956; 'Male and Female Forms in Eastern and Western Art', Artists Club, 1956.

129 Catalogue *Ad Reinhardt*, NEW YORK 1974.

130 McConathy in the catalogue *Ad Reinhardt*, NEW YORK 1974, p. 9.

131 REINHARDT, 1960, p. 33.

132 Invitation to the opening of the *Ad Reinhardt* exhibition in Düsseldorf in 1972.

133 Lippard in the catalogue *Ad Reinhardt*, NEW YORK 1966, p. 20.

134 LIPPARD, 1981, p. 191.

135 ROSE, 1991 (1975), pp. xv and 82. In her commentary accompanying Reinhardt's essays, she remarks that his Black Paintings reflected the values of Eastern cultures, in which he was becoming increasingly more interested. However, Rose does not specify to which values she is referring.

136 'Notes Reinhardt', REINHARDT PAPERS, Archives of American Art. Reinhardt proves to have considered the cross which frequently occurs in his later works as a universal form.

The series of slides which he made during his various journeys confirm that he encountered the cross and the circle in varying forms in many different cultures, including the mandalas in a number of Eastern cultures. The Brooklyn Museum in New York owns a Japanese Mandala, VARLEY 1984 (1973), p. 49 fig. 19, which is very similar in composition to that of Reinhardt's last square Black Paintings.

137 REINHARDT, 1960, p. 34.

138 REINHARDT, 1954, p. 27, about Zen painting. His description of the black-square paintings from 1961 was published in 1963 with the title 'Autocritique de Reinhardt' in *Iris-Time*, published by the Iris Clert gallery in Paris.

139 Dale McConathy in the catalogue *Ad Reinhardt*, EINDHOVEN 1972, p. 10.
 He seems to have used 'anonymous' to mean art which does not exhibit personal characteristics, but whose design in based on tradition.

140 KASS, 1983, p. 93. According to his friend Sal SIRUGO in an interview in New York on 10 May 1994, Crampton read a great deal on the subject of Far Eastern philosophies, including Zen.

141 KASS, 1983, p. 92. See the chapter 'The Zen arts in France' for more information on Yves Klein.

142 Wechsler in the catalogue *Abstract Expressionism*, CORAL CABLES 1989, p. 36.

143 According to the owner of the paintings, the artist Sal Sirugo, there was no reason whatso-ever to pre-date these paintings (measuring 122 x 183 cm. and 122 x 176.5 cm.), since the artist only wanted to show his most recent work at exhibitions. The art historian Jeffrey Wechsler, who is specialized in less well-known American artists of the fifties, also said he was inclined to consider the date to be correct. WECHSLER in an interview in New Brunswick on 3 May 1994.

144 FIELDS, 1981, p. 204.

145 Letter from Thomas Merton dated 31 October 1963, REINHARDT PAPERS, Archives of American Art.
 Reinhardt apparently did not only make the calligraphies in secret. He had more secrets. Although he claimed in public to be an atheist, Dore Ashton once saw him at a meeting of strict Catholics, which he proved to attend more often. Dore ASHTON in an interview in New York on 19 April 1994.
 John CHANDLER, 1971, p. 26, wrote

regarding the discrepancy between Reinhardt's works and statements: "I think nowhere was there a greater gulf between a man's paintings and his published statements". In the Western tradition, a person's statements are generally taken as absolute. In the Japanese tradition, the meaning of remarks and words would seem to be variable and sometimes conflicting, depending on the situation. That also explains the very divergent and often conflicting answers of Zen Masters to the same question. The difference in linguistic usage was explained to me by Toru MOMO, a culture historian, during an interview in Tokyo on 10 December 1993. This interpretation of Reinhardt's behaviour cannot be substantiated, but it could at all events be described as un-Western.

146 MERTON, 1968 (8th impression), p. 52.

147 The introduction to this catalogue, which travelled through eight countries in 1958/59, was reprinted in SANDLER (ed.) 1986, p. 231 ff. Barr is probably referring to artists like Philip Guston.

148 SANDLER, 1976, p. 221.

149 For instance the above mentioned artists Graves and Ray. Apart from these arguments, personal resentment may also have played a part. Reinhardt quarrelled with many artists because he was inclined to make insulting comments, as interviews with several of his acquaintances revealed.

150 BREUL, 1958, p. 65.

151 REINHARDT, 1967, unpaged: "But the idea of negativity is not a bad idea anymore. (...) It's the negativeness of black which interests me".

152 DENNY, 1967, pp. 264 and 267, quoting Reinhardt.
In one of his texts Reinhardt used the term 'the Buddhist theology of negation'. ROSE, 1991 (1975), p. 93.

153 Included in ROSE, 1991 (1975), pp. 50-51. The catalogue *Contemporary American Painting* was published for the exhibition with the same name, held at the University of Illinois, Urbana, 1952.

154 See the chapter 'Zen and the Zen arts', p. 19.

155 See ROSE, 1991 (1975), pp. 203-207. Reinhardt entitled the essay 'Twelve Rules for a New Academy'.

156 This text from the *New York Herald Tribune* was quoted in HARRIS, 1987, p. 226.

157 In Reinhardt's case a link with Dada is rarely made. However, it was found in the theory that non-objective monochrome painting had two very different sources, i.e. aestheticism and Dada, or art-for-art's sake and anti-art. Yet it was felt that American artists like Reinhardt could take the credit for synthesizing "these opposing and apparently mutually exclusive tendencies – aestheticism and anti-art, purist painting and the Dada purgative". CHANDLER, 1971, p. 22.

158 Hilton Kramer in a publication dating from 1992, title and place of publication unknown, in ARTIST'S FILE JOHN CAGE, MOMA New York.
After the Second World War, Dada underwent a slight revival. It is worth noting that the artist Robert Motherwell published the book *The Dada Painters and Poets. An Anthology*, in 1951. He especially emphasized the part played in the movement by Richard Huelsenbeck, who originally came from Zürich. In 1949 Huelsenbeck had tried to get Dadaists in America to sign a new Dada manifesto, which he had drawn up himself. He was also working in New York as a Jungian psychoanalyst, which is interesting in view of the previously mentioned enthusiasm among artists for Jung and his fascination with Zen. Motherwell referred in his book to the contact between Huelsenbeck and some of the modern artists in New York.

159 For instance the work entitled '3 Stoppages Etalon' of Marcel Duchamp from 1913-14. The work in question was created by throwing 1-metre long strings from a height of 1 metre (MOMA collection). In around 1980 Cage staged an event with some 20 strings which (determined by *I-Ching* as to size, colour, height) were thrown on sheets of paper and printed as monotypes. Information was supplied by Tz'art Gallery in New York, which still has a few of the prints made at that time.
The shock effect used in Dada can also be found in Zen literature. Since *Satori* can be achieved suddenly, the Zen Masters some-times use the shock effect as well, for instance, a sudden slap in the face for a monk.

160 ROSS, 1958, p. 116.

161 Interview with John IPPOLITO in New York on 11 May 1994.

162 Various members of Dada knew the previously mentioned books *Upanishads*, *Bhagavad Gita* and *Tao Te Ching*. Hans Arp illustrated an edition of *Bhagavad Gita* in 1914. Hannah Hoech owned copies of *Reden und Gleichnisse des Tschung-Tse* and *Die Bahn und der rechte Weg des Lao-Tse*, which Raoul Haussmann

gave her in 1916. In 1922 Tristan Tzara described Dada as a 'quasi-Buddhistic religion of indifference'. FOSTER, 1979, pp. 92-107.

163 CLARKE, 1988, p. 163.

164 CAGE, 1967 (1961), pp. 108-145.

165 CAGE, 1967 (1961), p. 126, wrote that after his 'Lecture on Nothing', the audience asked questions in the usual way. However, before the lecture he had written down six answers and gave one of those in reply to any of the questions. Cage claims to have been inspired in that by Zen; he was probably referring to the use of *Koans*. During their quest for Enlightenment, Zen monks were given a *Koan* to which they had to find an answer. The Zen Master assessed whether the reply confirmed the monk's state of Enlightenment. A typical example is: "What is the ultimate principle of Buddhism?" "The cypress tree in the courtyard". SUZUKI, 1991 (1949/1934), p. 106. Cage's question-and-answer session at The Club, despite its entirely different origination and purpose, produced a comparably irrational dialogue.

Cage not only spoke about 'nothing', but also used that element in his lecture. The published version of his lectures shows how he used, between the parts of the sentences, the medium of silence which he favoured so much.

166 CAGE included the text of the lecture in his book *Silence*, 1967 (1961), p. 143.

167 CAGE, 1967 (1961), p. 143.

168 REINHARDT PAPERS, Archives of American Art. In one of his notes he mentions Cage's name, adding "the necessity of doing nothing. The necessity of not doing anything. 'Striving' for nothing" (Ibid., note made in 1955). He also encountered this characteristic in Zen painting, in which there was "almost nothing to say, and sometimes nothing much to see" (REINHARDT, 1954, p. 26).

Reinhardt also made other remarks which are similar to some of Cage's comments, but they do not suggest any connection. It is, for instance, striking that Cage wrote about Rauschenberg's White Paintings: "... where nothing was done" (CAGE, 1967 (1961), p. 102) and Reinhardt also once said: "I often said to Rollin Crampton 'there's nothing to do'", in which he was probably referring to Lao-Tse's remark "by doing nothing everything is done" (Reinhardt in a letter to San Hunter in the summer of 1966, Archives of American Art.

These archives also contain the notes Reinhardt made during Alfred Salmony's courses, in which the Lao-Tzu quote can be found).

169 ROSE, 1991 (1975), p. 73, unpublished note from 1966-67; REINHARDT, 1954, p.26.

170 REINHARDT PAPERS, Archives of American Art.

171 REINHARDT PAPERS, Archives of American Art. According to McConathy, in the catalogue *Ad Reinhardt*, DÜSSELDORF 1972, Reinhardt's work is reminiscent of the Zen psalm: "Form is emptiness and emptiness is form".

172 SEITZ, 1965, p. 17. According to LIPPARD, 1981, p. 196, he achieved "'nothing' because he absorbed everything" in his monochromes (especially the Black Paintings).

173 CAPRA, 1985 (1975), p. 223. Capra claims that the discovery of the dynamic quality of the vacuum was seen by many physicists as one of the most important discoveries of modern physics.

174 Interview with Charles SELIGER in Mount Vernon on 9 May 1994, who often discussed new scientific developments with Tobey in the fifties.

175 MC.EVILLEY, 1992, pp. 99-100.

176 CAGE, 1967 (1961), p. 100.

177 Catalogue Mark Tobey, AMSTERDAM 1966, unpaged, and CLARKE, 1988, p. 191.

178 Tobey in an interview with William Seitz in 1962, on microfilm in the Archives of American Art, and Tobey during the symposium 'Artists from Eastern and Western Countries' in Vienna in 1960. Report in WILLARD PAPERS, Archives of American Art; DAHL, 1984, p. 22.

179 Interview by William Seitz with Mark Tobey in 1962. TOBEY PAPERS, Archives of American Art.

180 Katharine Kuh compared Tobey's White Writings with the work of the Futurists. However, she stressed that, unlike the Futurists' work, Tobey's had an overall movement, divided homogeneously over the surface because he had achieved total dematerialization. KUH, 1962 (1960), p. 30. She was also of the opinion that Tobey reached 'infinite levels of movement' as a result of an absence of focal centre or end.

181 YAO, 1983, p. 27.

In her thesis Marguerite HUI MÜLLER-YAO, 1985, makes a very detailed attempt to detect similarities in form (such as types of angles, curves and 'three-dimensionality')

between Tobey's lines and Chinese calligraphy.

182 He got that idea when visiting several Chinese friends in Seattle and saw them making *Sumi-e*. TOBEY PAPERS, Archives of American Art.

183 Catalogue *Reinhardt*, NEW YORK 1967, p. 9.

184 REINHARDT PAPERS, Archives of American Art.

185 CLARKE, 1988, p. 91, and ASHTON, 1990 (1976), p. 93.

In an interview with the Japanese art critic Tadao Takemoto in 1971, Tobey stressed the rhythmic power he had learnt in Japan. To which Tobey added "...it is the only thing that, as an American, I could take". As he put it, his interest in Japanese art concerned primarily the "dynamics of creation – whether gentle or powerful". YAMADA, 1976, p. 304.

Rhythm has become increasingly important in 20th century art, and with it the relationship with music. As a musician, Cage felt an affinity with visual artists. Tobey played the piano, and would have liked to have become a musician. Zen taught him to allow the details to merge in an all-embracing rhythm. Anon., *MD*, 1978, p. 121. It is interesting that Dow had already observed that Fenollosa believed that music was in some respects the key to the other arts.

186 Tobey in an interview with William Seitz in 1962, TOBEY PAPERS, Archives of American Art. ROBERTS, 1960, p. 13, describes the unplumbable depth which thus arose in Tobey's work as 'the search for the infinite'.

187 PAVIA, 1958, 2, p. 4.

188 PAVIA, 1958, 2, p. 5.

189 PAVIA, 1958, 1, p. 4.

190 REINHARDT, 1954, p. 27.

191 MC.EVILLEY, 1992, p. 99.

192 CAPRA, 1985 (1975), p. 62.

Before Einstein introduced his theory of relativity, space and time were usually seen as separate entities. Einstein's view led to a new entity: 'space-time'.

In the past there have regularly been philosophers in the West who suggested this type of connection, but they were always formed an undercurrent in Western cultural history.

193 DIENES, 1959, p. 63.

194 DIENES, 1959, p. 63.

195 CAGE, 1967 (1961), frequently refers indirectly in his essays (using descriptions of personal experiences) to the importance of intense experience. The unusual layout of the book in question makes the reading thereof an intense experience.

Cage formulated the attainment of new insight as 'Jumping into a field of human awareness'. TOMKINS, 1981 (1980), p. 69.

In 1948 Robert Motherwell, John Cage and the art critic Harold Rosenberg published the magazine *Possibilities*. The publication opened with the comment that it was a magazine for artists, who expressed in their work their own experience, 'the pure experience'. Kline's remark that he did not decide in advance what experience he would paint, but during the painting process 'a genuine experience' was expressed, indicates that the term 'experience' had become part of the professional jargon of some of the artists of the fifties. Kline in an interview with KUH, 1962 (1960), p. 144.

196 CAGE, 1967 (1961), p. 12; KOSTELANETZ, 1970 (1968), p. 77, quotes Cage: "Our business in living is to become fluent with the life we are living, and art can help this"; and MC. EVILLEY, 1992, p. 97, quotes Cage: "Zen helps us in the enjoyment of life".

DUBERMAN, 1974 (1972), p. 349: "Art should not be different than life, but an act within life".

197 TOBEY, 1958, p. 24.

198 Fragment from a letter which Tobey sent in 1954 from Paris, and which was published in the *Chicago Art Institute Bulletin* of February 1955.

199 CLARKE, 1988, p. 124.

200 Tobey quoted in the catalogue *Mark Tobey*, AMSTERDAM 1966, unpaged.

201 Schmied in the catalogue *Tribute to Mark Tobey*, WASHINGTON 1974, p. 6.

202 ROSS, 1958, p. 65.

203 "I'm (...) against the mixture of art and everyday life". Quote from Reinhardt in an interview with Mary Fuller in 1966, published in ROSE, 1991 (1975), pp. 23-29.

204 ROSE, 1991 (1975), p. 148, quotes this comment of Reinhardt's dating from 1953.

205 'Notes Brooklyn College', REINHARDT PAPERS, Archives of American Art.

206 Statement dating from 1946, REINHARDT PAPERS, Archives of American Art.

207 REINHARDT PAPERS, Archives of American Art.

208 ZELEVANSKY, 1991, p. 20: "Reinhardt's sketches for his paintings existed only in his mind until after a canvas was completed. The relatively few diagrams he created appear to

have been made after the art as a means of cataloguing his paintings, or of jogging his memory and assisting the restoration process".

209 Catalogue *The New Decade*, NEW YORK 1955, p. 73.

210 TOMKINS, 1981 (1980), p. 69.

211 Tobey in an interview with William Seitz in 1962, TOBEY PAPERS, Archives of American Art. The *Haiku*'s content is so formulated that the reader has ample scope for interpretation.

212 VOS, 1964, p. 177, characterizes *Haiku* as moments of experience. See p. 82 for Reinhardt and the *Haiku*.

213 See p. 54 and note 63 in which Ashton, referring to the interest in *Haiku*, is quoted.

214 CANADAY, 1962, p. 72.

215 CAGE, 1967 (1961), pp. 12-32, and TOMKINS, 1981 (1980), p. 69.

216 DOW, 1899, p. 24.

217 ROSE, 1991 (1975), pp. 46-47, observes: "In his insistence on 'timelessness' Reinhardt implies that abstract art can survive only in opposition to 'progress'".

218 REINHARDT, 1960, p. 34.

219 CLARKE, 1988, p. 143. REINHARDT, 1960, p. 35, quoted Alan Watts: "... not a situation from which there is anything to be grasped or gained".

220 CAGE, 1967 (1961), p. 93.

221 Robert Motherwell was also said to be fascinated by that book. SEITZ, 1983, p. 7.

222 "Experience occurs continuously, because the interaction of a live creature and environing conditions is involved in the very process of living". DEWEY, 1958 (1934), p. 35.

223 VAN METER AMES, 1962, chapter 15. Unfortunately this study has already become so extensive that there is no further scope for research into the influence of Zen on Dewey's famous book. There do appear to be several remarkable parallels.

In the context of the aspect of 'space', it is interesting to observe that Dewey discussed Chinese paintings which seemed to him to move outwards, thanks to the spatial effect used. DEWEY, 1958 (1934), p. 209.

When Dewey, who was then professor of Philosophy as Columbia University, celebrated his 90th birthday in 1949, he invited a great many famous people from all over the world to the university. Suzuki was most probably there too. And Suzuki, who was known in New York thanks to his books, might well have held his first lectures on Zen on that occasion. This

would confirm what was suggested in various sources, including by ASHTON in an interview on 19 April 1994 – i.e. that Suzuki had lectured in New York even before 1950.

224 COOMARASWAMY, 1934, pp. 15-16 and 40.

225 KRAUSS, 1994, p. 128. CAPRA, 1985 (1975), p. 172, also believes that in modern physics and Buddhism alike the perception of space-time is based on experience.

226 SEITZ, 1953, pp. 81 and 88.

227 SEITZ, 1953, p. 81.

228 SUZUKI, 1959 (1949/1934), p. 68.

229 REINHARDT PAPERS, Archives of American Art.

230 See p. 12.

231 Essay 'Dark', unpublished, undated. ROSE, 1991 (1975), p. 90.

232 See p. 12.

233 LIPPARD, 1981, p. 160.

234 REINHARDT PAPERS, Archives of American Art, notes for one of his lectures at The Club in the fifties, and REINHARDT, 1958, p. 42.

235 REINHARDT, 1958, pp. 22-23.

236 SUZUKI, 1991 (1949/1934), p. 68. See also ill. 5.

237 Catalogue *Fourteen Americans*, NEW YORK 1946, foreword. This exhibition included work by Mark Tobey, David Hare, Robert Motherwell and Isamu Noguchi. Various works had religious titles, such as 'The Dream of Sinai' and 'The story of Buddha' by David Aronson.

238 REINHARDT, 1967, unpaged; DUBERMAN, 1974 (1972), and HARRIS, 1987, had descriptions of Cage's Event, but did not specify which Eckhart items were read.

Tobey was acquainted with Eckhart, according to Tobey's friend Lyonel Feininger. Catalogue *Mark Tobey*, NEW YORK 1945, unpaged.

239 BENOIT, 1993 (1975), pp. 26 and 17. That book makes several references to the fact that Eckhart's view can be taken as a bridge between West and East.

According to Eckhart the spiritual experience was particularly important in the profession of a faith. Once a person had reached a state of *'Abgescheidenheit'* (disengagement of the spirit from ontological necessity), God could bring forth his Word in Man. Benoit believes that Eckhart primarily had an affinity with the 'detachment from matter' in Zen, an aspect to which I have paid little attention in my research, as it was not particularly relevant. Ibid. p. 36.

Suzuki refers to Eckhart on various

occasions in his books. SUZUKI, 1993 (1938/1927), pp. 294-296, makes a link between the restraint of the tea ceremony and Eckhart's 'Armut'. In SUZUKI, 1963 (1962), the following quotes from Eckhart can be found, and which Suzuki believes have parallels with Zen: p. 45 (text dating from 1955) "I was the origin of myself and all things..."; p. 57 (text dating from 1959) "What morning is not a good morning?"; p. 86 and p. 255 (texts from 1949) "Das Auge darin ich Gott sehe, ist dasselbe Auge, darin Gott mich sieht. Mein Auge und Gottes Auge ist ein Auge und ein Gesicht und ein Erkennen und ein Liebe"; pp. 366-369 (text from 1954) "God and I are one...". A remarkable quote can be found in SUZUKI, 1993 (1938/1927), p. 312: "Love him as he is; a not-God, a not-spirit, a not-person, a not-image; as sheer, pure, limpid one, alien from all duality. And in this one let us sink down eternally from nothingness to nothingness".

Back in 1891, K.E. Neuman had already published a paper entitled *Das innere Verwandtschaft buddhistischer und christlicher Lehren*. Neuman based it on the traditional Hinayana Buddhism. For the content of that doctrine, readers are referred to the wide range of literature dealing with Buddhism.

240 CAPRA, 1985 (1975), pp. 68 and 81.

241 COOMARASWAMY, 1934, pp. 3-4. Tobey's fascination with the connection between science and religion stemmed primarily from the ideals of Baha'i. TOBEY, 1955, unpaged, observed regarding the doctrine of Baha'i: "... that science and religion are the two great powers which must be balanced if man is to become mature".

242 Dorothy C. Miller in the catalogue *Fourteen Americans*, NEW YORK 1946, foreword. Remarkably enough, Africa is not mentioned.

243 Catalogue *Fourteen Americans*, NEW YORK 1946, unpaged.

244 Catalogue *Fourteen Americans*, NEW YORK 1946, unpaged.

On another occasion, Tobey remarked: "I have often thought that if the West Coast had been open to esthetic influence from Asia as from Europe, what a rich nation we would have...". SULLIVAN, 1973, p. 250

In 'The One Spirit', one of his essays, Tobey philosophized on the oneness of humankind. TOBEY PAPERS, Archives of American Art. He believed that the gap that had existed between West and East was bridged by the Second

World War. TOBEY, 1958, p. 21.

245 WHITE, 1951, quoted Tobey. Tobey probably made this observation in the late forties, since he was more positive on the subject in his essay of October 1951.

246 TOBEY, 1951, p. 232. Tobey is probably referring to the growing interest in America for the beliefs of the Far East, as was also apparent in the interest in Suzuki's lectures and books.

247 Tobey in an interview with William Seitz in 1962, TOBEY PAPERS, Archives of American Art.

248 CAGE 1967 (1961), p. 143 quotes Buckminster Fuller.

249 REINHARDT, 1964, p. 49: "The next revolution will see (...) the permanent acknowledgment of universal 'pure land school' paintings everywhere..." It is worth noting that in Buddhism there is a sect called the Pure Land School. VARLEY, 1984 (1973), p. 65, wrote with respect to their doctrine: "By simply reciting the *nembutsu* (an invocation of praise of Amida (Buddha), an individual could ensure that upon death he would be transported to the blissful 'pure land' of Amida in the western realm of the universe". Reinhardt's endless repetition of Black Paintings is reminiscent of such recitation to attain purification.

ROSE, 1991 (1975), p. 108, quotes a note made by Reinhardt: "pure land school (4c amida) vs. New York Zen School".

250 At times it even proves to be difficult to distinguish between artists who were and were not interested in Zen. Sometimes this can be explained by an indirect link with Buddhism. The artist Barnett Newman was, for instance, interested in the Transcendentalists, see p. 54, and Jackson Pollock in Jung's psychoanalysis. Both sources had an affinity with Buddhism, the basis of Zen.

251 Interview with Jeffrey WECHSLER in New Brunswick on 3 May 1994.

252 CLARKE, 1988, p. 223.

253 SWEENEY, 1956, p. 26.

254 Catalogue *The Trans Parant Thread*, HAMPSTEAD 1990 p. 11.

255 The descriptions 'left' and 'right' were chosen because the geographical words 'west' and 'east' could be confusing, since in American literature Europe is often called 'the West' and Japan 'the East' – the very opposite to the actual geographical location as regards America.

47. Georges Mathieu, 'Dana', 1958, oil on canvas, 65 x 100 cm.
Museum Ludwig, Cologne (photo: Rheinisches Bildarchiv, Cologne)

The Zen arts in France

Despite the resemblances between French and American art of the nineteen-fifties, there were distinct differences too. There were also similarities and dissimilarities between the French and American artists in their affinity with Zen and the Zen arts.

After the Second World War, a number of French artists chose to make abstract paintings; their styles were predominantly geometrical or 'lyrical', with the latter drawing inspiration from Nature. Several artists rebelled against the 'niceness' of these styles, preferring spontaneity in their abstract art. An important champion of 'direct expression by means of spontaneous brush-strokes' was the artist Georges Mathieu (b. 1921). He was very critical of Western aesthetics, on which Geometric Abstraction was felt to be based. Mathieu believed that painting should meet entirely new demands: no preconceived plan or preliminary sketch, but emphasis on speed, improvisation, spontaneity and chance.[1] The style of the American Abstract Expressionists particularly appealed to him. He succeeded in making it more widely known by organizing exhibitions of French works in that style, preferably combined with work by American artists, and by means of his publications.[2] The art critic and sculptor Michel Tapié assisted him and even took over the lead in the fifties. He preferred the terms 'Art Informel' (informal art) and 'Art Autre' (other art) for this free painting style, which he believed was an international phenomenon. Although Tapié promoted Mark Tobey in Paris and was interested in both traditional and modern Japanese art, he did not play a major role among the Parisian artists of the fifties who felt an affinity with Zen and the Zen arts.

Although Mathieu (ill. 47) has been described as 'the first Western calligrapher' [3], this chapter will reveal that in fact his works and those of many other artists working in a calligraphic style in the fifties were, formally speaking, primarily a continuation of a development which began at the end of the nineteenth century, during the 'Japonisme' period. This group of artists, whose style resembled that of Japanese calligraphy, included Hans Hartung, Pierre Soulages, Gérard Schneider, Pierre Tal Coat, Claude Bellegarde, René Laubiès, Wols, Jean Degottex and Pierre Alechinsky. A number of them were interested in Zen painting and the philosophies of the Far East.[4] This chapter will mainly focus on the last two members of this group – Alechinsky because he travelled specially to Japan to learn the art of *Shō*, and Degottex who tried to discover a universal view of writing, in which Zen proved to play a relevant role. Both can be classified as 'calligraphic gesture' artists. A third protagonist in this chapter is Yves Klein. He went to Japan to study the 'Kodokan' style of Judo, one which is closely connected with Zen. The work of this artist can be classified partly as

'art of the empty field' and partly as 'living art'. Alechinsky, Degottex and Klein all apparently read the French translations of Daisetz T. Suzuki's books on Zen.

During the Japonisme period in the nineteenth century, the interest in calligraphy and ink painting of the Far East began to develop. In 1879 Philippe Burty, a collector of Japanese art and the first person to use the term 'Japonisme', organized a demonstration of Japanese calligraphy, as a follow-up to the 1878 World Exhibition, at which Japanese art was on display. On that occasion, Burty also got the painter Watanobe Sei to paint a *Kakemono* (scroll painting) in public to give the audience some idea of Japanese techniques.

The collector Samuel Bing (1838-1905) played an important part in promoting the interest in Japanese art in Paris. At his shop in Rue de Provence he not only had Japanese crafts for sale, but also about a thousand *Ukiyo-e*. In 1888 Bing began the magazine *Le Japon artistique*; it was published in French, German and English. Bing wanted to present Japanese two- and three-dimensional artforms to artists and art connoisseurs, in this way propagating a new type of aesthetics.[5]

In the eighteen-eighties Ogata Korin became one of the leading Japanese artists for the French. The striking thing about his work is that he not only created highly decorative pieces – screens in particular – but also very expressive drawings, which were just as dynamic as works by Zen Masters. Both art-styles were greatly admired by the Japonistes: Samuel Bing and Claude Monet both owned several works by Korin and they were regularly depicted in *Le Japon artistique*. If we compare the issues of this monthly for the years 1888 and 1889, we see that to start with the main focus was the decorative aspects of Japanese art, but gradually more 'expressive' drawings were reviewed. The June 1889 issue contained a history of Japanese painting, also featuring the dynamic brush-work of the members of the 'Kanō' school and the Zen Master Gibon Sengai.[6] The September 1889 edition contains comments on Japanese brush-work, such as: "treated with great energy and swiftness..." and "only one single brush-stroke...".[7]

French artists had already begun to imitate Japanese brush-work, though admittedly only incidentally, as early as the eighteen-seventies. In 1875 Edouard Manet painted a raven accompanied by Japanese seals and characters (ill. 48), after a Japanese painting.[8] Henri de Toulouse-Lautrec (1864-1901) would seem to have been the first artist to integrate, from the end of the eighties, the 'spontaneous' Japanese lines in his personal style (ill. 49). His work sometimes contains humour which is comparable to that in some Zen ink paintings.[9]

The 'Nymphéas' by the Japoniste Claude Monet, the paintings he made of his Japanese garden in Giverny, constituted the end of Japonisme's hey-day. After that the movement waned, though it was not completely extinguished. I am of the opinion that the literature of art history too often makes reference to a particular influence only if the artist in question has experienced it directly. Little is said of the ongoing influence which is unconsciously absorbed. We might term it 'inherent influence'. So if twentieth century artists have been influenced by Japonistes like Manet, Monet, Van Gogh, Gauguin, Toulouse-Lautrec, Vuillard and Bonnard, the Japanese influence is an 'inherent' component, continuing in the work of post-1900 artists.

48. Edouard Manet, 'Corbeau avec sceaux et
calligraphie japonaise' (Raven with Japanese seals
and calligraphy), 1875, ink on paper, 25 x 32 cm.
Bibliothèque Nationale de France, Paris

49. Henri de Toulouse-Lautrec, 'Jane Avril', 1895,
litho, 25.2 x 22 cm.
Bibliothèque Nationale de France, Paris

At the start of the twentieth century the relevant literature reflected a distinct shift in the attitude to Japanese art. This is particularly apparent in two different books on the Japanese artist Hokusai. In 1896 Edward de Goncourt wrote a biography of Hokusai in which he summed up descriptions of the artist's works, along with anecdotes from his private life. The emphasis is on the commonplace and, for instance, the artist's original compositions.[10] The biography written in 1914 by Henri Focillon – a book which was popular among artists for many years[11] – pays considerable attention to the revolutionary aspects (from the Western point of view) of Hokusai's work and Japanese painting in general (Appendix I). The writer and art critic Michel Ragon even went so far as to claim that the first Japonisme was that of De Goncourt's *Hokousaï*, and that the 'second Japonisme' began symbolically with Focillon's *Hokousaï*.[12]

Although the avant-garde artists switched their focus towards the twenties to geometrical abstraction and, as a result, the 'Japonistic process' seemed to have come to a standstill, the Parisian public continued in its fondness for Japanese culture.[13] In 1922 Crès in Paris had published the book *Le Lavis en Extrême-Orient* by Ernst Grosse, translated from the German. It dealt with Zen painting and contained 161 full-page reproductions of ink paintings.[14] The text comprised a historical review of the 'wash drawing' as well as Grosse's comments on that art-form: "The line is of different and greater importance than in any other graphic art in Europe (...) The ink painter starts out as a calligrapher (...) and then makes the painting with the same brush".[15] The European use of line struck him as dry and lifeless, compared with the variation in size and intensity, and the gracious, energetic effect of the lineation of the Far East. He called the paintings of the Zen Masters 'the expression of their personal inner life'.[16]

Le livre du thé by Kakuzo Okakura, translated from English in 1927, was widely read and performances of Nō theatre were well attended. The latter was partly thanks to the author Paul Claudel, who was the French ambassador in Japan from 1921 to 1945, and stimulated interest with his own books.[17] For instance, from 1925 onwards he published instalments of *L'oiseau noir dans le Soleil Levant* in French magazines. It appeared in book form in 1927. In it Claudel writes about the literature, theatre, gardens, architecture and painting in Japan. And in passing he mentions several characteristics of Zen.[18] Since the present study relates primarily to the nineteen-fifties, it is interesting to note that the Academie Française published Claudel's entire *oeuvre* in 1952 in several volumes, including two entitled *L'Extrême Orient*. Claudel's books were very popular in the fifties, with artists and intellectuals.[19] He was even described in an interview as the Pierre Loti of the twentieth century.[20]

The world of poetry was also developing an interest in the culture of the Far East. Several poets, a number of whom from Belgium, turned their attention to 'calligraphed' poetry from the Far East.[21] The art critic Pierre Restany reasoned in 1956 that the development was due to the fact that 'our' era was one of 'the image', and that poets were also searching for 'direct' communication: the position of words, the line, point, colour of the *objet-poème* acquired importance. This led to an interest in traditional Japanese poetry, in which the poem and the

50. Henri Michaux, 'Composition', 1958-63, ink, 75.1 x 105.2 cm.
Stedelijk Museum, Amsterdam

image are one.[22] Francine Legrand stressed in 'Peinture et écriture' that it was not surprising that artists sought inspiration in the Far East. After all, that was where the most perfect unity between poetry and painting was exemplified, and where a new approach to poetry was to be found: "poetry is an experience one has undergone".[23]

The *objet-poème* links poetry with the work of the visual artist. The first step was taken by the poet Mallarmé, with his *Le coup de dés*, written in 1897. In 1914 the poet Apollinaire remarked "... and I am a painter too"[24] with respect to his *Calligrammes*. Henri Michaux (1899-1984) (ill. 50) would seem to have been the first to eliminate the boundary between poetry and painting. In 1927 he began making 'writings' which he called 'Alphabets'. Five years later he wrote *Barbare en Asie*, a report of a journey to the Far East. In the chapter 'Barbare en Japon' he especially praised the austerity of Japanese culture. He disparaged the fussy styles in French culture since the seventeenth century, expressing the opinion that to find such a chaste, clear style of painting in France, he would have to go back to the sixteenth or fifteenth century. He was struck by the fact that there was no pretentious style in Japan: neither houses nor rooms were painted. He encountered 'emptiness' everywhere.[25]

From the forties onwards this influence is apparent in his work (he was painting vast misty landscapes at that time). He came across the beliefs of Zen Buddhism in the fifties, through intellectuals and artists in Paris: "We were talking a lot about Zen in those restless days when tachism and lyrical abstrac-

51. Joan Miró, 'Composition', 1925,
oil on canvas, 116 x 89 cm.
Bayerische Staatsgemäldesammlungen,
Munich

tion held an important place".[26] Michaux began to simplify his material at that time, restricting his compositions to a few strokes and blots of paint.

Although Michaux never joined the Surrealists, his work is very much akin to theirs. Some actual painters of the Surrealist group also prove to have been interested in Japanese art. The Surrealist Joan Miró (1893-1983)(ill. 51) observed in 1918 that the Japanese, like the Primitives, had learnt to look at what is small and 'so divine', and six years after that he wrote of Hokusai that all he wanted was to make a line or a dot visible.[27] The works which Miró produced between 1925 and 1927 are noticeably empty, containing only a few expressive lines or tiny forms on a pictorial monochrome ground. The occasional words which he added are evocative of the Japanese *Haiku*.

The Surrealist André Masson (1896-1987) had been working with expressive brush-strokes from the beginning of the twenties, even before he came in contact with André Breton and the Surrealists. In about 1925 his interest (and that of the Surrealists) in the Orient gradually seemed to emerge, and in October 1925 he was to write in *La Révolution Surréaliste*:

"... life as Western civilization has made it, has no reason to exist, it is time to penetrate the inner night in order to find a new, profound 'raison d'être'".[28]

The editors added after this letter from Masson the manifesto 'La Révolution d'abord et toujours', containing a quotation of Louis Aragon from an earlier issue of the same periodical:

"The Orient is everywhere. It represents the conflict of metaphysics and the enemies thereof, who are also the enemies of freedom and contemplation. Even in Europe one can say: where do we not have the Orient? Even the man you pass by in the street has the Orient in his breast".[29]

Interest was growing among the Surrealists for non-Western cultures. However, they did not have a special preference for Zen or the Japanese culture. Nevertheless, several experts in the field of Surrealism were convinced that the movement generated the interest for Japanese culture which developed in the fifties.[30] At all events, Breton was not unfamiliar with Zen, and it was no doubt the Zen mentality that appealed to him. He concluded his discourse *Signe ascendant*, published in 1948, with the words:

"One day Basho, with 'Buddhist amiability', made an inventive alteration to a cruel Haiku written by his humorous disciple Kikakou. The latter had written: 'A red dragonfly – pull off his wings – a red pepper'. Basho altered it to: 'A red pepper – give it wings – a red dragonfly'".[31]

Breton wrote this text after his return from America, having acquired an interest there in the culture of the Far East.

At the end of the twenties André Malraux wrote in the *Nouvelle Revue Française* that Miró and Masson were certainly influenced by Japanese drawing and calligraphy. In an interview in 1969 Masson admitted that it was the case, adding that at that time knowledge of Japanese calligraphy was still very scanty.[32] He had become acquainted with the ink painting of the Far East when studying some of the originals which were available in Paris and several famous German books of reproductions.[33] He was no doubt referring to Grosse's book which was mentioned earlier. A few years later, he learned more about the beliefs of Zen:

"Kuninosuke Matsuo came to me in 1930 and told me about Zen. Crès had published a book by Matsuo and Oberlin on Japanese Buddhist sects. I had had the book in my possession for some time and in that way became familiar with Zen to some extent. Later I read books by Suzuki, the Englishman Waley and anything else I could find on Zen. I reached a stage that I thought 'I've really got into it'".[34]

Masson suggests that this was especially the case in the early fifties, when he had meanwhile seen Zen paintings in Boston.[35] The following comment, confirming this remark, was found: "...in 1950 he was drawing almost entirely according to the manner of Zen Buddhist painting, simplifying forms to their essence and using a variation of Oriental calligraphy".[36] Actually, this influence on his work is already appreciable in some works from 1949 (ill. 52). The role of Zen in his working method was described as the importance of the direct mystical experience as a way to the ultimate truth.[37]

Masson clearly expresses his admiration for Zen painting in his book *Le plaisir de peindre*.[38] In it he also describes the technique of *Sumi-e*, noting in that context: "A painter resolutely places a flowing, sensitive line on his ground...".[39] His 1956 essay 'Une peinture de l'essentiel' on Japanese ink paintings deals mainly with Sesshū's *Haboku* technique.[40]

In the context of the artists who have been discussed so far, it is interesting to discover that the art critic Georges Duthuit described in his book *Mystique chinoise et peinture moderne*, published back in 1936, the extent even then of the

52. André Masson, 'À une cascade' (At the waterfall), 1949, oil on canvas, 100 x 81 cm.
Galerie Louise Leiris, Paris

53. Hans Hartung, 'Composition', 1956, oil on canvas, 162.5 x 120.5 cm.
Stedelijk Van Abbemuseum, Eindhoven

parallels between modern art and Zen painting. He underlined his point by placing reproductions of work by Bonnard, Monet, Toulouse-Lautrec, Masson and Miró alongside depictions of Zen paintings. Although the title of his book refers to China, he explained that Ch'an painting was chiefly known in the West by way of Japan, as Zen painting. He was even of the opinion that if a Zen Master who had lived centuries earlier were to return in 1936, he would unwittingly find himself among the artists of the avant-garde.[41] Duthuit was on good terms with several artists. His friendship with Pierre Tal Coat which began in 1948, led to that artist making some large ink paintings.[42]

Before I discuss the impact of Zen in Paris in the fifties and the protagonists in this case study, I should like to say a few words about the artists Mathieu, Hartung, Soulages and Francis, since their work would, at first sight, appear to have connections with Zen.

Georges Mathieu, whose name has already been mentioned, was not only inspired by the ideas and works of the artists Wassily Kandinsky and Paul Klee, who were active in the early twentieth century, but also by the French artists Michaux, Masson and Hartung. The work of the American Expressionists, discussed in the previous chapter, also had an effect on him.[43] The various artists brought about what might be termed an 'inherent Japanese influence' on Mathieu. In the fifties his direct interest in the ancient art of the calligraphy of the Far East increased. It constituted for him a stimulus, as well as a justification of his ideas. This is confirmed by his texts in which he praised the methods

54. Pierre Soulages, Untitled,
12 January 1952, oil on canvas,
130 x 81 cm.
Museum Boijmans Van Beuningen,
Rotterdam

and views of Japanese and Chinese calligraphers and painters, and drew parallels with his own work and ideas (even trying to demonstrate that his own work was a greater value). In that way he was defending himself against critics who did not take him seriously.[44]

The works of Hans Hartung (1904-1989), who was of German origins and who was particularly active on the Parisian art scene after 1945, can be termed 'painting as meditative writing' (ill. 53).[45] Hartung drew his chief inspiration from the works Kandinsky made in the nineteen-tens. The character of the lines and the suggestion of movement were of particular importance for him. The lines he made, slowly but surely, merit the description 'homage to spontaneity' rather than 'dynamic'.[46]

The work of the artist Pierre Soulages (b. 1919) (ill. 54) would seem to be the outcome of the emancipation of the line. This process, which began in Japonisme, was continued by Soulages, with inspiration from his friend Hans Hartung and Hartung's friend Wassily Kandinsky. As was the case with the Japonistes, the formal aspects were of prime importance for Soulages. He differed from Mathieu, with his affinity to the spontaneous expression of the Surrealists' *écriture automatique* (automatic writing), in that Soulages was more inclined to endorse the 'dedication' of artists like Hartung.[47]

55. Sam Francis, Untitled, 1957 (-1988), tempera and acrylic on paper, 92 x 41.5 cm.
The Sam Francis Estate, Santa Monica, USA
56. Sam Francis, Untitled, 1968, acrylic on paper, 90 x 56 cm.
The Sam Francis Estate, Santa Monica, USA

Sam Francis (1923-1994), the artist of American origins, was working a great deal in Paris in the fifties. He too would seem to have been an heir of the first Japonisme movement. Although his works are abstract, his style was shaped by his interest in Japonistes like Monet and Bonnard (ill. 55). Towards the end of the fifties the influence of his visits to Japan emerged in his work. From then on his paintings bear similarities with some of the formal characteristics of *Sumi-e* (ill. 56).

Francis was not alone in his fascination for the Japonistes. In the fifties there was a striking reassessment of the work of Monet, Vuillard and Whistler, and, accordingly, the 'first' Japonisme movement was taken up again and continued. Interest in Monet's 'Nymphéas' was so great that in a publication in 1961 'Le Musée des Nymphéas' (the Orangerie) was even described as the 'Sistine Chapel of the new era'.[48]

So, in short, the interest in the formal aspects of Japanese Zen painting and calligraphy began in the eighteen-seventies with works like Manet's 'copy' of the Japanese painting of a raven. Toulouse-Lautrec integrated Japanese brush techniques into his personal style. The new contemplative direction of Japonisme, as

initiated by Kandinsky, was continued by Hartung and Soulages. Michaux and Masson steered the interest in writing in general to a specific focus on Oriental calligraphy and painting, and on to a quest for a better understanding of the beliefs of Zen. A comparable process took place, also in the fifties, with the artists Pierre Alechinsky, Jean Degottex and Yves Klein – artists who will be dealt with later in this chapter. In the second half of the fifties Mathieu also became acquainted with Zen and noted that the doctrine appealed to him, and to others, because of its tranquillity and its possibility of sudden enlightenment, which enables one to understand truth as a direct intuition and not as an intellectual abstraction.[49]

Interest in Japanese culture grew apace in Paris in the second half of the fifties in particular. An essay in the catalogue *Années 50* even described it as 'a veritable neo-Japonisme'.[50] A comparable conclusion had already been drawn in 1958 by Michel Ragon, who observed that 'a new Japan fashion' was being born, adding:

"The old traditional Japanese art strikes me as strangely modern, whilst art which is considered modern in Japan, appears somewhat old-fashioned. After all, in traditional Japanese painting we encounter, to our surprise, the style of signs and stains, the freedom of brush-work and the feeling for space which are so typical of today's abstract art of the European and American avant-garde".[51]

The fact that traditional Japanese art was considered modern is also confirmed by the venue for the 1958 exhibition *L'art japonais à travers les siècles* in Paris: the Musée d'Art Moderne. Ragon also noted:

"It is strange to see that the present Japan trend, both in America and Europe, is a purist reaction to Baroque art, from the 'modern' styles of 1900 to the decorative style of 1925, which was the result of the first Japonisme (...) The second European Japonisme is the opposite of the first. The pure Japan that is entrancing us today helps us to liberate ourselves from our grandparents' Baroque, which was inherited from Japan".[52]

As we have already seen, Japanese culture was never seen as a primitive manifestation. Ragon believed that contemporary art had renounced African primitive art, which was so popular among the Fauves and the Cubists, in favour of the 'sensitive' Asia.[53] He even felt that people were inclined to exaggerate. In *25 ans d'art vivant (1944-1969)* Ragon wrote, in amazement:

"What a lot is done in Europe and America in the name of Japan and Zen! Nothing surprises the Japanese more than to discover that there is a European Zen. The second 'rage' from Japan has been as infectious as American Pop Art was to become".[54]

Pierre Restany was one of the negative critics, stating in 1958:

"The Japanese myth in the 'Ecole de Paris' is persistent; it testifies to the need for an esoteric exoticism among groups of pretentious intellectuals. Calligraphy, Judo and Zen Buddhism are covered in a complex and subtle sauce, with many individual variations. Judo, the healthy Japanese gymnastics, is prescribed for schoolchildren in the same way as vaccinations or a glass of milk (...) and practical manuals of wisdom disseminate the essential secrets of human experience: Zen by day, Zen by night.(...) Calligraphy is in the process of taking over from the trend of woodcuts. It enabled

Mathieu to don a prophet's garb. The West rediscovered writing (...) and sought, out of self-doubt, hope and equilibrium elsewhere. Where? In the Orient, the counterpart, the beginning of our own destruction".[55]

It is curious that even Ragon inclines to exaggerate, noting in 1963 that "everyone is more or less Zen in the milieux of the abstract art of Paris and New York".[56] It is Ragon's belief that interest in Zen in the fifties was entirely thanks to Daisetz T. Suzuki's books, but artists read these books just as little as Marxists read Marx's *Das Kapital*.[57] Between 1940 and 1944 three volumes of Suzuki's *Essays* were published in French translation. In the early fifties they were republished, together with several other works by him and by other writers on Zen.[58]

According to the scholar Jacques Brosse, Zen was not as well received in the fifties in France as in Germany, England and America. He was of the opinion that the French public was more interested in books on the Zen arts, such as the tea ceremony, flower arragement, gardens, the martial arts, literature, painting and calligraphy than in books on Zen philosophy. Brosse does not give examples, but was very probably referring to the popularity of books like Okakura's *Livre du thé*, Claudel's works and Eugen Herrigel's book on the Zen art of archery *Le Zen dans l'art chevaleresque du tir à l'arc*, translated from German in 1953. Research has revealed that the latter was read by artists like Masson, Degottex and Klein.[59]

Several experts who were interviewed believed that Michel Tapié's book *Un art autre*, which was published in 1952, formed a 'symbolic beginning' of the revival in interest among French artists for Japan.[60] At the front of the book and on the back cover there are reproductions of works by Michaux, referring to the importance the author felt that he had for the fifties. In his text, Tapié chiefly points out the privileged position of American artists, who had the advantage of starting from zero, and from there were able to evolve an international art, i.e. a unification of Western and Eastern art:

"At last, at a time when artistic development, and other changes too, are taking place at a global level, America has become the true geographical crossroads in the confrontation of the deepest problems of the main artistic movements of East and West, in the convergences in which the upsurge in calligraphic significance and the intensity of the plastico-pictorial drama are intermingling with jolting vehemence...".[61]

Tapié goes on to state that the importance of Mark Tobey and Morris Graves cannot be emphasized enough, with Tobey constituting the foundations of an international style.[62]

In 1960 Tapié observed that French artists had by then been acquainted for ten years with the Far East and that, although their understanding had got going slowly, their knowledge of the Oriental suggestion of space and of its type of writing had placed the anarchic, audacious works of the West in the realms of the 'Absolute'.[63] Restany is of the opinion that Tapié tended to exaggerate:

"Tapié tried to mask the connection with German Expressionism via Hartung and Wols, by emphasizing the sign, the calligraphic structure, the relationships with Zen and the Oriental tradition".[64]

Restany has his own theory regarding the source of renewed interest for Japan in post-war Paris. He believed that it was proof of the artists' impotence in those post-war days. A French answer was being sought to the American Pollock, at a time that Sartre was formulating the French response to Heidegger's phenomenology. Zen comprised an interesting view of what went on behind calligraphy (or rather *Shō*) for the French artists who were obsessed with writing. And in that way, Restany claims, the limbo of the Parisian art scene was filled with a combination of ideas stemming from German philosophy and art, a formal solution from America and Japan, and an explanatory view from Japan. Robert Klein supports this view, suggesting that art history, when confronted with Tachisme, went looking for a 'conceptual skeleton' and found it in Suzuki's books.[65] Gillo Dorflès also sees Zen as a source of fresh opportunities for communication for the artists in a period of cultural crisis.[66]

After the Second World War many people wanted to determine their own fate, as independent individuals. Traditional Western religions had no answer to that, but nor did a great many Eastern religions. This explains much of the interest in Sartre's Existentialism, but in Zen too, since the latter differs from other religions, with its emphasis on personal experience and independence. According to Roland Rech, the director of the 'Association Zen Internationale', the time was 'ripe' for Zen in the fifties. He believed that it was Nietzsche who guided Western thought towards Zen.[67] In the forties, the 'liberation of mankind' followed, in Existentialism. Although it does contain the idea of 'personal liberation', Existentialism is connected with the Marxist ideology, and so with politics and history. Moreover, Existentialism focuses on a very 'external' view of life; Sartre does not indicate a 'practical way' of behaving. For intellectuals and artists who were looking for 'inner personal freedom' and 'spirituality' (elements which were absent in Existentialism and Marxism), Zen was a welcome alternative.[68] Among the artists I have been studying, Yves Klein was mainly the one who regularly referred to the relationship between art and freedom. He saw art as total freedom and described his monochrome works as the essence of a life in freedom. For Pierre Alechinsky and Jean Degottex, the main thing seems to have been to attain personal freedom by expressing themselves in their painting. They followed the Surrealists in that respect. If we compare the views of Psychoanalysis, a source for the Surrealists, with those of Zen, we see that there was a similarity in their 'liberation through self-knowledge'. Although 'Spontaneity' is important in both views, there is a difference, in that Freud sought a connection with a suppressed memory of a traumatic experience, wanting to reactivate that memory, unlike the Zen Master, who seeks to make the student independent from his past and from concepts or words – a difference between determinism and independence from determinism.

Pierre Alechinsky, Jean Degottex and Yves Klein

The French artists whose work and ideas have been selected for closer study, had little, if any, contact with one another, despite the fact that they were living in the same city in the nineteen-fifties.

57. Pierre Alechinsky, 'Debout' (Upright), 1959, oil on canvas, 171 x 61 cm.
Collection Van Stuijvenberg, Cobra Museum, Amstelveen

58. Pierre Alechinsky, 'Assis' (Sitting), 1960, oil on canvas, 180 x 97 cm.
Collection Casa dell'arte, Amsterdam

112

Pierre Alechinsky (b. 1927)

The artist Pierre Alechinsky (ills. 57 and 58), who was born in Belgium, developed an interest in writing at an early age. His mother was a graphologist. Moreover, he was lefthanded, which meant that he was forced at school to write with his right hand, and that focused his attention even more on the act of writing.[69] As a budding artist in Belgium he discovered that various fellow painters, Louis van Lint for instance, emphasized the line in their work.

The awareness of the importance of lines had also started to emerge in Belgium at the end of the nineteenth century, a period in which great interest developed in the expressive lines in the Japanese arts. Henry van de Velde, for example, observed that 'the strength of the line derives its energy from the one who has drawn it'. However, those lines were intended to be purely functional.[70]

The poet Jean Raine got Alechinsky to read the Surrealists and Freud in 1945. Four years later, the poet Christian Dotremont, whom Alechinsky met at that time, pointed out the possibilities of writing, suggesting that a word is never written in the same way twice and that every type of writing potentially contains a pictorial story. Both Dotremont and Asger Jorn, his colleague in the Cobra movement, had been interested in Oriental writing from around 1942, and Jorn even considered painting and writing as one activity.[71] Their interest in writing was in fact to become the chief characteristic of Cobra, the group which Alechinsky joined in 1949.[72]

From 1952 onwards, Alechinsky corresponded with the modern Japanese calligrapher Morita,[73] and two years later the Chinese artist Walasse Ting taught him the 'corporeal' manner of painting of the Far East. In 1955 Alechinsky travelled to Japan to learn about the methods of Morita and his colleagues in the 'Bokujin' group, and to make a film of them. In *L'autre main* he wrote that Michaux's *Un Barbare en Asie* had been the reason for his journey.[74] During his stay in Kyoto he became acquainted with Japanese painting materials and techniques, and the theory of writing: "don't write with your hand, don't write with your arm, write with your heart".[75] Moreover, calligraphy gave him a passion for paper, and for sitting and breathing properly.[76] It is interesting to note that he introduced pictures of Nature and everyday life in the film. He would seem in this way to have tried to emphasize the 'naturalness' of Japanese calligraphy. The expressive, long brush-strokes have a striking similarity with the branches of trees and the tracings of the waving banners which he incorporated in the film. In addition, he seems to have been suggesting with the scenes of everyday life that calligraphy is indeed part of daily life in Japan.[77]

Thanks to the contacts Alechinsky made during his trip, he was able to organize the exhibition *L'encre de Chine dans calligraphie et l'art japonais contemporain* in 1955. The exhibition travelled through Europe, starting at Amsterdam's Stedelijk Museum. A year later, when the Japanese works were on display at the Musée Cernuschi in Paris, Georges Mathieu wrote an essay on the calligraphy of the Far East, also referring to this exhibition.[78] The fact that by then the Oriental calligraphy was immensely popular with artists is apparent from a comment by the artist Bram Bogart, who was working in Paris: "Japanese calligraphy, which was discussed so much then, also made its mark".[79]

59. Pierre Alechinsky, 'Sumi', 1956,
ink on paper, 22.9 x 24.7 cm.
Centre Georges Pompidou, Paris

After his trip to Japan, Alechinsky began using Japanese paper, Japanese brushes and Japanese ink. He had read Suzuki's *Essais*, but the decisive thing for him was the practice of calligraphy. He wrote: "I approached calligraphy by way of the outside, by way of the film camera".[80] Shortly after his return from Japan he started copying: "I thought I might learn something imitating the movements".[81] In those exercises a parallel with *Shō* and *Sumi-e* can clearly be detected (ill. 59).[82]

According to Alechinsky, the minimal, an important characteristic of Zen, was not apparent in the outward appearance of his works, but in the minimal use of materials: a single brush, a little ink and a little water.[83] The works do indeed continue to exhibit the typical *horror vacui* of the European painting tradition, as did the paintings he made prior to his trip (ills. 57 and 58).[84] The brush-work in most of his works of the fifties, is also typically Western.[85] Conversely, the extreme vertical formats of some of his works of the late fifties, are typically Far Eastern.

It was not until the sixties that the influence of the Japanese trip was clearly discernible in his work.[86] In an attempt to relate as much as possible to the Japanese painting techniques, Alechinsky even sought to identify with a Zen Master. He selected the eighteenth century Master Sengai. Alechinsky wrote in *Roue Libre*:

> "Sengai would have drawn like this in similar circumstances, I believe, without pondering too much, [and] following my brush (...) I rediscover a gesture. The gesture of my master Sengai".[87]

Elsewhere in the same book he even wrote: "I am Sengai. No doubt about it".[88] These words date from 1971. By then French artists were acquainted with Sengai's work, thanks to a travelling solo exhibition of this Master's ink paintings held in 1961. It made a great impression on many artists.[89] Alechinsky's fascination is quite obvious, if we compare 'Symbol of the Universe' by Sengai

60. Pierre Alechinsky, 'Variations sur Sengai's symbole de l'Univers', 1968, inkt and litho, 55 x 76 cm.

61. Sengai, Symbol of the Universe, circa 1800, ink, 51 x 109 cm
Idemitsu Museum of Arts, Tokyo

62. Jean Degottex, 'Hagakure B II' (Under the leaves), 1957, oil on paper, 106.6 x 240.8 cm.
Centre Georges Pompidou, Paris

63. Jean Degottex, 'Vide du non-être' (Emptiness of non-being), 10 – 1959, oil on canvas, 150 x 235 cm.
Collection Galerie de France, Paris, (photo: Jacques l'Hoir)

with Alechinsky's 'Variations on Sengai's Symbol of the Universe' (cf. ills. 60, 61 and 4).[90]

In Alechinsky's work, it is always possible to recognize the representation, even though it is sometimes very summary. The mythical creatures he created were initially inspired by the imagery of Cobra, especially in Asger Jorn's work. Interestingly enough, it was only towards the end of the fifties, after the Cobra group had disbanded, that such creatures began to feature in Alechinsky's work.[91] It is hardly surprising that, several years later, he was so attracted to the strange beings in Sengai's ink paintings (cf. ills. 57, 58 and 4).

In view of the link made in the present study with nineteenth century Japonisme, it is interesting to note the similarity in imagination and expressivity between Alechinsky's work and the drawings in Hokusai's *Manga* and those of Symbolists who were inspired by Hokusai (cf. ills. 57 and 60 with ills. 17 and 16). In *Roue Libre* Alechinsky included a page of reproductions of Hokusai sketches. There are nevertheless distinct differences in Alechinsky's method, philosophy and results and those of the nineteenth century Japonistes: not only had understanding increased in the course of the twentieth century of the Zen Masters' and calligraphers' views and working methods, but the actual working process had become increasingly important in Western art. In addition, Alechinsky's work was shaped by the Surrealist heritage. In 1956 he wondered if it was not in fact Miró who drew his attention to the splendid signs of someone like Gakiù Osawa.[92]

Jean Degottex (1918-1988)

The artist Jean Degottex was greatly interested in both the literary and the visual work of Michaux,[93] as well as in the writing of the Far East – an interest he developed at he start of the fifties.[94] James G. Février's book *Histoire de l'Écriture*, which was published in 1948, was an important source for Degottex from about 1956 onwards.[95] Février divides the history of writing into four stages: the 'primitive' stage, incorporating drawings; the 'synthetic' stage, which ties in with the spoken language; an 'ideological' stage, in which a connection with a word comes about, and the 'phonetic' stage, with its relation with sounds (our Western style of writing). Degottex would seem to have felt most affinity with stages two and three: the last stage is more auditive than visual, and the first is realistic. Février bases his descriptions of handwriting from many different cultures on this classification. Although Degottex was most attracted to Eastern writing, particularly that from the Far East in the third stage, his aim was to develop a new universal way of writing: in the end, it proved unreadable, but he tried to give it a universal visual quality, by combining formal elements of writing from Western and Eastern cultures (ill. 62). On the face of it, his writing is reminiscent of the Surrealists' *écriture automatique*. However the intention of those artists was to find a means of bringing the subconscious to the surface. On closer inspection, Surrealist works prove to be more like a 'fantastic eruption of what is within', unlike Degottex's works which, like Japanese archery, are an expression of a lengthy disciplinary process, imbued with a certain view of life.

In the catalogue accompanying the exhibition *L'Épée dans les nuages* in the Galerie l'Étoile Scellée in 1955, André Breton commented that Degottex had

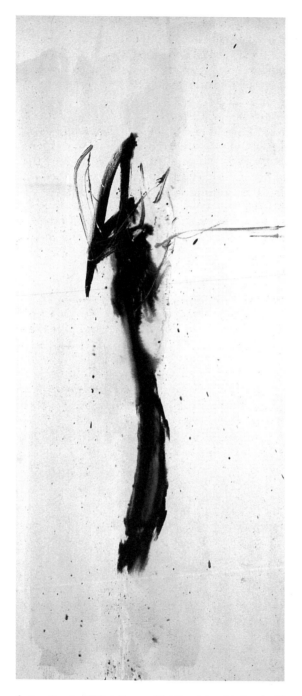

64. Jean Degottex, 'Vide de l'inaccessible' (Emptiness of the inaccessible),
22-10 1959, oil on canvas, 235 x 135 cm.
Musée d'Évreux, Evreux (photo: Jean-Pierre Godais)

unwittingly tied in with the great style of painting of the Far East – in particular that of the Zen Masters – which Grosse had introduced to the European public with his special study. Breton quoted Grosse as follows: "The ultimate art-work does not seem to result from a composition which is created laboriously and constitutes a systematic effort, but the ultimate idea of an art-work is a direct consequence of the artist's soul...".[96]

Degottex began to study Zen in 1957. 'Hagakure', the title of a series of works he made that year (ill. 62), is the name of a famous Samurai story dating from 1716. It describes the life of a heroic warrior, but also relates the Samurai philosophy with that of Zen. Degottex also used the title 'Épée du Samouraï' (Samurai Sword) for one of the 'expressive gesture' paintings he made that same year. From 1958 onwards, the titles of several of his works were direct references to Zen, such as the painting 'Lever le doigt et tout l'univers est là' (lift a finger and the whole universe is there), which he made in 1958. Degottex read Suzuki's books and was especially fascinated by the aspect of emptiness in Zen. He had also noted the similarity between the books he was reading and the works he made in that period:

> "At the same time I finished reading D.T. Suzuki's work *Essais sur le Bouddhisme Zen* with the enumeration of the 18 Emptinesses of the Prajna Paramita. I arbitrarily gave each painting the name of each of the 18 Emptinesses. These are 18 particular ways of attaining the idea of emptiness (not emptiness). Further, according to Suzuki 'The Great Emptiness' stands for the unreality of space...".[97]

The series of works which Degottex mentions, with titles after the types of emptiness described by Suzuki (ills. 63 and 64), are characterized by great simplicity. Although his early works already featured large zones of colour, the works he was making towards the end of the fifties seem even 'emptier', as Degottex was starting to use progressively fewer brush-strokes in his compositions. Their contemplative mood is evocative of Hartung's and Kandinsky's work.

Degottex's interest in Zen arts was not only reflected in his work, but also in his working method ("...the way of attaining the idea of emptiness").[98] He worked on canvas and on paper, which he placed on the studio floor. Before applying the ground, he cleaned the floor, out of respect and care for his material. The studio walls were white and bare, because he required empty space. And he used little material for painting. He exercised great concentration before he applied a few spontaneous brush-strokes, and in this way he created a personal ritual to which he was very much attached, since it gave him a special feeling and the opportunity to purify himself before he embarked on the painting process.[99] Degottex is said by his partner to have felt a very close kinship with the being and actions of the Masters from the Far East.[100] It did not mean that he felt more Eastern than Western. His interest in the writing and culture of the Far East was, as suggested earlier, chiefly the outcome of his desire for a universal language, in which Degottex in fact had a very flexible interpretation of what language entailed (ill. 65).[101]

65. Jean Degottex, 'Metasigne 1', 1961,
oil on canvas, 280 x 120 cm.
Peter Stuyvesant Collection, Amsterdam,
(photo: Euro Fotostudio Scholten, Zevenaar)

Yves Klein (1928-1962)

Generally speaking Yves Klein is classified in a different movement from
Degottex and Alechinsky – that of the 'Nouveau Réalisme' (despite the fact that
the group was only founded in 1960 and Klein was especially active in the fif-
ties). The reason for this classification is the absence of 'calligraphic expres-
sionism' in his monochrome paintings (ill. 66). There are indeed parallels
between the work of these three artists. According to Udo Kultermann, in the
catalogue *Monochrome Malerei*, monochrome painting is a logical consequence
of abstract expressionist painting: the dynamism and intensity which was aimed
at has now become the painting itself, in the form of *Wirkungsintensität*
(impact).[102]

66. Yves Klein, 'Monochrome blue', 1959, pigment, synthetic resin, canvas on panel, 92 x 73 cm.
Stedelijk Van Abbemuseum, Eindhoven

67. Yves Klein, 'Monogold MG II', 1961, gold leaf on canvas, 75 x 60 cm.
Kunstsammlung Nordrhein-Westfalen, Düsseldorf

It is appropriate at this stage to explain the term 'monochrome' in a little more detail. In general it refers to single-colour works, with only a few variations in shade. The same name is applied to Zen paintings, i.e. 'monochrome ink paintings'. A great many of Degottex's and Alechinsky's works are also monochromes, painted in black/grey tones. But from a theoretical point of view, the term for these paintings in shades of grey is incorrect. Since black is not really a colour, only the truly single colour works by Klein should bear the name 'monochrome'.

Klein's interest in Japanese culture began in the latter part of the forties. He had furnished a room, with his friends Claude Pascal and Arman, as a 'temple'. They spent time there reading Heindel (on the beliefs of the Rosicrucians[103]), but discussed Judo and its development in Japan as well. They studied books on Zen and worked out their own way of sitting in order to meditate.[104] Arman also claimed that they read Suzuki's books and a few years later Herrigel's famous book on archery.[105] In September 1952 Klein travelled to Japan to improve his Judo technique and stayed there fifteen months. There he hoped to immerse himself mainly in *l'espace spirituel* of Judo. He said in that respect that Judo helped him to understand that pictorial space was above all the product of spiritual exercise.[106] He would seem to have been influenced more by the *Katas* ('aesthetic exercises') than by the spontaneous action in Judo.[107]

The Kodokan method of Judo which Klein learned in Japan has similarities

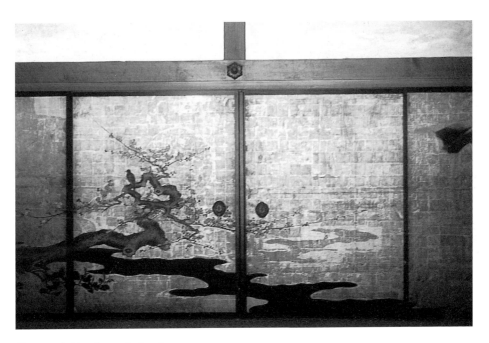

68. Screens in Kongobu temple, Koya San

with the beliefs of Zen. Both emphasize the unity and harmony of mind and body, the experience of true reality, transcendence above words, enlightenment through silence, thought surpassing logic and an awareness of the power of nothing.[108] Pierre Restany remarked with respect to Klein's interest in Judo, that this art was one of the foundations for Klein's personal culture. Judo had apparently taught him how to restore and control energy, how to breath and move, given him a feeling for balance, proportions and spatial harmony, as well as providing him with ways in which to express himself and with certain psychological rituals.[109]

Different people have different opinions on Klein's interest in Zen. Bernadette Allain, a good friend of his, believed that Zen had become part of his character and his friend Arman had also noted Klein's interest in Zen.[110] Yet Restany was of the opinion that Yves Klein's fondness for Japan was on account of the art of living and rituals, but that he had little affinity with the profound philosophy.[111]

An ever-recurring question in documents relating to Klein is whether there is a connection between his experiences in Japan and his monochromes. Klein denied on many occasions any such connection. In 'Hôtel Chelsea', dating from 1961, he stressed: "Seeing that I have been painting monochromes for fifteen years...".[112] Some reproductions of monochrome paintings which he made before he went to Japan would seem at first sight to confirm his claim. There are two small volumes, *Yves Peintures* and *Haguenault Peintures*, each containing ten depictions of single-colour rectangles – dated between 1951 and 1954 and giving the names of the towns where he was residing at that time and, occasionally, the measurements. Klein implied that the books in question contained reproductions of monochrome paintings, yet in actual fact the works never existed.[113]

69. Yves Klein, 'Anthropométrie', March 1960, 194 x 127 cm. Museum Ludwig, Cologne, (photo: Rheinisches Bildarchiv, Cologne)

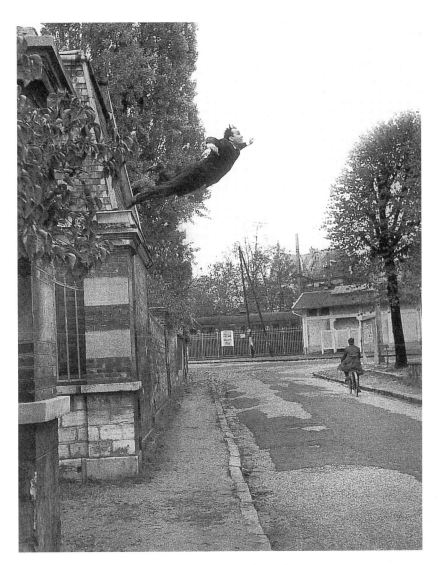

70. Yves Klein, 'Un homme dans l'espace' (A man in space), photo, 1960

Klein would seem to have described his time in Japan in a different light to his friends. The artist André Bloc wrote in 1956:

"His [Klein's] stay in Japan, he states, provided him with new facts: above all, the monochrome screen, placed in Japanese dwellings in accordance with cultural ritual, acquires full importance. The spectator becomes permeated with this colour, its radiations and its power of incantation".[114]

Recent research has also suggested that there was a connection between his monochrome paintings and meditative Japanese painting.[115] Having concen-

trated on producing primarily blue monochromes in the second half of the fifties, Klein went on to make forty monochromes with a gold-leaf surface between 1959 and 1961 (ill. 67). Klein's stay in Japan appears to have reinforced his fascination with gold; after all, Japan does have a great many gilded Buddha statues, walls and screens (ill. 68).[116] This gold surface has a spiritual value in Japan, as it did for Klein. However, the same significance is found in Christian art. The Japanese conception of gold as something and nothing at the same time apparently applied for Klein as well, as his remark that 'gold is imbued with emptiness' confirmed.[117]

In 1960 Klein embarked on a series of 'Antropométries' (ill. 69). In front of an audience, he got nude models, who were daubed in paint, to make imprints of their bodies against a ground. He is said to have been inspired in this by the imprint made by a Judoist on the Judo mat by the force of his fall.[118] Klein referred on several occasions to connections with Judo: "Hours of preparation for something that is executed with extreme precision, in a few minutes, as with Judo".[119]

Interestingly enough, a comparable 'art project' can be found in the history of Japanese art. It was a performance by Hokusai, who dipped a cockerel's feet in red paint and made the creature walk over a sheet of paper covered in blue paint.[120]

Zen in practice

Several aspects of Zen were discussed in relation to the ideas, works and methods of some American artists, and the same will be done as regards the art of Jean Degottex, Pierre Alechinsky and Yves Klein.

Emptiness and nothingness

The exercises in concentration during his Judo training and his interest in the immaterial taught Yves Klein to experience emptiness as something positive, unlike the French Existentialists, who considered that 'absence of something' as negative.[121] A Japanese Master in swordsmanship once said:

"Everything is emptiness, you yourself, your sword, your arms which are holding the sword. Even the thought of emptiness has disappeared. From such absolute emptiness, springs the most miraculous generation of action".[122]

Taken as a whole, Klein's oeuvre appears to figure 'emptiness' as one of its focal points. That applies to his approach and his work alike.[123] The emptiness he used does not make a particularly Western impression.[124] 'Le Vide', the empty space of the Iris Clert Gallery, which Klein presented as an exhibition in May 1958, is reminiscent of the emptiness in temples and gardens which is favoured in Zen.[125] Klein's intention with this work was to arouse an awareness of sensitivity and immateriality.[126] 'Théâtre du Vide', a project which Klein conducted in August 1960, of an artist plunging into space, is a 'falling action' which is similar to 'floating through air' which occurs during a Judo fight (ill. 70). 'Le saut dans le vide' (Leap into emptiness), as Klein entitled his project in

1961, is also a description used in Zen meditation, referring to the ultimate goal of *Satori*.[127]

Several of Klein's projects featuring emptiness (of which only a few were actually performed), bear some resemblance to events by the American artist John Cage. The exposure of an empty stage in the theatre has something in common with Cage's '4'33"'.[128] Although both strove to raise consciousness, Cage was concerned with the experience of the commonplace, and Klein with the spiritual.

For Degottex too, emptiness had considerable significance in his work. On the one hand, he equated the large empty expanses in his paintings with 'space', and on the other hand he saw them as the counterparts of the characters he painted, bringing about 'neutrality'. Initially Degottex used emptiness as a purely formal aspect. After he had read Suzuki's essays on Zen, the aspect of emptiness acquired greater depth for him. He was fascinated by the importance of emptiness in Far Eastern thinking especially by the types of emptiness which are found in the philosophy of Zen.[129] Margit Rowell, who approaches art from a psychological angle, associates Degottex's emptiness not only with the Far East, but also with the state of 'non-being' which figures in Existentialism.[130] However, in Sartre's way of thinking, unlike the view of the Far East, *l'être* (being) and *le néant* (nothingness) were irreconcilable opposites.[131] Degottex tried to bridge this typically Western difference.

Of all the French artists I have researched, Alechinsky cared least about emptiness. His works are actually an expression of a *horror vacui*. However, in Alechinsky's working method, as in that of Degottex and Klein, there is a similarity with the approach of the Zen Masters in the treatment of emptiness. The quotation of the swordsman's words concerning 'the state of emptiness', which is required for the practice of the Zen arts, also applies to the French artists in question. It would seem as if concentration on the act of painting is intended to keep their minds free from rational considerations. In that respect, their method resembles that of the Zen Masters, but also that of the Surrealists. The latter strove to approach the working process from the unconscious. For Alechinsky the unconscious appears to be chiefly a realm of the imagination, for Degottex the area of the universal *écriture automatique*, and for Klein the source of spirituality and emotion.

As I compared 'emptiness' as a formal aspect in the works of Degottex and Klein, the question arose: which is emptier? Do Klein's 'Monochromes' really seem more empty than Degottex's works, bearing in mind that 'light' and 'dark', for instance, can only be expressed as a reference, a contrast? Although Kumi Sugai, a Japanese artist who had been living in Paris since 1952, was of the opinion that Zen was 'the most minimal' and that consequently Klein's Monochrome was more Zen,[132] I must point out that in Zen paintings 'emptiness' is seldom portrayed by an entirely empty field, but by the fact that it is in balance with 'something'. The famous 'cartoon' from Zen literature was mentioned earlier[133], in which the moment that the man with the ox has attained *Satori* is depicted as a completely empty plane. Klein's Monochromes also suggest that spiritual moment.

According to Sugai, 'emptiness' in the Japanese way is 'form', which pro-

ceeds from the painted lines and shapes, and then becomes their equal. Emptiness in most Western works would seem to have a different meaning. There it is primarily a matter of an 'empty background'.[134] That also applies for Degottex's work. Only Klein's Monochromes are an exception, since their emptiness is both fore- and background, and has form (i.e. that of the painting). So in these works nothing and something have become identical.

Dynamism

The dynamic character of Alechinsky's works is typical of the art of the Cobra group, since spontaneity was an important feature of their work.[135] As is the case with the *Shō* artist, spontaneity with Alechinsky is a disciplined expression of a skill acquired through considerable practice, unlike the other members of Cobra. Alechinsky's brush-strokes did not express short spontaneous actions; his work process is more like an experiencing and utterance of the 'rhythm of body and life'. It is comparable with the monk in his meditation who concentrates on his own bodily rhythm. The representations in Alechinsky's works are also tied in with his life process. They do not portray a static 'snapshot', but a period in his imagined life. The borders Alechinsky began making around his works in 1965 particularly recall Zen's view of life as a dynamic process, which should be grasped as it goes along, and may not be halted.[136]

Degottex used the short dynamic action to pre-empt reason, and in that way to produce a universal sign out of the unconscious. This resulted in the sporadic simple dynamic dashes of paint. Degottex, like Alechinsky, derived his spontaneity from a process of practice and concentration, rather than from 'riotousness'.

Klein's approach can also be termed disciplined. In his works dynamism, in the sense of a repercussion of the energetic process of living, plays a part in his actions, as in the case of 'Antropométries' and 'Théâtre du Vide'. The Monochromes and projects with emptiness possess dynamism, in the sense of 'spiritual energy'.[137]

Indefinite and surrounding space

Space was important for Alechinsky, Degottex and Klein, in their working process and in their paintings. A hint of 'indefinite space' can be perceived in their works. Degottex was primarily involved with the relationship between sign and space.[138] His solution was to paint the background with very diluted paint, as in *Sumi-e*, and then let the calligraphic 'gestures' float there.[139] The time-space relationship is evoked in his work by the script-like signs and intervals. This gives the paintings more the character of text and music, in which the intervals are both space and time, than of the frozen moment of Western academic painting. The interval was important for Degottex in another context too, as revealed by his comment that the space between the works was more important than in the works themselves.[140]

Space in Alechinsky's work, as in that of Degottex, is neither indicated by perspective, nor is it entirely absent. The large empty planes in Degottex's works do, however, convey a more spatial effect, to my mind, than Alechinsky's *horror vacui* works. Margit Rowell is of the opinion that space in Alechinsky's

works is 'captured in the frame', unlike with Degottex, where it is 'open' but 'impenetrable'. She believes that space, for both artists, is not 'outward space', but the 'space of being'.[141] Rowell seems to be indicating that space is not only a formal aspect for them in their work, but that it played a part in how they experienced the work process. So actual space in which the artist moves during his work is just as important at that moment as the suggestion of space in the painting.

Klein felt that his blue monochromes referred to immaterial and infinite space. In 1957 he literally launched quantities of blue balloons, to rise up to the infinite space of the sky. Space as an experience of the surroundings is prominent in Klein's projects. In his 'Antropométries' the models did not pose in the traditional way, with the background experienced as space, instead they moved during the act of painting in the 'encompassing space'. The manner in which space is experienced is even more pronounced in Klein's leap into emptiness. The interweaving of space and time is much in evidence in all of Klein's projects. The human figure moves simultaneously in space and time.[142]

Direct experience of here and now

With the French artists the direct experience of here and now can mainly be perceived in the practice of their profession. Degottex characterized his work as an attempt to deepen the ontological experiences of pure action by way of the painterly and by way of gestures.[143] Margit Rowell opened her book *La Peinture-le geste-l'action* (with the subheading *L'Existentialisme en peinture*) with a quote from G. Lukàcs: "...the gesture is a fundamental requirement of life".[144] She wondered whether the gesture could reveal the essence of life. For some painters *la peinture gestuelle* (gestural painting) was, in her view, an attempt to reassess what was human and save individual existence from social alienation.[145] In abstract writing, the absence of meaning was transformed into the presence of 'being'. And she believed that a single brush-stroke by Degottex was 'the existential moment'.[146]

Degottex was interested in calligraphy, as well as in the technique of *Sumi-e* painting. In the context of 'direct experience', it is interesting to note that he had the following sentence above his studio door: "In Sumi painting, the merest brush-stroke which one goes over a second time, becomes a blot, the life has gone out of it".[147] His works attest to this pursuit of directness.

For Alechinsky, too, direct experience related primarily to his working process. Both he and Degottex worked with great concentration.

Writing would seem to have been a bridge between daily life and art for both artists. In Klein's work it is absent, but his lecture at the Sorbonne in Paris on 3 June 1959 reveals that he considered calligraphy to be the basis of everything, stating that everything starts with calligraphy, determines and conquers everything.[148] Interestingly enough, he painted the Japanese character *'ki'* (tree) to illustrate his point. However, his aim was to 'transcend' calligraphy, and he sketched the development to an undefinable nothing.[149]

With Klein the direct experience of here and now can be perceived in various events, like his leap into space. In his concepts he emphasizes the experience of emotion and mysticism. He believed that life can be touched through

'sensitivity', and that life, in turn, will become absolute art.[150] At first sight Klein appears to have been far removed from Zen in his interest for mysticism, yet if Suzuki's essay 'Zen and Mysticism' is compared with Klein's pronouncements, interesting parallels can be observed. Suzuki wrote in that essay:

> "Genuine mysticism rests on inner experience of a specific kind that is intuitive and independent of any discriminative and discursive knowledge (...) Mysticism is nothing other than the living and expression into thought of this inner life. Mystics see everywhere the oneness of things beyond every limitation of time and space. They enjoy freedom from formalities, conventionalities and worldly cares of every kind".[151]

It is striking that not only Klein, but also Alechinsky and Degottex saw the creation of an art-work as a kind of ritual. Georges Mathieu, the artist whose work was discussed at an earlier stage, often also turned the painting process into a ritual though a theatrical one. He produced several large paintings dressed in a kimono, with bandages round his legs, in the presence of an audience. During the journey to Japan which he and Michel Tapié undertook together in 1957 [152], he also made several paintings in public. Mathieu implied in his writings that the Japanese were enthusiastic about that work, but interviews in Japan suggested to the contrary.

Nondualism and the universal

After the Second World War there was a growing need to abolish the divisions between what was Western and what non-Western. In addition, in the second half of the nineteen-forties international communication was progressing so well that relations between East and West could be established and speedy exchange of ideas facilitated.[153] In 1955 Gyorgy Kepes observed in an essay in the art magazine *Cimaise* that in the distant past the difference between East and West had not been so great, but the balance had been upset (with the West pursuing intellect and the East emotion). In the fifties it was hoped that a more fundamental exchange between the Western structural discipline and the Eastern sensitivity might contribute to improved cultural equilibrium, and at a higher level this time.[154] Comparable observations can also be found in André Malraux's writings. He traces parallels between the Mediaeval art of West and East, and goes on to point out the differences in subsequent periods, in the hope that art might regain its 'balance'.[155]

Several French artists tapped their pursuit of universal art at the end of the forties from Surrealists like Masson and Michaux who were already seeking to reach a universal *écriture automatique* in the nineteen-thirties.

Initially Degottex had sought 'universality', or 'neutrality' as he preferred to call it, in writing, but went on to discover a 'neutral ' philosophy and method in Zen, since Zen wishes to remove any dualism. When Degottex chose the name 'Les Alliances' for an exhibition in 1960, he was referring to the coherence between everything – or nondualism – which had become important for him.[156]

Alechinsky primarily saw the sense of kinship with Japanese calligraphy as a basis for the universal, or international goal of art. In his essay 'Au delà de l'écriture', which he wrote shortly before he left for Japan, he concluded:

"European artists and Japanese calligraphers: our point of departure is not situated in the formal, but can be found in the same attempt to descend and rise again, the breath-taking dive for a magnificent shared pearl".[157]

Klein hoped with his monochromes to get in touch with 'the universal', which could more appropriately be described as 'the spiritual universe'. This was probably because religion and mysticism played an important part in Klein's life. He also wanted to give his work a universal (i.e. international) character, as can be deduced from the fact that he called his blue monochromes 'IKB' (International Klein Blue) from 1957 on.

Nondualism is particularly apparent in the artists' methods. Klein strove for unification with the spiritual during his work. For Alechinsky and Degottex it meant a feeling of oneness with the material. They hoped, with their approach, to achieve a more natural art-work.

The quest to abolish differences is, formally speaking, patently present in Degottex's work. He tried, for instance, to do away with the contrast between 'stillness' and 'speed', combining the meditative slowness in the painting of the ground with speed in making the signs.[158] In Klein's monochrome paintings even something and nothing, fore- and background, and form and formlessness have become one.

As the foregoing resemblances with aspects of Zen demonstrate, various developments were taking place in twentieth century Paris which helped to bring art closer to the beliefs and the art of the Far East. The Surrealists' interest in Man's inner life made for a different attitude among many French artists, which in turn opened up the beliefs of Zen to them in the fifties. However, there was a substantial difference between the Surrealists' interest, which was primarily geared to psychology, and that of the Zen Masters, whose orientation was on unity with the environment and even the Cosmos.[159]

Most experts were in agreement as to the role of Zen in French art in the fifties. It transpires that, for the French artists with their practical orientation, it was too abstract, though as 'backing' for the Zen arts it did reach them. For Alechinsky, Zen was an explanation for the attitude and method of the *Shō* artist. It constituted for Degottex a theoretical framework for his interest in calligraphy and his pursuit of a universal writing. In addition, Alechinsky and Degottex were interested in the formal aspects of *Sumi-e* and *Shō*. Klein was primarily fascinated by the relationship in Zen between spiritual and physical experience, especially in the form of Kodokan Judo.

So there are distinct similarities and distinct differences between French and American artists as regards their interest in Zen. The review of the German and Japanese art centres will clarify even more the range of the affinity with Zen and, more particularly, the diversity in interest.

Notes

1 Mathieu published his ideas, which stemmed from an aversion to the academic rules of aesthetics, in article form between 1947 and 1956. In 1963 the publications were collected in the book *De la Révolte à la Renaissance. Au delà de la Tachisme*.

MATHIEU, 1973 (1963), pp. 172 and 188, believed that the new style of painting would create new signs devoid of fixed meaning. For more information on Mathieu and 'sign-meaning', see the chapter 'Lyrische Abstractie', written by Mariette Niemeyer in the catalogue *Informele Kunst*, ENSCHEDE 1983.

Many French artists knew of Mathieu's views in the fifties. Yet in the course of this chapter it will become clear that the artists, Degottex and Alechinsky, whom I have studied, primarily reached their expressive style of painting via different routes.

2 Mathieu used the term Lyrical Abstraction for the very spontaneous abstract painting which he and a few comparable painters produced. However, art history literature only uses this name in a wider sense, for painterly abstract art between 1945 and 1960.

3 André Malraux described him as such in 1950. MATHIEU, 1973 (1963), p. 65.

4 The wide-ranging nature of the present research has meant that only a few artists in this group will be discussed in detail. Short comments will be found here to the artists whose works are not examined further.

In 1951 René Laubiès undertook the translation of the 'Discourse on painting' by Khu-Chi, a Chinese painter of the 12th century Sung period who worked in the style of the Ch'an ink painting. Khu-Chi's work had a pronounced impact on Laubiès' work.

Apart from an interest in artists like Paul Klee (who will be discussed in the chapter on Germany) and in Existentialism, Wols was attracted to the Tao doctrine (of Lao-Tzu) from China. Since Zen has adopted some aspects of that doctrine, Wols does to some extent belong to the group of artists who are the focus of this book.

Bellegarde was interested in both Zen painting and the books of Krishnamurti (1895-1986), an Indian spiritual leader.

The relevant literature on artists like Camille Bryen, Nasser Assar, Martin Barré, Brion Gyson and Jean Messagier also drew parallels between their work and Zen painting

and Japanese calligraphy. Further research will have to demonstrate whether that is pertinent.

5 WICHMANN, 1981 (1980), p. 8.

6 The 'Kanō School' stems from Masanobu (1434-1530). His son Motonobu (1476-1559) in fact established the characteristic style of the Kanō painters. The Kanō school continued for centuries, made up of skilled artists who worked both in the monochrome Zen painting style, with its concomitant spontaneous brush-strokes, and in a polychrome, more detailed decorative style. With the latter, they combined their inspiration from Zen with the traditionally Japanese, refined technique. Both styles were reproduced in *Le Japon Artistique*.

For information on Sengai readers are referred to the chapter 'Zen and the Zen arts', as well as to the part of this chapter concerning Pierre Alechinsky.

7 "...Traitées avec une grande energie, et une rapidité..." and "...qu'un seul coup de pinceau...".BING, September 1889, p. 66.

It is apparent from the words of Gaston MIGEON, 1898, p. 5, that knowledge of Japanese ink painting was by no means lacking at that time. Migeon could even appreciate the 'typical' Japanese characteristics: "...se marquent une personnalité de vision et une liberté de pinceau qui sont bien japonaises". In the same text he describes the collection of Japanese paintings at the Louvre, which by then comprised around ten works, two of which had come from Bing.

8 It was not possible to discover which Japanese artist had made this example.

9 WICHMANN, 1981 (1980), p. 384. Toulouse-Lautrec also owned several Japanese ink paintings. SULLIVAN, 1973, p. 235. However, I was unable to find out which artists painted the *Sumi-e*.

10 Edmond de Goncourt and his brother Jules, who wrote various books on Japanese art, had already been to see Von Siebold's collection of Japanese art and curios in 1861; it contained several volumes of *Manga*. ADAMS, 1985, p. 453 and the catalogue *Hokusai and his School*, HAARLEM 1982, p. 9.

The doctor, Franz Von Siebold (1796-1866), had worked on Deshima at the start of the 19th century and collected large quantities of Japanese objects, including many woodcuts. He took the collection back to Leiden with him, where it formed one of the first of its kind outside Japan. In 1831 Von Siebold published

his *Nippon Archiv zur Beschreibung von Japan*, of which a French edition, *Voyage au Japon*, was published in 1838. The book would seem to have enjoyed considerable interest. According to G.P. Weisberg, in the catalogue *Japonisme*, CLEVELAND 1975, p. 21, the influence of the said book should not be underestimated.

11 Interview with Michel RAGON in Paris on 15 June 1993.

12 Interview with Michel RAGON in Paris on 15 June 1993. This view was based on the relationship between the characteristics of Hokusai's work as described by Focillon, and the features of works by many artists in the nineteen-fifties.

13 Interview with Marie TSUKAHARA in Paris on 27 May 1993.

 According to Harry Bullet, who works at *Le Monde* and at Centre Pompidou, the fascination for Japan in the 20th century was partly stimulated by the Japanese victory in the war with Russia in 1905 – the first victory of a non-Western country over a Western nation. Interview with Harry BULLET in Paris on 24 June 1993.

14 Grosse depicts enlarged details of a number of works, making them appear like abstract paintings which would not in fact be painted until twenty-five years later in Paris.

15 "In einem ostasiatischen Tuschbilde hat z.B. die Linie eine ganz andere und viel größere Bedeutung als in irgendeinem Werke der europäischen Graphik, und sie erfordert deshalb von dem Beschauer ein ganz anderes Maß von apperzeptiver Betonung (...) Der Tuschmaler war zuerst für die Schreibekunst erzogen worden, das Werkzeug, mit dem er malte, war derselbe Pinsel, mit dem er schrieb...". GROSSE, 1922, pp. 6 and 25.

16 "...Ausdruck ihres eigenen inneren Wesens und Leben". GROSSE, 1922, p. 13. Research has shown that a number of artists knew that book in the fifties.

17 Interview with Marie TSUKAHARA in Paris on 27 May 1993.

18 Later in this chapter a quote will be given from that book, in the context of the discussion of Pierre Alechinsky's work.

19 Interview with Michel RAGON in Paris on 15 June 1993 and with Harry BULLET in Paris on 24 June 1993.

20 Interview with Harry BULLET in Paris on 24 June 1993. See also p. 31 regarding Van Gogh's interest in Loti.

21 There had been considerable interest in France, even at the end of the late 19th century, for translations of Japanese *Haiku*. LINHARTOVA, 1987, p. 13. She lists examples such as *L'Anthologie Japonaise. Poésies anciennes et modernes des insuraires du Japon*, Paris, 1871; *L'Anthologie de la littérature japonaise des origines au XX siècle*, Paris, 1910; *L'Anthologie de la poésie japonaise*, Paris, 1935.

22 RESTANY, 1956, pp. 18-23.

23 "La poésie est expérience vécue". LEGRAND, 1962, p. 28.

24 "... Et moi aussi je suis peintre". Catalogue *Écriture dans la peinture*, NICE 1984. This catalogue also mentions that the English painter Rossetti was probably the first to use text in a painting.

25 MICHAUX, 1967 (1933), pp. 205-206.

26 "On parle beaucoup de Zen en cette période agitée où le tachisme et l'abstraction lyrique (...) tiennent une place importante". BONNEFOI, 1976, p. 47.

 The term Tachisme is derived from the French word 'tache' meaning stain or blot. The art critic Charles Estienne was the first to use the word with reference to the painters working in an abstract and expressionist manner in the fifties.

27 ROWELL, 1987, pp. 57 and 87. Miró made these observations in letters he sent his friends from Paris. Rowell added in her comments on the letters in question that Miró had become acquainted with the Japanese sources in Barcelona.

28 "...La vie telle que la civilisation occidentale l'a faite, n'a plus aucune raison d'exister, qu'il est temps de s'enfoncer dans la nuit intérieure afin de trouver une nouvelle et profonde raison d'être". MASSON, 1925, p. 30.

29 "L'Orient est partout. Il représente le conflit de la métaphysique et de ses ennemis, lesquels sont les ennemis de la liberté et de la contemplation. En Europe même qui peut dire où n'est pas l'Orient? Dans la rue, l'homme que vous croisez le porte en lui: L'Orient est dans sa conscience". The Aragon quote is from *La Révolution Surréaliste*, (1925) 4.

30 Interviews with José VOVELLE, Françoise WILL-LEVAILLANT and Jean-Paul AMELINE in Paris on 2 and 4 June and 27 May 1993, respectively.

31 "Par bonté bouddhique, Bashō modifia un jour, avec ingéniosité, un haïkaï cruel

composé par son humoristique disciple,
Kikakou. Celui-ci ayant dit: "Une libellule
rouge – arrachez-lui les ailes – un piment".
Bashō y substitua: "Un piment – mettez-lui
des ailes – une libellule rouge". Catalogue
André Breton, PARIS 1991, p.42. The fact that
Breton closed his discourse with such a
simple, realistic comparison and no further
comment, suggests, according to Marguerite
Bonnet, Ibid., that his theory of 'le Signe
Ascendant' has nothing to do with elevated
language, but with reality.

32 YAMADA, 1976, p. 296.

33 MASSON, 1956, p. 40.

34 YAMADA, 1976, p. 297. In the book *The
Buddhist Secrets of Japan*, STEINILBER-
OBERLIN 1970 (1930), Suzuki is quoted
several times. The book was published by the
same publisher as the one by Grosse, referred
to above. See for Waley the chapter 'The Unity
between West and East'.

35 Masson was in the United States of America
from 1941 to 1946.

36 Comments in MASSON, 1976, p. 186.

37 Comments in MASSON, 1976, p. 186.

38 MASSON, 1950.

39 "Un peintre partageait résolument sa surface
par une ligne ascendante et sensible".
MASSON, 1950, p. 151.

40 See the chapter 'Zen and the Zen arts'.

41 DUTHUIT, 1936, p. 112.
SUZUKI, 1993 (1938/1927), p. 31, wrote about
Duthuit and this book: "He seems to
understand the spirit of Zen mysticism".

42 Catalogue *Tal Coat*, PARIS 1976, 'biography'.
In addition, his friendship with Masson,
dating from that period, is also relevant.
The artist Nicolas de Staël became friends
with Duthuit in around 1950. De Staël
produced various works in the fifties with a
similar meditative ambience to Zen paintings.

43 See relevant literature on Mathieu. These
influences were also mentioned by José
VOVELLE and Françoise LEVAILLANT in
interviews on 2 and 4 June 1993, respectively.
Paul Klee will be discussed in the chapter
'Release by Zen and German art'.

44 MATHIEU, 1973 (1963), pp. 197-204.
PELLEGRINI, 1966, p. 59, is of the opinion
that Mathieu's gestures had become quite
mechanical, which made the brush-strokes
lifeless and lacking the expressiveness of
Oriental calligraphy.

45 VOGT, 1972, p. 379.

46 Wieland SCHMIED during an interview in
Munich on 11 February 1994 and Werner
HAFTMANN during an interview in
Waakirchen on 13 February 1994. Both knew
Hans Hartung well.

47 The painter Gérard Schneider, who was a
friend of both Hartung and Soulages, appears
to have aligned himself with these two artists
as regards expressiveness and contemplation
in his works.

48 DECOUDILLE, 1961, p. 36, called this 'La
Sixtine des temps nouveau'.

49 MATHIEU, 1973 (1963), p. 125.

50 Dorival, in the catalogue *Les Années 50*, PARIS
1988, p. 54. This is the only time I encountered
literally the working title I had selected: 'Neo-
Japonisme'.
Furthermore, in the fifties Japan set up a
'promotion', within the framework of
revitalizing the economy and in which good
foreign relations were very important. The
publication in 1952 of a special supplement
with the December issue of *La Revue Française*
confirms the French willingness to cooperate.
It contained articles on the Japanese economy,
the Kabuki theatre, pearls and religions
(Suzuki had written the article on the latter
subject). In addition there were advertisements
by Japanese banks, offering help in setting up
projects in Japan, and the Japanese Tourist
Office offered trips to that country: "Le Japon
vous invite avec sa culture traditionelle et son
charme exotique d'Orient".

51 "Une nouvelle mode du Japon est en train de
naître" and "L'art ancien japonais traditionnel
m'a paru étrangement moderne, alors que
l'art considéré au Japon comme moderne m'a
paru plutôt ancien. En effet, dans la peinture
traditionnelle japonaise, on trouve avec
étonnement ce goût du signe et de la tache,
cette liberté de tracé du pinceau, ce sens de
l'espace, qui sont autant de caractéristiques
de l'art abstrait actuellement d'avant-garde en
Europe et aux États-Unis". RAGON, 1958,
pp. 11 and 25.

52 "Il est singulier d'ailleurs de constater que la
mode actuelle du Japon autant aux États-Unis
qu'en Europe, est une réaction puriste contre
les baroquismes qui allèrent du modern'style
1900 aux arts décoratifs 1925 et que ceux-ci
furent le résultat du premier japonisme
européen (...) Le second japonisme européen
est bien une contradiction du premier et le
Japon puriste, qui nous ravit aujourd'hui, nous

aide à nous délivrer du baroquisme hérité du Japon qui avait tant plu à nos grands-parents". RAGON, 1958, p. 25. Ragon meant with 'baroque' the direction in Art Nouveau which was characterized by an overabundance of ornamentation.

53 RAGON, 1963, p. 49.
For more information on the phenomenon of 'Primitivism' and the discussion concerning its exact definition, readers are referred to recent publications on this subject.

54 "Que n'a-t-on pas fait en Europe et aux États-Unis au nom du Japon et du Zen! Et rien n'étonne plus les Japonais que de savoir qu'il existe des Européens Zen. La seconde mode du Japon a été aussi contagieuse que plus tard le pop américain". RAGON, 1969, p. 12.

55 "Ce mythe du Japon dans l'École de Paris a la vie dure: il témoigne de ce besoin d'exotisme ésotérique, si nécessaire aux collectivités intellectuelles prétentieuses (...) Calligraphie, judo, bouddhisme Zen, sont enrobés d'une sauce complexe et subtile, riche de variantes individuelles. Le judo, cette gymnastique japonaise hygiéniquement imposée aux enfants des écoles au même titre que la vaccine ou le verre de lait... Des Manuels de sagesse pratique vous divulguent les secrets essentiels de l'expérience humaine: zen by day, zen by night. (...) La calligraphie est en train de rééditer le coup de l'estampe. Il faudrait conseiller à Mathieu d'adopter l'uniforme de Nabi Japonard. L'Occident vient de retrouver l'art de l'écriture (...) L'Occident doute de lui-même, et cherche ailleurs l'équilibre et l'espoir. Où? Si ce n'est vers l'Orient, son exact contraire, son essentielle antinomie, le germe de sa propre néantisation". RESTANY, 1958, p. 30.
Please note that artists were not only looking for solutions in the Orient, but in other non-Western cultures too, and in 'Art Brut'.
Mathieu's clothing to which Restany was referring was indeed strange. When he was painting in front of an audience he wore a Japanese kimono and various unidentifiable attributes.

56 "Tout le monde est plus ou moins zen dans les milieux de l'art abstrait parisien et new-yorkais". RAGON, 1963, p. 57. Ragon devotes a short chapter in his book to the Japanese influence, entitled 'Cent ans d'influence Japonaise sur l'art Occidental' (pp. 49-58).

57 RAGON, 1963, p. 57 and in an interview in Paris on 15 June 1993.

58 In 1952 Suzuki's Le Non-Mental selon la pensée Zen was published, and in 1955 his l'Essence du Bouddhisme. In 1952 La Doctrine Suprême: Réflexions sur le Bouddhisme Zen by Hubert Benoit was published and two years later his Lâcher prise. Théorie et pratique du détachement selon le Zen. The Englishman Alan Watts' book Le Bouddhisme Zen appeared on the French market in 1960 (see the chapter 'The Unity between East and West. American artists and Zen').
Surprisingly enough, the first Zen institute was only founded in 1967, by Taisen Deshimaru in Paris. (Deshimaru was the first Zen Master to live in Paris). Thanks to the considerable interest in Zen which had meanwhile come about, he was received by Parisian intellectuals and artists with open arms. Interview with Roland RECH, director of 'L'Association Zen Internationale' in Paris on 18 June 1993.

59 Masson writes on this subject in his article 'Une peinture essentiel', 1956; various interviews, with Renée Beslon and Pierre Restany, amongst others, and various literary sources, suggest that Degottex and Klein were familiar with the book. Readers are referred to the chapter 'Release through Zen and German art' for more information on Herrigel's book.
According to Harry BULLET in an interview in Paris on 24 June 1993, Zen also held a great fascination for Georges Braque at that time, in particular Herrigel's book, for which Braque even did the illustrations.

60 Jean-Paul AMELINE, interview on 27 May 1993; Michel RAGON, interview on 15 June 1993; Harry BULLET, interview on 24 June 1993.

61 "Enfin, à un moment où le devenir artistique, comme bien d'autres, se situe sur un plan mondial, l'Amérique est devenue le carrefour géographique réel de la confrontation des problèmes les plus profonds des grands courants artistiques d'Orient et d'Occident, dans des interférences où le jaillissement de la significance calligraphique et l'intensité du drame plastico-pictural se compénètrent dans une véhémence de choc...". TAPIÉ, 1952, unpaged.

62 TAPIÉ, 1952, unpaged.

63 TAPIÉ, 1960, unpaged.

64 "Tapié a essayé de masquer cette filiation

expressionniste et germanique évidente chez un Hartung ou un Wols en insistant sur le signe, sa structure calligraphique, ses rapports avec le Zen et la tradition orientale". RESTANY, 1979, p. 47.

65 Interview with Pierre Restany on 23 June 1993. KLEIN, 1969, pp. 411 ff.

66 WILL-LEVAILLANT, 1971, p. 64, quoting Dorflès, Simbolo Communicazione Consumo, 1962.

67 In Menschliches Allzumenschliches, published in 1878, Nietzsche wrote: "Seitdem der Glaube aufgehört hat, daß ein Gott die Schicksale der Welt im Großen leite (...) müssen die Menschen selber sich ökumenische, die ganze Erde umspannende Ziele stellen". HOLLINGDALE 1991 (1977), p. 30.

68 Interview with Roland RECH in Paris on 18 June 1993.
 The extended nature of my research means that it has not been possible to examine the names of the intellectuals involved. For the names of the artists, readers are referred to those mentioned earlier in this chapter.

69 STOKVIS, 1990 (1974), p. 227.

70 VOGT, 1972, p. 23. See also the chapter 'Release through Zen and German art'.

71 STOKVIS, 1973, pp. 169-170. Dotremont maintained in 1968 that he had begun study-ing the Chinese language and Eastern calli-graphy in 1941-42. In 1944 Jorn advocated in 'De profetiske harper' in Helbresten 2 (1944) 5 for closer ties between graphology and art, "not because a certain style is imposed on handwriting, but because, as conceived by the Chinese, it acquires expressive force".

72 STOKVIS, 1973, p. 122.

73 See the chapter 'The inherent Zen in Japan'.

74 ALECHINSKY, 1988, p. 61.

75 "N'écrivez pas avec la main, n'écrivez pas avec le bras, écrivez avec le coeur". ALECHINSKY, 1956, p. 47.

76 Alechinsky in the catalogue Middelpunt en kantlijn, BRUSSELS 1988, p. 22.

77 The Koninklijke Filmarchief (Royal Film Archives) in Brussels possess a copy of the film 'Calligraphie Japonaise'. The film lasts about seventeen minutes.

78 His essay was entitled 'Les rapports de certains aspects de la peinture non figurative lyrique et la calligraphie chinoise'.
 The artists Alcopley (see p. 61) and Morita (see p. 201) also assisted in organizing the exhibition in question.

79 "De Japanse kalligrafie, waar men toen veel over sprak, liet ook zekere sporen na". Quotation from the brochure Informele Kunst. Tussen Cobra en Zero, Amsterdam 1974, published in the catalogue Informele Kunst 1945-1960, ENSCHEDE 1983, p. 76.

80 VREE, de, 1976, p. 28, quotes Alechinsky in Dutch: "Ik heb de kalligrafie benaderd langs de buitenkant, langs de filmcamera".

81 VREE, de, 1976, p. 28, quotes Alechinsky in Dutch: "Ik meende iets te kunnen leren door het imiteren van bewegingen".

82 The Musée Nationale d'Art Moderne in Paris owns several sketches.

83 BOUÉ, 1983, p. 29.

84 In that respect his works bear a close resemblance to those of the French artist Jean Bazaine, who was a great example for Alechinsky.

85 There are only slight variations in width and character in a Western pencil line, a pen stroke or a brush-stroke, and similarly, that is the impression made by many of Alechinsky's brush 'gestures' of the fifties.

86 In the sixties Alechinsky stopped painting in oils and switched to acrylic paint. His Chinese friend Walasse Ting had encourage him to do so in 1964. From then onwards Alechinsky developed a painting style of his own, in which there is a strong resemblance with his drawings and graphic work. The borderline between drawing and painting then becomes almost non-existent. After that, Japanese brush technique also became increasingly more recognizable in his work.

87 "Sengaï aurait tracé ainsi en pareilles circonstances, pensai-je, sans trop réfléchir, en suivant mon pinceau (...) je retrouve un geste. Le geste de mon maître Sengaï". ALECHINSKY, 1971, p. 93.

88 "Je suis Sengaï. Pas de doute". ALECHINSKY, 1971, p. 147. STOKVIS, Vrij Nederland, 1974, p. 24, was the first to notice the importance of this statement.

89 John KOENIG told that many artists were very impressed with the works (70 paintings and 10 terracotta objects), especially the 'Symbol of the Universe', on account of the abstract forms and the freedom of execution. Interview 17 June 1993.
 The texts in the catalogue Sengai, travelling through EUROPE 1961-63, were by Sir Herbert Read and Daisetz T. Suzuki.

90 The way in which both artists painted the triangle calls to mind the quotation of a Japanese poet in CLAUDEL, 1929, p.321: "De plus les lignes du triangle grec ne font que relier trois points l'un à l'autre et déterminer entre elles un champ de rapports et de proportions mathématiques. Ce sont des lignes inertes ou disons éternelles. Elles ne bougent pas, elles ne partent de rien, elles ne vont nulle part. Le triangle Japonais au contraire est dirigé vers le dehors dans toutes les directions à la fois. Il est l'intersection devenue sur un point visible de lignes indéfinies. Il est par toutes ses pointes inachevé. Il est l'alliance de la ligne droite et de la courbe. Il ne tient à rien. Il est l'expression et moins la fusion que l'accolade de deux mouvements à la fois convergents et divergents. Il est la limite gracieuse et souple entre l'attraction et la pression, ce qui tire et ce qui cède, le ressort de ce qui plie, l'alliance de ce qui résiste".

This text would seem to apply to both triangles. But Sengai's is far more subtle. Alechinsky obviously wanted to apply a few typically Japanese characteristics, with a lack of Japanese subtlety which (although not mentioned in the foregoing quotation) is vital, to my mind.

Not only the forms at the centre, but also the drawings at the edges of the picture bring to mind works by this Zen Master (cf. the figure in the middle of the upper edge of ill. 60 with ill. 4). The borders containing series of drawings, which Alechinsky regularly applied around his works, are reminiscent of scroll paintings.

91 STOKVIS, 1990 (1974), p. 228.

92 ALECHINSKY, 1956, p. 162. Alechinsky probably did not mean this to be taken literally, but apparently became fascinated whilst in Japan with the works of the calligrapher Osawa, having learnt to appreciate a certain type of beauty through Miró's work.

93 Interview with Renée BESLON in Paris on 6 July 1993. That source of inspiration is quite apparent, bearing in mind the ink drawing and watercolours which Degottex was making in 1954. Representations can be found in the catalogues listed in the bibliography.

94 Interview with Renée BESLON in Paris on 6 July 1993.

95 In 1948 the exhibition Écritures et livres à travers les âges was also held (on the occasion of the XXI Congrès International des Orientalistes). Nineteen Japanese 'manuscripts' were on display there.

96 "L'idée définitive d'une oeuvre d'art ne semble pas résulter d'un travail de composition qui rassemble laborieusement et essaye méthodiquement... l'idée finale se précipite plutôt instantanément dans l'âme de l'artiste, préparée et fertilisée par l'ambiance et la vision". Catalogue L'Épée dans les nuages, PARIS 1955, unpaged.

97 "Je terminais dans le même moment la lecture de l'ouvrage de D.T. Suzuki, Essais sur le Bouddhisme Zen relatant l'énumération des 18 Vides de la Prajna Paramita. J'ai titré arbitrairement chaque tableau du nom de chacun des 18 Vides. Les 18 Vides sont 18 manières déterminées permettant d'arriver à l'idée de vide (non au vide). Plus loin selon Suzuki 'Le Grand Vide' veut dire l'irréalité de l'espace...". This remark by Degottex made at the exhibition 'Alliances' in 1959 is quoted in the catalogue Degottex, GRENOBLE 1978.

98 Beslon in the catalogue Degottex, PARIS 1961, unpaged. See also quote in note 97.

99 Beslon in the catalogue Degottex, PARIS 1961, unpaged.

100 Beslon in the catalogue Degottex, Signes et Métasignes, NÎMES 1992, p. 8.

101 In 1965 Rolf Wedewer explained the combination of East and West which Degottex pursued as the challenge of developing a European 'art of the sign' (un art du signe), based on calligraphy. Wedewer in the catalogue Degottex. Gemälde, COLOGNE 1965, unpaged.

102 Kultermann in the catalogue Monochrome Malerei, LEVERKUSEN 1960, preface. This comment in the catalogue was a reason for Klein to remove his work from the exhibition (JANSEN, 1987).

103 The Brotherhood of Rosicrucians is thought to have been founded by Christian Rosenkreutz (1378-1484), but only became a Brotherhood in the 17th century. The aim of its members was to find a philosophy which is at the foundations of all sciences. In 1909 the American Max Heindel (1865-1919), a follower of Rudolf Steiner, founded The Rosicrucian Fellowship. His doctrine is a form of esoteric Christianity.

104 McEvilley in the catalogue Yves Klein, PARIS 1983, p. 25; and STICH, 1994, pp. 18 and 255. The latter quoted from an interview with Arman in 1992. Arman claimed during the

interview that Klein was also involved in Zen meditation, but no other sources confirm this. However, the relevant literature reveals that he practised breathing exercises and meditation, though it is not clear to what extent he pursued Zen techniques.

105 Arman in an interview with McEvilley in the catalogue Yves Klein, PARIS 1983, p. 26.

106 Klein quoted in the catalogue Yves Klein, LONDON 1974, p. 25. See also the chapter 'Zen and the Zen arts', p. 13 and note 20.

107 Catalogue Yves Klein, 1928-1962, PARIS 1969, p. 31.

108 STICH, 1994, pp. 17, 33, 39, 40, 53, 55 and 256. Several sources indicate that Klein did not obtain his fourth Dan in Judo for his level of achievement. He wrote himself of 'bluff'. That might refer to his 'purchase' of the degree, his lie to the Masters that he had a Judo school in France and that its continuation depended on his attaining the degree, or a 'petition' from his parents to the school. STICH 1994, p. 37 and Peter van Beveren of 'Art Archives' in Rotterdam are two people who have researched this.

109 RESTANY, 1983, p. 23.

110 STICH, 1994, p. 40, referring to interviews in 1991 and 1992.
In the magazine Vernissage (1994) no. 10 (which was devoted entirely to Yves Klein on account of the exhibitions in Cologne, Düsseldorf and Krefeld) Carsten Neumärker, Valerian Maly and Karl Ruhrberg all mentioned in their essays the affinity they believed existed between Klein and Zen.

111 RESTANY, 1965, p. 80. The influence of the Far East on Klein's work should not be overestimated, according to RESTANY, 1983, p. 23. Klein is said to have actually discovered in Japan just how Western he was, and that after his stay there he ascertained that the path his spirituality had taken was deliberately Western.

112 "Attendu que j'ai peint des monochromes pendant quinze ans...". This Klein text dating from 1961 was also published in the catalogue Yves Klein, NEW YORK 1965.

113 The photographs proved not to be reproductions of paintings but of snippets of coloured paper, stuck on a ground. Nevertheless, McEvilley, in the catalogue Yves Klein, PARIS 1983, p. 34, did not want to describe them as falsifications, but rather 'artifices'. Be it as it may, Yves went to a great

deal of trouble to predate his Monochromes for the public.
Before he left for Japan, Klein apparently did paint several small monochrome fields with watercolour paint, but they do not seem to have been intended as serious 'art'. STICH, 1994, p. 23.

114 "Son [Klein's] séjour au Japon, déclare-t-il, lui a apporté de nouvelles données: Avant toutes choses, l'écran monochrome, placé dans les demeures japonaises selon des rites culturels, prend toute son importance. Le spectateur s'imprègne des pouvoirs de cette couleur, de ses radiations et de son pouvoir d'incantation". BLOC, 1956, p. 104.

115 STICH, 1994, p. 66. She does not quote her source. Since this publication came about in close cooperation with Rotraut, Yves Klein's widow, she was probably the one to make the remark.
In the halls in Madrid and Paris where he gave Judo classes after his return from Japan, he had hung various monochrome paintings. They may have been intended to create a meditative setting. STICH, 1994, p. 42 and GOODROW, 1994, p. 18. In 1957 he made a screen comprising five blue monochrome panels, intended to enable the viewer to 'swathe himself in blue'. STICH, 1994, p. 92.
The sponges which Klein started incorporating in his Monochromes at the end of the fifties, increase the relief of the surface and add differences in colour tone. On the use of these 'éponges' – and in relation to a Japanese influence – Nan Rosenthal expressed in her essay 'La lévitation assistée' an unusual opinion. She believes that the works were inspired by Zen gardens, and the Ryoanji (ill. 8) in particular. These gardens are made up of zones of raked gravel with a few rocks in them. Rosenthal goes so far as to compare the groups of rocks in the Ryoanji garden with the sponges on the walls of Gelsenkirchen theatre, extending the parallel to the fact that both works are surrounded by architecture. Rosenthal in the catalogue Yves Klein, PARIS 1983, p. 216.

116 Klein told a certain Harry Shunk about the gold he had seen in Japanese temples. STICH, 1994, p. 272, note 4.
Contrary to Klein's and Restany's view that the gilded screens only form a decorative ground, the gold-coloured empty spaces in the representations are certainly not part of the

background. They are independent elements of form and it is also worth noting that monochrome gold-painted screens can indeed be found in Japan.

117 Ulf Linde in the catalogue *Yves Klein*, AMSTERDAM 1965, unpaged.

118 RESTANY, 1990, p. 56: "la marque du corps du judoka tombant sur le tatami".

According to Arman, Klein had already had the idea during their Judo lessons in Nice to spread blue paint on Judoists in order to retain a clear imprint on the Judo mat. Arman in his essay 'L'esprit de la couleur' in the catalogue *Yves Klein*, PARIS 1983, p.260.

119 Klein quoted in English in the catalogue *Yves Klein*, LONDON 1974, p. 57.

According to Klein the origin of the 'Antropométries' can be found in his childhood, when he began making imprints of hands and feet on clothing. This is a very human activity, something many children do. Imprints of hands are also found on old Japanese scroll paintings. However, MILLET, 1983, p. 59, wonders if Klein, as an Orientalist, was familiar with the tradition of Japanese actors, who make imprints of their faces in order to repeat their stage make-up exactly. In both Klein's and Millet's quoted examples, the imprint in question is of the person's own body. Yet in an interview by Jean-Yves Mock with Shinichi Segi the latter says that he recalls a discussion with Klein in Tokyo in 1953, when they talked of the traditional Japanese technique of applying ink to a fish and then making an imprint of it on a piece of paper in order to get an impression of the arrangement of its scales. Klein, with his French accent, pronounced the name of the procedure, 'Gyotaku', as 'Jyotaku'. Segi pointed out that with this incorrect pronunciation he was in fact saying 'imprint of a woman'. Segi in the catalogue *Yves Klein*, PARIS 1983, p. 84.

120 FOCILLON, 1914, p. 77 (See Appendix 1, 'Action Painting'/'Living Art'), GONCOURT, de, 1916 (1896), p. 110.

121 STICH, 1994, p. 141. She is comparing Klein's positive view of 'nothing' with some Existentialists' negative view of it.

122 Kultermann in the catalogue *Monochrome Malerei*, LEVERKUSEN 1960, Preface.

123 Catalogue *Yves Klein, 1928-1962*, PARIS 1969, p. 31.

124 Remo Guidieri in the catalogue *Yves Klein*, PARIS 1983, p. 73. He adds that Klein always stressed that the Far East was his source. Guidieri goes on to discuss the Japanese word 'konon', meaning both emptiness, an open sky and transcendental. He quotes a Japanese who expresses surprise that emptiness is nihilism for Europeans (...) because for the Japanese it is a noble name for 'being'. Ibid., p. 74.

125 RAGON, 1958, p. 41, with respect to the connection between the Zen garden and 'Le Vide' remarked that the Japanese way of looking at emptiness is strange for the French: "Il est bien évident que si le Ryoanji était reconstitué à Paris, tout le monde ou presque prendrait ce jardin japonais pour une plaisanterie". This opinion is confirmed if one visits the Japanese garden at 'Le jardin d'Albert Kahn' in Paris (made in 1898-1915): a kind of small amusement park made up of different bits of Japanese gardens which Kahn had seen during his trip to Japan.

126 STICH, 1994, p 138.

127 McEvilley, catalogue *Yves Klein*, PARIS 1983, p. 242. This project, in which Klein used his own body as a vehicle of expression, brings to mind Suzuki's words – that Zen has no need of external things, but only the body in which it is incorporated. SUZUKI, 1959 (1938/1927), p.19.

128 See the chapter 'The unity between West and East. American artists and Zen'. Klein described various ideas for projects in a newspaper with the name *Dimanche*, which he published on 27 November 1960.

129 Bodhidharma, the founder of Zen, once said, for instance, regarding true knowledge that its essence is emptiness and tranquillity. Rolf Wedewer quotes Bodhidharma's words in the catalogue *Degottex. Gemälde*, COLOGNE 1965, unpaged. See the section 'Jean Degottex' regarding the title 'Emptiness'.

130 ROWELL, 1972, p. 99.

131 SARTRE, 1976 (1943), 'Conclusion'.

132 SUGAI in an interview in Paris on 16 June 1993. In 1958 Pierre Restany believed that he detected influence of the presence of Japanese artists on the Parisian art scene, and that they played an active part in it: many work in an exotic style 'à la sauce parisienne', speculating in this way on the strong Japanese myth of the times, a curiosity for intellectuals in Montparnasse, consisting of Judo, calligraphy and Zen Buddhism. RESTANY, 1960, p. 92. Unfortunately the scope of the present

research is so extended that there has been no opportunity to examine the work of those artists. However, the influence of the Japanese artists working in Paris on their French colleagues proves to have been minimal. Only Toshimitsu Imai, who had a lot to do with Michel Tapié, played an important role in stimulating, organizing and supervising the visits of both Tapié and Mathieu to Japan in 1957.

133 See the chapter 'Zen and the Zen arts'.

134 Examples are the paintings by Caravaggio and Velasquez, as well as paintings such as 'The death of Marat' by David and Manet's 'The flute player'.

135 STOKVIS, 1973, p. 4.

136 ROWELL, 1972, pp. 84, 117 and 132 describes Alechinsky's compositions as a sequence of depictions of simultaneous experiences appearing to a person during his life, in other words, the portrayal of 'the sequence of being'.

137 Jean-Yves Mock refers in the catalogue Yves Klein, PARIS 1983. p. 12, to the dynamic aura of Klein's Monochromes, suggesting that the blue monochromes contain "le plein visible d'un vide, énergie qui emplit l'espace". Klein himself regularly alluded to the spiritual element, as he also did to the aspect of 'space', as we shall see later.

138 Beslon, in the catalogue Degottex. Signes et Métasignes, NÎMES 1992, p. 7.

139 This conclusion was reached after analysis of Degottex's paintings in the archives of the Musée National d'Art Moderne in Paris and in the artist's collection.

140 Catalogue Degottex . Signes et Métasignes, NÎMES 1992, p. 5.

141 ROWELL, 1972, p. 123. The 'ontological' element in the work of both painters will be dealt with later in this book.

142 The relationship between space and time is clearest in Alechinsky's works with the borders which he began to make in 1965.

143 Rolf Wedewer quotes in the catalogue Degottex. Gemälde, COLOGNE 1965, unpaged, Degottex's observation in German: "Versuche, die ontologischen Erfahrungen des reinen Handelns im malerischen und 'gestischen' Ausdruck zu vertiefen".

144 "Le geste est un besoin fondamental de la vie". ROWELL, 1972, p. 7.

145 ROWELL, 1972, p. 10.

146 ROWELL, 1972, p. 127

147 "Dans la peinture Sumi, le moindre coup de pinceau sur lequel on repasse une seconde fois devient une tache, la vie l'a quittée". RESTANY, 1958, p. 33. In the catalogue Degottex, PARIS 1958, unpaged, Renée Beslon provides a comparable quotation from the French translation of Suzuki's Essais: "...Le trait tracé par l'artiste Sumiye est définitif, rien ne peut être mis par-dessus, rien ne peut le redresser, il est inévitable comme l'éclair; ... de là la beauté de ce trait...".

148 RESTANY, 1982, p. 70. Klein also used the calligraphy technique to make various works, including a portrait made in 1960, which can be found in the archives of the Musée National d'Art Moderne in Paris, which was, however, first sketched in pencil.

149 Extracts from this lecture were found in various sources.

150 RESTANY, 1979, p. 93, quoting Klein. Restany adds that Klein's art can be described as the identification of art with ontology.

151 HIROSHI, 1977, p. 55. This quotation would also seem to apply to Klein's work, although his mysticism mainly stemmed from his interest in the ideas of the Rosicrucians. However, there is a distinct difference in emphasis on the esoteric between Zen and the Rosicrucians. Hiroshi wrote in his comments accompanying this essay that Suzuki is speaking in terms of 'experience and life' and is far removed from 'mystification': unlike the interpretations in the West which link 'mysticism' with 'secrecy' and 'esotericism'. According to Hiroshi that is the reason why Suzuki claims in later works that Zen has nothing to do with mysticism. Ibid., p. 56.
For the Rosicrucians the esoteric and secretive side is very important.

152 See the chapter 'The inherent Zen in Japan'.

153 RAGON, 1956, 1, p. 29, gives an example of the reciprocity , in his observation that Kumi Sugai, the Japanese artist who lived in Paris, had been influenced by Klee, but that it might be pure coincidence, since Klee himself refers to Asiatic art.

154 KEPES, 1955/6, p. 14. Kepes gives an example of how Western Man might view Nature in future: not by analysing, but by observing its character. He illustrates this with the anecdote of the Zen Master Rykku, who had asked his son to prepare the garden for guests. The son cleared up, but Rykku corrected him, shaking a tree, and the leaves fell to the ground chaotically.

155 From that perspective, it is interesting to note that in 1958 Malraux became minister of culture. And that was the moment, according to the artist John-F. KOENIG in an interview on 17 June 1993, when the 'second Japonisme' made a real break-through.

I am of the opinion that the part Malraux played in French art from 1958 onwards, as minister of culture, is worth further research.

156 Renée BESLON in an interview in Paris on 6 July 1993.

157 "Artistes européens, calligraphes japonais, notre point de rencontre ne se situe pas aux sources formelles mais dans d'identiques tentatives de descente et de remontée, plongée émouvante vers une perle lumineuse et commune". ALECHINSKY, 1955, p.30

158 Beslon in the catalogue *Degottex. Signes et Métasignes*, NÎMES 1992, p. 7. He was interested in Pollock's and Mathieu's dynamism and energy, as well as in Newman's and Rothko's contemplative works. His own works could, therefore, be termed a synthesis of these styles. BESLON in an interview in Paris on 6 July 1993.

Moreover, nondualism can also be detected in Degottex, in that he strives to achieve equality of the different elements in his work, of figure and ground, or something and nothing, for instance. Rolf Wederer compares in the catalogue *Degottex. Gemälde*, COLOGNE 1965, unpaged, the 'equality of components' in the thinking of the Far East (unlike the hierarchical approach of the Western world) with the way in which Degottex arranges the various elements on his canvasses: "Das ist der Zustand geistiger Freiheit, von dem Degottex spricht, und worin hinreichend Raum ist für Widerspruch und zugleich die Einheit der Gegensätze". Yet I do not believe he has succeeded in integrating brush-stroke and ground in a manner which is comparable to that in *Sumi-e* and *Shō*. In those works the ink is 'sucked' into the paper or silk, unlike in Degottex's paintings, in which the painted background usually continues to run behind the brush-strokes. That difference could be interpreted as negative criticism. It is, to my mind, evidence of the 'Western side' of the work: the Western way of thinking in 'layers' and 'contrasts'. That very combination of the artist's own culture and the 'Japanese impulse' characterizes the works I have studied from the nineteen-fifties, and elevates them above 'playing at Zen monks'.

159 A phone call with Willemijn Stokvis on 24 September 1995 made this difference even clearer for me.

71. Hermann Obrist, 'Peitschenhieb' (Whiplash curve), circa 1893, silk on wool, 119 x 183,5 cm.
Collection Modemuseum im Münchner Stadtmuseum, Munich

72. Julius Bissier, 'Nest im Dornbosch' (Nest
in thorn-bush), 1938, ink on grey Ingrespaper,
63 x 47 cm.
Kunstsammlung Nordrhein-Westfalen, Düsseldorf

Release through Zen
and German art

Abstract painting with an expressive character was not only to be found in the fifties in America and France, but in Germany too. In 1952 the 'Neu-expressionisten' exhibition was held in Frankfurt. It can be seen as the start of the new way of painting, and it led to the founding of the Quadriga group. The artists of that group were the earliest representatives of the German *Informel*. Karl Otto Götz, a member of this group, was one of the first German artists to be in touch with the French avant-garde after the Second World War.[1] My decision to take him as one of the protagonists in this chapter was mainly motivated by the fact that he, like Pierre Alechinsky, had been corresponding with the Japanese *Shō* artist Shiryu Morita since 1952. His works can be classified in the category 'art of the calligraphic gesture'.

Before Götz is discussed, the spotlight will be directed on the artist Rupprecht Geiger. He had an affinity with Zen even before 1950. The artists' group Zen 49, of which he was a co-founder, is almost entirely unrelated to the German *Informel*, although their common sources and the comparable artistic climate do mean that parallels can be found between the works of the artists in these two groups. Geiger's view of art and his paintings, which belong to the 'art of the empty field', have certain resemblances with Zen.

So far no other German artists in the fifties, apart from Götz and the members of Zen 49, have been found who expressed an interest with Zen. Further study may come up with a few more names, since interest in Zen did increase considerably in the course of the fifties in Germany, as we shall see. However, in this chapter the Zero-artist Günther Uecker is mentioned. After all, he gradually discovered an empathy with Zen at the end of the fifties. For comparison with a number of artists from the other case studies, it is worth noting that some of Uecker's work can be classified as 'living art'.

As we have seen in relation to American and French art in the fifties, there was a link between Japonisme at the end of the nineteenth century and the renewed interest in Japan in the fifties. And that was the case in Germany as well.

The interest in Japanese art at the end of the nineteenth century is especially apparent in the style of Jugendstil, which was characterized by an emphasis on the plane and the line. Japanese woodcuts and applied arts were an important source of inspiration for formal aspects. The idea of Henry van de Velde, who exerted considerable influence on the German Jugendstil, that 'the strength of the line derives its energy from the one who has drawn it', has already been mentioned.[2] The architect and designer Hermann Obrist believed that 'the structures of drawn lines should interact on the human psyche' (ill. 71).[3]

Wassily Kandinsky's works from the first half of the nineteen-tens constitute a crucial transition towards a new interpretation of East Asian culture.[4] They have a kinship with the spirituality of the Far East and some formal features of *Sumi-e*.

In the twenties, various teachers at the Bauhaus developed an interest in the Far East. Oskar Schlemmer (1888-1943) and Johannes Itten (1888-1967) were inclined, prompted by that interest, to stress the unity of body and mind, with East Asian spirituality as the focal point, or at least, their personal inter-pretation of it.[5] Schlemmer said, concerning the interest in non-Western writ-ing, that a specifically European script should be sought, based on Oriental examples. He suggested that it would not be an easy matter:

> "We are all Europeans together, we may be able to assimilate what is Asian, but do have to find the forms which are legible for Europeans and at least contain the seed to grow into something universal. But what abysses sepa-rate us from such universality for the moment!".[6]

At the start of the thirties, Julius Bissier (1893-1963) began to concentrate on *Sumi-e* (ill. 72). He had been introduced to the technique by the Sinologist Ernst Grosse, whom he met in 1919. Grosse's book on *Sumi-e* was published in 1922, with the title *Die ostasiatische Tuschmalerei*.[7] Grosse described Zen pain-ting as an artistic expression of Oriental mysticism, with handwriting forming the portrait of the mind.[8] Bissier chiefly looked for common roots in the artist's creative process, and of processes which occur in Nature. For him, contempla-tive painting was a holy ritual, and consequently art, for him, had a spiritual function.[9] The 'esoteric' element was less important with Bissier than with Schlemmer and Itten.

In the second half of the nineteen-thirties Willi Baumeister (1889-1955), a veter-an of German abstract art, developed an interest in Asian cultures, including that of Japan. The titles of some of his works make reference to that (ills. 73 and 74). For example, the 'Torī' series alludes to the ceremonial Japanese wooden gateways.[10] On 2 November 1939 Baumeister wrote in his diary that he had embarked on Zen.[11] During the war, he wrote the book *Das Unbekannte in der Kunst*, which was published in 1947. His book reflects the Oriental influence on his ideas. For instance, he wrote about the '*hohen Zustand*' (exalted state) of the artist, meaning the state in which conscious will was suspended during paint-ing. This resembles the pursuit of *Satori* in Zen. Since Baumeister had become the symbol of German abstract art for many artists in the post-war years, and as a result exerted considerable influence on post-war German art [12], it is worth mentioning some of his theories.

Baumeister was of the opinion that object and subject were one. He believed that this unity was omnipresent, and would put an end to the 'Renaissancistic' idea that Man was the focal point of all things. It was his view that, for the artist, the sensory and the spiritual, idea and material, were inseparable, in the same way as, in modern physics, matter and energy were equal. Moreover, the phy-sicist had begun to see the world as a process of change, consisting of energy and rhythms.[13]

73. Willi Baumeister, 'Torī mit blauem Punkt' (Torī with blue point), 1937, oil on canvas, 99.5 x 65 cm. Baumeister Archiv, Stuttgart

74. Willi Baumeister, 'Ideogramm', 1938, 65 x 45 cm. Baumeister Archiv, Stuttgart

Baumeister believed that the artist based his ideas on similar theories to those in physics, transposing external forms into an internal motion. In addition, he linked unity and motion to 'the invisible presence of a spiritual other world'. In his opinion, it was only possible to experience 'being' by transcending the ego – something which he compared with what is sometimes called 'Worldly Spirit', 'Unconscious', what the Buddhists call 'Not-something' and Christians 'God'. Only the path of personal internalization can lead there.[14] Freedom is merely a matter of acting according to one's own inner laws, and can be termed *'Ausdrucksbewegung'* (expressive movement).[15] The artist's material should be his everyday surroundings, however impoverished, because that is where the model and the likeness of the eternal secret lies. If we continue in Baumeister's vein, abstract painting should emanate acceptance of life, in other words optimism, as does the philosophy of the mystics and the Buddhists.[16] The mentioned views of Baumeister's contain elements which are related to Zen. Since Baumeister was a good friend of Bissier's, some of his information must have come from or via that artist. In addition, since the publication of Grosse's book on Zen painting in 1922, other books on Zen had appeared on the German market.

Two years after Grosse's *Die ostasiatische Tuschmalerei* was published, the first book in German on the 'religion' of Zen Buddhism was brought out, its title *Zen: der lebendige Buddhismus in Japan*. It was a selection of texts from Zen literature, primarily *Koans*.[17] Rudolf Otto, a student in theological history, had written the preface. Otto had read several of Daisetz T. Suzuki's essays, published in the periodical *The Eastern Buddhist*, and they had made a great impact on him. In 1931 Otto published his book *Das Gefühl des Überweltlichen: Sensus Numinis*, in which he refers to pronouncements by Suzuki. Otto emphasizes in his book that it is not easy for the rational Westerner to grasp the fact that Zen, in which the irrational plays a big part, is a religion. He describes the ultimate truth in Zen as the inexpressible 'holy other'.[18]

A remarkable amount of information on Japanese culture was available in Germany in the nineteen-thirties. It was 'political propaganda in disguise'. The political alliance between Germany and Japan was underlined by studies on the parallels between the two cultures. Historic epics served to emphasize the 'comparable heroic character'. These thrilling epics were avidly read by the German population. There was also a magazine on Japanese culture, entitled *Nippon*, in which in 1935 a translated extract from Suzuki's *Essays* was published, under the heading 'Japanische Kultur und Zen'. The selected extracts dealt with the technique of *Sumi-e* [19] and the tea ceremony. The following year, that magazine contained an essay by Eugen Herrigel on the Zen art of archery, with the title 'Die ritterliche Kunst des Bogenschießens'. It was the text of a lecture which Herrigel had given in Berlin.[20]

The publisher Curt Weller produced Daisetz T. Suzuki's book *An Introduction to Zen Buddhism* in a German translation in 1939. Its German title was *Die große Befreiung. Einführung in den Zen-Buddhismus*. And in that same year Baumeister recorded that he had become interested in Zen. He was undoubtedly familiar with Suzuki's book.[21]

In 1947 *Die große Befreiung* (The Great Release) was reissued, and a year later an adaptation of Herrigel's text was published with the title *Zen in der Kunst des Bogenschießens* (Zen in the Art of Archery). It is remarkable that these 'post-war' books became very popular as symbols of a new era. The title of Suzuki's book even became a symbol of freedom. Within a couple of years three editions had appeared on the German market. The German Japanologist, Johannes Laube, explained that in the fifties 'post-war Zen' was not associated with 'the Zen of the Third Reich'. It was not felt to bear any guilt, but rather to have been 'abused in those days'.[22]

We can conclude from the popularity of books on Zen some fifteen years after the Second World War that interest in the Far Eastern view of life was no longer limited to a small group. Ernst Benz wrote in 1961 that "You can hardly find a station bookstall without a cheap paperback on Zen with an expert introduction" and in the big bookshops, especially in university towns, one could even find a comprehensive selection of works, in German, English and French.[23]

75. Rupprecht Geiger, '114 E', 1950, tempera on canvas, 46 x 44 cm.
Collection artist

Rupprecht Geiger (b. 1908) and Zen 49

The most literal projection of the interest in Zen can be found in the name of an artists' group in Munich: Zen 49. It was thought up by the artist Rupprecht Geiger (ills. 75, 76 and 77). He had heard of Japanese culture as a child. His father, the painter and graphic designer Willi Geiger, was a friend of the philosopher Karlfried Graf von Dürckheim-Montmartin. In the thirties Dürckheim had been in Japan studying Zen Buddhism.[24] After his return, he lectured at the Institut für Psychotherapie und Psychologische Forschung in Munich, and in 1949 his book *Japan und die Kultur der Stille* was published.

Although Rupprecht Geiger had heard stories about Japan from Dürckheim, he only began studying Zen after he had met a certain Carl Hasse. They actually met in August 1949, and Hasse recommended that he read Suzuki's *Die große Befreiung*. In a letter dated 2 October 1949 Hasse refers to the connection between Zen and abstract painting:

"The newly creative aspiration of Nonrepresentative painting has a parallel in the idea of Zen, *die große Befreiung* (the great release). It is devoid of everything that is representational, exhaling at the edge of consciousness to an overrational visual range of all material being. It opens itself up deep and wide to what is true, good and beautiful in life, whilst overcoming present-day, established existence which is deeply rooted in what is meaningless and inconsistent. It seeks, with receptive buoyancy, the inhalation of the exhalation directed towards it, from the field of nothing and non-truth, in which the resisting polarity of mind and matter has found harmony in abstract emptiness, yet so animated dimension".[25]

The same week that Geiger received the letter containing this passage, he appears to have proposed the name Zen 49 for the group of artists who were producing abstract work.[26]

After the exhibition 'Extreme Malerei', which had been held in Augsburg in 1947, showing what had previously been termed *Entartete* (degenerate) art, Geiger regularly discussed the future of German culture with his fellow-artist Gerhard Fietz (b. 1910). In their opinion abstract art was the best means of rebuilding their culture.[27] On 19 July 1949, during the opening of an exhibition of abstract paintings by Rolf Cavael (1898-1979) in the Otto Stangl Gallery in Munich, the British consul John Anthony Thwaites (b. 1909), a great admirer of abstract art, suggested to a few artists that they set up a group of artists making abstract work. A group was founded that very afternoon, by Cavael, Geiger and Fietz, plus Fritz Winter (1905-1976) and Willy Hempel (b. 1905). The name 'Freunde der Galerie Stangl' was proposed as its name, and rejected. For lack of anything better, they decided on the name 'Gruppe der Gegenstandslosen' (the Nonrepresentational Group) [28], on account of their aversion to the copying of Nature in painting.[29] Thwaites also joined the group, as a supporter. His example was followed by the art historians Franz Roh (1890-1965) and Ludwig Grote (1893-1974), and Hilla von Rebay (1890-1967), who was the director of the Museum of Non-Objective Art (now the Solomon R. Guggenheim Museum) in New York.[30] Immediately after it was founded, the members began an active

76. Rupprecht Geiger, '196 E', 1953, tempera on canvas, 70.7 x 54.4 cm.
Collection artist

77. Rupprecht Geiger, '429/65', 1965,
oil on canvas, 220 x 176 cm.
Deutsche Bank, Frankfurt am Main

policy to recruit new participants. Soon Willi Baumeister was asked to join, in order, as Gerhard Fietz put it, to add to the group's prestige and recognition.

The members did not publish any kind of manifesto. Only a few proposals had been noted and they set themselves the objective "to spread abstract painting by means of words and images, making it the specific form of expression of our time".[31] The Zen 49 artists had a close bond with Wassily Kandinsky's theories and works of the nineteen-tens, the period in which he was living in Munich. So on the day on which the 'Gruppe der Gegenstandslosen' was founded, the members vowed to carry on Kandinsky's abstract art.[32] Kandinsky's book *Über das Geistige in der Kunst* was very popular among German artists of the day. His theories could be considered as a means of achieving self-awareness in a free world.[33] As has already been observed, the ideas Kandinsky expressed in that book had some remarkable similarities with views from the Far East, such as Zen.[34]

The catalogue of the series of Zen 49's group exhibitions in America in 1956 and 1957 explained that the name was a reference to the similarities between the members' goals. They were against figurative art and against geometrical abstraction, and sought a more spontaneous, inner contemplative and cosmic expression, in short the aims of Zen Buddhism.[35]

When Geiger proposed Zen 49 as the new name for the group, not all members had the same reasons for concurring. At the end of 1949 Gerhard

Fietz wrote Geiger a letter reacting to the latter's suggestion. Fietz wrote that the idea of emptiness and nothingness appealed to him, because every artist starts time and again with an empty canvas, containing dormant and undiscovered possibilities, being at the same time nothing, infinite, surface and space. The symbolical also appealed to him, the idea of the *'Stunde Null'* (Zero Hour) and the *'Aufstieg aus dem Nichts'* (Arising from Nothingness).[36] Moreover, Fietz saw a parallel with the 'spiritual moment' in art: "Our painting should be a way, but not an aesthetic pleasure. So the name Zen 49 demonstrated the spiritual unity".[37] This remark recalls Baumeister's words, in which he describes artworks not as the end, but the means, comparable with the means in scientific

ZEN 49 ausstellung

4. APRIL bis 28. APRIL

in der galerie
des central collecting point
am königsplatz

EINTRITT FREI

experiments.[38] To start with, Fietz's work was clearly influenced by Baumeister, but later his inspiration came from *Sumi-e* and *Shō*. In one of his works a distinct similarity can be observed with the *Enso* (cf. ills. 78 and 7).

Rolf Cavael was also in favour of the name Geiger proposed (ill. 79). He recognized parallels between Zen's liberating effect for the individual and abstract art. Moreover, according to Cavael, the techniques of meditation gave access to the unconscious, in which the source of the form of abstract art was located.[39] This remark ties in with Baumeister's book on the one hand, and with the 'meditative' artists of the twenties and thirties on the other. In 1950 he was to add: "If the Zen artists unite, they do so under the condition that they will only adhere to what corresponds with consequence of an inner discovery".[40] In his artistic work there is clear evidence of Baumeister's and Kandinsky's influence.

Fritz Winter's (ill. 80) remark: "I am bound to Nature, though not to its formal expression, but to my own", ties in with the Zen view that the development of the inner life and the relationship with one's own true nature should be central.[41] A number of Winter's works, particularly a series of silk-screen prints dating from 1950 (ill. 81), contain characteristics of *Sumi-e* and *Shō* – for example the great attention to emptiness and to the relationship between form and residual form, the dynamic use of line and an indefinable or infinite space. However, such similarities are not proof of a direct influence of *Sumi-e* and *Shō*. Since Winter was mainly inspired by Kandinsky's work (cf. ills. 81 and 19), I am

78. Gerhard Fietz, Untitled, 1955/53, watercolour, ink, grease pencil on paper, 31.8 x 42.3 cm.
Stangl-Sammlung, Munich

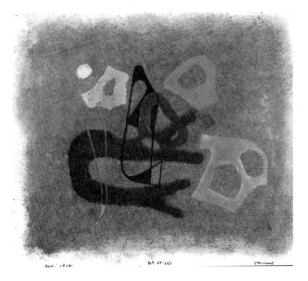

79. Rolf Cavael, 'Juni 1950, no.50/151' (June 1950), 1950, oil on cardboard, 24.5 x 27.9 cm.
Stangl-Sammlung, Munich

80. Fritz Winter, Untitled, 1960, mixed media on paper, 17.4 x 23.9 cm.
Stangl-Sammlung, Munich

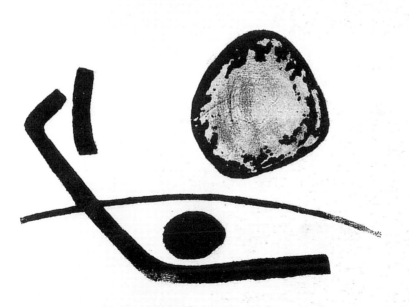

81. Fritz Winter, Untitled, 1950, screen print, 50 x 65 cm.

82. Theodor Werner, Untitled, 1955, gouache, 47.5 x 66.4 cm.
Stangl-Sammlung, Munich

of the opinion that it is more appropriate to describe these 1950 pieces as a combination of Kandinsky's Japanese-art-related works and the interpretation of Zen by the founders of Zen 49. This interpretation of Zen was formulated in 1955 by Franz Roh, one of the leading supporters of abstract art in Germany. He explained that some members had insisted on this name because they believed that in Zen Buddhism the contemplation and profundity could be found which enabled one to penetrate to the other side of the things in this world.[42] This view would seem to have been supported in particular by Rolf Cavael, Rupprecht Geiger, Fritz Winter and Theodor Werner (1886-1969). The latter artist, like Baumeister and Winter, was a veteran of German abstract art. Circumstances were such that he was only able to participate in the group a year after it had been founded. Werner was interested in both the formal characteristics of Far Eastern calligraphy and in the meditative ink painting of Zen (ill. 82). His reflection on the content of 'calligraphic painting' led him to join Zen 49.[43]

Baumeister upbraided the proponents of that name for the group for having overreached themselves, as the true nature of Zen was not easy to understand.[44] A few other members also had problems with the name. Brigitte Meier-Denninghoff (b. 1923), who had been a member of Zen 49 from the start, felt the name was too highly charged.[45] Hann Trier (b. 1915), who had been

154

a member since 1951, had read Ernst Herrigel's *Zen in der Kunst des Bogen-schießens*, and wondered whether it was sufficient to read about Zen in order to understand it.[46] Julius Bissier, who joined the group as a guest exhibitor in 1953, had also been irritated by its 'pretentious' name.[47]

Werner Haftmann, who, as an art historian, was already extremely interested in abstract art in the fifties, believes that the name Zen 49 was primarily 'fashionable'. In those days you made a good impression with such a name.[48] Recent research has suggested that the interest in Zen could be explained by the fact that after the war people were seeking the great harmony between their own existence and the cosmos, in the hope of finding a common foundation. And they tried to find that foundation by means of a kind of meditative concentration, akin to the practices of the Far East.[49] Artists also knew of this quest from *Das Unbekannte in der Kunst*. Consequently, it is difficult to determine whether it was Baumeister's book or the philosophy of Zen that most influenced the artists of Zen 49. Many artists were certainly acquainted with literature that had been published on Zen. It was clear from comments by various artists (including Rupprecht Geiger, Karl Otto Götz and Günther Uecker) that they had read either Suzuki's *Die große Befreiung* or Herrigel's book, or both.[50]

Zen 49's first exhibition was in April 1950 in the Central Art Collecting Point, an American cultural centre in Munich. It could be seen in seven different towns in Germany between May and December 1950.[51] At the second exhibition, held at the same venue in 1951, the ranks were swelled by a number of German sculptors and the painters Hans Hartung and Pierre Soulages from Paris. The members of Zen 49 hoped that the presence of artists from abroad would give the group an international character.[52] In 1953 K.R.H. Sonderborg, the pseudonym used by Kurt Hoffmann (b. 1923), joined the group. In his quest for new spirituality, he had already read Suzuki's *Die große Befreiung*, before coming in contact with the Zen 49 artists.[53] That year Julius Bissier, as well as the painters Gérard Schneider and Hann Trier, swelled Zen 49's ranks as guest exhibitors. Two years later. Karl Otto Götz and Bernard Schulze of the Quadriga group, took part in an exhibition with almost all the foregoing members of Zen 49.

The exhibition tour of the United States in 1956 and 1957 was a climax for Zen 49. But the end of the group was in sight.[54] After the American tour the group of artists forming Zen 49, if they had ever been a group, broke up, after having held exhibitions almost every year for eight years.

After this overview of the history and objectives of Zen 49, Rupprecht Geiger's work will now be examined in more detail. It is striking that all the Zen 49 members worked in the same style, with Geiger forming the only exception (although several of his works (ill. 75) do bear similarities to the style of other group members). This 'non-figurative' and 'expressionist' style, in which line and colour function independently and which have a rhythmic expression, is reminiscent of the 'Improvisationen' of Kandinsky. As observed,

Baumeister was also an important source of inspiration for most of the artists, including Geiger.

At the beginning of his career as a painter, Geiger was mainly involved in making renderings of landscapes. In about 1949 he started to experiment with abstract forms in his paintings, and gradually began to concentrate on colour (cf. ills. 75, 76, and 77. These clearly demonstrate the development in his work from landscape-like abstract paintings to colour-field paintings). He studied the muted transitions of colour (in ill. 75 and 76 from yellowisch brown to reddish brown), confrontations of colour (in ill. 76 brown with pink) and the effect of pure colour fields (in ill. 77 orange and red), which he called 'Farbform' (colour form) and 'Farbraum' (colour space). Simplicity became one of the main features of his paintings. That feature applies to the ideas on which the works were based as well as to their composition.[55] Suzuki says: "the truth and strength of Zen lie in its great simplicity" and "straightforward simplicity is the soul of Zen".[56]

One of Geiger's conclusions regarding colour was that it has a stimulating effect on people.[57] That coincides with Kandinsky's conviction that colour produces a vibration in the soul.[58] In a way Geiger's view is also related to Zen; he saw the experience of colour as a way of changing Man's awareness.[59] The experience a spectator undergoes when looking at the contrasting planes of colour can be seen as a process of 'relaxing' and 'tightening' the attention, a kind of breathing in and breathing out, in which there is an affinity with the importance of the rhythm of breathing in Zen.[60] Herrigel, for instance, had written that he did not perceive Zen in the technique of archery, but in breathing in and out.[61]

Geiger stresses the unity between the effects of colour on the 'mind' and the 'body' (the 'sensory').[62] In Zen too the unity of the effect of mind and body is emphasized, for example in meditation. That does not mean that Geiger felt his paintings should emanate tranquillity. In his book *Farbe ist Element*, he compares the confrontation with colour with the force of the beat of a kettledrum.[63] This idea, in turn, is comparable with Kandinsky's 'Innere Klang', and with Daisetz Suzuki's remark that *Satori*, the goal of Zen, is a sudden flash in the awareness, of a new, undreamed-of reality.[64] A connection between the 'drum beat' and the 'sudden flash' would seem to confirm the link between the effect of Geiger's colour fields and Zen. *Satori* also means liberation or release, and Geiger used the idea of release – one which proved to be important for all the members of Zen 49 – in the form of the releasing of colour from its traditional function in art. He wanted to liberate colour from its dependence on form.[65]

By appealing to the senses, paintings can only be understood instinctively, according to Geiger.[66] Here again we find a connection with Zen paintings, which are also intended to be experienced directly and intuitively.[67] The emphasis on the 'personal and inner spiritual experience' is, in Suzuki's reasoning, what makes Zen unique.[68] Thwaites wrote in the first catalogue of 1950 concerning Geiger's work: "Art is Man's experience of the surroundings and of his own inner spiritual world".[69] The contemplative element in Geiger's painting can, to my mind, be seen as a sequel to the 'meditative' works

of Kandinsky, Bissier and Baumeister. Geiger's works, as the 'next step', concentrate more closely on independent colour. Ultimately, his paintings consist merely of a few abstract monochrome zones of colour (ill. 77) He opted for that, because it was the only way to understand the fundamental characteristics of colour and reproduce in an abstract way the essence of perception in itself.[70]

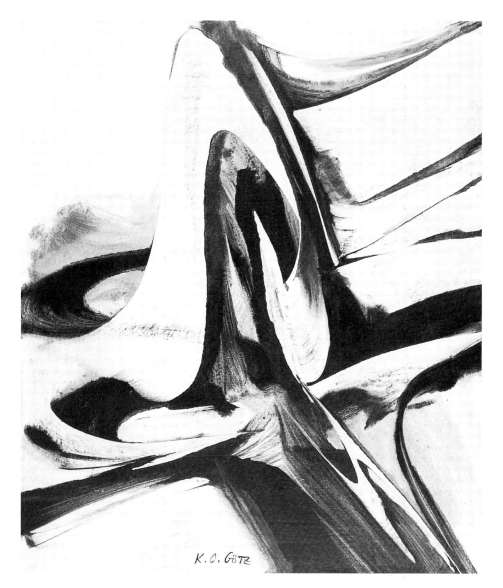

83. Karl Otto Götz, Untitled, 28.5.1954, mixed media on canvas, 70 x 60 cm.
Collection artist

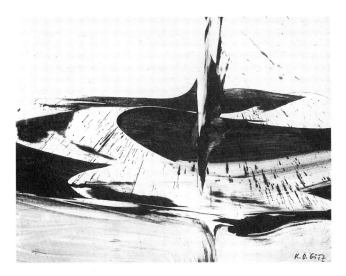

84. Karl Otto Götz, 'Hval', 1957, gouache on paper, 50 x 65 cm.
Collection artist

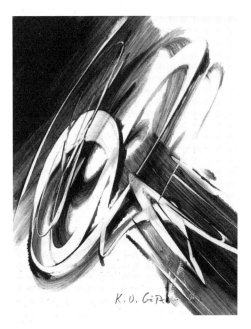

85. Karl Otto Götz, Untitled, gouache, 32 x 25 cm.
Collection artist

86. Karl Otto Götz, From: '24 Variationen mit einer Faktur' (24 Variations with a
structure), 1949, oil on hard-board, 92 x 18 cm.
Collection Wolfgang Mergelsberg, Düsseldorf

Karl Otto Götz (b. 1914)

Unlike Rupprecht Geiger, with his 'art of the empty field', Karl Otto Götz is an artist of the 'calligraphic gesture' category (ills. 83, 84, and 85). Earlier in this chapter the progression of the line was followed towards independence, beginning with the functional/symbolistic line of the Jugendstil to the spirituality of Kandinsky and the contemplative lines of Bissier. The lines in Götz's work are pure dynamism, in my view, and can be described as a projection of an intense experience of an action.[71]

Götz was already experimenting with 'movement' at the beginning of his artistic career, in the thirties. This led to experiments with films. In the war he worked as a radio operator, and was interested in the technology of radio frequencies. In that period he was using electronics in his attempt to set forms in motion and to distort them.[72] Movement continued to be one of the most important elements in his work. The 'kinetic' aspect of his films became 'dynamism' in his monotypes, and after 1953 dynamism was transformed into a 'rhythmical' infinite movement.

From the early forties, the influence of Surrealism became apparent in Götz's work. They display an affinity with the dream world and *écriture automatique* of Max Ernst, Jean Arp and André Masson. But it was not only Surrealism that had a liberating effect. According to Götz, the act of 'throwing oneself on the canvas' stemmed from Existentialism, "for which there was great interest in Germany at that time".[73] Moreover, in the fifties Götz began to develop an affinity with the *Shō* artists.

In 1952 he started corresponding with Morita,[74] who had sought contact with Götz on account of his interest in the 'scriptorial' trend in modern Western painting. Morita believed he detected a resemblance to *Shō* in it.[75] Although the one's work was typically Japanese and the other's decidedly European, there are several parallels. Take, for instance, the relationship between 'the movement in the mind' and 'the movement in the hand'. Furthermore, the moving hand is part of the total movement of the body. And in fact, for Götz and for the *Shō* artist, the term 'handwriting' could be replaced by 'bodywriting'.[76]

Both Götz and the *Shō* artist precede their fast, spontaneous painting act with meditation. With Götz it is object-oriented, which is typically Western. He concentrates intently on a visual concept (the preliminary study preceding the actual painting). What happens next is an 'invention' of his own. In the first stage Götz applies the paint expressively, within a few seconds, then partly displaces it with a squeegee. In the third and final stage, he finishes the work off with a paintbrush and paint.[77] This 'phased' and 'layered' method of painting is typically Western. Unlike in *Shō*, in which the total brush gesture reproduces a deeper consciousness in the unrepeatable here and now, Götz's 'painting moment' is 'corrected' at a subsequent stage. However, Götz's approach concerning composition differs from the Western theory, in that his works have no 'centre', but an equivalence of parts, as in calligraphy. He also has in common with the *Shō* artist a preference for the contrast between black and white rather than between colours. Both believe that colour detracts from the dynamism of the gesture.[78] And the 'synthesis' which Götz sought between the process of

transformations and rapid handwriting[79], can be found in *Shō* as well. For Götz, however, it was based on a typically Western idea of experiment and innovation.

In addition, he shared the preference for speed with calligraphers. His remark that he made his works in three to four seconds, but that they had taken three to four years (the time required to develop such work), is very reminiscent of a well-known Oriental anecdote, telling of a client who had to wait a long time for something which was actually completed in a couple of seconds.

In 1960 Götz had the following to say about the way he applied his paint: "Occasionally the energy causes the liquid colour to spatter across its own actual boundary, bringing about effects which we know from Zen painters in Japan".[80] However, in his autobiography he wrote that his work had little to do with Zen or *Shō*, but the remark which followed that "everything is interconnected" in his works and that "the spaces between the form elements are just as important as the form elements themselves" suggests the very opposite.[81] His reaction when presented with the foregoing similarities was that Western art had indeed evolved in the fifties into a style containing several remarkable similarities with *Shō*.

In *Shō* the artist seeks to transcend, to 'release' the Self. Various authors suggest that Götz's 'handwriting' is the vehicle for his personal emotion and so opt for the term 'psychogram'.[82] Götz does not agree, claiming that he in fact wishes to transcend the subjective. He tries to do so by working at speed, which in his opinion increases anonymity. Moreover, he claims that the 'Self' is not his own personality, but something 'impersonal'. In that process, the artist acts as an instrument of the universe, rather than being consciously focused on his surroundings.[83] Like many of his colleagues Götz had read Herrigel's and Suzuki's books in the fifties. He recognized some of his own ideas in their writings. For example, he could identify with the striving to transcend subjectivity and the idea of 'Everything and Nothing in one'. This recognition was undoubtedly due to the fact that his ideas had been influenced by Baumeister. In *Cobra*, the magazine published by the art group of the same name with which Götz became associated in 1949, he quoted Baumeister: "The original artist abandons what is familiar and feasible. He pushes forward to the zero mark. That is where his exalted state begins".[84] Baumeister's influence was not limited to Götz's ideas, it is also evident in his post-war works (cf. ills. 86 and 73). Yet, with their composition, format and character-like representations, the series '24 Variationen mit einer Faktur' brings to mind the Japanese *kakemono* (scroll painting) as made by *Shō* artists.

Nevertheless, there are some significant differences between Götz's work and *Shō*. In *Shō*, form and content are both important. The formlessness of many of Götz's works which mainly comes about because at each stage he obliterates the forms of the previous stage, would be impossible in *Shō*. He is completely taken up with energy and speed, rather than form.[85] Meaning or content is also absent in his work.

87. Günther Uecker, 'Weißes Bild' (White image), 1959, nails on wood panel, 55.5 x 60 cm.
Kaiser Wilhelm Museum, Krefeld

Another important difference is that Götz strives and struggles to conquer unity, achieving it in a confrontation of opposites, whereas that stage in *Shō* belongs in the training period – you are only an artist when you have gone beyond that stage and are basing your work on that unity. So the works constitute an antithesis between a conscious existential struggle on the one hand, versus intuitive harmony on the other.[86]

Götz's works and technique are by no means identical to *Shō*, but compared with the work and method of many other Western artists there is certainly some similarity.

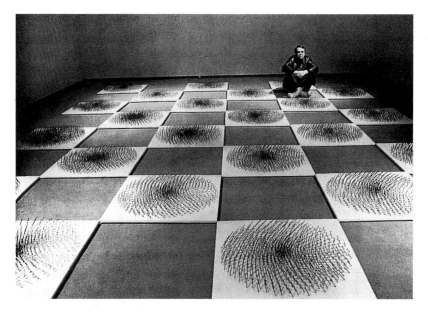

88. Günther Uecker, 'Zero-Garten' (Zero garden), 1966, New York

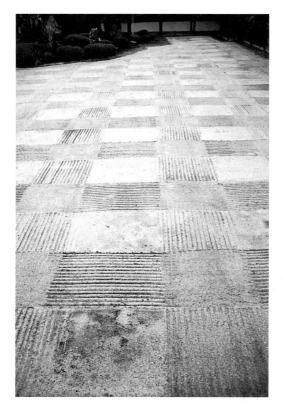

89. Zen garden in Tofuku temple, Kyoto

Günther Uecker (b. 1930)

Compared with Geiger and Götz, Günther Uecker's interest in Zen was late in developing. He himself explains the growing affinity with Zen in his work as the outcome of Zen's popularity among friends and critics, who brought it to his notice.[87]

At the start of the nineteen-fifties, when he was still living in the GDR, Uecker discovered not only the Bible and Anthroposophy in his search for different values, but Islam, Taoism and Buddhism as well. His fascination with the simplicity and repetition of 'purifying' rituals (like Gregorian chant) led to rituals of his own, such as the hammering of nails for hours on end. In 1957 he embarked on a series of 'nail reliefs' (ill. 87), since he considered the two-dimensional lines in drawings to be lifeless.[88] Nails gave him the opportunity to make three-dimensional lines. He went on to try making the 'lines' of the nails part of the actual space by shooting arrows on a canvas. The monotonous ritualistic repetition of hammering nails was a form of therapy for Uecker, of which the shooting of arrows was a part.[89]

Although Uecker believes he recalls having read the slim volumes by Herrigel and Suzuki, his friends and critics were the prime agents in acquainting him with the parallels between Zen (and the Zen arts) and his own outlook on life and work. And that recognition confirmed for Uecker that he had chosen the 'right way'.[90]

Some critics take the similarities with Zen as a substantiation that Zen was an important source of inspiration for Uecker. But in fact that only applies to the work he made in the sixties. Some of that clearly alludes to Zen gardens (cf. ills. 88 and 89). However, he himself believes that it is impossible for a Westerner to identify with Zen absolutely. In an interview in 1976 he said: "However you try, you are still an Occidental and continue in that tradition...".[91]

A meeting with John Cage when he was staying in Düsseldorf in 1959 made a great impression on Uecker. He was particularly taken with Cage's view that the artist only needs to set things in motion and reality will then complete the work. In addition, Cage propagated 'communication' between the many different types of art.[92] The presence of the 'physical element' implies that much of Uecker's work, like that of Cage, could be classified as living art. Uecker wrote:

> "...art itself has become a living act. The image is not as such of significance, but only a resolving factor in visualizing an idea, an impulse".[93]

In 1956 this *'lebendige'* (living) aspect was already present in his art, in the form of *'Fingermalerei'* (finger painting), about which has been written that the linking of the act to the person becomes clear. It is less a matter of experiencing a painterly than an existential effect.[94] It is interesting to note that the Japanese artist Kazuo Shiraga was painting with his hands two years before that.[95]

In the context of Cage's stay in Germany, a recollection of Karl Otto Götz is worth repeating: Cage apparently referred in his conversations with artists to Zen as something 'new', as he had in New York, to the amazement of the German artists, who had been familiar with it for many years.[96]

Emptiness and nothingness

The artists belonging to Zen 49 were primarily interested in the singular role played by emptiness and nothingness in Zen. For them it meant 'a zero base after the war' and 'a fresh start for art (following *Entartete* – degenerate – art)'. In that sense, emptiness is mainly related to the stage of *Satori* constituting a new perception (the empty frame in the 'cartoon' of the man with the ox). In Geiger's works the concept of 'emptiness' primarily emerged as an ever-increasing reduction of the compositions to a few expanses of colour. He started to see emptiness as a 'living dimension' in his work.[97] Werner once referred to Lao Tzu, who had stated that the essence of the barrel was not its sides, but the emptiness inside it.[98]

In the fifties, the empty areas in Götz's work were to become just as important to him as the painted parts.[99] Although his paintings do not make an 'empty' impression, but actually seem full and busy, the empty parts are indeed no longer part of the background.[100]

Emptiness for Uecker is an essential element of his visual work, as well as in his written and spoken words. He believes that the 'new' human being, and the only one who will survive, is the 'empty' human being.[101] Yves Klein's projects 'Vide' and 'Théâtre du Vide' were important sources of inspiration for him.[102] In Uecker's work the association with emptiness is mainly evoked by the absence of colour, form and composition.[103] At the end of the fifties he met the artists Heinz Mack and Otto Piene, joining the their recently founded Zero group.[104]

Empty stands for freedom from thought during the work process for Uecker and Götz.[105] In fact Götz tried to work fast and so precede thought. Uecker thought that emptiness was achieved by a lengthy process of repeated actions.

If we compare the works of Geiger, Götz and Uecker, as well as those of other German colleagues, with works by their French, American and Japanese contemporaries, the German works seem remarkably 'full'. However, Geiger's fields of colour and Uecker's nail reliefs could be described as 'living' or 'vibrating' emptiness, and thus evocative of the view in Zen that something and nothing are the same.

Dynamism

'Movement' as a characteristic of the line was an aesthetic feature of Jugendstil, for Kandinsky it was an 'alarm clock' for the inner self, for Baumeister a reflection of the new portrayal of mankind and the world, and in the fifties it was seen by artists, including Götz, as the dynamism of life itself, in particular that of physical actions. Götz considered dynamism to be so important that he even termed it the dominating problem in art.[106] Painting meant 'an action in time' for him.[107] His actions were short and violent, explosions lasting a few seconds, alternating with meditative periods of rest. They are comparable with the actions in the martial arts of Zen. Dynamism is recognizable as a formal aspect in his works in the expressive character of both the brush-strokes and the marks of the squeegee.

Dynamism is also crucial in Geiger's work. There it is primarily a matter of 'the dynamism of colour and its perception'. He does not see colour as something static: it covers everything with a movable veil.[108] Geiger tries to retain that movement on his canvas, guiding the eye from one particle of colour to another as a movement 'in space', and believes that colour has dynamic properties like pulsation, vibration and range.[109] 'Movement' is not a gesture for him, but is generated by the radiation of his colours. So his is not a dynamism running parallel to the pictorial plane, but a movement which comes forward out of the canvas, towards the spectator.[110] The effect recalls Kandinsky's remark that colour can project or recede on the painting.[111]

From the start Uecker's earliest nail reliefs contained dynamism. He calls them 'vibrating fields of energy' because the changing shadows brought about by light falling on the nails suggest movement.[112] Over the years his focus switched to 'visualizing the course of a movement'.[113] He became particularly fascinated by the changing character of movement: His first kinetic object, 'Licht Globus', made in 1958, comprises a nail-covered globe.[114] As it rotates it almost becomes dematerialized. And all that remains is 'a movement in space'.[115]

Uecker's technique, like that of Götz, can be termed dynamic. With Uecker it is predominantly 'disciplined' dynamism, with Götz 'practised spontaneity'. The Zen Masters are familiar with both approaches.

Indefinite and surrounding space

It is especially interesting to examine the connection the artists made between space and time.[116] According to Geiger the "A-perspektivischen Raum-Zeit-Kontinuum" (non-perspective space-time continuum) is the concrete perception of the space of the world itself. He wants to erase the limits to perspective thinking in terms of space, and add the dimension of time, by suggesting vibrating space.[117] Götz's view is that there is no measurable space, and certainly not a space that can be separated from time. He sees both the world and art as constantly renewing phenomena.[118] According to Götz, the foundation of painting is 'action in time', as noted earlier.[119] With his technique he tries to forge unity between space and time. And that results in works which are characterized by rhythm.[120] With Uecker we find a connection between time and space both in his approach – in the importance he attaches to the lengthy process of hammering nails, and in his works too – in the moving shadows between the nails.[121]

The 'interspace' or interval, which is also a form of space-time, signifies for Uecker, literally, that the space between the works, between the nails, and between the spectator and the work, is vital. For Götz, especially, the spaces between the formal elements are important. Geiger was mainly interested in the space between the painting and the spectator which he tried to 'fill' with the expression of his work.

Direct experience of here and now

The direct experience of the actual working process was of prime importance for Götz and Uecker. Great concentration played a significant part in that process.

For Geiger his fascination for colour was equated with the experience of here and now; he felt it was omnipresent, like water in the atmosphere. Colour, in his view, was what made our surroundings.[122] So he wanted, by means of his colour fields, the public to experience their surroundings in a 'new' and in particular 'more intense' way. That aim is similar to Suzuki's description of *Satori*, as a way of seeing from a different point of view. Götz and Uecker also considered the direct experience of the public to be important – so the liberating effect of art on the spectator. Götz believed that the rhythm in his works did indeed have that effect.[123] Uecker described the use of white not only a 'spiritual freedom' and 'self-realization' for himself, but for the spectator too.[124] In addition, the spectator was intended to undergo spiritual freedom by jointly experiencing the creative forces.[125]

In 1961 Graf von Dürckheim explained the great interest in Zen in Germany as liberating our 'being' and giving the opportunity to 'become as new'.[126] The Oriental philosophy need not lead to alienation from one's own traditions, since, as he predicted: "The encounter with Zen will contribute to our rediscovering and reviving the roots of experience of its inherent universal truth in our own tradition".[127] This experiencing of what is familiar 'in a new and intense way', as in the last two stages of the Zen story of the man with the ox [128], appears to have been an important aim of the German artists in question.

In the context of direct experience of being, it is worth noting that French Existentialism was also popular in Germany. Sartre, whose books were widely read, was especially 'existence-focused', concurring with Descartes' typically Western conclusion "I think [about being] therefore I am". Zen is 'existential' with its emphasis on 'being' in the most literal sense: the intensification of the pure experience of being, now. I have observed the concept of 'existential' in both its senses in the artists I have studied. Geiger, Götz and Uecker all 'reflected existence' and also tried to 'experience existence intensely'. The latter took place during the work process with Götz and Uecker. Their works reflect the projection of that action. Geiger intended his paintings to arouse that experience. The question of the meaning of life is a focal point in Uecker's life. An utterance like '*Sein in Weiß*' (being in white) and, more especially, the reference to the absolute experience of being, in which the borders between being and not-being disappear and a new '*Dasein*' (existence) comes about, is reminiscent of both Heidegger and the 'intense experience of being' in Zen.[129]

It is striking that, in speaking of their work, Geiger, Götz and Uecker all mention the notion of 'meditation'. Geiger describes the effect of his colour as '*die Meditationsmöglichkeit*' (the possibility of meditation). Uecker 'meditates' prior to releasing energy in work, meaning that he allows the energy within him to well up. For Götz meditation is a stage of contemplation vis-à-vis his composition prior to effectuating his work.[130]

Nondualism and the universal

Comments made by Geiger, Götz and Uecker reflect their interest in reconciling opposites. Geiger, for instance, pursues a 'harmony in opposites', as a remark made in 1952 reveals: "To reveal the absolute colour is to make it

discernible in the harmony of contrast".[131] For Uecker the ability to unite the greatest opposites is a very important human characteristic.[132] Götz embarked in the fifties on a quest for equilibrium between the conscious and the unconscious – also one of *Shō*'s objectives – after having been influenced by Surrealism in the nineteen-forties, in which the subconscious was emphasized.

The quest for total unity in the working process, which is so crucial to Zen, is also found with Götz, in his striving to become one with his materials and his work whilst he is painting. In a comparable way, Uecker also tried to feel at one with his materials, and thus attain a more universal form of expression.

All the artists I have studied of the fifties were distinguished by the search for a unity of subjective experience and the establishment of Man's place in the world; the unity of body and spirit, and of spirituality and materiality; the relationship between action and contemplation, and between optical and actual space, and the concession to the will of the material rather than the imposition of one's will on it. At that time too the distinction between 'painting', 'drawing' and 'writing' disappeared. In addition, the ideas which had been introduced from the Far East meant that many of the works became a combination of Western and East Asian aspects, which could no longer be distinguished from each other.

'Universality' is linked with the colour white, according to Uecker: "White is the most universal colour".[133] He used mechanical means to transcend the subjective gesture, in the hope of making the universal harmony visible and mankind aware of his participation in the 'Universe'.[134] *'Farbform'* (colour form) is a means of revealing the 'Absolute', in Geiger's view. He believed that by using colour fields in his work he could create the suggestion of cosmic space.[135] As was observed earlier, Götz claimed that 'self' is not one's own personality but something 'impersonal'. In that respect, the artist is an instrument of the universe, not a conscious orientation on his surroundings.[136]

The interest in the universal nature of Zen emerged in a period when something of 'an unconscious need for religious feeling' was growing. It is interesting that much of the literature published at that time on Zen referred to the parallels with Christian mysticism, for instance of Meister Eckhart. The religious feeling in some artists was undoubtedly stimulated by Willi Baumeister with his *Das Unbekannte in der Kunst*, for example with his description of the 'experience of oneness'.

The pursuit of 'Universality' can also be recognized in Götz and the Zen 49 artists in the sense of 'international art'. Götz, for instance, joined Cobra. The members of Zen 49 invited artists from abroad, like Soulages, to exhibit with them. Added to which, they organized exhibitions abroad, in the hope of acquiring international recognition for their work.

Some aspects of *Sumi-e* and *Shō* which can be detected in a number of works by members of Zen 49, prove to have been acquired indirectly by way of their predecessors (Kandinsky, for example) from Japanese art. The formal relationship between various aspects in Götz's works and in *Shō* provides an initial explanation for his affinity with Japanese calligraphy. Contact with a *Shō* artist may have had a stimulating effect on his work and his spontaneous approach to it.

Towards the end of the fifties, Uecker recognized an affinity in Zen with his own ideas and that was gradually reflected in his work.

Little has actually been written on the interest in the fifties of German artists for Zen, and as yet few art historians have expressed an interest in the subject. Interviews did reveal that a number of German art historians were aware of the affinity some artists had with Zen in the fifties. The German art historian, H.R. Crone, Professor of Modern Art at the Ludwig-Maximilian Universität in Munich, stated that he was of the opinion that 'in those days Zen was well known among German artists', since Zen was felt to be more positive than Sartre's philosophy, and offered more scope for formal solutions.[137] However, so far my research has not supplied any indications that, apart from the artists under discussion, others merited examination as regards a possible connection between their awareness of Zen and their work in the nineteen-fifties.

It is remarkable that at a time when Zen was enjoying greater popularity than ever, more facets comparable with Zen were in evidence in art than in the past. This is not proof of substantial influence, but the sense of recognition concerning Zen does say something about the views of the artists in question. The feeling of freedom, resulting from the deliverance from the 'Entartet' stigma, was important for avant-garde artists in post-war Germany. Especially those who belonged to Zen 49 were interested in Zen and its emphasis on freedom and nothingness as starting points.

Notes

1 The other members of the group were the painters Bernard Schultze, Otto Greis and Heinz Kreutz. For more information on this movement in German art, readers are referred to the thesis LUEG, 1983, and the catalogue/ publication *Documente zum deutsche Informel*, BONN, undated.

2 VOGT, 1972, p. 23. See also the chapter 'The Zen arts in France'.

3 Siegfried Wichmann in the catalogue *Hermann Obrist*, MUNICH 1968, unpaged.

4 See the section 'Kandinsky: a new perception of Japanese art'.

5 Dirk Teuber in the catalogue *Zen 49*, BADEN-BADEN 1986, pp. 33-34. In the catalogue *Zen 49*, SAINT-PRIEST 1989, p. 4, Teuber writes that Oskar Schlemmer had noted ideas in his diary back in March 1915 on an ideal humanity, in the sense of a Buddhist spiritual life.

6 "Wir sind allzumal Europäer, können wohl das Asiatische assimilieren, müssen aber die europäisch lesbaren Formen finden, die zumindest den Keim in sich tragen, einmal allgemeingültig zu werden. Aber welche Abgründe trennen uns vorerst von solchen Gültigkeiten!". Quote in the catalogue *Julius Bissier*, DÜSSELDORF 1994, p. 23.

7 See the chapter 'The Zen arts in France'.

8 Volkmar Essers in the catalogue *Julius Bissier*, DÜSSELDORF 1994, p. 19. In Western grapho-logy, the study of the connection between handwriting and personality, a comparable opinion can be found. This science emerged in the second half of the nineteenth century.

9 Armin Zweite in the catalogue *Julius Bissier*, DÜSSELDORF 1994, pp. 6 and 7.

10 "Torī-Bilder, da sie an die japanischen Holztorformen erinnern". Baumeister quoted in the catalogue *Baumeister*, TÜBINGEN 1971, p. 140.

11 GROHMANN, 1963, p. 63.

12 DIENST, 1970, unpaged; GROHMANN, 1958, p. 151.

13 LEONHARD, 1966 (1947), pp. 75-78. In his own words, Leonhard reports on a lengthy conversation he had at the end of 1946 with Baumeister about his work. He opted for the form of a fictitious interview between an art historian, a painter and a poet. In a preface he writes that he gave the text to Baumeister to read, and that he gave his approval.

It should be borne in mind, regarding the foregoing view, that Baumeister was referring

to Einstein's theories. That itself constitutes an interesting parallel with some remarks by the artist Paul Klee (1879-1940), who was regularly mentioned as one of the sources of inspiration in the fifties. In 1920 this Swiss artist, who was living in Bern when Einstein published his theory of relativity there in 1916, wrote: "Früher schilderte man Dinge, die auf der Erde zu sehen waren, die man gern sah oder gern gesehen hätte. Jetzt wird die Relativität der sichtbaren Dinge offenbar gemacht (...) Ein Mensch des Altertums als Schiffer im Boot, so recht genießend und die sinnreiche Bequemlichkeit der Einrichtung würdigend. Dementsprechend die Darstellung der Alten. Und nun: was ein moderner Mensch, über das Deck eines Dampfers schreitend, erlebt: 1. die eigene Bewegung, 2. die Fahrt des Schiffes, welche entgegen-gesetzt sein kann, 3. die Bewegungs-richtung und Geschwindigkeit des Stromes, 4. die Rotation der Erde, 5. ihre Bahn, 6. die Bahnen von Monden und Gestirnen drum herum". Quotations from Klee in his essay for the collection *Schöpferische Konfession*, Berlin, 1920, pp. 28-40. The essay was also published in GEELHAAR, 1976, pp. 118-122. Geelhaar indicates in a note that this essay had been written in 1918.

Since my knowledge of Physics is very limited, I was unable to make a detailed comparison between Klee's theories and Einstein's book *über die Spezielle und die Allgemeine Relativitätstheorie. Gemein-verständlich.*, of 1916, so I can only refer to what seem 'at first sight' to be similar comments. I should also like to refer readers to the chapter on American artists, in which Einstein's ideas are also discussed. I believe that it would be worth studying the subject of 'modern art and Einstein' in more detail.

In note 76 and 116 Klee's view on the dynamic line and the connection between space and time are discussed.

14 LEONHARD, 1966 (1947), pp. 76-78.

15 LEONHARD, 1966 (1947), p. 83.

16 LEONHARD, 1966 (1947), pp. 110-111.

17 The texts were translated by Shuei Ohasama. A young German scholar, August Faust, assisted him with the adaptation of the text and content for the German public.

18 DUMOULIN, 1989 (1976), pp. 7-8.

19 See the chapter 'Zen and the Zen arts', p. 16.

20 It is interesting that in 1937, within a few years

of publications in *Nippon* on Shinto and on archery, Baumeister made the series of paintings entitled 'Torī' and another work entitled 'Ideogramm, Form in Bewegung'.

21 Willi Baumeister's daughter Felicitas confirmed his interest in Zen and also told of his friendship with Curt Weller. Felicitas BAUMEISTER in an interview in Stuttgart on 13 March 1996.

Although there is no evidence of Baumeister having read that book, there are striking similarities between several passages in *Das Unbekannte in der Kunst* and *Die Große Befreiung* (as outlined in Appendix 2). Baumeister was interested in many non-Western cultures, for instance those of the Sumerians and of Africa. However, there seems to be a decided difference between his knowledge of Zen and of other non-Western sources of inspiration. In Suzuki's book, an 'insider' explains a non-Western philosophy (Zen) in a way that Westerners can understand. Moreover, it might well have constituted one of the few sources of a philosophy of a non-Western culture available in Germany in the early forties. Baumeister's interest in Zen has sometimes been termed an 'enforced escape'. Volkmar ESSERS, in an interview in Düsseldorf on 17 March 1994.

In Baumeister's visual work, little East Asian influence can be detected, other than the names of a few series or works. He does not seem to have discovered an artistic solution matching his ideas in *Das Unbekannte in der Kunst*. Werner HAFTMANN, in an interview on 13 February 1994, Werner SCHMALENBACH in an interview in Düsseldorf on 17 March 1994 and Volkmar ESSERS in an interview on the same day. The latter two pointed out the Western character of his works (along the lines on Miró and Léger), his focus on the result and lack of dynamic rhythm.

22 Johannes LAUBE in an interview in Munich on 8 February 1994.

23 "Es gibt kaum einen Bahnhofkiosk, in dem man nicht eine billige Taschenbuchausgabe mit einer sachkundigen Einführung in Zen erwerben kann. Und gar die großen Buch-handlungen, ganz zu schweigen von Buch-handlungen solcher Städte, die sich einer Universität rühmen, weisen nicht nur in ihren Regalen und Lagern, sondern bereits in ihren Schaufenstern eine ganze Auswahl von deutschen, englischen und französischen Werken über Zen auf". BENZ, 1962, p. 5.

24 According to Dirk Teuber in the catalogue *Zen 49*, BADEN-BADEN 1986, p. 41, Daisetz T. Suzuki had discovered parallels between Western and Eastern thought, thanks to the book on the Christian mystic Meister Eckhart, published by Dürckheim in Japan. SUZUKI, 1991 (1949/1934), ties Meister Eckhart's views in with those of Buddhism on several occasions (see p. 97), and that link might well have been initiated by Dürckheim, if Teuber's conclusion is correct.

25 "Das neu-schöpferische Streben der gegenstandslosen Malerei findet eine Parallele in der Idee des Zen, die große Befreiung. Von allem Gegenständlichen entleert, atmet es am Rande des Bewußtseins zu einem überrationalen Sehraum alles materiellen Seins aus. Es öffnet sich tief und weit dem Wahren, Guten und Schönen des Lebens. Dabei überwindet es das im Sinnlosen und Widerspruchsvollen verwurzelte, hart aufgerichtete Dasein unserer Zeit. Es sucht mit empfangsbereiter Spannkraft die Einatmung der ihm zugeneigten Ausatmung aus dem Raume des Nichts der Nichts-wahrheit, wo die widerstrebige Polarität von Stoff und Geist Harmonie gefunden hat in der abstrakten Leere und doch so lebendigen Dimension". The catalogue *Zen 49*, BADEN-BADEN 1986, p. 42, published the letter Carl Hasse had written to Rupprecht Geiger on 2 October 1949. The letter can be found in the Archiv Rupprecht Geiger in Munich.

26 Dirk Teuber in the catalogue *Zen 49*, BADEN-BADEN 1986, p. 42.

27 Dirk Teuber in the catalogue *Zen 49*, BADEN-BADEN 1986, p. 25. Since abstract art had been declared *Entartet*, many artists believed that through abstract art a new era could be begun.

28 Dorothea Cavael wrote in her diary on 19 July 1949, the day on which the group was founded "Das Wort ist nicht ganz glücklich, aber wir fanden kein besseres". Catalogue *Zen 49*, BADEN-BADEN 1986, p. 29.

29 Gerhard Fincklin in the catalogue *Zen 49*, BADEN-BADEN 1986, p. 79 and Dirk Teuber, Ibid., p. 25.

30 At Zen 49's first exhibition several paintings were on show by Hilla von Rebay, who also worked as an artist. In subsequent years she was to play an important part as the group's

'Mycaenas', supplying members with money and materials. Rebay was the first female director of the Museum of Non-objective art. The museum's collection, belonging to Solomon R. Guggenheim, contained many paintings by Kandinsky. In 1948 she had exhibited fifty of the works of modern art from the museum collection in a hall opposite the station in Munich. In 1950 it was repeated, at the Central Art Collecting Point in Munich, the building where Zen 49 exhibited that year too. In that way Hilla von Rebay provided information on developments in art outside Germany. Fincklin, catalogue *Zen 49*, BADEN-BADEN 1986, p. 79. She was also influential for abstract artists in America, with her translation of Kandinsky's *Über das Geistige in der Kunst*.

31 "...Die abstrakte Malerei durch Bild und Wort zu verbreiten, so daß sie die bestimmende Aussageform unserer Zeit wird". The catalogue *Zen 49*, BADEN-BADEN 1986, p. 26. Ibid., p. 343: several extracts from the declaration of intent follow: "Auf der Tradition des Blauen Reiters fußend, hatte diese Gruppe die Aufgabe, die abstrakte Kunst zu verbreiten, so daß sie Allgemeingut wird, d.h., daß sie die bestimmende Aussageform unserer Zeit wird. (...) Diese Gruppe, deren Sitz München ist, erstreckt sich über ganz Deutschland und hat Verbindungen zu allen internationalen abstrakten Kunstströmungen. Unter 'abstrakt' wird die gesamte moderne Kunstentwicklung angesehen, die mit Kandinsky, Klee und Marc begonnen hat. (...) Im Laufe der Zeit sind Querverbindungen aufzunehmen zu ähnlichen Bestrebungen in der Musik und Literatur und zur modernen Architektur. (...)
Aufgaben: Ausstellungen (In- und Ausland), Vorträge, Publikationen (dreisprachig), Mappenwerke mit Originalgraphik, Progaganda (Presse, Rundfunk, Zeitschriften, Flugblätter), Internationaler Austausch, Herausgabe einer Zeitschrift...".

32 Catalogue *Zen 49*, BADEN-BADEN 1986, p. 26.

33 Dirk Teuber in catalogue *Zen 49*, BADEN-BADEN 1986, p. 26.

34 See the section 'Kandinsky: a new perception of Japanese art'.

35 Catalogue *Zen 49*, BADEN-BADEN 1986, p. 3.

36 Fietz in an undated letter, probably written in October 1949, to Rupprecht Geiger. Part of the letter was published in the catalogue *Zen 49*, BADEN-BADEN 1986, p. 48.

37 "Unsere Malerei sollte ein Weg sein und nicht ein ästhetisches Vergnügen. Der Name Zen 49 dokumentierte dann die geistige Gemeinschaft." Fietz wrote for the catalogue *Zen 49*, BADEN-BADEN 1986, pp. 154-156, a contribution to the chapter entitled 'Erinnerungen an Zen 49'; he was further quoted on p. 65 of that catalogue.

38 LEONHARD, 1966 (1947), pp. 102 and 78.

39 CAVAEL in a manuscript kept in the Dorothea Cavael Archives in Munich and which was first published in *Zen 49*, BADEN-BADEN 1986, p. 46.

40 "Wenn sich die Künstler des 'Zen' zusammenschließen, so tun sie es unter der Bedingung, nur an dem zu hängen, was der Konsequenz einer innerlichen Entdeckung entspricht". DIENST, 1987, p. 78, quoting Rolf Cavael.

41 "Ich bin an die Natur gebunden, aber nicht an ihre Formäußerung, sondern an die meine". Winter quoted in the catalogue *Kunst in der Bundesrepublik Deutschland*, BERLIN 1985, p. 449. SUZUKI, 1959 (1949/1934), writes about the importance in Zen of developing the inner life.
Teuber, catalogue *Zen 49*, BADEN-BADEN 1986, p. 48, remarks that several passages in Winter's diary indicate an interest in Zen, though he does not give any concrete examples. Since further research into Winter's diaries did not fit within the constraints of this research, the subject will be dealt with in later studies.

42 ROH, 1955, p. 52. Roh claimed in his introduction to the catalogue of the first group exhibition, *Zen 49*, MUNICH 1950, p. 3, that, contrary to what the press had suggested, the group's name did not have any occult meaning. Judging by the fact that Suzuki calls Zen neither occult nor mystic, Roh's comment would seem to refer to the journalists' ignorance of Zen, rather than a denial of a connection with Zen Buddhism.
In the same catalogue, Ibid. p. 6, Roh stated that, as a group of abstract artists from the south of Germany, they wanted to give the public the opportunity to immerse themselves in this new art, by holding regular exhibitions. Moreover, the members hoped the group would become an example for others to be formed in other parts of Germany, the outcome of which might be a large exhibition of abstract art from the entire country.

43 Brigitte Lohkamp in the catalogue *Theodor Werner*, MUNICH 1979, pp. 7-8.

44 Interview with Werner HAFTMANN in Waakirchen on 13 February 1994.Teuber, in the catalogue *Zen 49*, BADEN-BADEN 1986, p. 25, quoted Baumeister: "Dieser Name paßt mir nicht".

45 Teuber, in the catalogue *Zen 49*, BADEN-BADEN 1986, p. 29. Brigitte Meier-Denninghoff was the only sculptor in the Zen 49 group.

46 Teuber, in the catalogue *Zen 49*, BADEN-BADEN 1986, p. 29.

47 Werner SCHMALENBACH in an interview in Düsseldorf on 17 March 1994. Bissier had once commented on this to him.

48 Interview with Werner HAFTMANN in Waakirchen on 13 February 1994.

49 Jochen Poetter in the catalogue *Zen 49*, BADEN-BADEN 1986, p. 9.

50 These comments were mainly noted in interviews.

51 Besides the members of Zen 49 at that time (Winter, Geiger, Fietz, Cavael, Hempel, Meier-Denninghoff and Baumeister) guest exhibitors at the exhibition were: Hilla von Rebay, Max Ackermann, E.F. Fuchs, Wolf Hildesheimer, W. Imkamp, Armin Sandig, Erwin Schott, Bettina Spitzer, Fred Thieler, Heinrich Wildermann, F.A.Th. Winter, and Frederique Walot (see catalogue *Zen 49*, MUNICH 1950). The exhibition was not only reviewed in German newspapers. The critic H.H. wrote an article about it in the French magazine *Art d'aujourd'hui* of May 1950, noting that interest for the first exhibition in 1950 had been considerable. This publication was included in the catalogue *Zen 49*, SAINT-PRIEST 1989.

John Thwaites had contacted the American cultural attaché Stefan P. Munsing, who was in charge of the Central Art Collecting Point. Munsing provided the exhibition space for Zen 49 and also designed the poster and catalogue layout.

In May 1950 the exhibition could be seen in Freiburg (venue unknown), in June in Constance (venue unknown), in July in Egon Günther Gallery in Mannheim, in August in the Amerikahaus in Fulda, from September to October in the Amerikahaus in Wiesbaden, from November to mid-December in Ruhrstrat Gallery in Hamburg, and at the end of December in Eutin (venue unknown).

52 Angela Schneider in the catalogue *Kunst in der Bundesrepublik Deutschland.1945-1985*, BERLIN 1985, p. 101.

53 Catalogue *Kunst in der Bundesrepublik Deutschland. 1945-1985*, BERLIN 1985, p. 53.

54 Catalogue *Kunst in der Bundesrepublik Deutschland. 1945-1985*, BERLIN 1985, p. 83.

55 HEIßENBÜTTEL, 1972, p. 23.

56 SUZUKI, 1991 (1949/1934), p. 85 and p. 61.

57 GEIGER, 1975, p. 3. "Farbe ist dem Licht verbunden. Über das Licht reflektierte Farbe wirkt stimulierend auf den Menschen. Das Wesen der Farbe ist diese Funktion".

58 KANDINSKY, 1973 (1912), Chapter 5 'Wirkung der Farbe'.

59 Teuber in the catalogue *Zen 49*, BADEN-BADEN 1986, p. 44.

60 Angela Schneider in the catalogue *Kunst in der Bundesrepublik Deutschland*, BERLIN 1985, p. 103.

61 HERRIGEL, 1953 (1948), evolved this conclusion in the course of his book.

62 Geiger in 'Erinnerungen an Zen 49' in the catalogue *Zen 49*, BADEN-BADEN 1986, p. 154.

63 GEIGER, 1975, p.6.

64 SUZUKI, 1959 (1949/1934), p. 95.

65 Catalogue *Rupprecht Geiger*, MUNICH 1988, p. 12, and *Geiger*, SAARBRÜCKEN 1990, p. 11.

66 HEIßENBÜTTEL, 1972, quotes in the introduction to his book from a letter which Geiger had written him in 1967.

67 ADDISS, 1989, p. 13.

68 SUZUKI, 1959 (1949/1934), p. 33.

69 "Kunst ist des Menschen Erlebnis der Umwelt und seiner eigenen inneren geistigen Welt". Thwaites in the catalogue *Zen 49*, MUNICH 1950, p. 11.

70 GEIGER, 1975, p. 3.
My comparisons of Geiger's paintings and Suzuki's words should not be taken to imply that there are only connections with Zen. In particular Kandinsky's and Malevich's work formed an important source of inspiration for Geiger. HEIßENBÜTTEL, 1972, Preface.

71 His work, according to G.R. in *Düsseldorfer Hefte*, 1966, p. 17, could be described as the 'expression of an extreme dynamic vital consciousness'.

If his work is compared with that of French artists like Degottex, Alechinsky and (even the 'dramatic' works of) Mathieu, the French work can be described as 'elegant'.

72 CATOIR, 1984.

73 Götz in LUEG, 1983, p. 357.

74 See the chapter 'The inherent Zen in Japan'.

75 Interview with Karl Otto GÖTZ in Niederbreitbach on 26 March 1994.

76 LUEG, 1983, p. 61.
Back in 1920 Klee had made a clear link in his essay 'Schöpferische Konfession' between writing and movement: "Die Genesis der 'Schrift' ist ein sehr gutes Gleichnis der Bewegung". GEELHAAR, 1976, p. 120.

77 Catalogue *K.O. Götz*, BONN 1978, and in many other publications, he describes his technique which he invented in about 1953.

78 LUEG, 1983, p. 81, and literature on Japanese calligraphy.

79 Götz in LUEG, 1983, p. 144.

80 "Gelegentlich läßt der Elan die dünnflüssige Farbe über ihre eigentliche Grenze hinaus- spritzen, und es entstehen Wirkungen, die wir von den Zen-Malern in Japan kennen". Catalogue *K.O. Götz*, BONN 1978, p. 31.

81 "Es gibt keine isolierten Formen mehr, sondern jedes Formelement geht in benachbarte Formelemente über, alles hängt zusammen. Der Zwischenraum zwischen zwei Formelementen ist genau so wichtig wie die Formelemente selbst, er ist *aktiv* und im modernen Sinn eigentlich kein Zwischen- raum". GÖTZ, 1983, p. 957.

82 For instance, Werner Schmalenbach in the catalogue *Götz*, HANOVER 1956, p. 5.

83 Catalogue *K.O. Götz*, BONN 1978, p. 26.

84 GÖTZ in an interview on 26 March 1994 about books on Zen. "Der originale Künstler verläßt das Bekannte und das Können. Er stößt bis zum Nullpunkt vor. Hier beginnt sein hoher Zustand". *Cobra* (1950) 8. Götz had also joined the Cobra group.

85 Werner Schmalenbach in the catalogue *Götz*, HANOVER 1956, p. 5.

86 In the catalogue *Schrift und Bild*, BADEN-BADEN 1963, pp. 70-71, Irmtraud Schaarschmidt-Richter compares Götz's work with that of *Shō*, and primarily underlines the differences. She contrasts individual experience, absence of meaning of the writing and 'plurality' in the works of Götz with transcendence of the individual, meaning of the written character and oneness in *Shō*.

87 Günther UECKER in an interview in Düsseldorf on 1 February 1994.

88 Catalogue *Uecker*, STUTTGART 1976, p. 9 and interview with UECKER in Düsseldorf on 1 February 1994.
Uecker began working with nails in 1957. Initially he made a brush of nails, using it to

'comb' the paint on his work. One morning he realized that the 'nail-brush' contained more expressive force than paintings. And from then on he applied nails to painted grounds. ENGELHARD, 1984, p. 71.

89 Catalogue *Uecker*, STUTTGART 1976, p. 25.

90 Interview with UECKER in Düsseldorf on 1 February 1994. See also note 129.

91 "Wie man es auch versucht, man bleibt ein Abendländer und bleibt in dieser Tradition...". Catalogue *Uecker*, STUTTGART 1976, p. 9.

92 Friedrich W. Heckmans in the catalogue *Uecker*, DÜSSELDORF 1975, unpaged.

93 "...Die Kunst selbst ist ein lebendiger Akt geworden. Das Bild an sich ist nicht von Bedeutung, nur ein auslösender Faktor für das Sichtbarmachen einer Idee, eines Impulses". UECKER, 1979, p. 108.

94 HONISCH, 1983, p. 16.

95 See the chapter 'The inherent Zen in Japan'.

96 Interview with Karl Otto GÖTZ in Niederbreitbach on 26 March 1994. In GÖTZ, 1983, pp. 835-6, he describes the performance by Nam June Paik and John Cage in Galerie 22 in Düsseldorf in October 1959.

97 Geiger in the catalogue *Rupprecht Geiger*, MUNICH 1988, p. 30. Geiger was an ardent admirer of Malevich and Kandinsky, a fact which was confirmed in a telephone call with Rupprecht GEIGER on 24 January 1994. His description of emptiness recalls the comment by Malevich concerning his black square, namely that it was not empty but filled with the absence of any object. It is striking that Malevich and Kandinsky, the fathers of abstract art, were both Russians, with one foot in Western modern art and the other in the Eastern (Russian) tradition, in which paintings (icons) were related to spirituality. However, Geiger's works do not emit a feeling of spirituality, but rather an association with the dynamism of modern society. See the following discussion of the aspect 'dynamism'.

98 Catalogue *Zen 49*, BADEN-BADEN 1986, p. 68.

99 Catalogue *K.O. Götz*, BONN 1978, p. 100.

100 See p. 160.

101 Uecker in 'Der Leere Mensch' of 1965, published in UECKER, 1979, p. 108.

102 Catalogue *Uecker*, BRUNSWICK 1979, p. 23. The projects by Yves Klein which are mentioned were discussed in the chapter 'The Zen arts in France'.

103 In 1957/1958 Uecker made the series 'Große Reihe Vertikal', which comprises six drawings.

He drew vertical lines on the square grounds. The first, containing numerous lines, is followed by five more, which become progressively emptier. It resembles the process of 'transcending' to 'emptiness', i.e. *Satori* in Zen. In 1976 Uecker said of the growing empty spaces between the lines: "Die Linien sind konkret, aber die Zwischenräume sind für mich die Absicht, genau wie in den Nägeln die Zwischenräume für mich eine Art neuer Realität sind". Uecker in 'Der Mensch von der Kunst erlösen' dating from 1976, published in UECKER ,1979, p. 157.

104 Yet Uecker did not feel a great affinity with their ideas. Interview with Günther UECKER in Düsseldorf on 1 February 1994.
In literature on Zero some references can be found to Zen. Dietrich HELMS, 1970, p. 9, sees a connection with Zen. He gives as Zero's most important significance the "Nullpunkt", the sign of a beginning, when everything else is left behind. He then adds the meaning of 'tranquillity', originality and openness, which he feels are linked with beliefs in Zen Buddhism. But in the magazine *Zero*, which Piene and Mack published, no reference at all is made to the Far East. In 1964 Piene explained the group's name as a word which refers to a zone of stillness and of opportunities for a fresh start, like the count-down before a rocket is launched. For Uecker, too, the name meant 'rebirth'. It is interesting to see that a decade after 'Zen 49' had been founded, another attempt was made to start anew, from nothing. It is also striking that in Japan, shortly after the Second World War, a 'Zero group' was set up, as early as 1952. See the chapter 'The inherent Zen in Japan'.

105 For Geiger emptiness would seem to have played no part in his working process.

106 Catalogue *K.O. Götz*, BONN 1978, p. 102.

107 Catalogue *K.O. Götz*, BONN 1978, p. 24. See also the aspect of 'indefinite and surrounding space'.

108 THWAITES, 1978, p. 74.

109 This description is based on Geiger's own words. DIENST, 1981, p. 5.

110 DIENST, 1970, p. 94, describes this effect as follows: "Bewegung entsteht eher durch die eingebettete Farbform im Farb-raum; sie vollzieht sich nie horizontal, sondern die Bewegung geht sozusagen in das Bild hinein oder aus ihm heraus".

111 KANDINSKY, 1973 (1912), p. 87.

112 Catalogue *Günther Uecker*, HANOVER 1972, p. 31; and Mahlow in the catalogue *Licht, Bewegung, Farbe*, NUREMBERG 1967, unpaged.

113 Catalogue *Uecker*, STUTTGART 1976, p. 14. He likes to describe the space in his works as 'dynamic continuity'. HELMS, 1970, p. 8.

114 UECKER, 1979, p. 105.

115 SHARP, 1966, p. 28, reviewed the object as follows: "'Light Globe' becomes a different work in movement. The whole sense of its existence is changed. When the work is spun, it becomes dematerialized (...) it becomes spatially elastic (...) its form becomes a process of its movement. The work is a continual process of discovering its form. This changes the way the work is perceived...".

116 Klee already observed in 1920 that: "Denn auch der Raum ist ein zeitlicher Begriff. Wenn ein Punkt Bewegung und Linie wird, so erfordert das Zeit. Ebenso, wenn sich eine Linie zur Fläche verschiebt. Desgleichen die Bewegung von Flächen zu Räumen". GEELHAAR, 1976, p. 120.

117 Catalogue *Rupprecht Geiger*, BERLIN 1985, p. 90.

118 Catalogue *K.O. Götz*, BONN 1978, p. 28.

119 Catalogue *K.O. Götz*, BONN 1978, p. 24.

120 Catalogue *K.O. Götz*, BONN 1978, p. 26.

121 Catalogue *Uecker*, BRUNSWICK 1979, p. 7, and catalogue *Günther Uecker*, HANOVER 1972, p. 43.

122 THWAITES, 1978, p. 74.

123 Catalogue *K.O. Götz*, BONN 1978, p. 106.

124 DIENST, 1970, p. 216; Catalogue *Uecker*, BRUNSWICK 1979, p. 19 and HONISCH 1983, p. 13.

125 Stefan von Weise in UECKER, 1979, p. 102.

126 DÜRCKHEIM, 1972 (1961), p. 7. Ibid., about the Zen rage: "Zen ist heute in aller Munde. Jede Veröffentlichung über den Zen-buddhismus findet durstige Leser".

127 "Die Begegnung mit dem Zen wird dazu beitragen, die Erfahrungswurzeln der in ihm enthaltenen universalen Wahrheit in unserer eigenen Tradition wiederzuentdecken und neu zu beleben". DÜRCKHEIM, 1972 (1961), p. 6.

128 See the chapter 'Zen and the Zen arts'.

129 Bernard Holeczek in catalogue *Uecker*, LUDWIGSHAFEN 1987, p. 17, and UECKER 1979, 'Vortrag über Weiß' of 1961.
Uecker mainly recognized in Zen its focus on now, its aimlessness, its conviction that everything is constantly changing and the

quest for inner enlightenment. Günther UECKER in an interview in Düsseldorf on 1 February 1994.

130 Catalogue *K.O. Götz*, BONN 1978, p. 60.

131 "Die absolute Farbe manifest zu machen, ist, sie in der Harmonie des Gegensatzes erkennbar zu machen...". Quotation in catalogue *Zen 49*, BADEN-BADEN 1986, p. 259.

132 Interview with Günther UECKER on 1 February 1994.

133 "Weiß ist die universalste Farbe". Catalogue *Günther Uecker*, HANOVER 1972, p. 25, and UECKER, 1979, p. 103.

134 STRELOW, 1965, p. 62.

135 Catalogue *Kunst in der Bundesrepublik Deutschland*. 1945-1985, BERLIN 1985, p. 78.

136 Catalogue *K.O. Götz*, BONN 1978, p. 26.

137 Interview with H.R. CRONE in Munich on 10 February 1994. However, he confirmed my view that there was no demonstrable influence, nor could he provide specific artists' names.

Paul MAENZ, 1978, p. 34, emphasizes in *Die 5oer Jahre* that the optimism of the fifties stemmed from the conviction that things could only get better.

90. Seiki Kuroda, 'Kohan' (Lake shore), 1897, oil on canvas

The inherent Zen in Japan

In the fifties Japanese avant-garde art was following a style which is highly reminiscent of American Abstract Expressionism, French *Art Informel* and German *Informel*, whilst at the same time evoking aspects of Zen and the Zen arts. In that respect, the work by artists of the Gutai group, especially those who had earlier belonged to the Zero group, is of interest. The Japanese works, in common with their Western counterparts, can also be classified as 'art of the calligraphic gesture', 'art of the empty field' and 'living art', though less strictly.

In this chapter the work and philosophy of the modern *Shō* artist Shiryu Morita, the leader of the Bokujin group, will also be discussed.[1] He united *Shō* and modern Western art into an art of avant-garde calligraphy. Although he was in contact with modern artists inside and outside Japan, his aim was to remain a *Shō* artist and to modernize that art-form.

The procedure will be as in the previous chapters: to start with the art of Japan will be followed from the end of the nineteenth century until the nineteen-fifties, tracing developments relating to the intermingling of Western and Japanese elements.

After contact between Japan and the outside world had been restored in the second half of the nineteenth century, many artists adopted Western techniques and styles. They chose the name *Seiyōga* for that approach, thus distinguishing it from *Nihonga*, the Japanese style of painting.[2]

The American scholar Ernest Fenollosa,[3] who lectured in philosophy and economics at the University of Tokyo, undertook an extensive study of Japanese art shortly after his arrival in Japan in 1878. His interest in the traditional culture resulted in lectures on the superiority of Japanese art compared with that of the West, and he encouraged the Japanese to stay loyal to their artistic heritage, rather than imitating foreign work. He also founded the *Kyuchi Society* for the advancement of traditional Japanese art. In 1889 Fenollosa was one of the co-founders of an art academy in Tokyo. His aim was to stimulate the combination of Oriental spirituality and Western techniques (such as perspective and modelling by means of light and dark).[4] Although his ideas were very influential, the European styles were once more to become increasingly popular as time went by.

However *Seiyōga* and *Nihonga* were rarely strictly separated. The artists who had chosen to paint in the Western style could never become real Western artists, and those who had opted for the Japanese style could not avoid being influenced by Western painting, consciously or unconsciously. The latter group, for instance, liked to paint in oils.

One of the most famous Japanese artists painting in the *Seiyōga* style at the end of the nineteenth and the beginning of the twentieth century was Seiki Kuroda (1866-1924). He had studied in Paris with Raphael Collin (1850-1916) and returned to Japan in 1893.[5] His painting 'Lake shore', made in 1897 (ill. 90) is representative of his work in the period after his return. He used Western materials – oils – and a Western technique – *chiaroscuro*. Yet the meditative stillness which the painting emanates is typical of the Far East. The asymmetry and simplicity of composition are more Japanese than European in effect. Hajime Shimoyama, the chief curator at the Shizuoka Prefectural Museum of Art, remarked that the Japanese artists of the *Seiyōga* style consciously sought a typically Japanese version of Western painting:

> "As a general rule in the history of Japanese Western-style painting, artists either searched for elements in imported styles that agreed with Japanese traditional aesthetics, or they sought to blend the two traditions".[6]

Some artists even used slogans like 'new Eastern taste' or 'new Japanism'.[7] According to Shimoyama the contemplative style of Kuroda's paintings, influenced by the French *plein-air* artists, was in fact the expression of a typically Japanese taste, in which only the design was derived from a kind of Impressionism. "It was *because* Kuroda's style appealed to native sensibilities that it became the official style".[8]

In the first two decades of the twentieth century a number of Japanese painters took French Postimpressionism and Fauvism or Futurism as their examples. Several artists developed an interest in Dada or Constructivism. In the thirties many began to resist Western modern art, especially abstract art.[9] Only a few artists continued to experiment in that vein, like Jiro Yoshihara, who will be dealt with later in this chapter. But after the Second World War interest among artists and public in Western modern art was rekindled and as a result, from 1950 onwards, exhibitions of work by European and American artists were organized, for instance by newspaper publishers.[10]

In the fifties many Japanese artists travelled to Paris for their studies, as had been the case in the first two decades of the present century. Some stayed a few years, others settled there for good. And some preferred New York.[11]

In the United States, Germany and France, Japonisme developed from a combination of distinct Western and Japanese elements into an almost homogeneous mixture of the two cultures in the nineteen-fifties. A similar development occurred in Japan. Until the middle of the twentieth century Western elements could be recognized quite clearly in Japanese paintings, and in the fifties some artists can be perceived to have integrated Western art to form a more constant blend. That was the case with several artists of the Zero group in Kansai district. This group, formed in 1952, merged a few years later partially with the Gutai group of artists. The product was what can be termed 'the starting point of living art and of abstract expressionistic Japanese art'.[12]

Saburo Murakami (b. 1925), Atsuko Tanaka (b. 1932), Akira Kanayama (b. 1924)
and Kazuo Shiraga (b. 1924)

The Zero period

In Tokyo nearly all the avant-garde artists in the fifties were very much geared to Western modern art movements, and the styles which best matched the Japanese character were followed very carefully. In the Kansai district, the region in which both Kyoto and Osaka are located, the culture of the fifties was more traditional than in Tokyo, in both a material and a non-material sense. That in itself would seem to be a significant explanation of the fact that modern art in Kansai displayed more Japanese characteristics.

In around 1950 the artists of what was called the 'Shinseisaku Kyokai' (those making new art), a group of some twelve artists, regularly met to criticize one another's work.[13] The meetings resulted in the formation of *Zero no kai* (Zero group) – Zero, or 'o' as it was generally written. The name was an idea of Saburo Murakami, one of the members. He chose it to refer to the members' basic principles. As he observed: "Zero means 'nothing': start with nothing, completely original, no artificial meaning. The only meaning is: being natural, by body".[14] This comment is reminiscent of something Suzuki said:

"When we speak of being natural, we mean first of all being free and spontaneous in the expression of our feelings, being immediate and not premeditating in our response to environment (...) to be like a child, though not necessarily with a child's intellectual simplicity or its emotional crudity".[15]

The Zero artist Kazuo Shiraga emphasized that in traditional Japanese arts there was a tendency to 'simplification', as in the art of the tea ceremony. He was of the opinion that Zero had a similar tendency.[16] He also added another meaning to the group's name: a point of neutrality, of balance between 'hot' and 'cold' abstraction (the two different preferences of the group's members). Another, but less important meaning was a new start, from point o, following the Second World War.[17]

The Zero group existed less than three years, during which the artists held only one group exhibition.[18] They met once a week or sometimes only once a month, and discussed 'new art'. The artists Saburo Murakami, Akira Kanayama, Atsuko Tanaka and Kazuo Shiraga have been chosen for further examination in this chapter. They turned out to be the most important members of the group. Moreover, after they joined the Gutai group of artists in 1955, they became foremost members there, alongside the founder Jiro Yoshihara (1905-1972) and Shozo Shimamoto (b. 1928).[19]

The style of the Zero works varied considerably, yet there are similarities. To start with, all the works were 'minimal': paintings with very slight differences in tone and colour, and very simple in composition. In 1953 Murakami made a series of works by bouncing a ball smeared with black ink against sheets of paper (ill. 91). The ball's imprint on the paper resembles an explosion of black ink. The name *Haboku* (splashed ink) would have been appropriate – actually the name of the painting style of Sesshū. Not that Murakami made a typical Zen painting. He worked with the same material and comparable spontaneity, yet his work was primarily 'Zero'. He believed that it was typical for Zero to

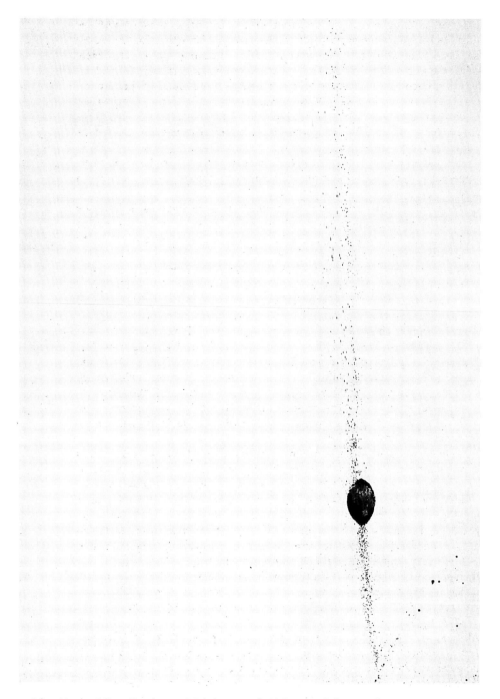

91. Saburo Murakami, 'Bōru. Nage dama ega' (Painting executed with throwing a ball), 1954, ink on paper, 105.8 x 75.7 cm.
Ashiya City Museum of Art & History, Ashiya

start with nothing: no subject, no paintbrush, no composition, no tonal values (just black ink on white paper) and completely original (the first time a painting had been made with a ball). Nor was any artificial meaning involved. He merely called the works 'Bōru' (ball). The only meaning that, according to Murakami, was permitted, was 'the natural, the physical' – to be found in the physical action of throwing the ball.[20] To my mind, this 'Bōru' series can be seen as an original integration of Western and Japanese elements, since it combines the characteristics of traditional Japanese ink painting with the Western artist's 'striving for something new'.

Murakami wrote in 1956, in the *Gutai* magazine (issued by the group of the same name) something about the will required in the context of the modern Japanese artist's intention:

"I set this will free in my way, an empty 'I' is created as a basis for a new will. (...) It is a good thing to let the will thrive limitless. A weak will is crushed by a strong one. A small but precise will resists an incapable will, and the surviving will certainly gets a shape".[21]

This quotation brings to mind the *vols* (will) to which the French philosopher Jean Paul Sartre often referred in his existentialist writings. And that is not by chance, since Murakami had become interested in Sartre's Existentialism when he was studying philosophy. Sartre's theories were very popular with students in Japan in the fifties. However, for Murakami 'will' mainly stood for the will an artist must find to create a distance between himself and his art-work.[22] It is interesting that in Zen especially there is a connection between 'will' and 'self-denial' (as between 'will' and 'distance from the self' with Murakami). According to Suzuki, Zen is "a religion of will-power, related to the Zen discipline, which is self-reliant and self-denying".[23] Murakami's will inclined more to the will to transcend subjectivity, like in Zen, than to the 'individual choices' propagated by Sartre.[24]

One of the topics on which Zero members debated was the relationship between art and the 'pure attitude of children to work'.[25] A series of works by Murakami which he began making in 1954 clearly reflects that connection. The series came about as a result of an incident which occurred with his son: after a minor quarrel Murakami shut the two-year old outside. The child was angry and banged so hard against the *fusuma* (sliding partition made of paper with an interior wooden frame) that he broke through it. This event inspired Murakami to produce square wooden frames across which he had stretched paper. He then proceeded to make holes in them with the same physical spontaneity with which he had made the 'Bōru' series.[26] When Murakami joined the Gutai group, the experiments with materials became even more 'event-like'.[27]

Akira Kanayama painted monochromes in a completely different style from Murakami. Yet they too coincided with Zero's basic principles. He took a rectangular white ground, and painted several narrow little rectangles at the edge, the effect of which was to give the large empty space of the paper a central place (ills. 92 and 93). These works are a combination of the Western geometric style, especially of Mondrian's works, and the Japanese preference for emptiness. According to Kazuo Yamawaki, the chief curator at Nagoya City Art

92. Akira Kanayama, 'Sakuhin' (Work), 1954, watercolour on paper, 79.3 x 60.2 cm.
Ashiya City Museum of Art & History, Ashiya

93. Akira Kanayama, 'Sakuhin' (Work), 1954, oil on board, 61.8 x 61.8 cm.
Collection of Museum of Contemporary Art, Tokyo

94. Atsuko Tanaka, 'Sakuhin' (Work), 1953, cloth, adhesive, ink, 21 x 46 cm.
Ashiya City Museum of Art & History, Ashiya

Museum, Kanayama, in his desire to transcend geometric art, unconsciously integrated in this way Japanese elements in his work.[28]

The relationship, the equality between the dark narrow shapes and the surrounding white, is characteristic of Oriental calligraphy. Particularly because of their thinness, the forms look more like lines, pointing to the emptiness, and because the small shapes do not divide the surface into strictly geometrical zones, allowing the organic form of the emptiness to dominate, the work retains a typical Japanese sensitivity.

Two Japanese curators of modern art explained in a discussion of the work by Kanayama with two small rectangles on the right-hand edge of the paper (ill. 92), that, being Japanese, the composition did not strike them as unusual. They went on to explain it with reference to the compositions in traditional Japanese painting and *Ukiyo-e* (ills 3 and 12).[29] Westerners would probably not experience Kanayama's composition as 'usual'.

Kanayama and Murakami painted on paper, so a traditional Japanese ground. Atsuko Tanaka experimented with different textiles. Her first works were on linen, but because she wanted to avoid the association with traditional Western painting, she switched to other materials, including cotton.[30] In 1955 she began experimenting with nylon, which actually alluded to modern Japan, since nylon was a product of the Japanese industrial revolution. Her main reason for using nylon was that she was trying to renounce traditional aesthetics.[31]

In 1953 Tanaka embarked on a series of monochromes in which she painted numbers (ill. 94). This was a consequence of her long stay in hospital in 1952 and 1953. There she kept a calendar of the days until she might leave. After her discharge, she began to place rows of numbers in her work. The interesting thing is that the lines actually constitute a repetition of the same number – a row with no beginning and no end.[32] The artists of the Far East paint in the same way as they write: 'in succession', from one side to another. In the works by Tanaka which are dealt with here, the connection between writing and art is evident, as it was in Kanayama's work.

Tanaka's experiments with materials are typical for the modern Western artist. The 'Japanese spirit' in her work was to increase after 1955. Then 'the natural and physical aspect' which Murakami described as characteristic of Zero became stronger, as it did in Kanayama's work.

Kazuo Shiraga's first monochrome paintings were made rather 'mechanically' – he applied the paint, in one colour and in a uniform pattern, with a palette knife. His intention was to ignore colour and composition alike. Like Murakami, he also avoided the use of a paintbrush. Their ambition was 'to be original', and consequently they rejected this most traditional of painting tools.

Shiraga aimed at a 'natural' and 'physical' form of expression, in common with Murakami. In 1953 he started to paint with his hands (ill. 95). The technique was not new; it had already been applied in China for centuries.[33] But the use of oil paints in the process was new. A few months later he developed a method of painting with his feet. That technique had actually been used in the eighth century by a number of Taoists in China. They stood on the paper and

95. Kazuo Shiraga, 'Tenohira' (Palms), 1954, oil on canvas, 49.5 x 64.5 cm.
Collection artist

96. Jiro Yoshihara, 'Sakuhin' (Work), 1957,
oil on canvas, 162,8 x 130,5 cm.
Hyogo Prefectural Museum of Modern Art, Kobe

applied the paint on the surface with hands and feet, whilst several people sat around them, beating drums.[34] In a lecture held in August 1993, Kei Suzuki, a specialist in this *I-P'in* style, compared Shiraga's works and those Chinese painters, demonstrating distinct similarities.[35] Yet Shiraga does not seem to have known anything about his predecessors.[36]

Shiraga did not use his feet in a personal, expressionist way, but more 'mechanically', as he had his palette knife. He continued to avoid composition, meaning and polychromy. In that way he tried to transcend the subjective element, recalling the Buddhist aim of Enlightenment (It is worth noting here that he in fact also became a Buddhist monk). The structure of the movements in a reddish brown monochrome painting made in 1954 is reminiscent of the 'mechanically' raked circles in Zen gardens (cf. ills. 95 and 8).

The Japanese art historians whom I interviewed were of the opinion that Shiraga's 'physicality' ties in with the arts of the Far East.[37] Shiraga believes that his 'painting action' is more akin to the arts of Zen, especially *Kendō*, than to American Action Painting. He believes that feeling, unity with the soul, directness, and concentration are related.[38] The affinity with traditional Japanese culture and the Zen arts was particularly clear during his action of 1957, in which he performed *Sanbaso*, a dance in Nō drama; moreover he got archers to shoot a hundred arrows through a white cotton backcloth.

Shiraga originally started painting monochromes in various colours, such as grey, blue and red. Towards 1954 he had developed a preference for red. We could go so far as to term his work from the second half of the fifties his 'red period'.[39] The red he used is one frequently found in Japanese culture.

The Gutai period

In 1955 the artist Shozo Shimamoto[40] called on the Zero artists to ask if they would like to join the Gutai group. According to Kanayama, the Gutai works appealed to them.[41] So they agreed, and in February 1955 Murakami, Kanayama, Tanaka, Shiraga and his wife Fukio joined the group. After the merger these Zero artists sensed that the Gutai group had the same objectives as they did, and so decided Zero might just as well be abolished.[42]

It is remarkable that in publications on Gutai the former Zero members' work is constantly referred to as the most important. Only Shimamoto and Yoshihara, who was mentioned earlier, and Sadamasa Motonaga (b. 1922) are considered to have produced work of comparable quality. That is why one must realize that their time in the Zero group was formative for the artists who went on to produce much of the important Gutai work. Shiraga believes that the works of various Gutai artists became more original under the influence of their Zero colleagues.[43]

The Gutai *Bijutsu Kyokai*, Gutai Art Association, was founded in July 1954. Several members had in fact formed a kind of group in 1951. Jiro Yoshihara (1905-1972) (ills. 96 and 97) founded the group with sixteen other artists, who were his pupils or his friends. Together they published a bulletin with the name *Gutai*, the first number of which appeared on 1 January 1955.

The Gutai members did not at first produce a manifesto or pursue an ideology. In the first bulletin Yoshihara wrote an English introduction saying that

the bulletin had been produced by seventeen modern artists who lived between Osaka and Kobe. Their aim was to show their work to the world and draw attention to it from people living overseas.[44] With respect to the members' philosophy, he wrote that they all believed that it was important for one's development to create an independent position. Moreover, they wanted to demonstrate that their spirit was free and that they sought a new impression for every creation.[45] The works which were reproduced in the bulletin bear little resemblance to one another, apart from the fact that they were all paintings and nearly all abstract. They vary from works in a calligraphic style to compositions of planes. Some are very busy, others austere.

In the second issue of *Gutai*, which appeared in October 1955 (after the group had linked up with Zero), Yozo Ukita, one of the Gutai artists, listed some of the features of Gutai art. His theory was that abstract expression was based on the direct materialization of perception. He emphasized that several works had been executed using 'all possible means', from fingernails to a hair-drier. Art is "how well the individuals can reflect the results of their conception of the very life they lead". Hence his translation of the word 'Gutai' with 'Embodiment'.[46]

In actual fact, the literal translation of the word Gutai is 'concrete'. Yoshihara gave an explanation of the name in 'the Gutai Manifesto' which was published in the art magazine *Geijutsu Shincho* in October 1956.[47] Because

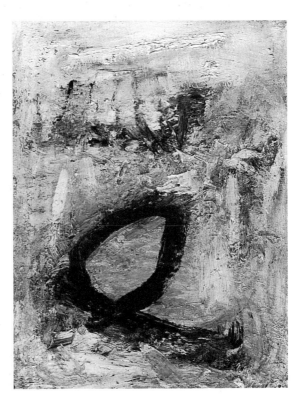

97. Jiro Yoshihara, 'Sakuhin' (Work), 1959, oil on canvas, 91 x 73 cm.
Galerie Stadler, Paris

"purely formalistic abstract art has lost its charm" they wanted to go "beyond the borders of Abstract Art" and so chose the name 'Gutai-ism' (Concretism).[48] Yoshihara accused traditional art of 'murdering' materials, remarking that Gutai art did not change the material, but brought it to life. "In Gutai art the human spirit and the material reach out their hands" and hence the group's aim was formulated as "combining human creative ability with the characteristics of the material".[49] The observations bear resemblance to the aim of the Zen Master. Suzuki wrote that the Zen Master tries to create life in his work: "Each brush-stroke must beat with the pulsation of a living being. It must be living too" and "The painter's business thus is not just to copy or imitate nature, but to give the object something living in its own right".[50] The term 'Gutai-ism' (Concretism) calls forth associations with 'Art Concret'. In 1930 Theo van Doesburg wrote a manifesto in Paris with that title. Interestingly enough, the characteristics which he formulated differ considerably from Yoshihara's descriptions of Gutai art. Van Doesburg's prime focus was on intellect and technical perfection. It is possible that Yoshihara had heard of 'Art Concret' from Taro Okamoto (b. 1911), who had gone to Paris in 1929 and in 1932 joined the 'Abstraction-Création' group, whose ideas closely resembled those of Van Doesburg.[51] The Gutai manifesto proves to have more in common with the 1946 'Manifesto Bianco' formulated by Lucio Fontana, in which he set himself the objective of reconciling himself with material and working with the energy it contained.[52]

Gutai's aim to 'go beyond the borders of existing art' is an especially Western idea of modern art. My conclusion was corroborated by Kazuo Yamawaki, who added that the Gutai artists tried to reach that Western goal by way of something familiar, namely the relationship between body, spirit and material.[53] Although that relationship can also be found in Western modern art of the fifties, there it related to 'something new'.[54]

In July 1955, five months after the Zero artists had associated themselves with Gutai, Jiro Yoshihara organized an open-air exhibition in a pine forest on the banks of the Ashiyakawa river. In October of the same year, they held an exhibition in the Ohara Kaikan Hall in Tokyo. In 1956 two exhibitions were again held in the same locations. In almost all the literature I studied relating to Gutai, the works are dealt with according to event, which might be explained by the fact that the prime interest was in Gutai as a group.[55] After all, the group is often felt in Japanese culture to be more important than the individual. However, it proved more interesting from my point of view to continue to follow the personal development of the four above-mentioned Zero artists during their Gutai period, rather than the actual development of the artists as a group, since they all evolved in different ways.

Kanayama, who, during the Zero period, was making white monochromes to which he added a few small shapes, began towards 1955 to develop three-dimensional monochromes, which he then even 'brought to life'. For Gutai's first open-air exhibition, he made a white wooden square on which he placed a small red sphere, thus bringing about a spatial note on the white monochrome. Three months later, at the first exhibition in Ohara Hall, he hung a large white

balloon from the ceiling, and a little further off a spherical red lamp which filled the area with red light, colouring half of the white balloon red (ill. 98).[56] The flat white surface had become 'spatial' and the red sphere had acquired light as an extra dimension.

In July 1956 Kanayama exhibited a work entitled 'Ashiato': a strip of white vinyl, about 150 metres long, on which he had made footprints. The strip was rolled out on the forest floor and at the end it ran upwards into a tree. In that way Kanayama succeeded in turning a flat painting, resembling in a way a traditional Japanese scroll painting, into something spatial, and making it one with its surroundings. On that occasion the red lamp had been turned into a railway signal in the woods. Two red lights flashed alternately and added in that way a dynamic element. At the next exhibition in Tokyo he showed a work called 'Bōru'. It was a white rubber balloon, several metres high, covered with little coloured dots. The object pulsated as if it were an enormous heart, and so resembled a living object.[57]

In Kanayama's works between 1953 and 1956 we can, therefore, perceive a progression from flat to spatial monochromes, and thence to 'living' art. The artist's reaction to that observation was that it was not deliberate, but a purely natural process.[58] That comment approximates one of Zero's basic principles, as formulated by Murakami, i.e. that 'naturalness was the only permitted meaning'. Tohru Matsumoto, the curator at the Museum of Modern Art in Tokyo, remarked during an interview "we Japanese, in our inner depths, believe that material lives".[59] This Japanese view is related to the ancient cult of animism in the Shinto religion, and, as stated earlier, can also be found in Zen.

98. Akira Kanayama, 'Sakuhin' (Work), 1955, balloon, red globe
Ashiya City Museum of Art & History, Ashiya

99. Akira Kanayama, 'Sakuhin' (Work), 1957, 77.6 x 100.3 cm.
Hyogo Prefectural Museum of Modern Art, Kobe

In 1957 Kanayama converted a toy truck into a painting machine for the third Gutai exhibition in Kyoto. He placed a pot of paint on the truck and sent it off in various directions across a large sheet of paper, causing it to deposit a never-ending trail of paint (ill. 99). The result, because of its formal similarity, seems like an ironic reaction to Jackson Pollock's action painting. Kanayama's reaction to that interpretation was just as sobering as many famous dialogues in Zen literature [60]: "I had no time to make a painting, so I let the machine do it: it made 10 metres of painting in 2 or 3 hours". His reply to the question why he used mainly white for his monochromes (which the German Zero artists later did as well) was equally down-to-earth: "I like white".[61]

With reference to these works by Kanayama, it is worth noting that the French artist Jean Tinguely exhibited the work 'Méta-matic 17' at the first Biennial in Paris in 1959, at the Musée d'Art moderne – it was made up of pieces of old iron, a moving roll of paper and a large balloon. This machine made thousands of drawings, assisted by the spectators.

A similar development to that in Kanayama's work, from static monochromes to 'living art', can also be observed in that of Atsuko Tanaka. During the 1955 open-air exhibition she displayed a large pink nylon 'canvas', measuring ten by ten metres, about twenty centimetres off the ground, with sunlight reflecting on it (ill. 100). The wind caused a constant wave motion in the cloth, bringing the monochrome she so favoured to life with its vibration. At the exhibition in Tokyo a few months later, she had a similar work on show. It consisted of plain-

100a/b. Atsuko Tanaka, 'Kaze to nuno' (Wind and cloth), 1955, rayon, 1000 x 1000 cm.
Ashiya City Museum of Art & History, Ashiya

coloured yellow cloths loosely attached to the wall which swayed slightly in the draught in the room. Another of her works at that exhibition was, in the artist's words, a sequel to the fluttering cloths. She had placed a series of bells on the floors of the various rooms of the exhibition centre. If someone touched just one bell, a chain reaction of ringing bells was set off: a wave of sound. Her work at the second out-door show comprised seven oversized figures clad in different coloured neon lights, which heightened the visual experience of dynamism.

At the next Tokyo exhibition her work literally came to life, as she draped one of these neon garments over her own body and walked through the halls. Her intention was to get as close as possible to her material and even become one with it, although she was in danger of being electrocuted![62]

The motto of the Gutai artists and of Zen Masters 'to transcend by means of personal experience of the commonplace' would seem to have been particularly appropriate to Tanaka's work. A transcendence takes place from the experience of the materiality of ordinary objects to the immateriality of light and sound, in which the limits of 'spatiality' are crossed.

Action and space were already features of Murakami's work in 1954. After he had joined the Gutai group, he continued along that path. At the first Gutai exhibition in Tokyo in 1955 he blocked the entrance with a huge sheet of packing paper, which he had painted gold. Jiro Yoshihara had to break through the paper in order to open the exhibition. Murakami had placed three frames covered with packing paper, one closely behind the other, in the hall: he made six holes straight through the three sheets of paper with his own body (ill. 101). That gave his work the appearance of a 'spatial' painting with a 'craquelure' surface. At the open-air exhibition of 1956 he shared with the public his experience of space by means of an opening in a shape. That work, entitled 'Sora' (air/sky), consisted of a cylinder-shaped tent topped by a truncated zinc cone, which was open at the top. The spectator who stood inside the tent and looked upwards only saw the sky, thus experiencing space directly.

Time, as well as space, held a fascination for Murakami. According to Nehei Nakamura it is typically Japanese to live in unity with time and space.[63] Murakami demonstrated that literally, by putting a ticking clock in a man-sized paper box. It was his challenge to allow the aspect of time, in the most literal sense, to play a leading role. He then looked for a way to include that aspect in a painting. At the third Gutai exhibition in the Municipal Art Museum in Kyoto, in April 1957, he revealed his solution. He had made several extremely fragile paintings. The paint flaked off with the slightest movement. After a while, the painting altered because the paint gradually fluttered to the floor, generating in that way a 'living' painting, comparable with the aforementioned 'living' works by Kanayama and Tanaka. Murakami wrote regarding these works that painting until then had never integrated the aspect of time.[64] Although Futurism had, in his view, dealt with time, it only related to a pictorial rendering of a theoretical idea, so a depiction of time.[65] Murakami saw his own works as a logical consequence of the Gutai group's basic principles. The enthusiasm of those artists for the quest for a total emotion required the integration of both the time factor and the space factor. He believed that they wanted to convert from immovable time in art to a 'living time', and so create a new style of painting.[66] Lily Abegg contends in her book *Ostasien denkt anders* that the concept of time for the Japanese is linked with personal experience, contrary to the traditional Western idea of absolute time.[67] According to Shinichiro Osaki, curator of the Hyogo Prefectural Museum of Modern Art in Kobe, the aspects of time and space, combined with the extreme physical element, are what make the Gutai works unique.[68]

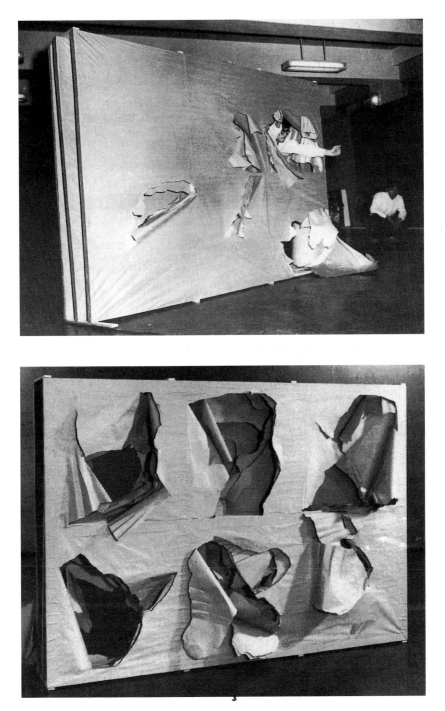

101a/b. Saburo Murakami, 'Sakuhin. Mutsu no ana' (Work Six Holes), 1955, paper, wood
Ashiya City Museum of Art & History, Ashiya

'Living art' for Shiraga was, more than for Murakami and Tanaka, linked with his own body. From about 1953 onwards Shiraga's works had become manifestations of the increasing melding of his body with the painting material. Accordingly, he supported a goal of Zero, as formulated by Murakami, purporting that 'naturalness and physicality should be the only meaning of a work'. As was stated earlier, he originally painted with his hands, then with his feet, meaning that he literally stood 'in' the painting. After he joined Gutai, he continued with that technique (ills. 102 and 103), adding to it several projects entailing 'setting foot on' the work. At the first open-air exhibition in 1955 he placed ten red stakes in a cone shape. The work was called 'Dozo ohairi kudasai' (Please enter) (ill. 104). When someone did go inside the cone he found himself surrounding by a 'painting' which could not be seen from the outside. Shiraga had cut notches in the stakes with an axe and painted them white inside.[69]

Yet Shiraga seems to have felt that the relationship between body and material could be even more intense. Three months later he dived into a pile of mud, remodelling it with the movements of his body (ill. 105). The physical experience was heightened by the abrasions on his body caused by the presence of chalk and cement fragments in the mud. At the second open-air exhibition he involved the public in his work. He had made two piles of mud – one round, the other oval, and covered them with cellophane to prevent them drying out.[70] Visitors were invited to touch and transform the heaps of mud, to enable them to get an idea of how Shiraga had felt nine months before.

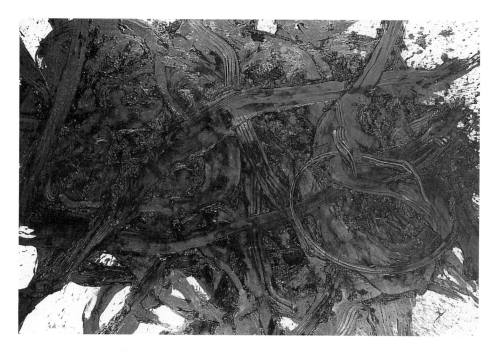

102. Kazuo Shiraga, 'Tennisei Sekihatsuki', 1959, oil on canvas, 182 x 272.5 cm.
Hyogo Prefectural Museum of Modern Art, Kobe

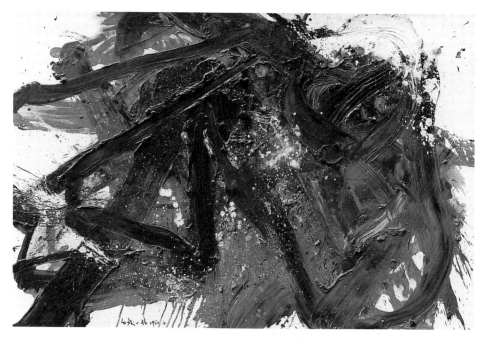

103. Kazuo Shiraga, 'Tenshohei Botsuusen', 1960, oil on canvas, 180 x 275 cm.
Galerie Stadler, Paris, (photo: Augustin Dumage)

104. Kazuo Shiraga, 'Dozo ohairi kudasai' (Please, come in), 1955,
wood, each post measures 403 x 6 cm.

105. Kazuo Shiraga, 'Doro ni idomu' (Challenging the mud), mud, 1955
Photo: Ashiya City Museum of Art & History, Ashiya

One often encounters in the relevant literature terms like 'the unconscious' and 'automatism' in connection with Shiraga. According to Yoshihiro Nakatani, assistant curator at the Kyoto Municipal Museum of Art, the unconscious and automatism in Oriental thinking relate primarily to the relationship, the tension between Man and material (and even the universe), in which there is no clear distinction between subject and object, consciousness and unconsciousness, unlike Western cultures, with their customary approach to these concepts as opposites.[71]

During the first half of the nineteen-fifties Japanese artists were still not very well informed about post-war modern art in the West. Art magazines like *Geijutsu Shincho* only contained the occasional small, black-and-white reproduction of work by artists like Jackson Pollock and Hans Hartung.[72] The first personal contacts with Western avant-garde artists took off in September 1957, when Michel Tapié, Georges Mathieu, Toshimitsu Imaï and Sam Francis visited the Gutai artists. The meeting with Tapié was to have repercussions for the Japanese artists and their work. In recent years there have been several publications featuring the effects of that encounter. Gutai definitely has Tapié to thank for the group's international renown. He considered the Gutai works as a variation on *Art Informel*, and a confirmation of *Art Autre*, which he had designated as an international movement in 1952. However, opinions differ as to the idealistic scope of Tapié's intentions, and the outcome of his visit for the

Gutai artists' works. Shinichiro Osaki was of the opinion that Tapié's approach was motivated to some extent by self-interest.[73] There are suggestions that after Tapié had fallen out with artists like Fautrier and Dubuffet, he dropped in esteem in the art world. He may have hoped, with the 'discovery' of Gutai, to restore his reputation.[74] Some critics, including Barbara Bertozzi, accuse him of having had commercial motives.[75] Bertozzi gives the example of Tapié's reaction to Murakami's fragile paintings. Murakami had told her that he was disappointed that Tapié had criticized the works because they were not lasting – a sign of his focus on the art market.[76]

Yamawaki remarked, concerning the exact consequences of Tapié's opinion of the Gutai works, that the artists would have evolved in the same way even without Tapié's visit.[77] But Shozo Shimamoto believes that Gutai art would have retained greater originality if Tapié had stayed away.[78] Tapié's influence is reflected chiefly in the increasing complexity of the works, in my opinion. Comparison of *Gutai* 9 and 11 of 1958 and 1960, makes that growing 'complexity' apparent. Study of Gutai works in various museum collections confirmed that observation. Not only were the compositions more complicated, but there were more layers of paint and more overlapping brush-strokes, as well as greater polychromy than before. Murakami, for instance, made several 'chaotic' paintings in that period, and Shiraga's works became more colourful and more elaborate. According to Osaki, some of Shiraga's works became lifeless because he had worked on them for too long.[79]

So were the Gutai artists' works indeed a form of *Art Informel*? That question is hard to answer, since Tapié was vague about what the characteristics of *Art Informel* actually were. Osaki felt that Tapié's complicated theories had nothing in common with the views of the Gutai artists. They were entirely 'practice-oriented'.[80] The work of Gutai artists may well have evoked for Tapié the 'matter art' of Fautrier and Dubuffet. They, to his mind, were the pioneers of *Art Informel*. Yoshihara's Gutai manifesto would seem to confirm the affinity with matter art: "The spirit does not force the material into submission (...) our work is the result of investigating the possibilities of calling the material to life".[81] That meant, for Gutai painting, that the work was made in the awareness of the material's independence. Consequently, in these works the material and the artist's action must retain a balance. According to Yamawaki the Gutai concept means a reversal of the academic Western view:

"The concept is not expression using the material but expression of the material itself. It reversed the concept of art, which was regarded as expressions of artists' thoughts and ideas, and attempted to draw into the realm of expression nature liberated from artists' egos and ideologies".[82]

If one compares this Japanese concept with several of Zen's objectives, one is struck by a number of similarities. Suzuki gives, as the foremost principles of Zen: identification of Self with the creative and artistic spirit of Nature, the absence of egocentric motivation and the removal of the rigidity of the ego, in order to accept everything that comes our way.[83]

Tapié referred in his book *Continuité et Avant-garde au Japon*, which was published in 1961, to the presence of Japanese elements in the Gutai works. He drew the reader's attention in particular to the *savoir-vivre* and expression of the

Zen arts which he perceived in the works in question. Some years earlier he had written an essay in the eighth number of *Gutai*, which was devoted entirely to his ideas on *Art Informel*. There Tapié opened his 'hommage à Gutai' with a quotation from Nietzsche: "Soyons durs" (Let us be hard), which would appear to refer to Nietzsche's belief that excellence cannot exist without suffering.[84] In the context of Gutai, he probably had in mind the great passion and great physicality.[85]

Dada fascinated Tapié, a fascination which was apparently shared by the leader of Gutai. Yoshihara is said to have wanted Gutai to play a part comparable with that of Dada after the First World War in Europe and Japan. Gutai's works would rise up out of the ruins and stir up the world, as Dada had before it.[86] The iconoclastic attitude and the combination of different art-forms in Dada were continued in Gutai. However, Yoshihara remarked in his Manifesto that the objectives of the two differed, in that Gutai members were not interested in politics. For Tapié, Dada stood for anarchism and a fresh start. In that sense Dada did also approximate Yoshihara's goals.[87]

Zen seems to have had a subliminal influence on the work of Zero and Gutai artists, in view of its formative role in Japanese culture.[88] Some artists prove to have had a conscious interest in Zen. In 1952 an essay by Yoshihara on the Zen Master Nantembō was published in the periodical *Bokubi* (ill. 106). And Shimamoto noted that Yoshihara took his pupils several times to the Kaisei temple in Nishinomiya, in 1953 and later. He showed them calligraphic works and ink paintings made by Nantembō. Yoshihara apparently frequently im-

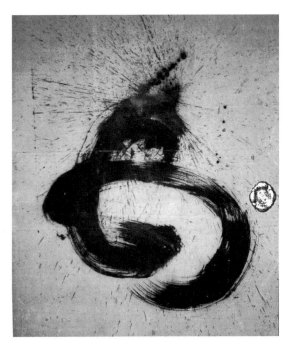

106. Cover of *Bokubi* 1 (1952) July, no.14

107. Nantembo, calligraphy on screen, Kaisei
temple, ink on paper, early 20th century
Kaiseiji, Nishinomiya

pressed on the Gutai artists that Nantembō's works should be considered as modern and contained solutions for modern Japanese art. He did not intend the works to be copied, but their characteristics should serve as an example (cf. ills. 107 with 96 and 97).[89] The fact that characteristics such as the connection between body and material, spontaneous expression, personal style, simplicity and immediacy are found in Nantembō's and in the Gutai artists' works suggests a connection with Zen.[90] Because Zen chiefly inspired Japanese artists 'from their own cultural background', Shimamoto feels that their work is more akin to Zen than the work of Western artists 'which is inspired by literature on Zen'.[91]

In post-war Japanese art magazines an interest was displayed in Zen, and in the Zen arts in particular. Leading art magazines like *Geijutsu Shincho*, regularly placed photographs of details of Zen gardens and Zen temples beside articles on and reproductions of modern Western and Japanese art. Much attention was also given to Zen arts like *Shō* and *Nō*.[92] However, it is unclear whether the editors intended to highlight parallels between Zen arts and modern, avant-garde art with this combination.

In addition, it is worth noting that Suzuki was quite well known in Japan, as a writer of Japanese books on Zen, and in the nineteen-forties he also held lectures in Japan on Zen, as he did several years later in New York. However his books were not easy to read, even for his fellow countrymen.[93]

The question still has not been answered how Japanese or how Western the works of Zero and Gutai actually were in the fifties. Some curators in Japanese museums of modern art were asked that same question.[94] Their answers varied from 'very Japanese' to 'very Western', with all the gradations in between. I found a possible explanation for the differing views in the studies I conducted in the West. The Western works often proved to combine developments in the history of painting (in which nineteenth century Japonisme played an important part), the West's new outlook on the world which was related to the outlook of the Far East, and new sources from Japan, such as Zen. The Western and the Japanese elements had become a homogeneous blend in the course of the fifties, in various works in the West.[95] And a similar process had taken place in Japan. Several Western elements had already been adopted in Japanese painting in the nineteenth century. In the course of the twentieth century the artist's attitude changed, and consciously or subconsciously, he began to mix Western elements with his own cultural heritage, to form a homogeneous whole. The differing opinions on the degree of Japanese-ness or Western-ness of these artists would seem to be due to the difficulty in analysing the 'mixture'.

For instance, we can conclude with respect to the materials used that the use of oils is purely Western. However, their techniques seem to be more Japanese. When traditional Japanese painting materials like ink and paper were used, immediacy played a vital role. That aspect is not necessarily present with oil paints, since the artist can continue to make alterations for quite some time. The experiments the artists in question conducted with their materials show that they preferred a direct approach, even with oils.

The objectives of 'bringing the material to life' and 'the close relationship between body and material' prove to be primarily Japanese, although, as we saw earlier, Western artists also began to pursue the same aims. Masaharu Ono, the curator of the National Museum of Art in Osaka, did, however, stress that 'experimenting' with materials was typically Western.[96]

The Zero and Gutai artists' pursuit of an entirely original style of painting is Western in character, since Japan has no tradition of innovation in art or of an individual style. These artists would mainly seem to have adopted 'originality' in the sense of differing from what was made in the past.[97] According to Shimamoto there was an important difference between the Gutai group and other modern Japanese artists, especially those in Tokyo. The latter for the most part copied Western art, whereas the members of Gutai were more inclined to adopt the attitude of modern Western artists.[98]

Although there is no tradition of individual-related original art in Japan, it was much appreciated in the history of Japanese art if an artist, after many years of copying, ended up developing an original style. Famous Zen Masters like Sesshū, Hakuin and Nantembō did have a personal style. One does wonder whether 'original' and 'self', as in terms like 'self-expression', have the same meaning in Japan as in the West. Shinji Kohmoto, a curator at the National Museum of Modern Art in Kyoto, explained that, in his opinion, the Japanese terms 'self-expression', and 'original' or 'personal' painting were different from in the West. In Japan 'self', 'original' and 'personal' do not refer to individuality in a Western sense, but to the personal experience of a world on which one is dependent, knowing that "a person does not live on his own, but by the grace of Nature".[99] Hajime Nakamura wrote concerning the difference between the Japanese and Western meanings of 'individuality' that it is incorrect to think that individuality does not exist for the Japanese. For them it means the focus on direct experience.[100] Nihei Nakamura, who has a similar opinion, observed that the academic Western artist looked for his own personality by setting his 'ego' off against the outside world. The tradition in the Far East entails the artist seeking an 'archetype', turning in his search to the depths of Nature and the Self.[101] The Japanese meaning of both self and individuality can also be found in the works of the Zero and Gutai artists. They do not express the 'individual story' in the Western sense, but 'the direct experience of the Self' in the Japanese sense.

Several of the Gutai projects suggest that the artists were in the process of liberating themselves. Take, for instance, Murakami's actions, which implied he was beating a path for himself through screens, towards freedom. The focus of the artists in question appears to have been to liberate themselves by surpassing the self. That in turn resembles the view of Zen on release. It is interesting to note that some Japanese artists realize that they experience the concept of 'freedom' differently from their Western colleagues. According to Murakami, the Japanese artists did not use the idea of freedom in the Western sense of 'individual freedom', because they were not familiar with it. For them freedom meant transcending cerebral limitation.[102]

In the same period in which Zero and Gutai were founded, an interesting development in the art of Japanese calligraphy was taking place. Shin'ichi Hisamatsu, a philosopher in the field of religions who had specialized in Zen,[103] played an important part in that process. He propagated a new style of calligraphy, fitting in with his philosophy. His views are very interesting in the context of the present study. He was eager to discover how the culture of the Far East could make a contribution to the modern world. For him Zen was a 'subjective liberation of the true self' and 'the living action of that self'.[104] Accordingly, calligraphy was felt to express the true self.

The calligrapher Morita, who knew Hisamatsu and identified with his ideas, founded several groups with colleagues who all wanted to modernize the traditional art of calligraphy, *Shō*. The groups, in chronological order, were 'Bokushō' (1941), 'Section Alpha' (1950) and 'Bokujin Kai' (Men of the ink group) (1952). The latter group published the magazine *Bokubi* (Beauty of ink) (ill. 106) and *Bokujin* (as from 1954 *Bokuzin*). In the first number of *Bokubi* Morita wrote that the aim of the group was to develop a calligraphy based on the philosophy of modern art, and to propagate that modern calligraphy.[105] Some copies of *Bokubi* were sent to artists abroad. They included Pierre Alechinsky and Karl Otto Götz, artists with whom Morita corresponded. Both *Bokujin* and *Bokubi* included on occasions works by the foregoing and other Western artists working in a comparable style, as illustrations beside works by Japanese calligraphers.[106] Various texts from these magazines, especially if they contained information on the objectives of the Bokujin group, were translated into French.[107]

Although Morita was a *Shō* artist, he was also in touch with artists in other disciplines. He attended meetings of the Genbi council and also gave several lectures there. Genbi (which stands for *Gendai bijutsu kondankai*, or discussion group on contemporary art) was founded in 1952 by six painters, including Yoshihara. The council organized meetings on a weekly or monthly basis for artists from various disciplines, including *Shō* and *Ikebana* (art of flower arrangement). The most important topic was 'the new expression', which referred to new developments in painting, sculpture, *Shō*, the applied arts and architecture. The visual work of the participants was not particularly innovative. The most interesting thing about the group is the fact that each discipline was equally appreciated and there was communication between disciplines. Morita and the Gutai artists took part in the exhibitions organized by Genbi. So they were acquainted with one another's work.[108]

Morita's work has always been based on *Kanji*, the Chinese characters used in the Japanese language (ills. 108, 109, 110 and 111). The *Kanji* he uses relate to life or human passions. Morita sees his pure, simple way of life as the inspiration for his works.[109] He describes his way of working as bringing the *Kanji* from within himself on to the paper, by way of his arm and brush. He believes that in that way he can express his vital energy, or inner force, and so liberate himself. This is his way of trying to achieve freedom of mind and body.[110] In order to appreciate Morita's work fully, one requires some knowledge of the *Shō*

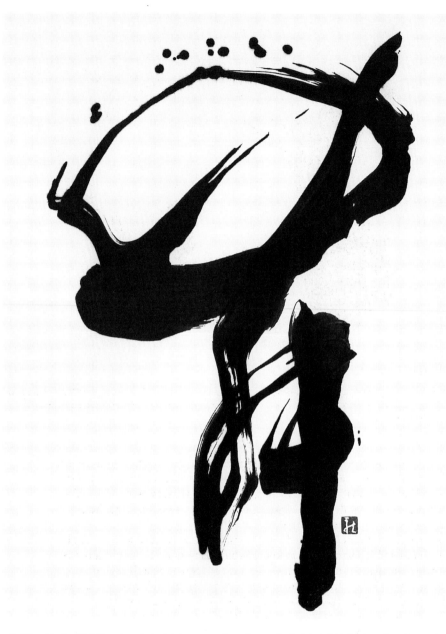

108. Shiryu Morita, 'Mai' (Dancing, soaring), ink on paper, 67 x 46.5 cm. Explanation of title by the artist: "A crane (bird) is living its own life in his dancing. Like a crane, I want to live my life to the full in my calligraphy".
Collection Van Stuijvenberg, Caracas

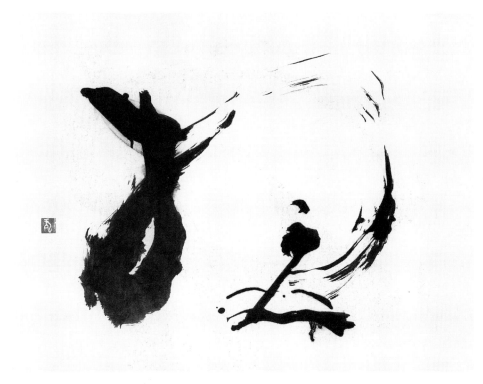

109. Shiryu Morita, 'So' (Musing, thought), ink on paper, 47 x 68.5 cm. Explanation of title by the artist: "Rather than how we think, we must grasp how the life throbs and the meaning of our existence. I try to confirm and express them using a brush". Collection Van Stuijvenberg, Caracas

technique, in the artist's opinion. Consequently, he has made a number of works, both in Japan and in the West, in the presence of spectators. Zen Masters used to do that in the past as well. Hisamatsu explains that it enables the artist to show that the essence of the painted line is not its symbolic character, but the action or movement.[111]

Morita was not only interested in *Shō*, but in Western abstract art too. He had encountered it when he got to know Saburo Hasegawa in 1950. Since the late forties Hasegawa had been looking for an abstract style based on both Western art and Zen Buddhism. Morita especially liked Western modern painting because of its freedom of expression and composition, which he considered as the philosophy of modern art.[112] I believe that this interest heightened the degree of abstraction in his own work. But he was also interested in Western techniques. When the German government invited him to visit their country in 1962, he called on Götz in his studio, and questioned him on his technique, in particular.[113] However, Morita never allowed himself to be influenced in his painting technique by the West.

In 1951 he first saw photographs of paintings by the American artist Franz Kline. Isamu Noguchi, the Japanese sculptor who was living in America, was

110. Shiryu Morita, 'Kanzan', 1958, ink on paper, 90 x 180 cm.
The National Museum of Modern Art, Kyoto

touring Japan that year, and had several photographs with him of Kline's work.[114] He showed them to Morita, who expressed his enthusiasm and subsequently reproduced five of the photographs in the first issue of *Bokubi*. One was even featured on its cover. Morita considered Franz Kline's work to exemplify a concise way of expression, but he also had objections to the work. He felt it lacked inner force.[115] Morita attributed that to the Western view of freedom. The aim of inner release for Western artists in the fifties was, in his opinion, merely a matter of being able to do everything they wanted. That is not freedom from within. "Instead of being termed 'free within' it is more appropriate to describe them as 'selfish'".[116]

The *Shō* artist's feeling of superiority vis-à-vis Western modern artists which Morita's words imply, is also evident in an essay written by Elise Grilli for *Bokubi*. She suggests that Western painters are like children who have not yet learnt to write. However, Japanese painters know how to write and so make better developed gestures. "Their hands move in response to the mind, filled with the most ancient of disciplines in abstraction", which does not mean that painting is an easy matter for the Japanese. The suggestion of coincidence, as opposed to pure coincidence, is a difficult problem for the *Shō* artist, requiring considerable experience.[117]

Morita is very fond of the *Kanji* character *Ryu*, meaning dragon. He even chose it as his artist's name: *Shiryu*.[118] Many Zen temples have a dynamic dragon painted on the ceiling or on a wall, in the highly expressive style of Zen painting. Comparison of Morita's works entitled 'Ryu' with these Zen paintings gives rise to the question whether the *Shō* works are 'figurative' or 'abstract'. It would seem

III. Shiryu Morita, 'To' (Frozen), 1957, ink on paper, 69 x 137 cm.
The National Museum of Modern Art, Kyoto

to be a case of nondualism, so the synthesis of the recognizable (the viewer recognizes the *Kanji Ryu*) and the abstract (an absence of naturalistic elements).[119]

Mitsugi Uehira, the director of the Kyoto Municipal Art Museum, commented that Zen and *Shō* have always had very close ties with each other, and that not only *Mu* (nothingness), but also *Ma* and the spontaneity of Zen can be found in Morita's works. According to Uehira, all Japanese art is about the tense unity (rather than dualism) between the personal and the universe, which also signifies the personal and Nature, in other words, matter.[120] It is interesting to recall that Morita accused Mondrian not only of rejecting individual expression, but also of equating space and form in order to banish dualism. He is of the opinion that these very elements must be 'a unity in tension', instead of equal.[121]

The affinity with Zen is also reflected in Morita's interest for the Zen Master Nantembō. Their works have a common factor in their simplicity and monumentality, and highly expressive brush gestures, with uneven contours and a multitude of paint splashes around them. Morita believes that he was mainly guided unconsciously by Nantembō's work.[122] So an apt description of Morita's work would be: *Shō*, influenced by both Western modern art and the works of Nantembō, but with the 'footnote' that Western avant-garde art had led Morita to rediscover Nantembō.[123]

The self-evidence of Zen

Various Zen concepts will be examined in relation to the Japanese artists, as they were in the chapters relating to their American, French and German colleagues.

Emptiness and nothingness

Both of these aspects tie in with the choice of the name *Zero* for a group of artists with the basic principles of 'starting with nothing' and 'no meaning'. For Morita too the idea of 'starting with nothing' was important. At first sight his premise and that of Zero are very similar.[124] Yet there was in fact an important difference in their interpretation of 'nothingness'. Murakami, for example, referred to the way a child draws, starting with scribbles with no predetermined plan. Morita formulates his goal of *'Mu'* (nothingness) as follows:

"The need is to attain a moment of complete 'mu', the Japanese word of positive negation implying 'release' or 'abandonment'. (...) Authentic perception requires a similar 'mu' in seeing: a bringing to bear of the body of experience and letting-go-of-it at moment".[125]

According to Morita 'starting with nothing' could only be achieved after many years of practice and experience of life. The spiritual significance of nothingness was also important for him, unlike the Zero and Gutai artists, who were primarily practical in their approach.

In Morita's *Shō* works, non-form played an active part as the counterpart to the 'form' of the *Kanji*. Emptiness was also of prime importance in the works of Murakami, Tanaka, Kanayama and Shiraga. In the second half of the nineteen-fifties emptiness even became a 'three-dimensional' aspect of their work – just think of the holes in Murakami's screens and tent, the hollow in Shiraga's pile of mud and the empty space in his cone of red stakes. It is striking that in all these works emptiness always had form, and was never a formless background.

In their working method, emptiness meant the absence of a preconceived plan and of thoughts during work. This was especially true of Morita, Murakami and Shiraga.

Dynamism

The emphasis on action, proceeding from the dynamic view of the world, is part of the Japanese tradition.[126] That could explain the fact that the Japanese artists in question were more inclined to experiment with actions, and possibly also found that more self-evident than their Western colleagues. The Japanese artist Toshimitsu Imaï believed that many Western artists made the mistake of seeing Zen chiefly as 'emptiness', whereas in his view 'dynamism' has greater priority.[127]

The important role of dynamism in the works under review proves to be the outcome of the aim to make art the expression of everyday experiences. In the paintings dynamism is especially discernible in the expressive character of the painted lines, or as subtle energy in the works which could be classified as 'art of the empty field'. Shiraga's action, as far as working method is concerned, is the most physical and violent, in comparison with the other artists.

The spontaneity in Morita's approach is the result of considerable practice, as was the case with the Zen Masters. The Zero and the Gutai artists aimed at a more unpractised form of spontaneity, although Shiraga's style does display a proficiency which comes from years of repeating the same technique.

The dynamism in the spatial works of Tanaka and Kanayama had a special

character. It was not the artist's action that was important, but the action in the work itself, such as movement by the wind, sound waves, flashing lights, the vibration of the balloon and the self-propelling painting toy.

Indefinite and surrounding space

In Japanese art indefinite space is the traditional and familiar way of depicting space. Even in *Seiyōga* space is usually not defined. Morita sees space as being unlimited, literally. He believes that the space in his work symbolizes the entire universe. And in the works of all the Gutai artists who have been studied, space also proves to be 'indefinite'.

Awareness of the surrounding space is most in evidence in the approach of Morita and Shiraga. The latter stated that space was not only important for him in the sense of the space surrounding him during his work, but also in the sense of the interval, the period in which he washed his feet before changing to another colour of paint.[128] In fact, for almost all artists under discussion, space was closely linked to time. Morita wrote in that connection that the calligraphic gesture "comprises, simultaneously, and homogeneously, both time and space".[129] One of Murakami's prime objectives was to make the relationship between space and time visible, as his works of 'living art' and some paintings reveal. In the works with the bells and flashing lights by Tanaka and Kanayama, a comparable relationship was created. Moreover, the gleam of the lamplight and the tinkling of the bells literally turned space in those works into something limitless.

Direct experience of here and now

Morita's views and working method both reflect the importance of the awakening of the Self through direct experience of here and now.[130] His calligraphic works show the spectator the product of that intense experience.

Shintoism and Zen both emphasize the experience of here and now, and that aspect seems to be part of the Japanese national character. Yozo Ukita's explanation of Gutai art as 'the reflection of the intense experience of life' recalls the emphasis Zen places on the personal and direct experience of everyday life. For the Gutai artists, the direct experience of here and now can mainly be noted in their actions. Murakami's work was close to real life, in that he performed actions like throwing a ball and using a variation on the screen, whilst Tanaka and Kanayama worked with bells, lamps and balloons. The focus on here and now is also linked with purposelessness. For the Zero artists the only permitted goal (if it can be termed a goal) was 'to be natural'.

The aspect of direct experience in the sense of concentration can be observed with Morita in particular, and Shiraga to a somewhat lesser extent. Both these artists demonstrated great discipline.[131]

Nondualism and the universal

According to Mitsugi Uehira, Morita's works are based on three important concepts, which are related to the ideas of Hisamatsu and Zen. These concepts are: the freedom of the individual, the question how to live life today, and the question how to attain universality.[132] In this, 'universal' refers to a spiritual

state of mind. The Gutai group mainly had a universal goal of a practical nature. The *Gutai* bulletin was published with a view to making contact with artists throughout the world. In their case, therefore, the concept of 'universal painting' can be interpreted as making 'international works'.[133] Interestingly enough, a comment in *Bokuzin* suggests that the aim of the group of *Shō* artists led by Morita was primarily 'to create a world filled with trust by means of an exchange of correspondence based on art-works'.[134]

The most important aim of the Gutai artists was to transcend existing art, a typically Western concept. However, Shiraga remarked that it can also be taken as a quest for nondualism, in the sense of 'transcending the old dualism of Japanese, as opposed to Western art' – thus making it a typically Japanese idea.[135]

The formal aspects of the works we have been discussing clearly reflect a pursuit of nondualism, or an equivalence of the various components. Nondualism is found in the artists' working methods in their striving to become one with their materials, and thus transcend their own will. We can also perceive a synthesis in their choice of techniques. The Western artists who have been studied, work in only one (possibly two) of the categories discussed ('art of the calligraphic gesture', 'art of the empty field' and 'living art'). Various Japanese artists were working in the fifties in all these styles, separately or in combination.[136] One may wonder whether that has something to do with a Japanese aversion to dogmas, which is so characteristic for Zen. One work which illustrates the combination of the three categories is the 'Bōru' series by Murakami.[137]

Remarkably enough, *Shō* and Japanese avant-garde painting only converged in the fifties. Calligraphers were bent on modernizing their art and sought inspiration in abstract painting. Avant-garde artists were drawing closer to the art of *Shō* as regards dynamism and the feeling of oneness with their material.[138]

It is difficult to indicate the exact importance of the Japanese and Western sources of inspiration. In the fifties there was world-wide communication. But that was not all. From the end of the nineteenth century Western and Japanese views of the world had been gradually changing and drawing closer together.[139]

A kinship with Zen is clearly apparent in the work, technique and views of the *Shō* artist Morita. As far as the Zero/Gutai artists are concerned, I must rely on a personal impression and the opinions of Japanese experts. To sum up, the most Japanese elements in the works in question proved to be the feeling of oneness with the material and surroundings, painting in succession, emptiness as form, freedom in the sense of unification, indefinite space, the relationship between space and time, the experience of the world as a continuum and the emphasis on the (visual) intuitive experience. The quest to 'transcend modern art' seems mainly to have amounted to a 'Japanization' of Western modern art, in which Zen, as a element of the cultural heritage, was able to play a part. Some artists were aware of that fact, others were not, or else they only discovered at a later stage that the more things change, the more they stay the same.

Notes

1 It is remarkable that all the reviewed Japanese artists, unlike many of their Western counterparts in the fifties, were members of a group. A study of the structure of Japanese society revealed that, in that culture, individuality can only be developed through group membership.

2 'Seiyō' means The West and 'Nihon' Japan.

3 See the chapter 'The unity between West and East. American artists and Zen'.

4 MUNSTERBERG, 1978, p. 20.

5 Upon his return to Tokyo, he founded a private school, joined the Imperial Art Commission, was appointed director of the Imperial Academy of Art and lecturer in the Seiyōga style at the Tokyo art academy. For further information on this artist, readers are referred to HARADA, 1974 (1968), pp. 62-78.

6 Shimoyama, in the catalogue Landscape Painting in the East and West, SHIZUOKA 1986, p. 338, and in an interview in Shizuoka on 10 October 1993.

7 Catalogue Landscape Painting in the East and West, SHIZUOKA 1986, p. 338. These terms are, for example, used by Tetsugoro Yorozu (1885-1927).

8 Shimoyama in the catalogue Landscape Painting in the East and West, SHIZUOKA 1986, p. 338, and in an interview in Shizuoka on 10 October 1993.

9 It is interesting to note that Western art in this period (even beginning in the early twenties) also tended to hark back to the tradition of figurative art. The movement in Surrealism, in which fantasy or dreams were depicted figuratively, also found a number of adherents in Japan from the early thirties onwards. The number of followers of Western Surrealism in Japan was to increase particularly after the Second World War, thanks to Taro Okamoto (b. 1911), who had joined the Surrealists in the thirties in Paris. When war broke out, he returned to Japan and provided inspiration for many young artists there.

10 Newspaper publishers not only played an important part in that they sponsored exhibitions of modern Western and Japanese art, but also because they wrote about it. In 1950 the publisher of the newspaper Yomiuri organized the 'Gendai Sekai Bijutsu Ten' (Exhibition of contemporary world art) and in 1951 the Mainichi newspaper organized a 'Salon de Mai' at which paintings by American artists like Pollock, Rothko and Still were on show. In 1952 the latter embarked on a 'Biennial'. In 1956 the publisher of the Asahi newspaper took the initiative for an exhibition entitled 'Sekai Konnichi no Bijutsu Ten' (World Art today), with works by Fautrier, Dubuffet, Mathieu and Fontana, amongst others.

The first museums of modern art were also built in the nineteen-fifties. In Kamakura one was built in 1951 and a year later a second in Tokyo.

11 As was said in the Introduction, the present study has become so extended that these artists could not be reviewed.

12 Introduction by the directors of the Penrose Institute in the catalogue The Gutai Group 1955/56, TOKYO 1993, p. 11.

Alexandra Munroe calls Gutai in the catalogue Japanese Art after 1945. Scream against the Sky, YOKAHAMA 1994, p. 185: "Japan's most significant, influential, and arguably first international avant-garde movement in the postwar art". This catalogue provides a good overview of modern Japanese art after 1945. I do not wish to express an opinion on the text relating to art after 1960, but concerning the Gutai text, I have to conclude that the catalogue does not shed new light on the group.

13 Interview with Kazuo SHIRAGA in Amagasaki on 11 November 1993. He added that the meetings were held at his house, and sometimes at Kanayama's. The Metropolitan Museum in Tokyo has a list of members who attended the meetings.

14 Interview with Saburo MURAKAMI in Kobe on 31 August 1993. Akira Kanayama, another member of the group, remarked that it was worth remembering that Murakami had studied philosophy, thus intending to emphasize that the name Zero was not without significance. Interview with Akira KANAYAMA in Kobe on the same day.

15 SUZUKI, 1993 (1938/1927), p. 375.

16 Shiraga did, however, comment that the same trend could be found in international art. One wonders whether Suzuki might not have been right with his remark that every human being longs for simplicity.

17 Interview with Kazuo SHIRAGA in Amagasaki on 11 November 1993.

It is remarkable that in Germany, though admittedly six years later, a group was also founded with the name Zero. Although Günther Uecker, who was discussed in the

chapter on Germany, belonged to the Zero group, his ideas were different from those of the founders Otto Piene and Hans Mack. Their ideas were not discussed in more detail, in view of the already extensive scope of the present study.

18 This exhibition was held in the Sogo department store in Osaka.

19 Later in this chapter the views of Yoshihara and some works of Shimamoto (note 40) will be discussed.

20 Interview with Saburo MURAKAMI in Kobe on 31 August 1993.

21 Saburo Murakami in *Gutai* 4, 1956. The English translation of this article is published in the catalogue *Gutai*, DARMSTADT 1991, p. 399.

22 Interview with Saburo MURAKAMI in Kobe on 31 August 1993.

23 SUZUKI, 1993 (1938/1927), pp. 62-63.

24 See for references to Sartre pp. 61, 111 and 166.

25 Interview with Saburo MURAKAMI in Kobe on 31 August 1993.

26 Interview with Saburo MURAKAMI in Kobe on 31 August 1993.

27 That period will be discussed later in this chapter.

28 'Japanese elements' refer to the predominating emptiness and extreme asymmetry. Interview with Kazuo YAMAWAKI in Nagoya on 15 September 1993.

These aspects can also be found in Western works. Often, as in Mondrian's paintings, there is some allusion to the artist's interest in the Far East. Mondrian, for instance, was an adherent of Theosophy. Kanayama knew his work from art magazines.

Masaharu ONO emphasized in an interview in Osaka on 16 September 1993 that 'geometric abstraction' had not had much influence in Japan because it was too rational for the Japanese character.

29 Interview with Yuko HASEGAWA and Masako SHIMIZU, curators at the Setagaya Art Museum in Tokyo, on 26 November 1993.

30 Interview with Atsuko TANAKA in Kobe on 31 August 1993.

31 Interview with Atsuko TANAKA in Kobe on 31 August 1993.

32 In Soun-Gui KIM, 1986, p.227, one can read in an essay on the difference between Chinese and Japanese art that the theme of repetition, of echoes combined with 'emptiness', is typically Japanese.

33 Teng Kuei, Mark Tobey's Chinese friend (see the chapter 'The unity between West and East. American artists and Zen') also used that technique.

34 Interview with Hajime SHIMOYAMA in Shizuoka-shi on 10 October 1993.

35 Interview with Hajime SHIMOYAMA in Shizuoka-shi on 10 October 1993.

36 Interview with Hajime SHIMOYAMA in Shizuoka-shi on 10 October 1993.

37 It is striking that in that period there was also a 'physical automatism' in the West. Asger Jorn, an artist of the Cobra group, defined it in 1949 as expressing oneself in the form of a physical action which materializes in thought. So mental automatism is organically linked to physical automatism. JORN 1949, p. 8, STOKVIS 1990 (1974), p. 84.

The American artist Jackson Pollock also worked in a similar way, partly under the influence of his interest in non-Western cultures. See the chapter 'The unity between West and East. American artists and Zen'.

38 Interview with Kazuo SHIRAGA in Amagasaki on 11 November 1993.

39 Interview with Shinichiro OSAKI in Kobe on 1 September 1993.

40 Shimamoto was not only active as an artist in Gutai. He also edited and published the *Gutai* bulletin. Like his counterparts in the Zero movement, he was painting monochromes in the first half of the fifties. In 1950 he made a work comprising several layers of newspaper which he then painted with white enamel. The surface acquired a texture of small holes and cracks, which the artist claims took place by chance. The weight of the thick layers of paint caused holes in the paper. He liked the texture and exhibited the work in 1952. He went on to produce several works in which he deliberately made slashes. In around 1955 Yoshihara showed Shimamoto a reproduction in a magazine of a painting by Lucio Fontana with knife cuts, advising Shimamoto to stop making cuts in his work and undertake new experiments.

At Gutai's first open-air event in 1955, Shimamoto placed a zinc wall, which was white on one side and dark blue on the other. He had made holes in several places through which trees could be seen. From a distance, the holes resembled points of light, because the sun shone through them. The work was a visualization of the title of the exhibition: 'An open-air exhibition of modern art to challenge

the summer sun'. The white side of the surface reflected the sun, and in that way the work was a 'two-sided' monochrome.

41 Interview with Akira KANAYAMA in Kobe on 31 August 1993. Moreover, they also knew that Jiro Yoshihara, the group's leader, was a good organizer.

42 Interview with Kazuo SHIRAGA in Amagasaki on 11 November 1993.

43 Interview with Kazuo SHIRAGA in Amagasaki on 11 November 1993.

44 Jiro Yoshihara in *Gutai* 1, 1955, p. 27.

45 Jiro Yoshihara in *Gutai* 1, 1955, p. 27.
 In this first edition of *Gutai* works were reproduced by the following members: Sadani Azuna, Yutaka Funai, Masakoshi Masanobu, Hiroshi Okada, Hajime Okamoto, Yoshio Sekina, Shozo Shimamoto, Taniko Ueda, Chiyu Uemae, Toshio Yoshida and Michio Yoshihara.

46 Jozo Ukita in *Gutai* 2, 1955, foreword.

47 It is odd that the Gutai group only published their manifesto after two years. It looks as if they did so to give the group international credibility, since they apparently did not feel the need to draw up a manifesto before that – in the same way as Zen did not feel the need for rules either. The manifesto was published in English in the catalogue *Gutai*, DARMSTADT 1991, pp. 364-369.

48 YOSHIHARA, 1956, pp. 202-205.

49 YOSHIHARA, 1956, pp. 202-205.
 This aim resembles that of several Western artists in the same period, including the previously mentioned members of the Cobra group, Action Painters in America and artists like Jean Dubuffet and Antoni Tapiès, who created 'matter art'.

50 SUZUKI, 1970 (1953), p. 351, and SUZUKI, 1993 (1938/1927), p. 36.

51 After a few years Okamoto switched to a Surrealist style of painting. See note 9. Kazu Kaido wrote about Okamoto in the catalogue *Reconstructions*, OXFORD 1985, p. 14: "His role in the development of the Japanese avant-garde was extremely important as he not only linked pre-war European avant-garde art to that of post-war Japan but also managed to establish a sense of persona of the artist as it is understood in the Western avant-garde".

52 BALLO, 1971 (1970), p. 188.

53 Interview with Kazuo YAMAWAKI in Nagoya on 15 September 1993.

54 In the West, artists derive inspiration from works of non-Western cultures as well as works made by the mentally-handicapped and by children. For more information on these subjects, when not relating to the Far East, readers are referred to literature dealing with Primitivism and Art Brut. Developments in psychology in the first half of the twentieth century were also relevant for the Western artist's alternative perception of his environment. See the previous chapters concerning the roles of Freud and Jung.

55 See literature on Gutai.

56 Description of the work by Barbara Bertozzi in the catalogue *Gutai*, DARMSTADT 1991, p. 33.

57 NAKAMURA, 1992, p. 58, believes, as we saw earlier in this chapter, that it is typical Japanese that the material is allowed to lead its own life.

58 Interview with Akira KANAYAMA in Kobe on 31 August 1993.

59 Interview with Tohru MATSUMOTO in Tokyo on 13 October 1993.
 SUZUKI, 1993 (1938/1927), p. 363, wrote about this aspect in Japanese culture. The new position on 'matter' in the Western world is dealt with earlier in this chapter and in preceding chapters.

60 This can be illustrated with the following Zen anecdote. A man saw a Zen monk praying in front of a statue of Buddha and the next day, to his surprise, saw the monk burning the same statue. The monk's response was: "Now I'm cold".

61 Interview with Akira KANAYAMA in Kobe on 31 August 1993.

62 Interview with Atsuko TANAKA in Kobe on 31 August 1993.

63 NAKAMURA , 1992, p. 58.

64 Murakami in *Gutai* 7, 1957, which was published three months after the exhibition.

65 Murakami in *Gutai* 7, 1957. An English translation was published in the catalogue *Gutai*, DARMSTADT 1991, pp. 401-402.

66 Murakami in *Gutai* 7, 1957. An English translation was published in the catalogue *Gutai*, DARMSTADT 1991, pp. 401-402.

67 ABEGG, 1970, p. 336.
 The absence of time in Western art had already been noted by the philosopher Kitaro Nishida in 1934, in his comparison of Western and Eastern art. He believed that the Greeks had begun with the denial of the concept of time. CHARLES, 1986, p 190.

68 Shinichiro Osaki in the catalogue *Giappone all'avanguardia*, ROME 1990, pp. 31-33.

69 The description of the work is given by Barbara

Bertozzi in the catalogue *Gutai*, DARMSTADT 1991, p. 22.

70 Barbara Bertozzi in the catalogue *Gutai*, DARMSTADT 1991, p. 26.

71 Interview with Yoshihiro NAKATANI in Kyoto on 14 September 1993.

72 In addition, in the first half of the fifties several exhibitions of Western art were held in Tokyo. See the Introduction to this chapter. The Zero artists from the Kansai district, far from Tokyo, did not visit the exhibitions.

73 Shinichiro Osaki in the catalogue *Gutai*, DARMSTADT 1991, p. 70.

74 Interview with Toshimitsu IMAI in Tokyo on 8 October 1993 and interview with Koichi KAWASAKI in Ashiya on 10 September 1993.

75 Barbara Bertozzi in the catalogue *Gutai*, DARMSTADT 1991, p. 50.

76 Barbara Bertozzi in the catalogue *Gutai*, DARMSTADT 1991, p. 50.
Tapié had only exhibited the paintings by Gutai artists in the West, which gave them the impression that Westerners were only interested in that kind of work. When the Dutch art group Nul organized an exhibition together with the German Zero for the Stedelijk Museum in Amsterdam (which took place in May 1965), the Gutai artists were asked to participate. The organizers were dismayed when they discovered that only paintings and not the expected 'installations' had been sent from Japan. In Amsterdam a few old projects were reconstructed at the last minute by several Gutai members. Within the framework of the present study, it is interesting to note that Yves Klein (who was mentioned earlier) who also took part in the exhibition, was initially against Gutai participation, because he feared the public might think that Western artists had been influenced by Gutai. This information was supplied by Henk Peeters, member of Nul and one of the organizers of the exhibition and noted during one of our conversations in 1993.

77 Interview with Kazuo YAMAKAWI in Nagoya on 15 September 1993.

78 Interview with Shozo SHIMAMOTO in Nishinomiya on 18 September 1993. See note 40 for more information on this artist.

79 Interview with Shinichiro OSAKI in Kobe on 1 September 1993.

80 Shinichiro Osaki in the catalogue *Gutai*, DARMSTADT 1991, p. 71.

81 YOSHIHARA, 1956, pp. 202-205.

The following remark must be made in the context of the differences between Tapié and Gutai, concerning the name 'Art Informel', which literally stands for 'art without form'. In that sense it appears to be a reaction to the art of geometric abstraction. However, Toshimitsu Imaï noted that 'informel' is situated between form and non-form, and that it was connected with 'becoming form'. According to Imaï he had often spoken to Tapié about Zen, in particular about Suzuki's books, and Tapié had understood Zen at that time (Interview with Toshimitsu IMAI in Tokyo on 8 October 1993). However, I am of the opinion that there is an important difference: Tapié's aim is to 'work in a field between form and non-form', and Zen's aim is 'the tension between form and non-form'. In Zen 'becoming form' is related to the imperfection of forms: "Perfect forms are felt to draw the attention to the form rather than to its inner truth" (NAKAMURA, 1992, p. 290). In that area Zen and Tapié would seem to have more in common.
Many works by French artists of the *Art Informel* movement certainly make a more 'formless' impression than many of the Zero and Gutai groups' pieces. It is odd that Zero's basic principles: "no meaning, no composition, no colour" do not include "no form".

82 Yamawaki in the catalogue *The Gutai Group 1955/56*, TOKYO 1993, p. 50.
A view which was comparable to that of Gutai regarding material was to be found in the previously mentioned 'Manifesto Bianco' by Fontana and in an expression like 'the dialogue with the material' by Asger Jorn in *Cobra*. JORN in *Cobra* no. 2, 1949. In her thesis STOKVIS, 1973, p. 102 ff., links the interest of the Cobra artists in matter with the dialectic materialism of Marx and the philosophy of Gaston Bachelard.

83 SUZUKI, 1993 (1938/1927), pp. 258, 164 and 144.

84 SPRIGGE, 1990 (1985), p. 106 and p. 96, remarks that, according to Nietzsche, an artistic creation is, above all else, the motive to impose one's own personality on the crude material, which is then transformed, a dominance over things through the suffering of pain. It is not clear from Tapié's texts whether he agreed with Nietzsche in that respect.

85 SPRIGGE, 1990 (1985), p. 100.

86 ROBERTS, 1992, pp. 114 and 155. 'Dada' was known in Japan thanks to Tomoyoshi Murayama, who had studied in Berlin and

founded a 'Dada' group in Japan called 'MAVO'.

87 Interview with Shozo SHIMAMOTO in Nishinomiya on 18 September 1993.

88 This opinion was confirmed frequently during interviews with Japanese art historians.

89 Interview with Shozo SHIMAMOTO in Nishinomiya on 18 September 1993.

90 Interview with Shozo SHIMAMOTO in Nishinomiya on 18 September 1993.

91 Interview with Shozo SHIMAMOTO in Nishinomiya on 18 September 1993.

92 In the fifties the following were important art magazines: *Geijitsu Shincho*, *Mizue*, *Bijutsu Hihyo* and *Bijutsu Techo*.

93 The artist Toshimitsu IMAI recounted during an interview in Tokyo on 8 October 1993 that when he was a schoolboy he had heard lectures by Suzuki. His headmaster was a friend of Suzuki's.
 According to Y. IWATA, in an interview on 2 May 1995, Suzuki's books are currently popular in Japan.

94 My reference here is to the list of interviews conducted in Japan.

95 See preceding chapters.

96 Interview with Masaharu ONO in Osaka on 16 September 1993.

97 Yoshihara learned the importance of originality from his teacher Fujita. During his period in Paris Fujita had been influenced by Western views on art. The Western idea of developing a new style had also been introduced in Japan by Okamoto. Catalogue *Reconstructions: Avant-Garde Art in Japan*, OXFORD 1985, p. 14. As Gutai's leader, Yoshihara stimulated this attitude among the Gutai members. The fact that Yoshihara advised them to sign their works with 'Gutai' rather than their own names, suggests that 'individual-related original art' was not important for him. And at some exhibitions the works were indeed signed 'Gutai'.

98 Interview with Shozo SHIMAMOTO in Nishinomiya on 18 September 1993.

99 Interview with Shinji KOHMOTO in Kyoto on 21 September 1993.

100 Nakamura in MOORE, 1967, p. 195.

101 NAKAMURA, 1992, p. 91.

102 Interview with Saburo MURAKAMI on 31 August 1993.

103 Shin'ichi Hisamatsu learned about Zen from his Master Ikegami Shozan of the Myoshin-ji temple in Kyoto.

104 These remarks by Shin'ichi Hisamatsu come from his lecture at Harvard University in 1957.

Both extracts from this lecture are published in the article 'Morita Shiryu, calligraphe japonais' by Francette DELALEU, in an anthology of the publication which she supervised herself in 1984.
 An important part has been played by Kitaro Nishida in the revaluation of Zen in the context of a view of the modern international world. The ideas of Hisamatsu and Suzuki, who was a school friend of Nishida and with whom he kept on touch for many years, were greatly influenced by Nishida's views.

105 Morita in *Bokubi* 1, June 1951, unpaged.

106 For example, several works by Alechinsky were reproduced in 1953 in *Bokubi* 26. *Bokujin* 33 of 1955, contained a 1953 Monotype by Götz, with texts by that artist and by Edouard Jaguer. In *Bokubi* 55 of 1956 a letter by Götz was printed. It dealt with 'Informal' art.
 In issues of the first two years of that magazine's publication (1952 and 1953) reproductions of work by Alcopley, Kline and De Kooning can be found, as well as an interview with Soulages, illustrated with examples of his work.

107 The *Gutai* bulletin contained English translations of several pieces. It is not clear why the Gutai artists preferred English, and the Bokujin artists French.

108 The members of Genbi organized three exhibitions of works by participating artists. The first was in July 1953 in Kobe, the second in November 1954 in Osaka, Kobe and Kyoto, and the third in November 1955, in the same locations.

109 Interview with Shiryu MORITA in Kyoto on 17 April 1991.

110 Interview with Shiryu MORITA in Kyoto on 17 April 1991.

111 Shin'ichi Hisamatsu in BUCHNER, 1989, p. 212.

112 Interview with Kazuo AMANO in Tokyo on 10 December 1993.

113 GÖTZ, 1983, pp. 955 and 957.

114 See the chapter 'The unity between West and East. American artists and Zen' for Kline's work.

115 Interview with Shiryu MORITA in Kyoto on 17 April 1991.

116 Interview with Shiryu MORITA in Kyoto on 17 April 1991.

117 GRILLI, 1954, p. 30.

118 Derived from 'Ryu-wa ryu-o shiru' which means 'a dragon knows a dragon'. MORITA in *Work and Thought*, undated and unpaged.
 There he also observes that the dragon

has positive associations in the East. In the Western world it tends to be the creature slain by St. George. It was not until he had travelled through Europe in 1963 that he discovered that traditionally Nature is seen in Western culture as a force to be restrained, enslaved or even destroyed. Only then did he realize that it was quite different in the East. There people feel Nature breathing within them, and all creatures are in and with mankind, not opposite or separate.

119 In Western modern art, 'texts' have been introduced and called 'Conceptual art'. Morita's works are not Conceptual art, because the formal aspects, the artist's contact with the material and the 'implementing' action are of vital importance. *Shō* cannot be compared with Western calligraphy either; in the latter only the formal elements are important.

120 Interview with Mitsugi UEHIRA in Kyoto on 14 September 1993.
Mr. KASHIMOTO, lecturer of linguistics and interpreter during my interview with Murakami, gave an example of this relationship with Nature: Even in a Christian church recently built on Hokkaido there is a large window looking out on Nature. (Although the original inhabitants of Hokkaido are Ainus, they have much in common with the Japanese, spiritually).

121 Morita in 'Calligraphie et peinture abstraite' of 1969, published in DELALEU, 1984, and an interview with Shiryu MORITA in Kyoto on 17 April 1991.

122 Interview with MORITA on 17 April 1991. Morita explained that he was a great admirer of Nantembō's work, which, he believes, fulfil his own ideals. Consequently, he is of the opinion that he was, to some extent, influenced unconsciously by the works in question.

123 Interview with Kazuo AMANO in Tokyo on 10 December 1993.

124 This analogy was confirmed during interviews with various experts. For example by Mitsugi UEHIRA and Koichi KAWASAKI in interviews on 14 September 1993.

125 Shiryu MORITA in *Work and Thought*, undated and unpaged.

126 MOORE, 1967, pp. 288 and 291.

127 Interview with Toshimitsu IMAI in Tokyo on 8 October 1993.

128 Interview with Kazuo SHIRAGA in Amagasaki on 11 November 1993.

129 MORITA in 'Calligraphie et peinture abstraite'

of 1969, published in DELALEU, 1984, p. 25.

130 See the chapter 'Zen and the Zen arts' for the views and working methods of the Zen Masters. They coincide with those of Morita, as explained earlier in this chapter.

131 Such concentration was not only achieved during painting. At the opening of the exhibition of Gutai works in December 1993 I witnessed how Murakami concentrated and then with great dynamism, as in the martial arts of Zen, burst through his paper screen, thus opening up a way into the exhibition hall.

132 Interview with Mitsugi UEHIRA in Kyoto on 14 September 1993.

133 Kazuo Yamawaki stressed, as regards 'universality', that since the introduction of Western painting in the 19th century, 'Western style painting' was seen by the Japanese as a 'Universal style'. Interview with Kazuo YAMAWAKI in Nagoya on 15 September 1993.
Shimamoto believes that this goal, to form an international network, is akin to Zen, in that "Zen is a communication with body and mind without words". Interview with Shozo SHIMAMOTO in Nishinomiya on 18 September 1993. After he had distributed the *Gutai* bulletin, he continued with 'Mail Art', in which he was to become one of the most active artists in the world.

134 *Bokuzin* 50, 1956, p. 0.

135 Interview with Kazuo SHIRAGA in Amagasaki on 11 November 1993.

136 Tanaka began with 'empty field painting' containing 'calligraphic' figures. She then made 'living art', and in the late fifties her works resumed a 'calligraphic' character with coloured spheres.
Kanayama started off with 'minimal painting' which he transformed into 'living art'. At the end of the fifties he was making 'calligraphy-like' works with the toy engine.

137 The action of throwing the ink-smeared ball on the paper is what made these works 'living art'. They can also be classified as 'art of the calligraphic gesture' on account of the materials used: *Sumi* ink and paper, and the ink spatters on the paper. The predominating emptiness (there is only one blot of ink with a few spatters around it) means that they also count as 'art of the empty field'.

138 However, in the sixties they grew apart. Interview with Shinichiro OSAKI in Kobe on 8 September 1993.

139 NAKAMURA, 1992, p. 185.

Conclusions

The interest of Western artists in Zen Buddhism can be seen as part of the age-old relationship between East and West. As earlier in history, the focus of the fascination for the East in the fifties gives insight into some aspects of the nature of Western culture at that moment. So the interest in Zen in the Western centres studied had common factors, but there were differences too. For example, the 'introduction' of this Oriental philosophy in the West varied from one country to another, in both procedure and period. In Germany the ideas of Zen became known in the thirties, within the framework of the promotion of cooperation with Japan. In that period a number of German artists became preoccupied with Zen. After the war, Zen acquired a new meaning for some artists, who considered it to be a suitable symbol of freedom, and consequently, in 1949 founded the art group Zen 49. In the thirties, only summary reference to Zen could be found in a few books in America. Interest in the subject there was gradually emerging in the late forties, as a reaction to what was felt to be an inordinate focus on Europe, and in the awareness of America's ideal geographic location for promoting an interchange between West and East. Fenollosa had, admittedly, already drawn attention to that fact at the start of the century, and Tobey was propagating it in the thirties and forties, but it was not until the fifties that a larger group of artists proved to be receptive to these views. In Paris a serious interest in Zen only came about in the mid-fifties, when literature on the subject proved to provide a 'theoretical framework' for imported Japanese arts.

All the centres in the West had in common the important part played by Daisetz T. Suzuki's books in shaping ideas on Zen. In addition, a Zen 'boom' was growing in these centres at the end of the fifties, especially in conversations in intellectual and artistic circles.

The original working title of this treatise was 'Neo-Japonisme'. However, in the course of the research it proved to be inappropriate. 'Neo' implies that Japonisme experienced a second flowering, but that was not the case. In actual fact, a sequence of phenomena occurred, starting during the Japonisme period. Although the nineteenth century 'Japonistes' were primarily interested in Japanese woodcuts, those works comprise a number of aspects which are also found in the Zen arts. For instance, the consiousness that the world is something dynamic and constantly changing is reflected in the term *Ukiyo-e* (pictures of a fleeting world). The prints show the spectator the artist's 'direct experience' of the most commonplace of things. In addition, emptiness plays an important and independent part on the composition. There is an almost complete absence of linear perspective, but many prints comprise the suggestion of undefined or infinite space.

Research revealed that the Japonistes were not only aware of *Ukiyo-e*, but also of *Sumi-e*. However, in those days the latter was rarely associated with Zen. Awareness of such works was fostered in the West mainly thanks to books by Ernest Fenollosa and Ernst Grosse. Since calligraphy prevails in both *Ukiyo-e* and *Sumi-e* the Japonistes were acquainted with the characteristics of Japanese calligraphy, and also applied them in some works.

So it transpires that the similarity between Western works with calligraphic gestures of the nineteen-fifties and the calligraphy of the Far East did not suddenly come about after the Second World War. The use of line, as applied by artists from the turn of the century to the fifties, underwent a gradual development. Toulouse-Lautrec was trying, at the end of the nineteenth century, to master the formal characteristics of Japanese line. In the first three decades of the twentieth century Kandinsky, O'Keeffe, Bissier and Hartung sought to give their works an Oriental contemplative ambience, by means of lines which arose from their inner feelings. In the thirties and forties Surrealists like Michaux and Masson, with their interest in the Orient, strove to achieve a use of line expressing an unconscious inner life. In the calligraphy-like lines in works by Pollock, Götz and Mathieu in the fifties the emphasis shifted to spontaneous expression and the intense experience of the formation process. For artists like Degottex and Alechinsky the fascination for the expressive nature of handwriting led to an interest in the technique of the *Shō* artist and the philosophy of Zen.

The present research was not only directed at paintings with calligraphic gestures, but also at what might be termed 'art of the empty field'. Those works did not happen by chance in the fifties either. They bore a resemblance to works which could already be found in the second half of the nineteenth century. Various Japonistes adopted the simplicity of the large expanses of solid colour from *Ukiyo-e*. In the early nineteen-tens Kandinsky stressed the *Innere Klang* which the combined effect of blots of colour in his works was intended to produce. Developments in the twentieth century in Western society were such that in the fifties a number of artists went in search of the essence of art and life, as well as a strong existential experience. The outcome was works which consisted of large fields of colour with minimal variations in tone. Some artists who produced these works felt an affinity with the philosophy of Zen and several formal aspects of the Zen arts such as emptiness.

The fifties prove to have been a suitable breeding-ground for Zen. The predilection of artists in the first half of the twentieth century for the Far East coincided with their inclination to withdraw from everyday life. In the fifties, the interest in direct experience of 'here and now' put the artist right back in the middle of life – not social or political life, but 'human existence'. Both Existentialism and Zen admonished the artist not to flee. Although most artists in the Western centres studied, and in Japan, were interested in French Existentialism, it is striking that the protagonists of this research actually tried to suppress or, rather surpass, their own will, whilst Sartre stressed that will so emphatically. In that respect they were getting close to the views of Zen.

Symbolism, Freud's theories and Surrealism had opened up the way for Western artists to express their inner selves and seek the essence of mankind. The views of Jung, who was also absorbed with the Orient, prove to have been of importance as well. His theories, with their emphasis on *Ganzwerdung* (becoming whole) and the universal, are closer to those of Zen than Freud's are. In the fifties Jung's ideas were particularly well known in America. Although the focus of psychoanalysts and Surrealists on Man's inner life and oneness gave some Western artists the feeling that kinship with Eastern artists was growing, there was still a difference between artists of the West, for whom their own psyche was central, and those of the East, who were seeking within themselves unity with their surroundings and even with the entire cosmos. And although Western artists in the fifties were generally more optimistic than the Surrealists, they were still unable to shake off the problems of psychology entirely, to become as optimistic as Zen would like Man to be.

In addition, theories originating from disciplines other than Philosophy and Psychology were important. The view of the world which had been changed by developments in modern Physics, for instance, would seem to have reduced the gap between Western ideas and those of the Far East.

As a result of the Second World War, amongst other things, there was more interest in the Western world among artists for international art and for the phenomenon of 'liberty'. The latter is also one of Zen's main aims, and was an important explanation for the affinity with Zen. But generally speaking, the concept of liberty has a different meaning for Westerners than for the Japanese.

In Japan the 'fifties' artists I studied were especially influenced by Western avant-garde's desire for innovation. In reforming modern Japanese art, the Zero artists unconsciously integrated elements of Zen.

The non-figurative works of the scrutinized American, French, German and Japanese artists were divided into three categories. Alongside 'art of the calligraphic gesture' and 'art of the empty field', the category 'living art' was applied. They were encountered in all locations, so it constituted an international phenomenon, with local and individual differences.

The works of the artists in the 'art of the calligraphic gesture' and 'art of the empty field' categories have a common factor, in that polychromy was practically or entirely absent, as is the case in *Sumi-e*. Another common feature was the insubordinate role played by mass.

'Art of the empty field'

The foremost analogies between the works of these artists, apart from the minimal variations in colour, are the great simplicity of composition, the absence of artist's handwriting and the contemplative character. It is striking that the latter element is precisely the one which is least in evidence in the works of the Japanese Zero/Gutai artists, who were primarily practice-oriented.

The artists in this category, like Reinhardt, Klein, Geiger, Tanaka and Kanayama, have in common that they were outsiders among their 'expressive gesture' colleagues. So the differences are more personal than local, and relate particularly to colour or composition preferences.

'Art of the calligraphic gesture'

The main common features are an interest in Japanese calligraphy, the relationship between the artist's personal handwriting and a 'universal' writing, and a use of black and white contrast.

Several of the works have a meditative character. In Tobey's work, for instance, this is brought about by the suggestion of infinite depth and the overall composition of the writing structure. The meditative character of Degottex's works stems from the simplicity of a single or occasional brush-stroke, complemented by a large empty expanse of one single colour. As was the case with the preceding category, the meditative nature is less in evidence in the Zero and Gutai works than in the Western works.

The *Shō* artist and artists creating modern works differ distinctly, in that the calligrapher strives to achieve professional skill according to the rules of his craft, and then tries, by way of a personal style, to transcend himself from within. The modern artist seeks to reach a personal discovery of a form of expression conveying both his individual inner self and something universal. Moreover, a piece of *Shō* is always based on a *Kanji*, and so always has a meaning, however indecipherable it may be. There is also a difference between the painting method of the calligrapher, who paints the whole work in one layer, without corrections, and the Western approach, in which the paint is layered and corrected, even though the Western artists who have been discussed were pursuing an increasingly more direct method. So the calligrapher paints, as in writing, from one side to another, unlike the Western artist, who builds his work up, layer upon layer. Unlike the Western modern artist, who prefers to let chance takes its course, the *Shō* artist aims to infer chance.

The *Shō* artist Morita sought to contact artists in Europe like Alechinsky and Götz, and was very interested in Kline's works. Of these four artists, from four different areas of research, Morita is obviously the most akin to Zen. Alechinsky was chiefly interested in the technique of *Shō*, and was the most inclined of all the Western artists under review to use Japanese materials. Götz's work is further than Alechinsky's from the calligraphic line, on account of the technique he used. Yet with Götz there is more unity between black and white, as in *Shō*. Kline strove to achieve the same equilibrium, and would seem to have been inspired by both the *Ukiyo-e* and the calligraphy of the Far East. When the four artists are compared, it emerges that Kline was the least interested in the philosophy of Zen and the views of the *Shō* artist.

'Living art'

Examples of this style were found in the work of Cage, the Zero and Gutai groups, and Klein; Uecker inclines towards that style. The common denominator of these works is performance, which constitutes the physical presence of the artist, and involves the direct experience of both the artist and the spectator.

In Zen the world is considered to be dynamic and art should be part of this movement. Conversely the traditional Western artist has, for the most part, been concerned with freezing movement. So it is hardly surprising that Japan was the very place in which 'living art' was being produced by a group of artists, as early as 1955.

Unlike traditional Western culture, in which the mind is always viewed as superior, the union of body and mind is an important aspect of Zen. Accordingly, in the 'living art' of the fifties, the 'physicality' of Western artists usually lagged behind that of their Japanese colleagues, like Shiraga and Tanaka, who allowed their bodies to fuse completely with their material. This difference can be described, in extreme terms, as 'observation' as opposed to 'participation'.

Another striking difference between the studied works of the West and Japan is that, in Western 'living art', form is subservient or absent, whereas the Japanese Zero/Gutai artists' 'living' works are made up of simple geometrical forms.

The connection of 'living art' with the irrational works of Dada is sometimes raised. Cage was quite clear about his interest in the ties between Zen and Dada. Klein denied any consanguinity with Dada. Yet critics have often wondered about a connection with Dada or Zen. My research suggests that Klein, like Cage, was living proof of some parallels between the two philosophies. It is reasonable to assume that Yoshihara, the leader of Gutai, was acquainted with Dada and with the Japanese Dada, which was inspired by Berlin artists. And that might well have contributed to some of Gutai's projects. Yet there are distinct differences between Dada and Zen. Dada is more negative in mood and geared to the conflictual and the bizarre, unlike the positive nature of Zen, with its pursuit of nondualism and direct experience of the commonplace.

When the various centres were discussed, the procedure was to compare and contrast several aspects of Zen with the views, techniques and/or works of the selected artists. A number of conclusions can be drawn in that respect, and will be dealt with aspect by aspect.

Emptiness and nothingness

During Japonisme Western artists became increasingly interested in the formal aspect of emptiness. It was seen as an 'absence of something'. In the course of the twentieth century, the meaning of emptiness was to change for some Western artists. The challenge of 'nothingness and emptiness' as a basic concept in art particularly appealed to the Frenchman Klein, and the Americans Reinhardt and Cage. The latter two artists were particularly fascinated by the idea that nothing and something were equal. The German artists were attracted to the idea of 'nothingness' as symbolizing the start of a new era in which abstract art was allowed. The Japanese Zero artists had no philosophy about nothingness as such, though they did take it as a point of departure. They wanted to begin with nothing and refer to nothing. For Morita 'nothingness' primarily had a spiritual significance, of 'transcending'. For the French artists Klein and Degottex the effect of emptiness was especially important in their art, for the former the spiritual effect, for both the universal and meditative expression.

When emptiness is examined as a formal aspect, the question arises in which of the works under review it is, formally, most important. Subjectivity is the greatest impediment in an appraisal of this type, the only solution to which is to compare and contrast 'types'. Two groups emerge: the 'overall composi-

tions' of Reinhardt, Tobey, Uecker and Tanaka on the one hand, and the 'compositions of the occasional line or form contrasting with large empty planes' (as made by Degottex, Kline, Murakami and Kanayama) on the other. The effect of the former works would seem most in keeping with the idea of emptiness in Zen, being empty and full at the same time, and the latter with the visible unity of figure and emptiness found in *Shō* and *Sumi-e*.

The working process of almost all the artists in question reflected emptiness in the absence of rational considerations during their work. That applies in particular to the artists who expressed themselves in expressionistic actions, like Morita, Götz and Degottex.

Dynamism

In general terms, art was considered by the principal artists in this study as an expression of 'life as a dynamic process'. For them, abstract art was a suitable vehicle for expressing non-visible dynamism, i.e. energy. Suzuki's description of Zen's striving to 'grasp life in the midst of its flow' reflected for various Western artists the new sense of how to depict reality.

The 'actions' of the Zero and Gutai artists demonstrate the important part played by dynamism. It transpires that those artists also preferred to make moving objects. In Western works, too, dynamism was most apparent in the 'living art' category, and, accordingly, the connection with the dynamic Zen arts proved to be the least disputed in Cage's and Klein's happenings. Those projects had most in common with the martial Zen arts, in terms of action, with action forming an important contrast to the meditative silences.

The works with the most affinity with the dynamism of the brush-stroke of the Zen art of *Shō* as found in Morita's works, are by Alechinsky, Degottex, Tobey and Götz. Degottex's and Götz's gestures are closest to *Shō* in vehemence and simplicity.

The category of 'art of the empty field' also contains dynamism, in the form of the spare, 'subtle dynamism' as found in Zen gardens, Nō drama and the tea ceremony. Reinhardt's Black Paintings, Tobey's White Writings, Geiger's monochromes and Uecker's 'nail reliefs' suggest a 'subtle dynamism' in their effect of 'vibration'.

The term 'practised spontaneity' is appropriate with respect to the method of the artists whose work entailed calligraphic gestures, since, for years, they had been repeating the same technique. The spontaneity of the Zen Masters is also based on practice, albeit very strict training, in their case.

Undefinite and surrounding space

In the second half of the nineteenth century doubts had begun to arise in Europe about the academic rules of perspective based on a suggestion of receding space. Woodcuts imported from Japan stimulated a more decorative type of painting. In the twentieth century the Cubists, for example, began to experiment with new ways of expressing space. Gradually, from the thirties and forties onwards, an awareness of a new kind of space evolved – 'infinite' and 'undefined' space. Moreover, Western artists were developing an interest in the space around and between objects, the space around (rather than in front of) the artist and the

space between the work and the spectator. Space was also experienced as 'changeable'. A number of artists felt that Zen confirmed their point of view, because they recognized their new ideas about space in those of Zen and the concomitant Zen arts. In the same way as Japanese woodcuts had satisfied the Westerners' needs for a new way of expressing space in the nineteenth century, Zen and the Zen arts served a similar purpose in the fifties.

It is worth noting that the undefinite and surrounding space in modern Japanese works should, in fact, be termed a traditional aspect.

Research into the spatial effect in the 'art of the calligraphic gesture' has shown that the French artists whose work was studied were quite traditional Western: Alechinsky, Degottex and Mathieu, who was touched on briefly, allow the figures to come to the fore; the emptiness in their works, when present, recedes into the background. In the works of Morita, Götz and Kline there is an equality, so unity between figure and residual form, implying that there is practically no foreground or background as such, with the different works seeming to be trying to continue on into actual space.

The artists classified in the category of 'art of the empty field' aimed to unite internal space in the art-work with external or actual space. In their works, space seems to alternate between receding and advancing. Tanaka's large bright pink monochrome was literally even moved to and fro in space, by the wind.

In 'living art' especially there is a sense of experiencing surrounding space. The artists and/or participants carried out their actions in the distinct awareness of the space surrounding their bodies. In this category there is a clear relationship between time and space, though it proves also to be present in many of the other studied works.

Direct experience of here and now
In Zen, *Satori* is acquired by the intense experience of here and now. We can generalize and say that the modern artists who have been researched, also expressed a direct experience of existence in their work. Several artists (including Cage, Geiger, Götz and Klein) were of the opinion that when, in turn, a spectator looked at their works, his awareness could also be heightened. The public can perceive the artist's interest in the intense experience of the moment in the highly expressive rendering of lines, comprising the traces of vehement action, as well as in the effect of the colour fields or in the everyday actions and objects of 'living art'.

The direct experience of existence was also linked with the artistic process in the form of intense concentration during work, adding a ritualistic character to the creation of art-works. It was a disciplined ritual, comparable in a way with the practice of the Zen arts. The artists in question differed, with their preference for concentration and discipline, from the Surrealists, who tried, for instance by using drugs, to avoid all awareness.

The interest in existence is closely linked with the artists' choice for non-figurative work. When the outside world is no longer an example, the artist must create the subject himself, which inevitably leads to questions about 'self' and 'being'. A focus on one's own inner life can also instigate a non-figurative style, which implies a reverse effect.

The term 'purposelessness', which is related to the focus on here and now, was frequently encountered in artists' ideas on art. In the sense of an absence of development, it can also be found in the production of almost identical works, as was the case with Reinhardt, Klein and Uecker.

Nondualism and the universal

In the fifties a number of Western artists began to address the matter of transcending the individual personality. Jung, with theories based on psychoanalysis, set out to prove that what was universal (collective) was part of one's own personality. Anthropology, too, was concerned with the possible presence of something universal in mankind. Knowledge of Zen confirmed the belief in the universal and the possibility of passing from an individual self to a more universal self.

The reasons for striving towards universal art proved to differ somewhat between locations and individuals. The American artists' desire for universal art, in the sense of unity between the art of the West and the Far East, was mainly a reaction to what was felt to be an exaggerated focus on Europe. For German artists, universal art constituted an opportunity to rejoin the international art world. Furthermore, their preference for universal art based on a synthesis of Western and non-Western art was inherited from their great examples, Kandinsky and Baumeister. The goal of universal art for the French artists chiefly followed on from the work of some Surrealists, who had already sought to create universal writing. However, with the French artist Klein, it was his interest in religions and mysticism that led to his quest for universal art. A number of Japanese artists hoped they would be able to participate fully in the international art world by pursuing universal art instead of an imitation of Western art. For Morita, the exercise of *Shō* required unity with the universal. The term here not only refers to what is general in human terms, but also to unification with the cosmos.

The artists in the 'art of the calligraphic gesture' category believed that universally-applicable expression could be found through writing. In the 'art of the empty field' the field of colour, of black or of white was felt to evoke universal feelings in terms of spirituality, and in 'living art' the universal aspect was pursued in the choice of natural actions. Many artists in the various categories tried, in their work process, to achieve unity with their materials and thus transcend their own will, and in that way achieve a more universal, so natural form of expression.

Nondualism, which is such an essential aspect of Zen, could also be found in many of the works I studied. The spectator can perceive nondualism in the equivalence of elements, and in the phenomenon that emptiness can appear full, and dynamism tranquil, as well as an interchangeability of foreground and background.

In the different Western countries there also proved to be a religious undercurrent among the artists under review; this was particularly true of Tobey, Graves, Crampton, Reinhardt, Baumeister and Klein. Some of their observations reveal that they were not unfamiliar with the Christian mystics of the Middle Ages, especially Meister Eckhart. Their interest would seem to coincide

with the focus of Suzuki, Coomaraswamy and Jung on the similarities between that mystic's beliefs and Zen. Meister Eckhart's writings reflect a desire to reach, by means of inner harmony, the 'universal' (in the sense of 'the One' or 'the All') which is comparable to some extent with Zen.

The present study has clearly revealed a wide interest in Zen among artists of the nineteen-fifties. The said affinity was widespread and multifarious. Study of the assembled material confirmed that it is a complex matter to draw conclusions on the implications of this affinity. The views of Zen, but also new views among some art historians, were motives for me to moderate the demand for causal connections and adversative reasoning.

On the whole, the traditional academic approach to art history, based on traditional Western dualism, requires that conclusions be based on differences and antitheses, so on a discriminatory approach. Yet Zen is characterized by nondualism. In that context Suzuki has written:

"We generally think that 'A is A' is absolute, and that the proposition 'A is not A' or 'A is B' is unthinkable" and "we dare not go beyond an antithesis just because we imagine we cannot".[1]

However, when Zen has been studied:

"we now realize that 'A is not A' after all, that logic is one-sided, that illogicality so-called is not in the last analysis necessarily illogical; what is superficially irrational has after all its own logic, which is in correspondence with the true state of things" and "Zen is not bound by the rules of antithesis".[2]

My research has revealed that the traditional opposites of conscious/unconscious, painting/drawing, foreground/background, artist/material, mind/body, something/nothing, artist/work/spectator, and subject/object need not necessarily be real opposites. Nondualistic thinking makes it possible to deal with various categories, such as 'art of the calligraphic gesture', 'art of the empty field' and 'living art' in one study, though traditionally they have always been considered very different. In the course of my research, it became increasingly clear that terms like 'typically Western' and 'typically Eastern' are extremely relative. Features which are frequently termed 'typically Eastern' prove to have been almost constantly present over the centuries as undercurrents in the Western world. Many of the artists in question were aware of that fact, as their references to past thinkers like Meister Eckhart testify.

Through my research I have discovered that the answer to the question regarding the exact consequence of the affinity with Zen must be *A is A, but just as easily not-A and even B*. In this case *A is A* means that all the artists studied had an affinity with Zen, in some way or another, which irrefutably affected their work, in some way or another. *A can also be not-A and even B* because neither I, nor an expert in a subdiscipline, nor the artist himself can say with certainty exactly how the relationship between affinity and effect on his work proceeds, and so whether any correspondence entails influence or coincidence. Since all the artists who have figured in this study also had other interests, which often entailed various aspects comparable with Zen, the consequences of the affinity with Zen cannot be pinpointed with certainty in their works. Suzuki once said in that context:

"The idea is that the ultimate fact of experience must not be enslaved by any artificial or schematic laws of thought, nor by any antithesis of 'yes' and 'no', nor by any cut and dried formulae of epistemology".[3]

For the traditional art historian it is important to examine 'influences', in the widest sense, on artists, and then prove them. However, a feature of Zen's thinking in terms of 'oneness' is that the thought process is not based on cause and effect, but on an interconnection of everything, in equality and without a centre. On this subject Suzuki said:

"'Why' is a word useful only in a world of relativity where a chain of causes and effects has some meaning for human intellection. When we desire to transcend it the question ceases to have sense".[4]

My research demonstrates that Zen and the Zen arts cannot be described as 'influence' or 'cause', or 'merely recognition'. They are an element which existed alongside other elements, and between which there prove to have been many cross connections. So the significance of my research does not rest in determining Zen's influence exactly, but in elucidating the complexity of the phenomenon of the affinity of artists with Zen and the Zen arts in the fifties and explaining the origins of the said affinity. The arrangement of the material into categories, and the elaboration of a number of comparisons based on the characteristics of Zen and the Zen arts (derived from Suzuki's books) resulted in the following conclusion: in view of the recorded connections with Zen, the art of the fifties I have studied can be termed 'Zen – like art', or rather, **'Suzuki-Zen – like art'**.

Notes

1 SUZUKI, 1991 (1949/1934), p. 66.
2 SUZUKI, 1991 (1949/1934), p. 66.
3 SUZUKI, 1991 (1949/1934), p. 55.
4 SUZUKI, 1993 (1938/1927), p. 156.

Appendix I

Extracts from *Hokousaï* by Henri Focillon, 1925 (1914)

– 'Action Painting'/'Living Art'
p. 75: 23 May 1804: "Il exécutait en public une figure gigantesque de l'ascète légendaire Dharma. (Il y avait eu jadis au Japon une école vouée exclusivement à la peinture de sujets religieux de dimensions colossales.) Sur une feuille de papier de deux cents mètres carrés, Hokousaï, armé d'un balai trempé dans un tonneau d'encre de Chine, court en tout sens, excitant la curiosité admirative de la foule...".
p. 76: "On voyait aussi l'homme extraordinaire dessiner avec son doigt trempé dans l'encre, avec un fond de bouteille, avec la pointe d'un oeuf-jeux auxquels le contraignait peut-être sa pauvreté, où sa curiosité du moins trouvait un enseignement et sa virtuosité un exercice".
p. 77: "...sur un des panneaux de papier de la salle, l'artiste étala des ondes sinueuses de bleu, puis, prenant un coq dont il teignit les pattes en rouge, il le laissa se promener sur son dessin".

– 'Chance'
p. 115: "Il arrive qu'Hokousaï pose les pinceaux et se serve d'outils de hasard: ces exercices l'aident à se départir des habitudes et des conventions".

– 'Emptiness'
p. 9: "C'est par les vides ménagés entre les derniers plans et les premiers (...) par l'économie d'un travail qui réserve de grands espace déserts, transparents, lumineux, que l'artiste symbolise l'éloignement et l'atmosphère".

– 'Energy'
p. 128 on figures in works: "ils propagent les vibrations et les ondes de l'universel mouvement".

– 'Essence'
p. 127: "...nous recédons sans peine à l'essentiel: le caractère saillant d'un être".

– 'Humour'
p. 103: "Gai, curieux, poli, sensible, l'humour japonais,...".

– 'Immediacy/Spontaneity'
p. 112: "...il m'est arrivé d'employer le mot *instantané* pour qualifier le soudain passage d'une activité...".
p. 113: "Nos peintres sont pesamment armés. Ils ont à lutter contre une sorte de glu, contre le volume et la densité d'une matière que leur pinceau, parfois, semble sculpter. Tous ceux [Japanese painters] qui sont passionnés pour l'action et pour le mouvement ont allégé leur bagage et peint avec économie. Ils ont essayé de conserver à leurs tableaux le caractère vigoureux et vif de l'esquisse.(...) L'art, ainsi dépouillé, ne devient pas forcément plus sec – mais plus léger et plus fort. (...) Il est peut-être la ressource la plus expressive et la signature la plus authentique du génie. (...) J'ai célébré les vertus du pinceau japonais, sa souplesse, sa fermeté. La plus remarquable peut-être, celle qui nous intéresse le plus ici, c'est qu'il n'interpose ni lenteur ni complications entre l'artiste et son modèle. Il ne pèse ni n'appuie, il court agilement sur le papier ou la soie".

– 'Infinite space'

p. 9: Concerning Sumi-e technique: "Elles contribuent à faire fuir la montagne et les lointains neigeux, mais avant tout à équilibrer la composition et l'effet".

p. 140: "... l'atmosphère: pour éviter de rompre l'unité harmonique..."

– 'Lines: dynamic and direct'

p. 12: "L'élégance calligraphique de la ligne et l'impossibilité de la reprendre, de la rattraper par des repentirs exigent de la part de l'artiste une exceptionelle sûreté de main. Aussi bien n'est-ce pas le poignet qui se meut, mais l'avant-bras ou l'épaule, tandis que les doigts crispés sur la hampe, quelquefois serrée à pleine poigne, ne servent qu'à la tenir".

p. 13: "La peinture européenne est une sorte d'escrime où tous les coups n'ont pas besoin de porter juste, puisque la plupart d'entre eux ne servent qu'à faire le ton et qu'au surplus il est facile de revenir sur une touche maladroite en la recouvrant. Ici [Japanese painting] le trait doit être déterminé du premier coup (...), les Japonais assuraient à la ligne toute sa franchise".

p. 115: "Le trait est un langage, le plus concis et le plus vigoureux".

– 'Meditativeness'

p. 90: "L'art japonais n'a jamais été traversé par une méditation plus large".

– 'Painting process'

p. 32: "L'occident lutte contre la matière elle-même.(...)Pour faire passer en nous tous les rêves du peintre, il dispose de formes enchaînées par leur propre lourdeur. Il les heurte, il les entrechoque, il se débat avec une force (...), ses triomphes sont baignés de sueur. Le Japon se limite: il réduit l'espace, il chasse la nuit, il simplifie et raffine son savoir et, si son génie nous déconcerte encore, c'est peut-être parce que nous y cherchons en vain les traces de nos propres combats et de nos antiques douleurs".

– 'Personal character'

p. 120: "Il a mis le puissant relief de la vie personnelle".

– 'Relation with life itself'

p. 113: "...la poursuite de la vie dans son activité rapide."

– 'Simplicity'

p. 17: Concerning Japanese painting: "...la simplicité du sujet".

– 'Technique of Sumi-e'

p. 9: "La vogue du genre vaporeux, 'Soumiyé' dès la fin du xve siècle, avec Sesshiou et ses disciples, (...) provoquée par la diffussion de la philosophie zèn.

p. 9: A description of a painting by Sesson, one of Sesshū's pupils: "Un arbre (...) s'enlève sur l'harmonie des fonds gris. Ce ne sont guère que deux taches, d'une saisissante vigueur d'accent, dont le modelé est à peine indiqué par des dégradés qui semblent fortuits".

pp. 15-16: In 1878 Edmont de Goncourt met the Japanese painter Watanobe Seï at Philippe Burty's; they watched him as he worked: "Il n'a pas de modèle. Il travaille avec la surprenante sûreté d'un homme qui 'possède' son sujet...".

p. 17: "...la traditionelle dextérité graphique. La transparence et la légèreté sont indispensables, l'eau est ici l'agent essentiel".

p. 19: "...une technique toute personelle".

p. 31: "L'exquise *spiritualité* de cet art".

– 'Zen'

p. 119: "L'observation d'Hokousaï va droit au caractère et s'en empare. Elle pratique scrupuleusement ce respect de l'individu qui est si frappant déjà dans la philosophie et la pédagogie zèn".

In creating avant-garde painting of the fifties the only term missing in Focillon's 'Recipe' is *abstract*.

Appendix II

Comparison of some extracts from the book *Das Unbekannte in der Kunst* written during the war years by Willi Baumeister (shortly after his interest in Zen was kindled) with Daisetz T. Suzuki's book *An Introduction to Zen Buddhism* published in German in 1939.

BAUMEISTER, W., *Das Unbekannte in der Kunst*, 1947

SUZUKI, D.T., *An Introduction to Zen Buddhism*, 1991 (1934), German translation entitled: *Die Große Befreiung* in 1939 (and 1947)

29/Der Betrachter soll nicht denkerisch reflektieren, sondern die Empfindungen allein öffnen.

33/Personal experience is everything in Zen.
104/The questioning is meant to open the mind of the listener.

33/Wichtig ist die Welt der Neutralität, des Einheitempfindens.

35/The East is synthetic in its method of reasoning; (...) a comprehensive grasp of the whole

34/'Zustand': das Nichtwollen, das Nichts tun, die Neutralität.

50/Emptiness, nothingness, quietude, no-thought...
64/Life is an art and like perfect art it should be self-forgetting; there ought not to be any trace of effort or painful feeling. Life ought to be lived as a bird flies....

41/Alles, Raum, Zeit, Farben, muß in uns neu entstehen.

96/There must be the awakening of a new sense which will review old things from a hitherto undreamed-of angle of observation.

51/ ...die innige Verbindung des Einzelnen mit dem Weltleben.

62/When a humble flower is understood, the whole universe and all things in it and out of it are understood.

53/Jedes Kunstwerk ist Selbstdarstellung des Künstlers.

93/The ultimate destination of 'Satori' is towards the Self.

64/Das Leben ist an Bewegung und Relation gebunden.

75/The idea of Zen is to catch life as it flows.

64/[Many artists lack] das Leben begleitende sublime Bewegungen des Wimperschlags, der Atmung.

132/Life itself must be grasped in the midst of its flow; to stop it for examination and analysis is to kill it, leaving its cold corps to be embraced.

83/...unternimmt es der einzelne Künstler (...) die Urkräfte sichtbar zu machen.

119/...nicht Nachbildung der Natur....

155/Der Künstler stößt bis zum Nullpunkt vor. Hier beginnt sein hoher Zustand.

156/Im Vertrauen auf seine einfache Existenz...

156/Der Künstler ist das Organ eines Weltganzen.

156/Er entscheidet sich nie, sondern seine 'Mitte' führt eine Reife herbei, bei der es keine Entscheidung mehr gibt.

159/Das Formbilden entsteht ohne Dualismus.

159/Befreiung der Kunst und des Lebens.

164/...dem Unbekannten, aus dem Nichts geholt...

165/...mittels Sprache nie ausdrücken, was in den Kernbezirk der bildenden Kunst gehört.

166/Der Lehrer hat vor allem die Aufgabe, den Schüler durch Entschlackung, durch Leerung in den künstlerischen Zustand zu bringen. Der Lehrer hat zu leeren.

166/Der Lehrer hat den Schüler gleichsam zum Rein-Autodidaktischen hinzuführen. In diesem Zustand angekommen hat der Schüler keine Führung mehr nötig.

169/Der Unterschied zwischen Vorarbeit und Bild ist verwischt, ja aufgehoben worden.

174/Künstler: Das Unbekanntem zu Bekannte machen.

42/Concentration of the mind (...) in the nature of things.

72/Copying is slavery.

96/'Satori': general mental upheaval which destroys the old accumulations of intellection and lays down the fundation for a new life.

44/Absolute faith is placed in man's own inner being.

54/The thing is to see one spirit working throughout all these, which is an absolute affirmation.
67/The One pervades All, and the All is in the One. This is so with every object, with every existence.
98/Life's expanse broadens to include the universe itself.

68/Any answer is satisfactory if it flows out of one's inmost being, for such is always an absolute affirmation.

39/Zen wants to find a higher affirmation where there are no antitheses.

41/If there is anything Zen strongly emphasizes it is the attainment of freedom.

21/The answer which appears to come from a void.

49/In Zen there is nothing to explain by means of words.

78/Their [the masters] intention is to set the minds of their disciples free from being oppressed by any fixed opinions or prejudices or so-called logical interpretations.

105/To force the student to assume this inquiring attitude is the aim of the 'koan'.

42/Zen defies all conceptmaking.
33/Penetrate through the conceptual superstructure.

45/Zen opens man's eye to the greatest mystery as it is daily and hourly performed.

Appendix III

Zen Group Nederland

In 1960 the artist Theo Bennes (1903-1982) took the initiative to found a group of artists interested in Zen for which he conceived the name 'Zengroep Nederland'. He was supported in particular by his colleagues Peter Royen (1923), Tajoka (the pseudonym of Theo Kemp) (b. 1933) and Cor de Nobel (b. 1929). These artists got to know one another at De Nobel's gallery .31, in Dordrecht. They regularly met up with like-minded artists to discuss topics such as Zen. Although the Zengroep Nederland never claimed to have 'members' as such, this enterprise was confirmed by a manifesto issued by Theo Bennes and Hans Wesseling in 1960 (ill. 112b and a)). The tropic merits further study.

112/a. Theo Bennes and Hans Wesseling, 'Manifest van de Zengroep Nederland' (back), 1960
Archief Theo Bennes; Henk van Laatum, Amsterdam

229

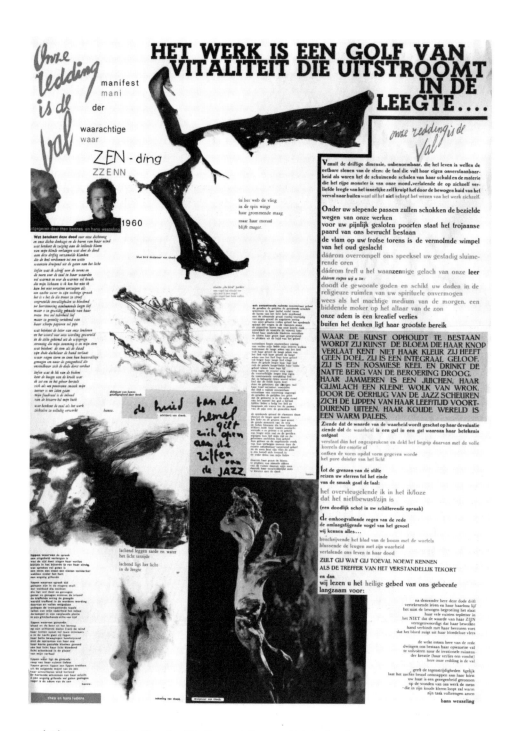

112/b. Theo Bennes and Hans Wesseling, 'Manifest van de Zengroep Nederland', 1960
Archief Theo Bennes; Henk van Laatum, Amsterdam

Bibliography

The bibliography has been arranged chapter by chapter. The divisions comprise a general literature section and a section according to protagonist. The books and articles are arranged in alphabetical order according to author's name; catalogues are listed separately, in alphabetical order of place name.

1. Zen and the Zen Arts

– Abbate, F., *Chinese Art*, London, 1972 (1966)
– Addiss, S., *The Art of Zen*, New York, 1989
– Baker, J.S., *Japanese Art*, London, 1986 (1984)
– Bowie, H.P., *On the Laws of Japanese Painting*, San Francisco, 1911
– Brinker, H., *Die Zen-Buddhistische Bildnismalerei in China und Japan von den Anfängen bis zum Ende des 16.Jahrhunderts*, Wiesbaden, 1973
– Brinker, H., *Zen in the Art of Painting*, New York, 1987 (1985)
– Dreesmann, W.J.R., *A Study of the Zen Master Hakuin (1686-1769) as a Painter*, (Diss. Leiden) Leiden, 1988
– Dürckheim, K., Graf, *Japan und die Kultur der Stille*, Munich, 1949
– Dürckheim, K., Graf, *Erlebnis und Wandlung*, Zürich, 1956
– Dürckheim, K., Graf, *Zen und wir*, Weilheim, 1972 (1961)
– Dumoulin, H., *Zen Enlightenment. Origins and Meaning*, New York, 1989 (1976 *Der Erleuchtungsweg des Zen im Buddhismus*)
– Dumoulin, H., *Zen Buddhism in the 20th Century*, New York 1992 (1990)
– Fontein, J., Hickman, M.L., *Zen: Painting and Calligraphy*, Boston, 1970
– Fujisawa, C., *Zen and Shinto*, New York, 1971 (1959)
– Hempel, H.P., *Heidegger und Zen*, Frankfurt-am-Main, 1987
– Hendry, J., Webber, J. (ed), *Interpreting Japanese Society. Anthropological Approaches*, Oxford, 1986
– Hisamatsu, Sh., *Zen and the Fine Arts*, Tokyo, 1971
– Linhart, S., *Japanische Geistesströmungen*, Vienna, 1983
– Mistry, F., *Nietzsche and Buddhism*, Berlin, 1981
– Moore, C.(ed), *The Japanese Mind. Essentials of Japanese Philosophy and Culture*, Honolulu, 1967
– Munsterberg, H., *Zen and Oriental Art*, Tokyo, 1971 (1965)
– Nakamura, H., a. o., *Japan and Buddhism*, Tokyo, 1959
– Nakamura, H., *A History of the Development of Japanese Thought*, Tokyo, 1967
– Nishida, K., *Art and Morality*, Honolulu, 1973 (1923)
– Nishida, K., *Fundamental Problems of Philosophy*, Tokyo, 1970 (1933)
– Ohashi, R., *Die Philosophie der Kyoto-Schule*, Munich, 1990
– Omori, S., Terayama, K., *Zen and the Art of Calligraphy. The Essence of Sho*, Tokyo, 1990 (1983)
– Paine, R.T., Soper, A., *The Art and Architecture of Japan*, Middlesex, 1974 (1954), pp. 77-91
– Sagara, T., *Japanese Fine Arts*, Tokyo, 1953 (1949)
– Schierbeek, B., *De tuinen van Zen, een essay over het Zenbuddhisme*, Amsterdam, 1960 (1959)
– Schinzinger, R., *Japanisches Denken. Der Weltanschauliche Hintergrund des heutigen Japan*, Berlin, 1983
– Schmied, W., Rombold, G., e.a., *Zeichen des Glaubens. Geist der Avantgarde. Religiöse Tendenzen in der Kunst des 20.Jahrhunderts*, Berlin, 1980

– Snelling, J., Sibley, D. T. (ed.), *The Early Writings Of Alan Watts. Essays by the leading interpreter of Zen to the West*, London, 1988 (1987)
– Sogen, O., Katsujo, T., *Zen and the Art of Calligraphy. The Essence of Sho*, London, 1990 (1983)
– Suzuki, D.T., *Essays in Zen Buddhism*, London, 1st series 1970 (1927), 2nd series 1970 (1933), 3rd series 1970 (1934).
– Suzuki, D.T., *Zen and Japanese Culture*, New York, 1993 and 1959 (revised edition of *Zenbuddhism and its Influence on Japanese Culture*, 1938/Kyoto 1927)
– Suzuki, D.T., *An Introduction to Zenbuddhism*, London, 1991 and 1959 (1949/Kyoto 1934)
– Suzuki, D.T., *Manual of Zen Buddhism*, Kyoto, 1935
– Suzuki, D.T., *The Zen Doctrine of No Mind*, London, 1972 (1949)
– Suzuki, D.T., *Studies in Zen*, London, 1955
– Suzuki, D.T., *The Essentials of Zen Buddhism*, London, 1963 (1962)
– Suzuki, D.T., *Sengai, the Zen Master*, London, 1971
– Vos, F., Zürcher, E., *Spel zonder snaren. Enige beschouwingen over Zen*, Deventer, 1964
– Waldenfels, H., *Begegnung mit dem Zen-Buddhismus*, Düsseldorf, 1980
– Watts, A.W., *The Spirit of Zen. A Way of Life, Work, and Art in the Far East*, New York, 1960 (1958)
– Wetering, van de, J., *De Lege Spiegel. Ervaringen in een Japans Zen klooster*, Amsterdam, 1978
– Wienpahl, P., *The Matter of Zen*, New York, 1964
– Yanagi, S., *The Unknown Craftsman. A Japanese insight into beauty*, Tokyo, 1972

Catalogues
– *Schrift und Bild*, Staatliche Kunsthalle, Baden-Baden, 14-6 – 4-8 1963
– *Japanese Ink Paintings. From American Collections: The Muromachi Period*, The Art Museum, Princeton, 25-4 – 13-6 1976

2. West looks East: A short history

– Abegg, L., *Ostasien denkt anders. Eine analyse des west-östlichen gegensatzes*, Munich, 1970
– Anh, T.T., *Eastern and Western Cultural Values. Conflict or Harmony?*, Manila, 1975
– Benoit, J., *Meester Eckehart*, Deventer, 1993 (1975)
– Benz, E., *Zen in westlicher Sicht*, Weilheim, 1962
– Berger, K., *Japonismus in der westlichen Malerei 1860-1920*, Munich, 1980
– Bowie, T., a.o., *East-West in Art. Patterns of Cultural and Aesthetic Relationships*, Indiana, 1966
– Chipp, H.B., *Theories of Modern Art. A Source Book By Artists and Critics*, Berkeley, 1968
– Dawson, R., *De Chinese Traditie*, Amsterdam, 1973 (1964)
– Evett, E., 'The late nineteenth-century European critical response to Japanese art: primitivist leanings', *Art History*, 6 (1983) 1, pp. 82-106
– Floyd, P., 'Documentary Evidence for the Availability of Japanese Imagery in Europe in Nineteenth-Century Public Collections', *The Art Bulletin*, 68 (1986) 3, pp. 105-141
– Fromm, E., Suzuki, D.T., Martino, de, R., *Zen Buddhism and Psychoanalysis*, New York, 1960
– Grosse, E., *Die Ostasiatische Tuschmalerei*, Berlin, 1922
– Hamilton, G.H., *Painting and Sculpture in Europe 1880-1940*, Middlesex, 1985 (1967)
– Herrigel, E., *Zen in der Kunst des Bogenschießens*, Munich, 1953 (1948)
– Lancaster, C., *The Japanese Influence in America*, New York, 1963
– Okakura, K., *The Book of Tea*, New York, 1968 (1906)
– Rewald, J., *Post-Impressionism. From Van Gogh to Gauguin*, New York, 1978 (1956)
– Rowland, B. Jr., *Art in East and West. An Introduction through Comparisons*, Cambridge, 1954
– Said, E.W., *Orientalism*, New York, 1979 (1978)
– Sprigge, T.L.S., *Theories of Existence*, London, 1990 (1985)
– Sullivan, M., *The Meeting of Eastern and Western Art*, London, 1973
– Versluis. A., *American Trancendentalism and Asian Religions*, New York, 1993
– Vos: see section 1
– Watanabe, T., 'Eishi prints in Whistler's studio? Eighteenth-century Japanese prints in the West before

1870', *The Burlington Magazine*, 128 (1986) 12, pp. 874-880
– Watanabe, T., 'Paris, Grand Palais, Japonisme', *The Burlington Magazine*, 130 (1988) 7,
 pp. 554-555
– Whitford, F., *Japanese Prints and Western Painters*, London, 1977
– Wichmann, S., *Japonisme*, London, 1981 (1980)
– Yamada, C.F., *Dialogue in Art: Japan and the West*, Tokyo, 1976

Catalogues

– *Japanse Prenten*, Palais des Beaux-Arts de Charleroi, Charleroi, 8 – 12 1989
– *James McNeill Whistler*, The Art Institute of Chicago, Chicago, 13-1 – 25-2 1968
– *Japonisme. Japanese Influence on French Art*, The Cleveland Museum of Art,
 Cleveland, Ohio, 9-7 – 31-8 1975
– *.31*, Dordrechts Museum, Dordrecht, 1990
– *Okkultismus und Avantgarde*, Schirn Kunsthalle, Frankfurt, 3-6 – 20-8 1995
– *The Spiritual in Art: Abstract Painting 1890-1985*, Los Angeles County Museum of Art, Los Angeles
 23-11 1986 – 8-3 1987
– *Weltkulturen und moderne Kunst. Die Begegnung der europäischen Kunst und Musik im 19. und 20.
 Jahrhunderts mit Asien, Afrika, Ozeanien, Afro- und Indo-Amerika*, Haus der Kunst, Munich, 16-6 –
 30-9 1972
– *Henri de Toulouse Lautrec*, The Museum of Modern Art, New York, 1985
– *Le Japonisme*, Galeries Nationales du Grand Palais, Paris, 1988
– *Le livre des expositions universelles*, Musée des arts décoratifs, Paris, 6 1983
– *John la Farge*, The Carnegie Museum, Pittsburgh, 12 1987 – 2 1988

Kandinsky

– Fischer, A., 'Die Münchener Ausstellung Ostasiatischer Kunst', *Kunst und Künstler*, (1909) 8,
 p. 570-574.
– Graf-Pfaff, C., 'Zur Ausstellung "Japan und Ostasien in der Kunst" München 1909', *Münchner Jahrbuch
 der Bildenden Kunst*, Band IV (1909), pp. 107-126
– Grohman, W., *Wassily Kandinsky. Leben und Werk*, Cologne, 1958
– Haftmann, W., *Malerei in 20. Jahrhundert*, Munich, 1954
– Kandinsky, W., 'Pis'mo iz Miunkhena', *Apollon*, (1909) 10, pp. 19-20
– Kandinsky, W., Almanak *Der Blaue Reiter*, Munich, 1965 (1912)
– Kandinsky, W., Almanak *Der Blaue Reiter*, Munich, 1912
– Kandinsky, W. *Über das Geistige in der Kunst*, Bern, 1973 (1912)
– Lindsay, K.C., Vergo, P. (ed.), *Kandinsky. Complete Writings on Art*, Vol.1, London, 1982
– Long, R.C.W., *Kandinsky. The Development of an Abstract Style*, Oxford, 1980
– Myers, B.S., *Expressionism. A Generation in Revolt*, London, 1957
– Ringbom, S., *The Sounding Cosmos*, 1970
– Roethel, H.K., *Kandinsky. Das grafische Werk*, Cologne, 1970
– Sihare, L., 'Oriental Influences on Wassili Kandinsky and Piet Mondriaan 1909-1917', Summary of
 Dissertation, *Marsyas*, (1968) xiv, pp. 102-103
– Suzuki: see section 1
– Weiss, P., *Kandinsky in Münich. The Formative Jugendstil Years*, Princeton, 1979

Catalogues

– *Japan und Ostasien in der Kunst*, Ausstellungsbauten, Munich, zomer 1909
– *Kandinsky und München. Begegnungen und Wandlungen 1896-1914*, Städtische Galerie Lenbachhaus,
 Munich, 18-8 – 17-10 1982
– *Wassili Kandinsky 1866-1944*, Sol. Guggenheim Museum, New York, 1962
– *Kandinsky*, Centre Georges Pompidou, Paris, 11 1984 – 1 1985
– *Le Japonisme*, Galeries Nationales du Grand Palais, Paris, 1988

3. The unity between East and West. American artists and Zen

– Abe, M., *Zen and Western Thought*, London, 1985
– Abe, M., *A Zen Life: D.T. Suzuki Remembered*, New York, 1986
– Adams, H., 'John La Farge's Discovery of Japanese Art: A New Perspective on the Origins of "Japonisme"', *The Art Bulletin*, 68 (1985) 8, pp. 449-485
– Albin, E.A., 'Oriental Culture and the West', *College Art Journal*, XV (1955) 2, pp. 340-346
– Alcopley, L., 'Drawings as Structures and Non-Structures' *Leonardo*, I (1968) 1, pp. 3-16
– Alloway, L., 'Sign and Surface', *Quadrum*, (1960) 9, pp. 49-62
– Alloway, L., *Robert Rauschenberg*, Washington, 1976
– Ames, V.M., *Zen and American Thought*, Honolulu, 1962
– Ando, S., *Zen and American Transcendentalism*, Tokyo, 1970
– Anfam, D., *Abstract Expressionism*, London, 1990
– Ashton, D., 'L'Automne à New York', *Cimaise*, (1958) 2, pp. 37-40
– Ashton, D., *The Unknown Shore. A View of Contemporary Art*, London, 1964 (1962)
– Ashton, D., 'Philip Guston', *Studio International*, 169 (1965) 862, pp. 64-67
– Ashton, D., *Life and Times of the New York School*, Bath, 1972
– Ashton, D., *Yes but... A Critical Study of Philip Guston*, Berkeley, 1990 (1976)
– Ashton, D., *American Art Since 1945*, London, 1982
– Ashton, D., *Noguchi. East and West*, New York, 1992
– Auping, M., *Abstract Expressionism. The Critical Developments*, New York, 1987
– Baur, J.I.H., *Nature in abstraction*, New York, 1958
– *The Bhagavad Gita*, n.p., 1968(?)
– Benedict, Ruth, *The Chrysanthemum and the Sword*, Boston, 1946
– Benoit: see section 1
– Blyth, R.H., *Haiku. Eastern Culture*, Tokyo, 1952
– Bowie, Th., a.o., *East-West in Art. Patterns of Cultural and Aesthetic Relationships*, Indiana, 1966
– Breul, S., 'Kill the Buddha. A Cahier Leaf', *It is*, I (1958) 2, p. 65
– Brinker: see section 1
– Brooks, Van Wyck, *Fenollosa and his Circle*, New York, 1962
– Bryant, K.L., *William Merrit Chase, A Genteel Bohemian*, Columbia, 1991
– Buchner, H.(ed), *Japan und Heidegger*, Sigmaringen, 1989
– Buettner, S., *American Art Theory*, Ann Arbor, Michigan, 1981
– Buhler Lynes, B., *O'Keeffe, Stieglitz, and the Critics*, Chicago, 1989
– Capra, F., *The Tao of Physics*, Boston, 1985 (1975)
– Charmion, von, W., 'The Oriental Tradition and Abstract Art', *The World of Abstract Art*, New York, 1957
– Chisolm, L.W., *Fenollosa: The Far East and American Culture*, New Haven, 1963
– Clarke, D., *The Influence of Oriental Thought on Postwar American Painting and Sculpture*, (Diss. New York), New York, 1988.
– Cohn, S., *Arthur Dove. Nature as Symbol*, Ann Arbor, 1985 (1982)
– Coomaraswamy, A.K., *The Transformation of Nature in Art*, Cambridge (Mass.), 1934
– Craven, D., 'Abstract Expressionism, Automatism and the Age of Automation, *Art History*, 13 (1990) 1, pp. 72-103
– Dewey, J., *Art as Experience*, New York, 1958 (1934)
– Dienes, S., 'Notes on Japan', *It is*, 2 (1959) 4, p. 63
– Dow, A.W., *Composition. A Series of Exercises Selected From a New System of Art Education*, New York, 1899
– Duhrssen, A., 'Exercise Required to Arrive at Nothing', *It is*, I (1958) 1, p. 21
– Elsen, A., *Paul Jenkins*, New York, 1974
– Feinstein, R., 'The Unknown Early Robert Rauschenberg: The Betty Parsons Exhibition of 1951', *Art Magazine*, 59 (1985), nr.5, pp. 126-131
– Ferren, J., 'On Innocence in Abstract Painting', *It is*, I (1958) 2, p. 12
– Fields, R., *How the Swans came to the Lake*, New York 1981
– Flam, J., *Robert Motherwell*, Buffalo, 1983
– Foster, S.C., Kuenzli, R.E., *Dada Spectrum: The Dialectics of Revolt*, Iowa, 1979

234

– Foster, S.C., *The Critics of Abstract Expressionism*, Ann Arbor, 1980

– Gaugh, H.F., *The Vital Gesture. Franz Kline*, New York, 1986

– Geldzahler, H., *New York Painting and Sculpture 1940 – 1970*, New York, 1970

– Graham, L. *The Spontaneous Gesture*, Canberra, 1987

– Gray, C., Rowley, G., 'Chinese and Western Composition', *College Art Journal*, XV (1955) 3, pp. 6-17

– Hasegawa, S., 'Abstract Art in Japan', *The World of Abstract Art*, New York, 1957

– Heisenberg, W., *Physics and Philosophy. The Revolution in Modern Science*, London, 1990 (1958)

– Hess, Th.B., *Abstract Painting. Background and American Phase*, New York, 1951

– Hillier, J.R., *Japanese Drawings of the 18th and 19th Centuries*, Washington, 1980

– Hobbs, R.C., *Abstract Expressionism.The Formative Years*, London, 1981

– Kerouac, J., *On the Road*, New York, 1957 (1955)

– Kerouac, J., *The Dharma Bums*, New York, 1958

– Krauss, L.M., *Het geheim van de natuurkunde*, Amsterdam, 1994 (*Fear of Physics*, New York, 1993)

– Kuh, K., *the Artist's Voice. Talks with Seventeen Artists*, New York, 1962 (1960)

– Lancaster, C., *The Japanese Influence in America*, New York, 1963

– Langsner, J., 'Franz Kline, Calligraphy and Information Theory', *Art International* VII (1963) 3, pp. 25-29

– Leja, M., 'Jackson Pollock: Representing the Unconscious', *Art History*, 13 (1990) 4, pp. 542-565

– Loughery, J., 'Charles Caffin and Willard Huntington Wright, advocates of Modern Art', *Arts Magazine*, 59 (1985) 5, pp. 103-109

– Maritain, J.J., Things and the Creative Self, *Magazine of Art*, 46 (1953) 2, pp. 51-58

– Masson, A., 'Une peinture de l'essentiel', *Quadrum*, (1956) pp. 37-42

– Motherwell, R., Rosenberg, H., Cage, J., *Possibilities* ('Problems of Contemporary Art'), I (1947/1948) 1

– Motherwell, R., *Modern Artists in America*, New York, 1950

– Motherwell, R.(ed), *The Dada Painters and Poets. An Anthology*, New York, 1951

– Munsterberg, H., 'Zen and Art', *The Art Journal*, XX (summer 1961) 4, pp. 198-202

– Northrop, F.S.C., *The Meeting of East and West*, New York, 1946

– Occi, G., 'Notes on Franz Kline', *Quadrum*, (1961) 12

– O'Keeffe, G., *Georgia O'Keeffe*, New York, 1976

– Onslow-Ford, G., *Towards a New Subject in Painting*, San Francisco, 1958

– Onslow-Ford, G., *Painting in the Instant*, New York, 1964

– Pavia, P.G., 'The Problem as the Subject-Matter', *It is*, I (1958) 1, pp. 2-5

– Pavia, P.G., 'The Second Space: the American Sense of Space on Space. A Manifesto-in-Progress', *It is*, I (1958) 2, pp. 4-6

– Polcari, S., *Abstract Expressionism and the Modern Experience*, Cambridge, 1993 (1991)

– Pomeroy, R., *Stamos*, New York, 1975

– Read, H., *Icon and Idea. The Function of Art in the Development of Human Consciousness*, London, 1955

– Read, H., 'An Art of Internal Necessity', *Quadrum*, 1 (1956) 5, pp. 7-22

– Read, H., *Art and Alienation. The Role of the Artist in Society*, London, 1967

– Reich, S., *John Marin*, Turson, 1970

– Rodman, S., *Conversations with Artists*, New York, 1957

– -, 'Rollin Crampton', Abstract Artist, Pioneer in Monochrome Paintings in the 1950's, Dies', *New York Times*, Jan.20, 1970

– Rose, B., *Rauschenberg*, New York, 1987

– Rosenberg, H., *The Tradition of the New*, London, 1962 (1959)

– Rosenblum, R., *Modern Painting and the Northern Romantic Tradition*, London, 1975 (1972)

– Ross, N.W., 'What is Zen?', *Mademoiselle*, (1958) Jan., pp. 64-65, 116

– Ross, N.W., 'The Square Roots of Zen', *Horizon*, I (1959) 6, pp. 71-77, 126-127

– Rowland, B.Jr., *Art in East and West. An Introduction through Comparisons*, Cambridge, 1954

– Rubin, W., *Dada and Surrealist Art*, London, 1960

– Rubin, W., *Primitivism in 20th. Century Art*, New York, 1984

– Sandler, I., 'The Club'. How the Artists of the New York School found their first Audience themselves', *Artforum*, IV (1965) 1, pp. 27-31

– Sandler, I., *Triumph of American Painting: A History of Abstract Expressionism*, New York, 1976
– Sandler, I., *Defining Modern Art. Selected Writings of Alfred H. Barr Jr.*, New York, 1986
– Sargeant, W., 'Suzuki. Profiles, Great Simplicity', *New Yorker*, 31-8 1957, pp. 23-26
– Sartre, J. P., *L'existentialisme est un humanisme*, Paris, n.d. (1946)
– Sawyer, K.B., 'L'expressionisme abstrait. La phase du Pacifique', *Cimaise*, (1954) 7, p. 3-5
– Sawyer, K.B., *Stamos*, Paris, 1960
– Seitz, W.C., *The Responsive Eye*, New York, 1965
– Seitz, W.C., *Abstract Expressionist Painting in America*, Cambridge, 1983
– Seuphor, M., *A Dictionary of Abstract Painting*, London, 1957
– Sullivan, M., *The Meeting of Eastern and Western Art*, London, 1973
– Sutton, D., 'Cathay, Nirvana and Zen', *Apollo*, (1966) 8, p. 148-157
– Suzuki: see section 1
– Suzuki, D.T., Watts, A., Kerouac, J., 'Zen', *Chicago Review*, 12 (1958) 2
– Sweeney, J.J., 'The Cat that walks by itself', *Quadrum*, 1 (1956) 2, pp. 17-28
– Tomkins, C., *Off the Wall*, New York, 1981 (1980)
– Tuchman, M., *The New York School. Abstract Expressionism in the 40s and 50s*, London, 1971
– Varley, H.P., *Japanese Culture*, New York, 1984 (1973)
– Versluis: see section 2
– Vos: see section 1
– Waddington, C.H., 'New Visions of the World', *Leonardo*, I (1968) 1, pp. 69-75
– Waley, A., *Zen Buddhism and Its Relation to Art*, London, 1959 (1922)
– Wankmüller, R., 'Tachisten in USA', *das Kunstwerk*, 1956, p. 23-26
– Watts, A.W., *The Spirit of Zen*, San Francisco, 1954 (1936)
– Watts, A.W., *This is it and other essays on Zen and Spiritual Experience*, New York, 1967 (1958)
– Watts, A.W., *In my own Way. An Autobiography*, London, 1973
– Yamada, C.F., *Dialogue in Art: Japan and the West*, Tokyo, 1976

Catalogues
– *L'encre de Chine dans la calligraphie et l'art japonais contemporains. Exposition circulaire pour l'Europe*, Stedelijk Museum, Amsterdam, 2-12 1955 – 4-1 1956
– *Abstract Expressionism: Works on Paper*, The High Museum of Art, Atlanta, 26-1 – 4-4 1993
– *American Art since 1950*, Institute of Contemporary Art, Boston, 21-11 – 23-12 1962
– *Expressionism in American Painting*, Albright Art Gallery, Buffalo, 10-5 – 29-6 1952
– *Europa/America. Die Geschichte einer kunstlerischen Faszination seit 1940*, Museum Ludwig, Cologne, 1986
– *Abstract Expressionism. Other Dimensions*, Lowe Art Museum, Coral Cables, Florida, 26-10 – 3-12 1989
– *Informele Kunst 1945-1960*, Rijksmuseum Twenthe, Enschede, 4-12 1982 – 16-1 1983
– *The TransParent Thread. Asian Philosophy in Recent American Art*, Hofstra Museum, Hampstead (N.Y.), 16-9 – 11-11 1990
– *Richard Pousette-Dart*, Indianapolis Museum of Art, Indianapolis, 4-10 – 30-12 1990
– *Ulfert Wilke: A Retrospective*, Museum of Art, Iowa City, 9-4 – 12-6 1983
– *Japonisme comes to America. The Japanese Impact on the Graphic Arts 1876-1925*, Nelson-Atkins Museum of Art, Kansas City, 22-7 – 2-9 1990
– *Kawahara Keiga*, Rijksmuseum voor Volkenkunde, Leiden, 17-12 1987 – 10-4 1988
– *Painting and Sculpture of a Decade*, Tate Gallery, London, 1964
– *New York School. The First Generation Paintings of the 1940s and 1950s*, County Museum of Art, Los Angeles, 1965
– *Fourteen Americans*, The Museum of Modern Art, New York, 1946
– *Toward Self Realization and Self Liberation*, Willard Gallery, New York, 1955
– *The New Decade. 35 American Painters and Sculptors*, Whitney Museum of American Art, New York, 11-5 – 7-8 1955
– *Georgia O'Keeffe*, Whitney Museum of American Art, New York, 8-10 – 29-11 1970
– *American Imagination and Symbolist Painting*, Grey Art Gallery, New York, 24-10 – 8-12 1979
– *Robert Rauschenberg*, Albright-Knox Art Gallery, New York, 1-10 – 27-11 1983

Archives
– Archives of American Art, Washington D.C.:
 – Thomas Hess Papers
 – William Littlefield Papers
 – William Seitz Papers
 – Reinhardt Papers
 – Tobey Papers
 – Wilard Gallery Papers
– Artists' Files, Museum of Modern Art, New York City:
 – Tobey File
 – Cage File
 – Reinhardt File

Mark Tobey and Morris Graves

– Brinker: see section 1
– Canaday, J.D., 'Vibrant Space of Mark Tobey', *The New York Times Magazine*, (1962), Sept. 9, pp. 64-65, 70, 72
– Cohen, G.M., 'The Bird Paintings of Morris Graves', *College Art Journal*, pp. 2-19
– Dahl, A.L., Seitz, W., a.o., *Mark Tobey. Art and Belief*, Oxford, 1984
– Gibbs, J., 'Tobey the Mystic', *The Art Digest*, (1945) 4 Nov.15, p. 39
– Graves, M., *The Drawings of Morris Graves*, Boston, 1974
– Greenberg, C., 'The Present Prospects of American Painting and Sculpture', *Horizon*, (1947) Oct., pp. 20-25
– Hoffman, F., 'Mark Tobey's Paintings of New York', *Artforum*, (1979) 4, pp. 24-29.
– Hui-Müller Yao, M., *Der Einfluß der Kunst der Chinesischen Kalligraphie auf die westliche informelle Malerei*, (Diss. Bonn), Bonn, 1985
– Kass, R., *Morris Graves. Vision of the Inner Eye*, New York, 1983
– Kochnitzky, L., 'Mark Tobey', *Quadrum* (1957) 4, pp. 15-26
– Kuh, K., 'Mark Tobey: A Moving Encounter', *SR*, Oct.27, 1962, p. 30
– Malone, P.T., 'Film Review. Mark Tobey', *Magazine of Art*, 46 (1953) 2, p. 89
– -, 'Mystic Painter', *MD*, (1978) june, pp. 116-121
– -, 'Northwest Painting', *Fortune*, 31 (1945) 2, pp. 164-166
– Patterson, F., 'Tobey and Cornish', *Northwest Today*, April 20, 1969
– Plagens, P., *Sunshine Muse. Contemporary Art on the West Coast*, New York, 1974
– Rexroth, K., 'The Visionary Painting of Morris Graves', *Perspectives USA*, 10 (1955) winter, pp. 58-66
– Roberts, C., *Mark Tobey*, New York, 1960
– Rowland: see section 1
– Schmied, W., *Tobey*, New York, 1966
– Seitz, W.C., 'Spirit, Time and Abstract Expressionism', *Magazine of Art*, 46 (1953) 2, pp. 80-88
– Smith, V., 'Morris Graves', *Artforum*, I (1963) 11, pp. 30-31
– Tobey, M., 'Reminiscence and Reverie', *Magazine of Art*, 44 (1951) 6, pp. 228-232
– Tobey, M., 'Experts From a Letter of October 28 1954 from Paris', *Chicago Art Institute Bulletin*, (1955) Febr., n.p.
– Tobey, M., 'Japanese Traditions and American Art', *College Art Journal*, XVIII (1958) 3, pp. 20-24
– Tobey, M., *The World of a Market*, Seattle, 1964
– White, N., 'Current Show Charts Tobey's Career From 1917 to Present', *San Francisco Californian News*, April 7, 1951, n.p.
– Yao, M.-Ch., *The Influence of Chinese and Japanese Calligraphy on Mark Tobey, 1890-1976*, n.p., 1983

Catalogues
– *Mark Tobey*, Stedelijk Museum, Amsterdam, 3 – 5 1966
– *Contemporary Calligraphers: John Marin, Mark Tobey, Morris Graves*, Contemporary Arts Museum, Houston, 1956

– *Americans 1942: 18 Artists from 9 States*, The Museum of Modern Art, New York, 1942
– *Mark Tobey*, Willard Gallery, New York, 4-4 – 29-4 1944
– *Mark Tobey*, Willard Gallery, New York, 13-11 – 8-12 1945
– *Mark Tobey*, Willard Gallery, New York, 1-11 – 26-11 1949
– *Mark Tobey. Retrospective Exhibition*, Whitney Museum of American Art, New York, 4-10 – 4-11 1951
– *Mark Tobey*, The Museum of Modern Art, New York, 12-9 – 4-11 1962
– *Mark Tobey. Paintings from the 1950's*, Philippe Daverio Gallery, New York, 25-9 – 26-10 1991
– *Mark Tobey*, Foster/White Gallery, Seattle, 1973
– *Mark Tobey*, The Phillips Collection, Washington DC, 6-5 – 6-6 1962
– *Tribute to Mark Tobey*, National Collection of Fine Arts, Washington DC, 1974
– *Mark Tobey. City Paintings*, National Gallery of Art, Washington DC, 18-3 – 17-6 1984

John Cage

– Bernlef, J., Schippers, K., *Een cheque voor de tandarts*, Amsterdam, 1967
– Cage, J., *Silence*, Middletown, 1967 (1961)
– Cage, J., *A Year from Monday*, Middletown, 1967
– Cage, J., *Diary: How to Improve the World (You will only make matters worse)*, New York, 1967
– Cage, J., *M: Writings '67-'72*, Middletown, 1978 (1974)
– Cage, J., *For the Birds*, Salem New Hampshire, 1981 (1976)
– Cage, J., Charles, D., *For the Birds*, 1981 (1976)
– Cage, J., *Empty Words. Writings '73-'78*, Middletown, 1979
– Cage, J., Barnard, G., *Conversation without Feldman*, Darlinghurst, 1980
– Danuser, H., *Die Musik des 20.Jahrhunderts*, Munich, 1974
– Duberman, M., *Black Mountain. An Exploration in Community*, London, 1974 (1972)
– Friedman, K.S., *The Three Legs of Teaching*, n.p. or d.
– Hansen, A., *A Primer of Happenings and Time/Space Art*, New York, 1965
– Harris, M.E., *The Arts at Black Mountain College*, Cambridge (Mass.), 1987
– Henahan, D., 'John Cage, Elfin Enigma, at 64', *New York Times*, Oct.22, 1976
– Kostelanetz, R., *The Theatre of Mixed Means*, New York, 1966
– Kostelanetz, R., *John Cage*, New York, 1970 (1968)
– Kramer, H., 'Cage's Obituarists, Limming the Gadget-Fair Giant', *The New York Observer*,
 Sept. 14, 1992
– Mc.Evilley, Th., 'In the Form of a Thistle', *Artforum* (1992) 10, pp. 97-101
– Meyer, Th., 'Der Komponist John Cage in Gespräch mit Thomas Meyer', *Bühne*, (1992) 9, pp. 65-68
– Yanagi: see section 1

Catalogues
– *John Cage: Scores from the Early 1950's*, Museum of Contemporary Art, Chicago, 8-2 – 19-4 1992
– *John Cage. Rolywholyover A Circus*, The Museum of Contemporary Art, Los Angeles, 12-9 – 28-11 1993
– *John Cage*, Galleria Schwarz, Milan, 3-3 – 31-3 1971
– *John Cage: Scores & Prints*, Museum of Art, Philadelphia, 11-9 – 31-10 1982

Ad Reinhardt

– Chandler, J.N., 'The Colors of Monochrome. An Introduction to the Seduction of Reduction',
 ArtsCanada, (1971) 10/11, pp. 18-31
– Danto, A.C., 'Ad Reinhardt', *The Nation*, (1991) Aug.26, pp. 240-243
– Denny, R., Kallick Ph., 'Ad Reinhardt, *Studio*, (1967) 174, pp. 264-267
– Frank, P., 'Painter of the Last Paintings Anyone Could Paint', *Columbia College Today*, 8 (1981) 2,
 pp. 39, 69
– Fuller, M., 'An Ad Reinhardt Monologue', *Artforum*, (1970) 10, pp. 36-41

– Kozloff, M., 'Andy Warhol and Ad Reinhardt: The Great Accepter and the Great Demurrer', *Studio International*, 18 (1971) March, 931, pp. 113-117
– Kramer, H., 'Ad Reinhardt's Black Humor', *New York Times*, Nov.27, 1966
– Lippard, L.R., *Ad Reinhardt*, New York, 1981
– Masheck, J.(ed.) 'Five Unpublished Letters from Ad Reinhardt to Thomas Merton and Two in Return', *Artforum*, (1978) 12, pp. 23-27
– Merton, Th., *Raids on the Unspeakable*, New York, 1966 (1960)
– Merton, Th., *New Seeds of Contemplation*, New York, 1961
– Merton, Th., *Mystics and the Zen Masters*, 1967 (1961)
– Merton, Th., *Zen and the Birds of Appetite*, New York, 1968 [8]
– Reinhardt, A., 'Cycles through the Chinese Landscape', *Art News*, 53 (1954) 8, pp. 24-27
– Reinhardt, A., '44 Titles for Articles for Artists under 45', *It is*, 1 (1958) 1, pp. 22-23
– Reinhardt, A., '25 Lines of Words on Art Statement', *It is*, 1 (1958) 1, p. 42
– Reinhardt, A., 'Timeless in Asia', *Art News*, 58 (1960) 9, pp. 32-35
– Reinhardt, A., 'The Next Revolution in Art', *Art News*, 62 (1964) 10, pp. 48-49
– Reinhardt, A., a.o., 'Black as Symbol and Concept', *ArtsCanada*, (1967) 113, n.p.
– Rose, B., 'ABC Art', *Art in America*, (1965) 10/11, pp. 57-69
– Rose, B. (ed.), *Art-as-Art. The Selected Writings of Ad Reinhardt*, New York, 1991 (1975)
– Varley: see section 1
– Zelevansky, L., 'Ad Reinhardt and the Younger Artists of the 1960's', *American Art of the 1960's*, MOMA, (1991) 1, pp. 16-37

Catalogues
– *Ad Reinhardt. 1913-1967. Malerei, Kollagen, Cartoons*, Städtische Kunsthalle, Düsseldorf, 15-9 – 15-10 1972
– *Ad Reinhardt*, Van Abbemuseum, Eindhoven, 15-12 1972 – 28-1 1973
– *Ad Reinhardt, Francesco Lo Savio, Jef Verheyen*, Städtisches Museum, Leverkusen, 27-1 – 19-3 1961
– *Ad Reinhardt. Twenty Five Years of Abstract Painting*, Betty Parsons Gallery, New York, 1960
– *Ad Reinhardt*, Betty Parsons Gallery, New York, 1965
– *Ad Reinhardt. Paintings*, The Jewish Museum, New York, 23-11 1966 – 17-1 1967
– *Ad Reinhardt. A Selection from 1937 to 1952*, Marlborough Gallery, New York, 2-3 – 23-3 1974
– *Ad Reinhardt*, The Solomon R. Guggenheim Museum, New York, 1980
– *Ad Reinhardt. 1945-1951. Paintings and Watercolors*, The Pace Gallery, New York, 11-12 1981 – 9-1 1982
– *Ad Reinhardt*, Museum of Modern Art, New York, 30-5 – 2-9 1991
– *Les forces immobiles de Ad Reinhardt*, Galerie Iris Clert, Paris, 10-6 – 10-7 1963
– *Ad Reinhardt*, Staatsgalerie, Stuttgart, 13-4 – 2-6 1985

4. The Zen Arts in France

– Adams: see section 3.
– Alvard, J., *Témoignages pour l'Art Abstrait*, Paris, 1952
– Alvard, J., 'Voyage en Chine', *Cimaise*, (1954) 3, p. 22
– Aragon, L., 'Fragments d'une conférence', *La Révolution Surréaliste*, (1925) 4, pp. 23-25
– Askénazi, J., Bafaro, G., e.a., *Analyses et réflexions sur Michaux. Un Barbare en Asie*, Paris, 1992
– Barthes, R., *Le Degré zéro de l'écriture*, 1972 (1953)
– Barthes, R., *L'empire des signes*, Geneva, 1970
– Bayard, É., *Le Style japonais*, Paris, 1928
– Beauvoir, de, S., *La Force des Choses*, Paris, 1963
– Bing, S., *Le Japon Artistique*, (1888/1889), Paris
– Bonnefoi, G., *Hantaï*, n.p., 1973
– Bonnefoi, G., *Henri Michaux. Peintre*, Lexos, 1976
– Boudaille, G., 'Influence de l'Ecole de Paris sur les peintres japonais. Que viennent chercher à Paris les peintres japonais?', *Cimaise*, (1958) 5, p. 26-29
– Breton, A., *Manifeste du Surréalisme*, St.Amand, 1989 (1924)

– Breton, A., *Le Surréalisme et la Peinture*, Paris, 1979 (1965)

– Brosse, J., *Zen et Occident*, Paris, 1992

– Cabanne, P., Restany, P., *L'Avant-Garde au xxe siècle*, n.p., 1969

– Cassou, J., 'Variations du dessins', *Quadrum*, (1961) 10, pp. 27-42

– Cattaui, G., *Entretiens sur Paul Claudel*, Paris, 1968

– Centre Georges Pompidou, *Bibliothèque André Malraux*, Paris, 1986

– Centre Georges Pompidou, *Les enjeux philosophique des années 50*, Paris, 1989

– Chalumeau, J.-L., *Initiation à la lecture de l'art contemporain. Réflexion esthétique et création plastique en France*, Paris, 1976

– Choay, F., *Peintres D'Aujourd'hui. Tobey*, Paris, 1961

– Claudel, P., *Connaissance de l'Est*, 1960 (1900/1907, 1952 in book form)

– Claudel, P., *L'oiseau noir dans le soleil levant*, Paris, 1929 (1925-1927)

– Claudel, P., *Oeuvre Complètes de Paul Claudel*, Vol. III *Extrême Orient*, Paris, 1952

– Claus, J., 'Sky Art. Der Himmel wird bunter. Aufbruch der Kunst in den Raum', *Das Kunstwerk*, (1985) 2, pp. 6-46

– Courthion, P., *Okamoto*, Paris, 1937

– Damisch, H., *Fenêtre jaune cadmium, ou les dessous de la peinture*, Paris, 1984

– Découdille, R., 'L'approche du Divers', *Cimaise*, (1961) 52, pp. 28-39

– Delaleu, F., Inaga, S, *Aspects de l'art japonais moderne. Interactions de l'art japonais et de l'art européen depuis Meiji*, Paris, 1984

– Dominique, J., *Henri de Toulouse-Lautrec-Monfa. Entre le mythe et la modernité*, Marseille, 1991

– Duthuit, G., *Mystique chinoise et peinture moderne*, Paris, 1936

– Elisséev, S., *La Peinture contemporaine au Japon*, Paris, 1923

– Estienne, Ch. *L'Art Abstrait, est-il un Académisme?*, Paris, 1950

– Etiemble, -, *L'écriture*, Paris, 1961

– Février, J.G., *Histoire de l'Ecriture*, n.p., 1984 (1948)

– Focillon, H., *Hokousaï*, Paris, 1925 (1914)

– Goncourt, de, E., *Hokousaï*, 1916 (1896)

– Grenier, J., *Entretiens avec dix-sept peintres non-figuratifs*, Paris, 1963

– Grohmann, W., *Neue Kunst nach 1945*, Cologne, 1958

– Grosse, E., *Le lavis au Extrême Orient*, Paris, 1922

– Henri, A., *Environments and Happenings*, London, 1974

– *Hermès: Le Vide, Expérience Spirituelle en Occident et en Orient*, Paris, 1969

– Hiroshi, S., 'D.T.Suzuki and Mysticism', *The Eastern Buddhist*, (1977) 1, pp. 54-67

– Hoffmann, W., 'Rembrandt et l'Asie', *l'Oeil*, 16 (1956) 4, p. 36-41

– Hollingdale, R.J., *De draagbare Nietzsche*, Amsterdam, 1991 (1977)

– James, M.I., 'Bram van Velde, Masson, Alechinsky', *The Burlington Magazine*, 132 (1990) 2, pp. 156-158

– Kasulis, T.P., 'Zen Buddhism, Freud and Jung', *The Eastern Buddhist*, (1977) 1, pp. 68-91

– Kepes, G., 'Art et science' *Cimaise*, (1955/6) 6, pp. 14-19

– Klein, *La forme et l'intelligible*, Paris, 1969

– Kultermann, U., 'Die Sprache des Schweigens. Uber das Symbolmilieu der Farbe Weiss', *Quadrum*, (1966) 20, pp. 7-30

– Lambert, J.-C., *Sugaï*, Paris, 1990

– Legrand, F.C., 'Regards sur l'art moderne', *Quadrum*, (1958) pp. 95-136

– Legrand, F.C., 'Peinture et écriture', *Quadrum*, (1962) 13, pp. 5-48

– Linhartova, V., *Dada et Surréalisme au Japon*, Paris, 1987

– Malraux, A., *La tentation de L'Occident*, Paris, 1926

– Malraux, A., *Les voix du silence*, n.p., 1951

– Malraux, A., *La Métamorphose des Dieux*, n.p., 1957

– Malraux, A., *La Métamorphose des Dieux. L'Intemporel*, 1976,

– Masson, A., *La Révolution Surréaliste*, (1925) 5, p. 30

– Masson, A., *Le plaisir de peindre*, Paris, 1950

– Masson, A., 'Une peinture de l'essentiel',*Quadrum* (1956) 1, pp. 37-42

– Masson, A., *Vagabond du Surréalisme*, Paris, 1975

– Masson, A., *Le rebelle du surréalisme. Écrits*, Paris 1976
– Mathieu, G., *De la Révolte à la Renaissance. Au-delà du Tachisme*, Paris, 1973 (1963)
– Mèredieu, de, F., *André Masson. Les dessins automatiques*, Paris, 1988
– Merleau-Ponty, M., *Phénoménologie de la perception*, Paris, 1945
– Michaux, H., *Un Barbare en Asie*, Paris, 1967 (1933)
– Michaux, H., *Mouvements*, Paris, 1982 (1951)
– Michaux, H., *Idéogrammes en Chine*, Montpellier, 1975
– Migeon, G., *La Peinture Japonaise au Musée du Louvre*, Paris, 1898
– Moretti, L., Tapié, M., *Museé Manifeste.Structures et Styles Autres*, Turin, 1962
– Okakura, K., *Le Livre du Thé*, 1969 (1927)
– Pellegrini, A., *New Tendencies in Art*, Buenos Aires, 1966
– Platschek, H., *Neue Figurationen. Aus der Werkstatt der Heutigen Malerei*, Munich, 1959
– Ragon, M., *Expression et Non-Figuration, problèmes et tendences de l'Art d'Aujourd'hui*, Paris, 1951
– Ragon, M., *L'aventure de l'art abstrait*, Paris, 1956
– Ragon, M., 'Sugaï', *Cimaise*, (1956) I, pp. 28-29
– Ragon, M., 'Tabuchi', 'Shinoda', *Cimaise*, (1957) 2, p. 38
– Ragon, M., 'Le Japon et nous', *Cimaise*, (1958) 5, pp. II, 25
– Ragon, M., *L'honorable Japon*, Paris, 1959
– Ragon, M., *Naissance d'un art nouveau*, Paris, 1963
– Ragon, M., *Vingt-cinq ans d'art vivant*, n.p., 1969
– Restany, P., 'Le objet poem', *Cimaise* (1956) 3, pp. 18-23
– Restany, P., 'Le geste et le rythme', *Cimaise* (1956) 3, p. 30
– Restany, P., 'Influence du Japon sur l'Ecole de Paris. Japon made in Paris', *Cimaise*, (1958) 5, p. 30
– Restany, P., *Lyrisme et Abstraction*, Milan, 1960
– Restany, P., *L'autre face de l'art*, Paris, 1979
– *La Revue Française: Le Japon. Grand pays moderne*, Numéro Spécial, Supplément au numéro 41, 5 (1952) Décembre
– Roh, F., 'Georges Mathieu', *Das Kunstwerk*, (1959) 10, pp. 20-28
– Rowell, M., *La peinture-le geste-l'action. L'existentialisme en peinture*, Paris, 1972
– Rowell, M., *Miro. Selected Writings and Interviews*, London, 1987
– Sartre, J.P., *L'être et le néant*, Paris, 1976 (1943)
– Schmidt, G., 'Mesures et valeurs de l'art moderne', *Quadrum*, (1960) 8, pp. 5-16
– Selz, P., *Sam Francis*, New York, 1982 (1975)
– Seuphor, M., *Écritures. Dessins Alcopley*, Paris, 1954
– Seuphor, M., *A Dictionary of Abstract Painting*, London, 1957
– Sibert, C.-H., 'Calligraphie chinoise de Tsu Ta Tee', *Cimaise*, (1953) 2, p. 12
– Sicard, M., *Sartre et les Arts*, Nyons, 1981
– Steinilber-Oberlin, E., Matsuo, K., *The Buddhist Sects of Japan*, Westport, Connecticut, 1970 (Paris, 1930/London 1938)
– Sullivan: see section 2
– Suzuki: see section 1
– Tapié, M., *Henri Michaux*, Paris, 1948
– Tapié, M., *Un art autre. Où il s'agit de nouveaux dévidages du réel*, Paris, 1952
– Tapié, M., Alvard, J., Simmons, F., 'L'Ecole du Pacifique', *Cimaise*, (1954) 7, p. 6-9
– Tapié, M., *Morphologie Autre*, Turin, 1960
– Tapié, M., *Manifeste indirect dans un temps autre*, Turin, 1961
– Tapié, M., *Art et Continuité*, Turin, 1966
– Trotet, F., *Henri Michaux ou la sagesse du Vide*, n.p. or d.
– Vogt, P., *Geschichte der deutschen Malerei in 20.Jahrhundert*, Cologne, 1972
– Waley, A., *An Introduction to the study of Chinese Painting*, n.p., 1958 (1923)
– Wescher, H., 'Vitalité de Paris', *Cimaise*, (1956) 2, pp. 32-34
– Wichmann: see section 2
– Will-Levaillant, F., 'La Chine d'André Masson', *Revue de l'Art*, (1971) 12, pp. 64-74
– Yamada: see section 3

– Yee, C., *Chinese Calligraphy. An Introduction to its Aesthetic and Technique*, London, 1961 (1938)
– Young, A., *The Paintings of James Mc Neill Whistler*, New Haven, 1980

Catalogues

– *Hartung*, Stedelijk Museum, Amsterdam, 12 1963 – 1 1964
– *Henri Michaux*, Stedelijk Museum, Amsterdam, 7-2 – 22-3 1964
– *Masson*, Stedelijk Museum, Amsterdam, 12-6 – 19-7 1964
– *Wols*, Stedelijk Museum, Amsterdam, 22-4 – 12-6 1966
– *Zero Onuitgevoerd*, Kunsthistorisch Instituut, Amsterdam, 24-4 – 13-5 1970
– *Toulouse-Lautrec et le Japonisme*, Musée Toulouse-Lautrec, Albi, 29-6 – 1-9 1991
– *Tendances Actuelles 3*, Kunsthalle, Bern, 29-1 – 6-3 1955
– *Profile I. Michel Tapié. Strukturen und Stile*, Städtische Kunstgalerie, Bochum, 13-1 – 10-2 1963
– *Signes &: Écritures*, Centre d'Art Contemporain, Brussels, 11-10 1984 – 25-5 1985
– *Japonisme*, Cleveland 1975: see section 2
– *Informele Kunst 1945-1960*, Enschede 1983: see section 3
– *Sengaï*, Exhibition travelling through Europe (Italy, France, Swiss, Germany, Netherlands, England), 1961-1963
– *Hokusai and his School*, Frans Halsmuseum, Haarlem, 28-2 – 9-5 1982
– *Sengai*, Haags Gemeentemuseum, The Hague, 26-5 – 23-6 1963
– *La couleur seule. L'expérience du monochrome*, Art Contemporain, Lyon, 7-10 – 5-12 1988
– *Autour de Michel Ragon*, Musée des Beaux-Arts, Nantes, 15-6 – 14-9 1984
– *Younger European Painters*, The Solomon R.Guggenheim Museum, New York, 2-12 – 21-2 1954
– *Écritures dans la peinture 1+2*, Villa Arson, Nice, 4 – 6 1984
– *Pictura Loquens. 25 ans d'art en France*, Centre National d'Art Contemporain, Nice, 14-2 – 14-4 1986
– *Le Japon à L'Exposition Universelle de 1878*, Paris, 1878
– *Exposition d'Art Japonais*, Grand Palais, Salon de la Société Nationale des Beaux-Arts, Paris, spring 1922
– *H W P S M T B*, La Galerie Allendy, Paris, 1948
– *Écritures et livres à travers les âges*, Bibliothèque Nationale, Paris, t.g.v. XXIe Congrès International des Orientalistes, 23-7 – 31-7 1948
– *Peintres Américains en France*, Galerie Craven, Paris, 1953
– *Deux mille ans de peinture chinoise*. Exposition Itinérante de L'Unesco, Musée Cernuschi, Paris, 1955
– *La calligraphie dans l'art japonais contemporains*, Musée Cernuschi, Paris, 5 1956
– *Bellegarde*, Galerie H. Kamer, Paris, 4 1957
– *L'Art japonais à travers les siècles*, Musée National d'Art Moderne, Paris, 1958
– *Pierre Fichet*, Galerie Arnaud, Paris, 10 1960
– *L'Au-delà dans l'art japonais*, Petit Palais, Paris, 10-12 1963
– *Mathieu*, Galerie Charpentier, Paris, 1965
– *Soulages*, Musée National d'Art Moderne, Paris, 3-5 1967
– *André Masson. Période asiatique 1950-1959*, Galerie de Seine, Paris, 26-4 – 27-5 1972
– *Tal Coat*, Grand Palais, Paris, 4-2 – 5-4 1976
– *Henri Michaux. Peintures*, Fondation Maeght, Paris, 3-4 – 30-6 1976
– *Poésie et spiritualité dans les peintures japonaise du XVe au XIXe siècle*, Galerie Janette Ostier, Paris, 12 1976
– *Paris-New York 1908-1968*, Musée National d'Art Moderne, Paris, 1977
– *André Masson*, Galeries Nationales du Grand Palais, Paris, 3 – 5 1977
– *Pierre Fichet*, Galerie Regards, Paris, 1980
– *Écritures*, Fondation Nationale des Arts Graphiques et Plastiques, Paris, 23-9 – 2-11 1980
– *Paris/Paris 1937-1957*, Musée National d'Art Moderne, Paris, 5 – 11 1981
– *Charles Estienne et l'Art à Paris. 1945-1966*, Le Centre National des Arts Plastiques, Paris, 21-6 – 2-9 1984
– *Les Années 50*, Musée National d'Art Moderne, Paris, 1988
– *André Breton*, Musée National d'Art Moderne, Paris, 1991
– *European Art Today*, o.a.San Francisco Museum of Art, San Francisco, 1960
– *Arte Nuova*, Palazzo Granera, Turin, 5-3 – 15-6 1959
– *Hans Hartung*, Kunsthaus, Zürich, 2 – 3 1963

Pierre Alechinsky

– Alechinsky, P., *Les Poupées de Dixmunde*, Brussels, 1950
– Alechinsky, P., 'Abstraction Faite', *Cobra* (1951) 10
– Alechinsky, P., 'Au dela de l'écriture', *Phases*, (1955) 2, pp. 27-31
– Alechinsky, P., 'Calligraphie Japonaise', film, 1955, Koninklijk Filmarchief, Brussels
– Alechinsky, P., 'Calligraphie Japonaise', *Quadrum* (1956) 1, pp. 43-52
– Alechinsky, P., 'De Japanse calligrafie in een nieuwe phase' *Museumjournaal*, 2 (1956) 1/2, pp. 1-5
– Alechinsky, P., 'Tekens en vormgeving', *Museumjournaal* 2 (1956) 1/2, pp. 161-163
– Alechinsky, P., *Titres et pains perdus*, Paris, 1965
– Alechinsky, P., *Ting's Studio*, La Louvière, 1967
– Alechinsky, P., *Roue Libre. Les Sentiers de la Création*, Geneva, 1971
– Alechinsky, P., *A la ligne*, Paris, 1973
– Alechinsky, P., *Paintings and Writings*, Paris, 1977
– Alechinsky, P., *L'autre main*, n.p., 1988
– Bosquet, A., *Alechinsky*, Paris, 1971
– Boué, M., 'Interview met Pierre Alechinsky', *Flash Art*, 111 (1983) 3, pp. 28-30
– Butor, M., Sicard, M., *Alechinsky. Frontières et bordures*, Paris, 1984
– Butor, M., Sicard, M., *Alechinsky. Travaux d'Impression*, Paris, 1992
– Legrand, F.C., 'Pierre Alechinsky', *Quadrum* (1956) 11, pp. 123-132
– Putman, J., *Alechinsky*, Paris, 1967
– Vree, de F., *Alechinsky*, Antwerp, 1976
– Sicard, M., *Alechinsky sur Rhône*, Paris, 1990
– Stokvis, W.L. *Cobra. Geschiedenis, voorspel en betekenis van een beweging in de kunst van na de tweede wereldoorlog*, Amsterdam, 1990 (1974) (Diss. Utrecht, 1973)
– Stokvis, W., 'De gedrochtelijke wezens van Pierre Alechinsky. Een Belgisch schilder onder Japanse invloed', *Vrij Nederland*, 14-12 1974, p. 24

Catalogues
– *Alechinsky + Reinhoud*, Stedelijk Museum, Amsterdam, 26-5 – 26-6 1961
– *Que d'encre... maar inkt*, Stedelijk Museum, Amsterdam, 18-1 – 4-3 1963
– *Alechinsky*, Stedelijk Museum, Amsterdam, 17-2 – 27-3 1966
– *Pierre Alechinsky. Middelpunt en kantlijn*, Kon. Musea voor Schone Kunsten, Brussels, 6-5 – 26-6 1988
– *Alechinsky*, Galerie D.Benador, Geneva, 1961
– *Pierre Alechinsky. Bilder. Aquarelle. Zeichnungen.*, Kestner Gesellschaft, Hanover, 7-11 – 7-12 1980
– *Pierre Alechinsky. Aquarelle und Tuschzeichnungen*, Galerie van de Loo, Munich, 13-10 – 31-11 1961
– *Pierre Alechinsky*, Lefebre Galerie, New York, 17-2 – 24-3 1962
– *Dessins d'Alechinsky*, Musée National d'Art Moderne, Paris, 11-7 – 11-9 1978
– *Pierre Alechinsky*, Museum of Art, Carnegie Institute, Pittsburgh, 10 1977 – 1 1978

Jean Degottex

– Frémon, J., *Degottex*, Paris, 1986
– Restany, P., 'Degottex', *Cimaise*, (1956) 2, p. 42
– Restany, P., 'Degottex', *Cimaise*, (1958) 6, pp. 32-35

Catalogues
– *Degottex. Essais de Voix*, Palais des Beaux Arts, Brussels, 13-5 – 28-5 1961
– *Degottex*, Galerie Cogeime S.A., Brussels, 22-11 – 5-12 1966
– *Foire D'Art Actuel 2*, Galerie Cogeime S.A., Brussels, 3-10 – 13-10 1969
– *Degottex. Gemälde. Gouachen*, Kölnischer Kunstverein, Cologne, 20-5 – 20-6 1965
– *Degottex. Repères 1955-1985*, Musée d'Évreux, Evreux, 18-6 – 18-9 1988
– *Les jeux mêlés de l'encre, du vide, et du temps*, Musée d'Évreux, Evreux, 7 – 9 1991

– *Degottex*, Musée de peinture et de sculpture de Grénoble, Grenoble, 1978
– *Degottex. Signes et Métasignes. 1954-1967*, 'Carré D'Art' Musée d'Art Moderne Contemporain, Nîmes, 1 – 3 1992
– *Degottex. Peintures*, Galerie Kléber, Paris, 7 1956
– *L'Épée dans les nuages*, Galerie L'Étoile Scellée, Paris, 1955
– *Tensions*, Galerie René Drouin, Paris, 6-7 – 1-10 1956
– *XIIIe Salon de Mai*, Musée d'Art Moderne de la Ville de Paris, Paris, 4-5 – 30-5 1957
– *Degottex. Peintures récentes*, Galerie Kléber, Paris, 6-6 – 30-6 1958
– *Degottex*, Galerie Internationale d'Art Contemporain, Paris, 1959
– *Degottex*, Galerie Internationale d'Art Contemporain, Paris, 11 – 12 1959
– *Degottex*, Galerie Internationale d'Art Contemporain, Paris, 1961
– *Donnez à Voir 2*, Galerie Creuze, Paris, 1-12 – 22-12 1962
– *Degottex, Horspheres 67*, Galerie Jean Fournier et cie, Paris, 15-11 – 31-12 1967
– *Premio Marzotto*, Valdagno, 9 1962
– *Couleur Vivante*, Städtischen Museum, Wiesbaden, 7-4 – 30-6 1957

Yves Klein

– Allain, B., 'Propositions monochromes du peintre Yves', *Couleurs*, (1956) 5/6, p. 24
– Bloc, A., 'Yves Klein et ses Propositions Monochromes', *Aujourd'hui*, 7 (1956) 3, p. 104
– Calvocoressi, R., 'Yves Klein at the Centre Georges Pompidou', *The Burlington Magazine*, 125 (1983) 10, p. 642
– Goodrow, G.A., 'Wer war Yves Klein', *Vernissage*, (1994) 10, pp. 18-23
– Jansen, B., 'Beter ten halve gekeerd dan ten hele gedwaald. Yves Kleins deelname aan de Nultentoonstelling in het Stedelijk Museum', *Jong Holland*, 3 (1987) 1, pp. 24-33
– Klein, Y., *Le dépassement de la problématique de l'art*, n.p., 1959
– Millet, C., *Yves Klein*, n.p., 1983
– Ragon, M., 'Yves', *Cimaise*, (1958) 5, p. 41
– Restany, P., Mathey, F., 'Yves Klein et son mythe', *Quadrum*, (1965) 18, pp. 79-98
– Restany, P., *Les Nouveaux Réalistes. Un manifeste de la nouvelle peinture*, n.p., 1968
– Restany, P., *Yves Klein. Le Monochrome*, Paris, 1974
– Restany, P., *Yves Klein*, New York, 1982
– Restany, P., *Une vie dans l'art*, Neuchâtel, 1983
– Restany, P., *Yves Klein. Le feu au coeur du vide*, Paris, 1990
– Stich, S., *Yves Klein*, Stuttgart, 1994
– Wember, P., *Yves Klein*, Cologne, 1969

Catalogues
– *Yves Klein*, Stedelijk Museum, Amsterdam, 22-10 – 13-12 1965
– *Yves Klein*, Palais des Beaux Arts, Brussels, 3-3 – 3-4 1966
– *Monochrome Malerei*, Städtisches Museum, Leverkusen, 18-3 – 8-5 1960
– *Yves Klein*, The Tate Gallery, London, 20-3 – 15-5 1974
– *Yves Klein. Le Monochrome*, Galleria Apollinaire, Milan, 11 1961
– *Yves Klein*, Alexandre Iolas Gallery, New York, 1965
– *Licht, Bewegung, Farbe*, Kunsthalle, Nuremberg, 28-4 – 18-6 1967
– *Yves Klein in Nürnberg*, Kunsthalle, Nuremberg, 2-4 – 12-5 1968
– *Yves Klein 1928 – 1962*, Centre National d'Art Comtemporain, Paris, 1969
– *Yves Klein*, Karl Flinker, Paris, 2 – 3 1973
– *Yves Klein*, Musée National d'Art Moderne, Paris, 3-3 – 23-5 1983
– *Yves Klein*, Galleria Civica d'Arte Moderna, Turin, 2-12 – 31-12 1970
– *Yves Klein*, Gimpel & Hanover Galerie, Zürich, 30-3 – 5-5 1973

5. Release through Zen and German Art

– Addiss: see section 1

– Bangert, A., *Die 50er Jahre*, Munich, 1983

– Baumeister, W., *Das Unbekannte in der Kunst*, Stuttgart, 1947

– Benz: see section 2

– Bronowski, J., 'Albert Einstein', *Der Monat*, 7 (1954) 73, pp. 61-65

– Claus, J., *Theorien zeitgenössischer Malerei*, Reinbek, 1963

– Dienst, R.-G., *Deutsche Kunst: eine neue Generation*, Cologne, 1970

– Dienst, R.G., 'Absolute Malerei. Zu einer Kunst der Reduktion und Differenzierung', *Das Kunstwerk*, xxxiv (1981) 4, pp. 3-48

– Dürckheim: see section 1

– Dumoulin: see section 1

– Einstein, A., *Über die spezielle und die allgemeine Relativitätstheorie (Gemeinverständlich)*, Brunswick, 1921 (1916)

– Franck, D., *Die fünfziger Jahre. Als das Leben wieder anfing*, Munich, 1981

– Geelhaar, C.(ed), *Paul Klee. Schriften*, Cologne, 1976

– Graham, L., *The Spontaneous Gesture*, Canberra, 1987

– Grohmann, W., 'Situation actuelle de l'art allemand', *Cimaise*, (1954) 4, pp. 3-5

– Grohmann, W., *Neue Kunst nach 1945*, Cologne, 1958

– Grohmann, W., *Willi Baumeister*, Cologne, 1963

– Grosse, E.: see section 2

– Haftmann, W., *Malerei im 20.Jahrhundert*, Munich, 1954

– Hassenpflug, G., *Abstrakte Maler lehren*, Munich, 1959

– Herrigel, E., *Zen in der Kunst des Bogenschießens*, Munich, 1953 (1948)

– Hippius, M.(ed), *Transzendenz als Erfahrung. Beitrag und Widerhall. Festschrift zum 70.Geburtstag von Graf Dürckheim*, Weilheim, 1966

– Hofmann, W., *Zeichen und Gestalt. Die Malerei des 20.Jahrhunderts*, Frankfurt am Main, 1957

– Honisch, D., 'What is admired in Cologne may not be accepted in Munich, *Art News*, 77 (1978) 8, pp. 62-67

– Kandinsky: see section 2

– Leonhard, K., *Die heilige Fläche. Gespräche über moderne Kunst*, Stuttgart, 1966 (1947)

– Leonhard, K., *Augenschein und Inbegriff. Die Wandlungen der neuen Malerei*, Stuttgart, 1953

– Lueg, G., *Studien zur Malerei des deutschen Informel*, (Diss. Aachen) Aachen, 1983

– Maenz, P., *Die 50er Jahre. Formen eines Jahrzehnts*, Stuttgart, 1978

– Nemeczek, A., 'Wir hielten Marx für einen Russen und flohen zur Kunst', *Art. Das Kunstmagazin*, (1984) 9, pp. 41

– Otto, R., *Das Gefühl des Überweltlichen (Sensus Numinus)*, Munich, 1932

– Paltzer, R.A., 'Großes Comeback der Informellen. Malerei der Fünfziger Jahre wiederentdeckt', *Art. Das Kunstmagazin*, (1984) 9, pp. 21-30

– Platschek, H., *Neue Figurationen. Aus der Werkstatt der heutigen Malerei*, Munich, 1959

– Pobé, M., *Schneider*, Paris, 1959

– Poensgen, G., Zahn, L., *Abstrakte Kunst. Eine Weltsprache*, Baden-Baden, 1958

– Roh, F., 'Thesen und Gegenthesen zur Gegenstandslosen Kunst', *das Kunstwerk*, (1953) 3/4, p. III

– Roh, F., *Deutsche Maler der Gegenwart*, Munich, 1957

– Schmid, K., 'Neue Bilder für Neubeginn', *Art. Das Kunstmagazin*, (1984) 9, pp. 31-40

– Schmied, W., *Malerei nach 1945 in Deutschland, Österreich und der Schweiz*, Frankfurt am Main, 1974

– Schmied, W., Rombold, G., u.a., *Zeichen des Glaubens. Geist der Avantgarde. Religiöse Tendenzen in der Kunst des 20.Jahrhunderts*, Berlin, 1980.

– Suzuki: see section 1

– Thomas, K., *Bis Heute: Stilgeschichte der bildenden Kunst im 20.Jahrhundert*, Cologne, 1971

– Thomas, K., de Vries, G., *Du Mont's Künstler Lexikon von 1945 bis zur Gegenwart*, Cologne, 1977

– Thomas, K., *Zweimal deutsche Kunst nach 1945. 40 Jahre Nähe und Ferne*, Cologne, 1985

– Thwaites, J.A., 'Notizen über drei Maler des neueren Stils', *das Kunstwerk*, (1953) 3/4, p. 38-47

– Trokes, H., 'Moderne Kunst in Deutschland', *das Kunstwerk*, (1946/1947) 8/9, pp. 73-75
– Vogt, P., *Malerei der Gegenwart von 1945 bis Gegenwart*, Munich, 1981
– Vogt: see section 4
– Wedewer, R., *Bildbegriffe. Anmerkungen zur Theorie der neuen Malerei*, Stuttgart, 1963
– Weigert, H., *Die Kunst am Ende der Neuzeit*, Tübingen, 1956
– Wescher, H., 'Peintures et sculptures non-figuratives en Allemagne d'aujourd'hui', *Cimaise*, (1955) 6, pp. 11-12
– Wescher, H., 'Voyage en Allemagne', *Cimaise*, (1956) 3, pp. 24-25
– Zahn, L., 'Abkehr von der "Natur"', *das Kunstwerk*, (1946/1947) 8/9, pp. 3-6

Catalogues

– *Schrift und Bild*, Staatliche Kunsthalle, Baden-Baden, 14-6 – 4-8 1963
– *Kunst in der Bundesrepublik Deutschland 1945-1985*, Nationalgalerie, Berlin, 27-9 1985 – 21-1 1986
– *Dokumente zum deutschen Informel*, Galerie Hennemann, Bonn, n.d.
– *Julius Bissier*, Institute of Contemporary Art, Boston, 11 – 12 1963
– *Julius Bissier*, Kunstsammlung Nordrhein-Westfalen, Düsseldorf, 3-12 – 6-2 1994
– *Julius Bissier*, Haags Gemeentemuseum, The Hague, 11 1959 – 1 1960
– *Bewegte Bereiche der Kunst*, Kaiser Wilhelm Museum, Krefeld, 1963
– *Monochrome Malerei*, Städtisches Museum Schloß Morsbroich, Leverkusen, 18-3 – 8-5 1960
– *Neue Tendenzen*, Schloß Morsbroich, Städtische Museum, Leverkusen, 13-3 – 3-5 1964
– *Deutsche Kunst. Meisterwerke des 20.Jahrhunderts*, Kunstmuseum, Luzern, 4-7 – 2-10 1953
– *Hermann Obrist. Wegbereiter der Moderne*, Stuck Villa, Munich, 3 1968
– *Theodor Werner*, Staatsgalerie moderner Kunst, Munich, 22-3 – 29-4 1979
– *Peintures et Sculptures Non-Figuratives en Allemagne d'Aujourd'hui*, Cercle Volney, Paris, 1955
– *Avantgarde 61*, Städtische Museum, Trier, 7-10 – 5-11 1961
– *Baumeister. Dokumente, Texte, Gemälde*, Kunsthalle, Tübingen, 1971
– *Konkrete Kunst. 50 Jahre Entwicklung*, Helmhaus, Zürich, 8-6 – 14-8 1960

Rupprecht Geiger and Zen 49

– Dienst, R.-G., *Noch Kunst*, Düsseldorf, 1970
– Dienst, R.-G., 'Zen 49', *Das Kunstwerk*, 40 (1987) 5, p. 78-79
– Geiger, R., *Farbe ist Element*, Düsseldorf, 1975
– Heißenbüttel, H., *Geiger*, Stuttgart, 1972
– Roh, F., 'Zen 49 – eine Gruppe Gleichgesinnter', *Frankfurter Rundschau*, 29-4 1950
– Roh, F., 'Zen 49', *Das Kunstwerk*, (1955/1956) 9, p. 49
– Roh, J., 'Rolf Cavael', *das Kunstwerk*, (1956/1957) 5, pp. 51
– Roh, F., 'Uber Rupprecht Geiger', *Das Kunstwerk*, xii (1959) 9, pp. 21-22
– Thwaites, J.A., 'Eight artists, two generations, singular preoccupations', *Art News*, 77 (1978) 8, pp. 70-77

Catalogues

– *Rupprecht Geiger*, 'Gegenverkehr' Zentrum für Aktuelle Kunst, Aachen, 7-11 – 30-11 1968
– *Zen 49*, Staatliche Kunsthalle, Baden-Baden, 6-12 1986 – 15-2 1987
– *Rupprecht Geiger*, Akademie der Künste, Berlin, 10-2 – 17-3 1985
– *Rupprecht Geiger*, Moderne Galerie, Bottrop, 26-6 – 14-8 1977
– *Rupprecht Geiger. 'Rot Form' Bilder*, Kunstverein, Brunswick, 20-10 – 10-12 1989
– *Rupprecht Geiger*, Galerie Rudolf Zwirner am Folkwang Museum, Essen, 6-7 1961
– *25 Künstler auf den Spuren von Zen 49*, Galerie Heimeshoff, Essen, 12 1989 – 1 1990
– *Rupprecht Geiger*, Kestner-Gesellschaft, Hanover, 16-6 – 16-7 1967
– *Zen 49*, Central Art Collecting Point, Munich, 4 1950
– *Zen 49*, Galerie des Amerika Hauses, Munich, 23-6 – 23-7 1951
– *Rupprecht Geiger, Gerhard von Graevenitz, Nikolaus Lang, Rainer Wittenborn*, Kunstverein, Munich, 17-4 – 1-6 1969

– *Rupprecht Geiger*, Städtische Galerie im Lenbachhaus, Munich, 22-2 – 26-3 1978
– *Rupprecht Geiger*, Staatsgalerie Moderner Kunst, im Haus der Kunst, Munich, 30-3 – 8-5 1988
– *Zen 49*, Galerie Michael Pabst, Munich, 1990
– *Réalités Nouvelles. 3ème Salon*, Palais des Beaux Arts, Paris, 23-7 – 30-8 1948
– *Rolf Cavael. Oeuvres de 1928 à 1978*, Galerie Franka Berndt, Paris, 28-9 – 11-11 1989
– *Geiger. Zeichnung als Licht*, Saarland Museum, Saarbrücken, 10-6 – 12-8 1990
– *Zen 49. Renaissance d'une peinture abstraite en Allemagne Fédérale. 1949-1955*, Centre d'Art Contemporain, Saint-Priest, 10-10 – 26-11 1989
– *Rupprecht Geiger. Rot und Schwarz*, Städtischen Galerie Haus Seel, Siegen, 28-6 – 2-8 1992
– *Rupprecht Geiger. Werkverzeichnis der Grafik 1948-1964*, Kunstverein, Wolfsburg, 4 1964
– *Rupprecht Geiger. Gemälde*, Kunst und Museumverein, Wuppertal, 17-10 – 21-11 1965

Karl Otto Götz

– Catoir, B., 'Die spontane Malerei und die Ästhetik der Geschwindigkeit', *Frankfurter Allgemeine Zeitung*, 6-7 1984
– Dienst, R.-G., 'Räumliche Farbgesten', *Frankfurter Allgemeine Zeitung*, 3-12 1981
– Götz, K.O., *Erinnerungen und Werk*, Band 1a + 1b, Düsseldorf, 1983
– Grohmann, W., u.a., *Karl Otto Götz*, Rome, 1962
– Jaguar, E., 'K.O.Götz', *Bokuzin*, (1955) 33
– Jappe, G., 'Vernichtung der Alpträume' *Frankfurter Allgemeine Zeitung*, 29-1 1975
– Klapheck, A., 'Der Aufbruch zur Freiheit', *Rheinische Post*, 10-2 1973
– Meister, H., 'Prinzip spontan-oder: Es begann mit der Luftpumpe', *Düsseldorfer Hefte*, (1984) 13, p. 10
– Motte, de la, M., 'Geisterbeschwörung', *Kunst-Zeitung*, (1989) 6
– Röder, H., 'Vom Motiv zur Komposition. Auszug aus der "Fakturenfibel" von Karl Otto Götz', *das Kunstwerk*, (1950) 8/9, pp. 30-31
– Schmidt, D., 'Die entrückten Silbergäule. Zur Ausstellung "Quadriga" im Frankfurter Kunstverein', *Süddeutsche Zeitung*, 13-10 1972
– Stachelhaus, H., 'Karl Otto Götz', *Kunstwerk*, (1984) 5, pp. 59-60
– Wiedemann, Ch., 'Blick zurück. Aktuell in Münchner Galerien', *Süddeutsche Zeitung*, 18-10 1990

Catalogues
– *K.O.Götz*, Studio B, Bamberg, 7-5 – 28-5 1966
– *K.O.Götz*, Galerie Henneman, Bonn, 10 1978
– *K.O.Götz*, Palais des Beaux-Arts, Brussels, 10-4 – 26-4 1964
– *Karl Otto Götz. Arbeiten auf Papier 1934-1993*, Städtische Kunstsammlungen, Chemnitz, 10-10 1993 – 2-1 1994
– *Karl Otto Götz*, Die Galerie Gunar, Düsseldorf, 3 1966
– *Tachismus in Frankfurt. Quadriga 52*, Historischen Museums Frankfurt-am-Main, 16-10 – 7-11 1959
– *K.O.Götz. Bilder von 1961-1964*, Galerie Appel und Ferstsch, Frankfurt-am-Main, 9-4 – 8-5 1965
– *K.O.Götz. K.R.H.Sonderborg*, Kestner-Gesellschaft, Hanover, 10-11 – 9-12 1956
– *Karl Otto Götz. Informelle Arbeiten 1952-1992*, Kunstverein Ludwigshafen, 5-5 – 20-6 1993
– *K.O.Goetz*, Galleria L'Attico, Rome, 3 1963
– *K.O.Götz*, Galerie Müller, Stuttgart, 21-11 – 20-12 1961

Günther Uecker

– Bongard, W., 'Günther Uecker', *Kunstforum*, 1 (1973/74)8/9, pp. 81-89
– Dienst, R.-G., *Noch Kunst*, Düsseldorf, 1970
– Engelhard, G., 'Reise übers Meer der Nägel', *Art. Das Kunstmagazin*, (1984) 8, pp. 63-75, 117
– Gomringer, E., *wie weiß ist wissen die weisen. hommage à uecker*, Nuremberg, 1975
– Helms, D., *Günther Uecker*, Recklinghausen, 1970

– Honisch, D., *Uecker*, Stuttgart, 1983
– Schmied, W., *Uecker*, St.Gallen, 1972
– Sharp, W., *Günther Uecker – 10 Years of a Kineticist's Work*, New York, 1966
– Strelow, H., 'Günther Uecker' in *Jünge Künstler 65/66*, Cologne, 1965, pp. 53-76
– Uecker, G., *Weißstrukturen*, Düsseldorf, 1962
– Uecker, G., *Gedichte-Projektbeschreibungen-Reflexionen*, St.Gallen, 1979
– Uecker, G., *Littenheid. Eine Studie*, Düsseldorf, 1980
– Uecker, G., *Island-Aquarelle. Vorfeldzeichen Vatnajökull*, Augsburg, 1986

Catalogues

– *Zero Onuitgevoerd*, Kunsthistorisch Instituut, Amsterdam, 24-4 – 13-5 1970
– *Günther Uecker*, Galerie Ad Libitum, Antwerp, 10-11 – 29-11 1962
– *Günther Uecker. Objekte-Zeichnungen*, Bielefelder Kunstverein, Bielefeld, 8-1 – 19-2 1984
– *Zero in Bonn*, Städtische Kunstsammlungen, Bonn, 22-11 – 31-12 1966
– *Günther Uecker*, Moderne Galerie, Bottrop, 14-4 – 26-5 1985
– *Uecker. Bilder und Zeichnungen*, Kunstverein, Brunswick, 6-4 – 13-5 1979
– *12 sinds '45*, Kon. Musea voor Schone Kunsten, Brussels, 1-10 – 27-11 1977
– *Uecker*, Galerie Schmela, Düsseldorf, 7 1961
– *Uecker. Zeichnungen*, Kunstmuseum, Düsseldorf, 9-10 – 27-11 1975
– *Günther Uecker. Zum Schweigen der Schrift*, Galerie Lüpke, Frankfurt, 20-2 – 23-3 1991
– *Uecker. Dzamonja*, Internationale Galerij Orez, The Hague, 4-3 – 2-4 1965
– *Zero. Mack Piene Uecker*, Kestner-Gesellschaft, Hanover, 7-5 – 7-6 1965
– *Günther Uecker*, Kestner-Gesellschaft, Hanover, 5-5 – 18-6 1972
– *Mack, Piene, Uecker*, Museum Haus Lange, Krefeld, 20-1 – 17-3 1963
– *Atelier Günther Uecker*, Schloß Morsbroich, Leverkusen, 22-3 – 11-5 1980
– *Uecker. Struktury*, Muzeum Sztuki W, Lodzi, 20-12 1974 – 19-1 1975
– *Günther Uecker. Man and ashes*, Muzeum Sztuki, Lodzi, 5 1989
– *Uecker*, Wilhelm-Hack-Museum und Kunstverein, Ludwigshafen, 12-12 1987 – 31-1 1988
– *Otto Piene-Lichtballett und Künstler der Gruppe Zero*, Galerie Heseler, Munich, 1972
– *Günther Uecker. Zum Schweigen der Schrift oder die Sprachlosigkeit*, Galerie Edition-e, Munich, 2 – 3 1982
– *Zero. Vision und Bewegung*, Städtische Galerie im Lenbachhaus, Munich, 28-9 – 6-11 1988
– *Uecker*, Howard Wise Gallery, New York, 1-11 – 19-11 1966
– *Licht, Bewegung, Farbe*, Kunsthalle, Nuremberg, 28-4 – 18-6 1967
– *Günther Uecker. Bildobjekt 1957-1970*, Moderna Museet, Stockholm, 1971
– *Uecker*, Staatsgalerie Stuttgart, 13-3 – 23-5 1976

6. The inherent Zen in Japan

Zero and Gutai

– Abegg: see section 2
– Ballo, *Lucio Fontana*, Milan, 1971 (1970)
– Charles D., 'Lignes du temps', *Traverses* 38 (1986) 1A, pp. 188-203
– Clark, J., 'Modernity in Japanese Painting', *Art History*, 9 (1986) 2, pp. 213-231
– Edmonds, I.G., 'Art is a Hole in the Ground', *Pacific Stars and Stripes*, 22-10 1955, p. 16
– Falk, R., 'Japanese Innovators', *New York Times*, 8-12 1957
– *Geijutsu-Shincho, A Monthly Review of Fine Arts, Literature, Play, Movies, Radio, etc.* (1951 – 1959)
– Goldberg, R.L., *Performance Art. From Futurism to the Present*, London, 1988 (1979)
– *Gutai*, (1955 – 1960), 1 – 12
– Harada, M., *Meiji Western Painting*, Tokyo, 1974 (1968)
– Hawkins, R.B., 'Contemporary Art and the Orient', *College Art Journal*, XVI (1957) 4, pp. 118-131
– Heartney, E., 'The Whole Earth Show. Part II', *Art in America*, (1989) July, pp. 90-97
– Henri, A., *Environment and Happenings*, London, 1974

– Ichiro, H. 'L'art japonais moderne', *XXe Siècle* (1976) 9, pp. 57-67
– Jorn, A., 'Discours aux pingouins. L'automatisme', *Cobra*, 1 (1949) 1, p. 8
– Kaprow, A., *Assemblage, Environment and Happenings*, New York, 1965
– Kamon, Y., *Modern Art of Japan since 1950. Painting II*, Tokyo, 1985
– Kim, S.G., 'Eclats du vide. L'espace – temps dans l'art Japonais' *Traverses* (1986) 38/39, pp. 224-229
– Koplos, J., 'Through the Looking Glass. A Guide to Japan's Contemporary Art World', *Art in America*, (1989) July, pp. 98-107
– Koplos, J., 'The Two-Fold Path: Contemporary Art in Japan', *Art in America*, (1989) July, pp. 201-211
– Kung, D., *The Contemporary Artist in Japan*, Honolulu, 1966
– Langsner, J., 'Gutai: an on-the-spot report', *Art International*, 9 (1965) 3, pp. 18-24
– Love, J., 'The Group in Contemporary Japanese Art. Gutai and Jiro Yoshihara', *Art International*, 16 (1972) 6-7, pp. 123-127, p. 143
– Mitoma, K., 'Outdoor Exhibition of Gutai Art', *The Mainichi*, 13-8-1956
– Moore: see section 1
– Munsterberg, H., 'East and West in Contemporary Japanese Art', *College Art Journal*, XVIII (1958) 3, pp. 36-41
– Munsterberg, H., *The Art of Modern Japan. From the Meiji Restauration to the Meiji Centennial 1868-1968*, New York, 1978
– Nakamura, N., *Urfiguration*, Tokyo, 1992
– *Notizie*, 11 (1959) 8 [special issue about Gutai with articles by Murakami, Shiraga, Yoshihara, Tapié, e.a.]
– Ragon, M., Seuphor, M., *L'Art Abstrait*, Paris, 1974
– Restany, P., 'Le Groupe Gutai où le Japon précurser', *XXème siècle*, 46 (1976) September
– Roberts, J., 'Painting as Performance', *Art in America*, (1992) 5, pp. 112-119, 155
– Rosler, M., et al, 'The Global Issue: A Symposium', *Art in America* (1989) July, pp. 151-153
– Segui, S., 'L'aventure de l'art abstrait dans les quatre îles du Japon', *Cimaise*, (1958) 5, pp. 12-21
– Sprigge: see section 2
– Stokvis: see section 4
– Suzuki: see section 1
– Tapié, M., Haga, T., *Continuité et avant-garde au Japon*, Turin, 1961
– Yoshiaki, I., '15 Years of Gutai Art', *Mizue*, (1967) November pp. 79-84
– Yoshihara, J., 'Gutai Manifest', *The Geijutsu-Shincho*, (1956) 12, pp. 202-205
– Zumi, I., 'Contemporary Japanese Painting', *Mizue* (1955), July pp. 14-17

Catalogues

– *Kazuo Shiraga*, Amagasaki Cultural Center, Amagasaki, 3-11 – 3-12 1989
– *Nul*, Stedelijk Museum, Amsterdam, 5 1965
– *Zero Onuitgevoerd*, Kunsthistorisch Instituut, Amsterdam, 24-4 – 13-5 1970
– *Gutai, Japanische Avant Garde 1954-1965*, Mathildenhohe, Darmstadt, 4-3 – 5-5 1991
– *Hedendaagse Japanse Schilderkunst*, Haags Gemeentemuseum, The Hague, 1 – 3 1963
– *Jiro Yoshihara and Today's Aspects of the 'Gutai'*, The Hyogo Prefectural Museum of Modern Art, Kobe, 5-1 – 28-1 1986
– *Gutai*, The Hyogo Prefectural Museum of Modern Art, Kobe, 30-8 – 9-9 1986
– *The Yamamura Collection. Complete Works*, The Hyogo Prefectural Museum of Modern Art, Kobe, 1989
– *Seductive Brush Marks, from the late 19th century to the present day*, Kyoto Municipal Museum of Art, Kyoto 1- 11 – 29-11 1992
– *The New Japanese Painting and Sculpture* 3, Museum of Modern Art, New York, 1966
– *Shiraga*, Gutai Pinacotheca, Osaka, 1962
– *Murakami*, Gutai Pinacotheca, Osaka, 4 1963
– *Contemporary trends/ Le dynamisme du present*, Wereldtentoonstelling, Osaka, 1970
– *Action et Emotion. Peintres des Années 50. Informel, Gutai, Cobra*, National Museum of Art, Osaka, 27-9 – 26-11 1985
– *Traditie en vernieuwing in de Japanse kunst.Hakuin, Shiko Munakata, Toko Shinoda, Nankoku Hidai*, Rijksmuseum Kröller Müller, Otterlo, 1959
– *Reconstructions: Avant-Garde Art in Japan 1945-1965*, Museum of Modern Art, Oxford, 8-12 1985 – 9-2 1986

– *Shiraga*, Galerie Stadler, Paris, 26-1 – 22-2 1962
– *Groupe Gutaï*, Galerie Stadler, Paris, 30-11 1965 – 8-1 1966
– *Japon des Avant-gardes 1910-1970*, Centre Georges Pompidou, Paris, 1986
– *Kazuo Shiraga. Peintures*, Galerie Stadler, Paris, 1-12 1986 – 17-1 1987
– *Giappone all'avanguardia– Il Gruppo Gutai negli anni Cinguanta*, Galleria Nazionale d'Arte Moderna, Rome, 12 1990
– *The Space: Material, Tension, Vacancy in Japanese Modern Art*, The Museum of Modern Art, Saitama, 3-2 – 21-3 1989
– *Landscape Painting in the East and West*, Shizuoka Prefectural Museum of Art, Shizuoka, 1986
– *Exhibition of Seiki Kuroda*, The National Museum of Modern Art, Tokyo, 8-7 – 27-7 1954
– *Gutai Art on the Stage*, Sankei Hall, Tokyo, 17-7 1957
– *Kazuo Shiraga*, Tokyo Gallery, Tokyo, 20-9 – 3-11 1964
– *Seiki Kuroda*, The National Museum of Modern Art, Tokyo, 1-8 – 19-8 1973
– *The Gutai Group, 1955/1956. A Restarting Point for Japanese Contemporary Art*, Penrose Institute of Contemporary Arts, Tokyo, 15-10 – 19-12 1993
– *Dipinti di Shiraga*, International Center of Aesthetic Research, Turin, 1962
– *Japanese Art after 1945. Scream against the Sky*, Yokohama Museum of Art, Yokohama, 5-2 – 30-3 1994

Morita Shiryu and Bokujin

– Alechinsky: see section 4
– *Bokubi* (1952) 1 – (1953) 28
– *Bokujin* (1953) 1 – (1954) 29/ *Bokuzin* (1954) 30 – (1956) 50
– Buchner: see section 3
– Delaleu, F., Inaga, S, *Aspects de l'art japonais moderne. Interactions de l'art japonais et de l'art européen depuis Meiji'*, Paris, 1984
– Götz: see section 5
– Grilli, E., 'The Beauty of Ink', *Bokuzin*, (1954) 30, pp. 23-24
– Kawahita, M., *Shiryu Morita*, Kyoto, 1970
– Lelong, M.H., 'Un sommet de la peinture japonaise', *Bokuzin*, (1954) 31, pp. 22-24
– Morita, 'On looking at Mr. Kline's Latest Works', *Bokubi*, (1952) 12, p. 6
– Morita, 'La conception du signe dans la calligraphie', *Cimaise*, (1958) 5, pp. 22-25
– Morita, *The Works of Shiryu Morita. Selected by the Artist*, Kyoto 1970
– Morita, *Morita, Work and Thought*, n.p. or d
– Sogen, Katsujo: see section 1

Catalogues
– *Schrift und Bild*, Staatliche Kunsthalle, Baden-Baden, 14-6 – 4-8 1963
– *La Calligraphie dans l'Art Japonais Contemporain*, Musée Cernuschi, Paris, 5 1956
– *Morita*, Hyogo Prefectural Museum of Modern Art, Kobe, 23-5 – 5-7 1992
– *Calligraphy and Painting, The Passionate Age*, O-Art Museum, Tokyo, 25-1 – 26-2 1992

Author's interviews

About American Art

– David ANFAM, curator of The National Gallery of Art, Washington DC, specialized in Abstract
 Expressionism, 5-4 1994, Washington DC
– Dore ASHTON, professor of art history, New York City University, specialized in Abstract
 Expressionism, 19-4 & 4-5 1994, New York City
– Douglas BAXTER, proprietor of The Pace Gallery, New York, 7-5 1994, New York City
– Louise BOURGEOIS, artist, knew many Abstract Expressionists in the fifties, 5-5 1994, New York City
– Mary FARKAS, lady Master of the First Zen Institute, New York, 16-10 1990, New York City
– Mary Emma HARRIS, art historian, specialized in Black Mountain College, 2-5 1994, New York City
– Helene HUI, artist, from fifties on practising artist, 27-4 1994, New York City
– John IPPOLITO, curator of The Solomon R. Guggenheim Museum, New York, 11-5 1994, New York City
– Stephen POLCARI, president of the Archives of American Art, specialized in Abstract Expressionism,
 5-5 1994, New York City
– Robert ROSENBLUM, professor of art history, New York City University, 18-4 1994, New York City
– Irving SANDLER, art historian, specialized in Abstract Expressionism, 26-4 1994, New York City
– Charles SELIGER, artist, a friend of Mark Tobey's in the fifties, 9-5 1994, Mount Vernon
– Sal SIRUGO, artist, a friend of Rollin Crampton's in the fifties, 10-5 1994, New York City
– Frederieke TAYLOR-SANDERS, proprietor of the TZ'ART Gallery, 22-4 1994, New York City
– Calvin TOMKINS, art critic, 29-4 1994, interview by telephone
– Jeffrey WECHSLER, curator of The Jane Voorhees Zimmerli Art Museum, New Brunswick, 3-5 1994,
 New Brunswick
– Philip YAMPOLSKY, professor of East-Asian Studies, Columbia University, New York, 15-10 1990,
 New York City

About French Art

– Jean-Paul AMELINE, curator of the Musée National d'Art Moderne, Paris, specialized in the art of the
 fifties, 27-5 1993, Paris
– Renée BESLON, art critic, widow of the artist Jean Degottex, 6-7 1993, Paris
– Harry BULLET, art critic of Le Monde, specialized in modern art, 24-6 1993, Paris
– Jacques FOUSSADIER, artist and calligrapher, 1-7 1993, Paris
– John-Franklin KOENIG, artist from Seattle (VS), living/working since 1954 in Paris, 17-6 1993, Paris
– Michel RAGON, writer and art critic, specialized in art of the fifties, 15-6 1993, Paris
– Roland RECH, president of the 'Association Zen Internationale', 18-6 1993, Paris
– Pierre RESTANY, art critic, specialized in Yves Klein and the Nouveaux Réalistes, 23-6 1993, Paris
– Jean Noël ROBERT, president of the 'Section des Sciences Religieuses', Sorbonne, specialized in (Zen)
 Buddhism, 7-7 1993, Paris
– Kumi SUGAI, Japanese artist, living/working since 1952 in Paris, 16-6 1993, Paris
– Marie TSUKAHARA, professor Université Paris IX, specialized in Japanese culture, 27-5 1993, Paris
– José VOVELLE, professor Université Paris I, specialized in Surrealism, 2-6 1993, Paris
– Françoise WILL-LEVAILLANT, professor Université Paris I, specialized in André Masson, 4-6 1993,
 Paris

About German Art

– Hans Mattheus BACHMAYER, artist and philosopher, 15-2 1994, Munich
– Felicitas BAUMEISTER, daughter of the artist Willi Baumeister, 13-3 1996, Stuttgart
– H.-R. CRONE, professor of modern art history, Ludwig-Maximilian Universität München, 9-2 1994, Munich
– Volkmar ESSERS, curator of the Kunstsammlung Nordrhein-Westfalen, Düsseldorf, 17-3 1994, Düsseldorf
– Rupprecht GEIGER, artist, 31-1 1994, interview by telephone
– Karl Otto GÖTZ, artist, 26-3 1994, Niederbreitbach
– Werner HAFTMANN, art critic and emeritus professor of art history, Ludwig-Maximilian Universität München, 13-2 1994, Waakirchen
– Jean-Loup KORZILIUS, art historian, specialized in German art 1933-1955, 2-7 1993, Paris
– Johannes LAUBE, professor of Japan studies, Ludwig-Maximilian Universität München, 8-2 1994, Munich
– Otto van de LOO, proprietor of the Galerie Van De Loo, Munich, 9-2 1994, Munich
– Werner SCHMALENBACH, art critic, 17-3 1994, Düsseldorf
– Wieland SCHMIED, art historian and president of the Kunstakademie München, 11-2 1994, Munich
– Clelia SEGIETH, curator of the Bayerischen Staatsgemäldesammlungen/Staatsgalerie Moderner Kunst, Munich, 14-2 1994, Munich
– Günther UECKER, artist, 1-2 1994, Düsseldorf
– Ulrich WEISNER, curator of the Museum für Ostasiatische Kunst, Cologne, 5-12 1990, Cologne

About Japanese Art

– Kazuo AMANO, curator of the O-art Museum, Tokyo, 10-12 1993, Tokyo
– Yuko HASEGAWA, curator of the Setagaya Art Museum, Tokyo, 26-11 1993, Tokyo
– Hariu ICHIRO, art critic, 23-11 1993, Tokyo
– Toshimitsu IMAI, artist, lived/worked in the fifties in Paris, 8-10 1993, Tokyo
– Y. IWATA, professor of 'comparative arts', Yamaguchi Women's University, Yamaguchi-City, 2 & 24-5 1995, Haarlem
– Kakichi KADOWAKI, professor of philosophy and president of the Institute of Oriental Religions, Sophia University, Tokyo, 26-10 1993, Tokyo
– Akira KANAYAMA, artist, 31-8 1993, Kobe
– Koichi KAWASAKI, chief curator of the Ashiya City Museum of Art & History, Ashiya, 10-9 1993, Ashiya
– Shinji KOHMOTO, curator of the National Museum of Modern Art, Kyoto, 21-9 1993, Kyoto
– Tohru MATSUMOTO, curator of the National Museum of Modern Art, Tokyo, 13-10 1993, Tokyo
– Toru MOMO, curator of the Project Office, Kobe City Government, 10-12 1993, Tokyo
– Shiryu MORITA, artist, 17-4 1991, Kyoto
– Saburo MURAKAMI, artist, 31-8 1993, Kobe
– Hiroshi MURATA, curator of the Yokohama Museum of Art, 2-11 1993, Yokohama
– Yoshihiro NAKATANI, assistant curator of the Kyoto Municipal Museum of Art, 14-9 1993, Kyoto
– Ryosuke OHASHI, professor of philosophy, Kyoto Institute of Polytechnology, 9-11 1993, Kyoto
– Masaharu ONO, curator of the National Museum of Art, Osaka, 16-9 1993, Osaka
– Shinichiro OSAKI, curator of the Hyogo Prefectural Museum of Modern Art, Kobe, 1-9 & 8-9 1993, Kobe
– Klaus RIESENHUBER, professor of philosophy, Sophia University, Tokyo, 22-11 1993, Tokyo
– Midori SANO, professor of Japanese traditional art, Musashino Art University, Tokyo, 25-10 1993, Tokyo
– Shinichi SEGI, art critic, 2-12 1993, Tokyo
– Shozo SHIMAMOTO, artist, 18-9 1993, Nishinomiya
– Hajime SHIMOYAMA, chief curator of the Shizuoka Prefectural Museum of Art, 10-10 1993, Shizuoka-shi
– Kazuo SHIRAGA, artist, 11-11 1993, Amagasaki
– Hiroko TAKAHASHI, professor of art history, Musashino Art University, Tokyo, 25-11 1993, Tokyo
– Atsuko TANAKA, artist, 31-8 1993, Kobe
– Mitsugi UEHIRA, president of the Kyoto Municipal Museum of Art, 14-9 1993, Kyoto
– Miyoko URUSHIHARA, art critic, 2-12 1993, Tokyo
– Kazuo YAMAWAKI, chief curator of the Nagoya City Art Museum, 15-9 1993, Nagoya

List of illustrations

Zen and the Zen Arts

1. Unidentified seal, 'Daruma' (i.e. Bodhidharma), 19th century (?), ink on paper, 29.5 x (including calligraphy above) 128 cm.
2. Sesshū, 'Haboku sansui zu' (Landscape in splashed ink), 1495, ink on paper, 148.6 x 32.7 cm.
3. Hakuin, 'Bodhidharma', 18th century, ink on paper
4. Sengai, 'Daruma', circa 1800, ink on paper, 17 x 6 cm.
5. Nantembō, 'Bō' (Staff), early 20th century, ink on paper, 148.6 x 44.5 cm. The translation reads: "If you can answer forty whacks! If you can't answer forty whacks!"
6. Nantembō, Untitled, Kaisei temple, Nishinomiya, early 20th century, ink on paper screen
7. Bankei, 'Enso' (Circle), 17th century, ink on paper, 28.6 x 54 cm.
8. Ryoanji Zen garden, Kyoto
9. Nantembō, *Sumi-e* of an old bull grazing, probably referring to the tamed ox, picture no.5 of 'The Ox and its Herdsman', 1925, ink on paper
10. Anonymous, *Sumi-e* of a man sitting on the back of an ox, picture no.6 of 'The Ox and its Herdsman', 15th century (?), ink on paper

West looks East. A short history

11. James McNeill Whistler, 'Caprice in Purple and Gold: The Golden Screen', 1864, oil on panel, 50.1 x 68.5 cm.
12. Hiroshige, 'Bikunibashi setchū' (The bridge Bikuni under the snow), 1858, woodcut, 35 x 23 cm.
13. Edouard Manet, 'Portrait de Faure dans le rôle de Hamlet' (Portrait of Faure playing the role of Hamlet), 1877, oil on canvas, 196 x 131 cm.
14. Shunkosai Hokuei, 'Sasaki saburo moritsuna arashi rikan' (The actor Arashi Rikan II playing the role of Sasaki Saburo), circa 1835, woodcut, 37 x 25.5 cm.
15. Vincent van Gogh, 'Japonoiserie', 1887, oil on canvas, 55 x 46 cm.
16. Alfred Kubin, illustration in *Der Blaue Reiter*, 1912
17. Katsushika Hokusai, print from *Manga*, Vol.XII, 1834, woodcut
18. Odilon Redon, 'L'Intelligence fut à moi! Je devins le Buddha' (the spirit came to me, I became a Buddha), 1895, litho, 32 x 22 cm.
19. Wassily Kandinsky, 'Mit dem schwarzen Bogen' (With the black bow), 1912, oil on canvas, 189 x 198 cm.
20. Wassily Kandinsky, illustration in *Über das Geistige in der Kunst*, 1911, woodcut
21. Illustration in *Der Blaue Reiter* of Japanese ink painting

The unity between West and East. American artists and Zen

22. John La Farge, 'A Rishi Calling up a Storm, Japanese Folklore', 1897, watercolour on paper, 33 x 40 cm.
23. Katsushika Hokusai, print from *Manga*, 1814-78, woodcut
24. William Merritt Chase, 'Hide and Seek', 1888, oil on canvas, 70.1 x 91.1 cm.
25. Georgia O'Keeffe, 'Blue Lines no.10', 1916, watercolour on paper, 63.3 x 48.1 cm.
26. Mark Tobey, 'Broadway', 1936, tempera on masonite board, 65 x 48,7 cm.
27. Mark Tobey, 'New York', 1944, tempera on paperboard, 83.7 x 53.2 cm.

28. Mark Tobey, 'Shadow Spirits of the Forest', 1961, tempera on paper, 48.4 x 63.2 cm.

29. Morris Graves, 'Blind Bird', 1940, gouache, watercolour on mulberry paper, 76.5 x 68.6 cm.

30. Barnett Newman, Untitled, 1945, ink on paper, 27.5 x 18.7 cm.

31. Daisetz T.Suzuki in conversation with John Cage

32. John Cage, 'Water Music', 1952

33. John Cage, 'Music for piano 2', 1953

34. Alcopley, 'Composition', 1961, black paint, 194 x 104 cm.

35. Robert Motherwell, 'Blue with China Ink. Homage to John Cage', 1946, mixed media

36. Robert Motherwell, 'Composition', serigraphy and collage, undated, 61.1 x 50.9 cm.

37. Franz Kline, 'Accent Grave', 1955, oil on canvas, 191 x 131.6 cm.

38. Kunisada (Toyokuni III), 'Taimen' (Meeting), 1830's, woodcut, 38.6 x 26.6 cm.

39. Jackson Pollock, 'Number 15', 1951, mixed media on canvas, 142,2 x 167,7 cm.

40. Ad Reinhardt, 'Abstract Painting', 1954-59, oil on canvas, 276 x 102 cm.

41. Ad Reinhardt, 'Calligraphic Painting', 1949-50, oil on canvas, 127 x 50.8 cm.

42. Ad Reinhardt, 'Abstract Painting', 1960, oil on canvas, 152.4 x 152.4 cm.

43. Rollin Crampton, 'no.8', 1952, oil on board, 76.2 x 101.6 cm.

44. Ad Reinhardt, 'Abstract Painting-Grey', 1950, oil on canvas, 76.2 x 101.6 cm.

45. Mark Tobey, 'Space Ritual no.1', 1957, sumi ink, 74.3 x 95.1 cm.

46. John Marin, 'Street Crossing, New York', 1928, watercolour on paper, 66.6 x 55.2 cm.

The Zen Arts in France

47. Georges Mathieu, 'Dana', 1958, oil on canvas, 65 x 100 cm.

48. Edouard Manet, 'Corbeau avec sceaux et calligraphie japonaise' (Raven with Japanese seals and calligraphy), 1875, 25 x 32 cm.

49. Henri de Toulouse-Lautrec, 'Jane Avril', 1895, litho, 25.2 x 22 cm.

50. Henri Michaux, 'Composition', 1958-63, ink, 75.1 x 105.2 cm.

51. Joan Miró, 'Composition', 1925, oil on canvas, 116 x 89 cm.

52. André Masson, 'À une cascade' (At the waterfall), 1949, oil on canvas, 100 x 81 cm.

53. Hans Hartung, 'Composition', 1956, oil on canvas, 162.5 x 120.5 cm.

54. Pierre Soulages, Untitled, 12 January 1952, oil on canvas, 130 x 81 cm.

55. Sam Francis, Untitled, 1957 (-1988), tempera and acrylic on paper, 92 x 41.5 cm.

56. Sam Francis, Untitled, 1968, acrylic on paper, 90 x 56 cm.

57. Pierre Alechinsky, 'Debout' (Upright), 1959, oil on canvas, 171 x 61 cm.

58. Pierre Alechinsky, 'Assis' (Sitting), 1960, oil on canvas, 180 x 97 cm.

59. Pierre Alechinsky, 'Sumi', 1956, ink on paper, 22.9 x 24.7 cm.

60. Pierre Alechinsky, 'Variations sur Sengai's symbole de l'Univers', 1968, ink and litho, 1968, 55 x 76 cm.

61. Sengai, 'ΔO□' (i.e. Symbol of the Universe), circa 1800, ink, 51 x 109 cm.

62. Jean Degottex, 'Hagakure B II' (Under the leaves), 1957, oil on paper, 106.6 x 240.8 cm.

63. Jean Degottex, 'Vide du non-être' (Emptiness of non-being), 10 – 1959, oil on canvas, 150 x 235 cm.

64. Jean Degottex, 'Vide de l'inaccessible' (Emptiness of the inaccessible), 22-10 1959, oil on canvas, 235 x 135 cm.

65. Jean Degottex, 'Métasigne 1' (Metasign), 1961, oil on canvas, 280 x 120 cm.

66. Yves Klein, 'Monochrome blue', 1959, pigment, synthetic resin, canvas on panel, 92 x 73 cm.

67. Yves Klein, 'Monogold MG 11', 1961, gold leaf on canvas, 75 x 60 cm.

68. Screens in Kongobu temple, Koya San

69. Yves Klein, 'Anthropométrie', March 1960, 194 x 127 cm.

70. Yves Klein, 'Un homme dans l'espace' (A man in space), photo, 1960

Release through Zen and German Art

71. Hermann Obrist, 'Peitschenhieb' (Whiplash curve), c.1893, silk on wool, 119 x 183.5 cm.

72. Julius Bissier, 'Nest im Dornbusch' (Nest in thorn-bush), 1938, ink on grey Ingrespaper, 63 x 47 cm.

73. Willi Baumeister, 'Torī mit blauem Punkt' (Torī with blue point), 1937, oil on canvas, 99.5 x 65 cm.

74. Willi Baumeister, 'Ideogramm' (Ideogram), 1938, 65 x 45 cm.

75. Rupprecht Geiger, '114 E', 1950, tempera on canvas, 46 x 44 cm.

76. Rupprecht Geiger, '196 E', 1953, tempera on canvas, 70.7 x 54.4 cm.

77. Rupprecht Geiger, '429/65', 1965, oil on canvas, 220 x 176 cm.

78. Gerhard Fietz, Untitled, 1955/53, watercolour, ink, grease pencil on paper, 31.8 x 42.3 cm.

79. Rolf Cavael, 'Juni 1950, no.50/151' (June 1950), 1950, oil on cardboard, 24.5 x 27.9 cm.

80. Fritz Winter, Untitled, 1960, mixed media on paper, 17.4 x 23.9 cm.

81. Fritz Winter, Untitled, 1950, screen print, 50 x 65 cm.

82. Theodor Werner, Untitled, 1955, gouache, 47.5 x 66.4 cm.

83. Karl Otto Götz, Untitled, 28.5.1954, mixed media on canvas, 70 x 60 cm.

84. Karl Otto Götz, 'Hval', 1957, gouache on paper, 50 x 65 cm.

85. Karl Otto Götz, Untitled, gouache, 32 x 25 cm.

86. Karl Otto Götz, From: '24 Variationen mit einer Faktur' (24 Variations with a structure), 1949, oil on hard-board, 92 x 18 cm.

87. Günther Uecker, 'Weißes Bild' (White image), 1959, nails on wood panel, 55.5 x 60 cm.

88. Günther Uecker, 'Zero-Garten' (Zero garden), 1966, New York

89. Zen garden in Tofuku temple

The inherent Zen in Japan

90. Seiki Kuroda, 'Kohan' (Lake Shore), 1897, oil on canvas

91. Saburo Murakami, 'Boru. Nage dama ega' (Painting executed with throwing a ball), 1954, ink on paper, 105.8 x 75.7 cm.

92. Akira Kanayama, 'Sakuhin' (Work), 1954, watercolour on paper, 79.3 x 60.2 cm.

93. Akira Kanayama, 'Sakuhin' (Work), 1954, oil on board, 61.8 x 61.8 cm.

94. Atsuko Tanaka, 'Sakuhin' (Work), 1953, cloth, adhesive, ink, 21 x 46 cm.

95. Kazuo Shiraga, 'Tenohira' (Palms), 1954, oil on canvas, 49.5 x 64.5 cm.

96. Jiro Yoshihara, 'Sakuhin', 1957, oil on canvas, 162,8 x 130,5 cm.

97. Jiro Yoshihara, 'Sakuhin' (Work), 1959, oil on canvas, 91 x 73 cm.

98. Akira Kanayama, 'Sakuhin' (Work), 1955, balloon, red globe. Postcard of the 1st Gutai Exhibition.

99. Akira Kanayama, 'Sakuhin' (Work), 1957, 77.6 x 100.3 cm.

100a/b. Atsuko Tanaka, 'Kaze to nuno' (Wind and cloth), 1955, rayon, 1000 x 1000 cm.

101a/b. Saburo Murakami, 'Sakuhin. Mutsu no ana' (Work Six holes), 1955, paper, wood

102. Kazuo Shiraga, 'Tennisei Sekihatsuki', 1959, oil on canvas, 182 x 272.5 cm.

103. Kazuo Shiraga, 'Tenshohei Botsuusen', 1960, oil on canvas, 180 x 275 cm.

104. Kazuo Shiraga, 'Dozo ohairi kudasai' (Please, come in), 1955, wood, each post measures 403 x 6 cm.

105. Kazuo Shiraga, 'Doro ni idomu' (Challenging the mud), mud, 1955

106. Cover of *Bokubi* 1 (1952) July, no.14

107. Nantembo, calligraphy on screen, Kaisei temple, early 20th century, ink on paper

108. Shiryu Morita, 'Mai' (Dancing, soaring), undated, ink on paper, 67 x 46.5 cm.
Explanation of title by the artist: "A crane (bird) is living its own life in his dancing. Like a crane, I want to live my life to the full in my calligraphy".

109. Shiryu Morita, 'So' (Musing, thought), undated, ink on paper, 47 x 68.5 cm.
Explanation of title by the artist: "Rather than how we think, we must grasp how the life throbs and the meaning of our existence. I try to confirm and express them using a brush".

110. Shiryu Morita, 'Kanzan', 1958, ink on paper, 90 x 180 cm.

111. Shiryu Morita, 'To' (Frozen), 1957, ink on paper, 69 x 137 cm.

Appendix III

112. Theo Bennes and Hans Wesseling, 'Manifest van de Zengroep Nederland', 1960

Zen in de jaren vijftig

Wisselwerking in de beeldende kunst tussen Oost en West

Samenvatting

De belangstelling van Westerse kunstenaars voor het Zenboeddhisme kan als een onderdeel van de eeuwenoude West-Oost relatie beschouwd worden. Zoals steeds in de geschiedenis het geval is geweest, zegt het karakter van de interesse voor de Oosterse wereld ook in de twintigste eeuw meer over de plaats waar, de periode waarin en degene bij wie die belangstelling bestond dan over de culturen aan de andere kant van de wereld. Deze studie betrof dan ook vooral de interpretaties van Zen van verscheidene kunstenaars op verschillende plaatsen.

De betekenis van dit onderzoek is vooral gelegen in het beschrijven en het verhelderen van de complexiteit van de affiniteit van kunstenaars in de jaren vijftig met Zen en de Zenkunsten en in het verklaren van het ontstaan van die affiniteit. In vier *case-studies* zijn verschillende centra van moderne kunst belicht, met name New York, Parijs, München en het Kansai district in Japan, en zijn enkele kunstenaars nader bestudeerd. Deze kunstenaars zijn de Amerikaanse kunstenaars Mark Tobey, John Cage en Ad Reinhardt; de Franse kunstenaars Pierre Alechinsky, Jean Degottex en Yves Klein; de Duitse kunstenaars Rupprecht Geiger (met de kunstenaarsgroep Zen 49), Karl Otto Götz en Günther Uecker; en de Japanse kunstenaars Saburo Murakami, Atsuko Tanaka, Akira Kanayama, Kazuo Shiraga (die lid waren van de Japanse Zero groep) en Shiryu Morita. Bij het bespreken van de affiniteit van deze kunstenaars met Zen zijn enkele aspecten van Zen naast de visie, werkwijze en/of het werk van de geselecteerde kunstenaars gelegd. Deze aspecten zijn: leegte en niets, dynamiek, onbepaalde en omgevende ruimte, directe ervaring van het hier en nu, en nondualisme en het universele.

De affiniteit met Zen vertoont op verschillende plaatsen in bepaalde opzichten overeenkomsten, maar er zijn ook verschillen waar te nemen. De introductie van Zen in het Westen blijkt in de bestudeerde centra op verschillende wijzen verlopen te zijn en vond niet in hetzelfde decennium plaats. In Duitsland werden in de jaren dertig de ideeën van Zen geïntroduceerd in het kader van een propagandacampagne voor de samenwerking met Japan en in diezelfde periode begonnen ook enkele Duitse kunstenaars zich in Zen te verdiepen. De interesse voor Zen verdween niet na de oorlog en in 1949 richtte een aantal kunstenaars, die meenden dat Zen een geschikt symbool voor een nieuwe periode van vrijheid was, de groep Zen 49 op. In Amerika groeide aan het einde van de jaren veertig geleidelijk de interesse voor Zen, enerzijds als reactie op de sterke

oriëntatie op Europa en anderzijds als gevolg van het zich bewust worden van de ideale geografische ligging voor de ontwikkeling van een universele kunst. In Parijs is pas halverwege de jaren vijftig de fascinatie voor Zen ontstaan, toen kunstenaars ontdekten dat Zen de visie was die ten grondslag lag aan de geïmporteerde Japanse kunsten.

Voor alle Westerse kunstcentra die bestudeerd werden, blijkt te gelden dat de boeken van de Japanse onderzoeker Daisetz T. Suzuki een belangrijke rol speelden in de beeldvorming van Zen. In deze centra werd Zen aan het eind van de jaren vijftig een rage in intellectuele en artistieke kringen, vooral in de communicatie.

De jaren vijftig blijken ten gevolge van een aantal ontwikkelingen in de Westerse samenleving een goede voedingsbodem voor Zen geweest te zijn. Voor kunstenaars uit de eerste helft van de twintigste eeuw hing de belangstelling voor het Verre Oosten samen met het verlangen om zich af te keren van het dagelijkse leven. In de jaren vijftig zet de interesse voor de directe ervaring en het hier en nu de kunstenaar weer midden in het leven, niet in de betekenis van het maatschappelijke of politieke leven maar in de betekenis van 'het bestaan als mens'. Zowel het Existentialisme als Zen houden de kunstenaar voor dat hij niet moet vluchten. Doordat de in dit onderzoek genoemde kunstenaars probeerden de eigen wil te onderdrukken of zelfs te overstijgen – in plaats van het belang van de wil te benadrukken, zoals Sartre deed – benaderden zij de visie van Zen.

Onder invloed van de theorieën van Sigmund Freud en het Surrealisme was voor de Westerse kunstenaars de weg geopend naar het uiten van het innerlijk en het zoeken naar de essentie van de mens. De visie van Carl Gustav Jung, die grote belangstelling voor het Oosten had, was in dit verband eveneens van belang. Zijn theorieën, met nadruk op *Ganzwerdung* en het universele, zijn meer dan die van Freud verwant aan Zen. In de jaren vijftig waren zijn ideeën vooral bekend in Amerika.

Een belangrijk verschil tussen de Westerse kunstenaars en de Zenmeesters was dat bij de Westerse kunstenaars de eigen psyche centraal stond terwijl de Zenmeesters in hun innerlijk naar de eenheid met hun omgeving en zelfs met de hele kosmos zochten. De moderne Japanse kunstenaars die in het onderzoek behandeld worden, zijn meer verwant aan deze instelling van de Zenmeesters dan aan die van hun Westerse collega's, ondanks het feit dat zij tevens sterk beïnvloed waren door de Westerse avant-garde. In het ontwikkelen van een nieuw soort Japanse moderne kunst integreerden de leden van de kunstenaarsgroep Zero, die later deel uitmaakte van de Gutai groep, onbewust elementen van hun eigen cultuur waar Zen onlosmakelijk mee verbonden is.

Bij vrijwel alle kunstenaars die bestudeerd zijn, is in de jaren vijftig de aandacht gegroeid voor een internationale kunst en voor het verschijnsel vrijheid. In het Westen was dit ondermeer een gevolg van de Tweede Wereldoorlog. Het feit dat het verkrijgen van vrijheid een van de kerndoelen in Zen is, bleek in alle centra van onderzoek een belangrijke reden te zijn geweest voor de affiniteit met Zen, hoewel de betekenis van het begrip vrijheid voor de Westerlingen verschilt van die voor de Japanners.

De aanvankelijke werktitel van deze studie was 'Neo-Japonisme'. Tijdens het onderzoek bleek deze term niet van toepassing te zijn. 'Neo' suggereert dat het Japonisme uit de negentiende eeuw opnieuw tot bloei kwam in de twintigste eeuw. Dit is echter niet het geval geweest. Er is sprake van een aaneenschakeling van verschijnselen die ten tijde van het Japonisme begon.

De Japonisten bleken behalve met *Ukiyo-e* (Japanse houtsneden) ook met *Sumi-e* (inktschilderkunst) bekend te zijn. *Sumi-e* werd destijds slechts terloops in relatie gebracht met Zen. Zowel in *Ukiyo-e* als in *Sumi-e* is meestal kalligrafie aanwezig; de eigenschappen van de Japanse kalligrafie waren dus bekend bij de Japonisten en werden in verschillende werken ook toegepast.

De gelijkenis tussen Westerse werken met kalligrafische gebaren uit de jaren vijftig van de twintigste eeuw en de kalligrafie uit het Verre Oosten blijkt dan ook niet op puur toeval te berusten. Vanaf de eeuwwisseling tot de jaren vijftig heeft het lijngebruik van kunstenaars een geleidelijke ontwikkeling doorgemaakt. De fascinatie van verscheidene kunstenaars voor het expressieve karakter van niet alleen het Oosterse maar ook het Westerse handschrift leidde tot belangstelling voor de werkwijze van de *Shō*-kunstenaar (de kalligraaf) en voor de visie van Zen.

Het onderzoek betrof niet alleen schilderijen met kalligrafische gebaren, maar ook werken die als 'kunst van het lege veld' gekarakteriseerd kunnen worden. Deze werken vinden eveneens hun oorsprong in het negentiende-eeuwse Japonisme. Verschillende Japonisten hadden zich door de grote egale kleurvlakken uit de *Ukiyo-e* laten inspireren. In de jaren vijftig groeide bij een aantal kunstenaars de aandacht voor het zoeken naar de essentie van kunst en leven en een sterke existentiële ervaring. Die belangstelling leidde tot werken die bestonden uit grote kleurvelden met minimale kleurvariatie. Verscheidene kunstenaars uit deze categorie voelden affiniteit met de visie van Zen en enkele formele aspecten van de Zenkunsten, zoals leegte.

De non-figuratieve werken van de bestudeerde Amerikaanse, Franse, Duitse en Japanse kunstenaars zijn in dit onderzoek op grond van overeenkomsten onderverdeeld in drie categorieën: 'kunst van het kalligrafische gebaar', 'kunst van het lege veld' en 'levende kunst'. Naast overeenkomsten bleken ook enkele verschillen te bestaan.

'Kunst van het lege veld'
De belangrijkste overeenkomsten tussen de werken van de kunstenaars in deze categorie zijn de minimale variaties in kleur, de grote eenvoud in compositie, de afwezigheid van het handschrift van de kunstenaar, de afwezigheid van de suggestie van massa en het contemplatieve karakter van het werk.

Van de in dit onderzoek betrokken kunstenaars kunnen de volgenden in deze categorie worden ingedeeld: Ad Reinhardt, Yves Klein, Rupprecht Geiger, Atsuko Tanaka en Akira Kanayama.

'Kunst van het kalligrafische gebaar'
Als belangrijkste gemeenschappelijke kenmerken zijn te noemen: de belangstelling voor de Japanse kalligrafie, de relatie tussen het persoonlijke hand-

schrift van de kunstenaar en een universeel schrift, het gebruik van het zwart/wit contrast en de ontkenning van massa.

Er is een duidelijk verschil tussen de *Shō*-kunstenaar en degenen die moderne beeldende kunst willen maken. De kalligraaf streeft naar vakmanschap volgens de regels van zijn ambacht en hij probeert vervolgens in een eigen stijl zichzelf vanuit zijn innerlijk te overstijgen om het universele zelf te bereiken. De moderne kunstenaar streeft naar een nieuwe uitingsvorm waarin zowel zijn individuele innerlijk als iets algemeen-menselijks vertolkt worden. Er bestaat ook verschil tussen de wijze van schilderen van de kalligraaf, die het hele werk in één laag en in één richting schildert zonder correcties, en de Westerse manier, waarbij de penseelstreken elkaar vaak overlappen en waarbij in verschillende lagen geschilderd wordt. In tegenstelling tot enkele Westerse kunstenaars die een voorkeur voor het gebruik van toeval hebben, streeft de *Shō*-kunstenaar naar de suggestie van toeval. Bovendien is het uitgangspunt van het *Shō*-werkstuk altijd een *Kanji*. Er is dus altijd sprake van een betekenis, hoe onleesbaar die ook is. Het onderzoek toont aan dat de moderne *Shō*-kunstenaar en de moderne kunstenaar met een interesse voor Zen elkaar met betrekking tot de genoemde aspecten in de jaren vijftig weliswaar geleidelijk naderen, maar dat er desondanks verschillen bleven bestaan.

Deze categorie betreft vooral de volgende kunstenaars: Shiryu Morita, Pierre Alechinsky, Jean Degottex, Karl Otto Götz en Mark Tobey.

'Levende kunst'

Het gemeenschappelijke kenmerk in deze werken is de *performance*, waarbij de kunstenaar lijfelijk aanwezig is en de directe ervaring van de kunstenaar en de toeschouwer een rol speelt.

In tegenstelling tot de traditionele Westerse cultuur waarin de geest vrijwel altijd als superieur aan het lichaam werd beschouwd, is de eenheid van lichaam en geest een belangrijk aspect van Zen. Ook in de 'levende kunst' van de jaren vijftig blijven de Westerse kunstenaars meestal achter in 'lichamelijkheid' bij de bestudeerde Japanse collega's, die hun lichaam helemaal één laten worden met hun materiaal. Dit verschil kan uitgedrukt worden met de begrippen 'observatie' tegenover 'participatie'.

De belangrijkste kunstenaars in deze categorie zijn: John Cage, de leden van de Zero/Gutai groep en Yves Klein.

Het naast elkaar leggen van verschillende aspecten van Zen en de visies, werken en/of werkwijzen van de geselecteerde kunstenaars blijkt een interessant beeld op te leveren. Vijf aspecten zijn nader bestudeerd.

Leegte en niets

In de periode van het Japonisme was bij sommige Westerse kunstenaars de belangstelling voor het formele aspect leegte gegroeid. Zij beschouwden leegte als 'afwezigheid van iets'. In de loop van de twintigste eeuw veranderde voor verschillende Westerse kunstenaars de betekenis van leegte. De Amerikaanse kunstenaars werden vooral aangetrokken door het idee dat 'niets' en 'iets' gelijk konden zijn. De Duitse kunstenaars werden gefascineerd door het idee van 'niets'

als een symbool voor het beginpunt van een nieuwe tijd waarin abstracte kunst is toegestaan. De Japanse Zero-kunstenaars hadden geen visie op het 'niets', maar kozen het 'niets' zelf als uitgangspunt. Zij wilden vanuit het 'niets' beginnen en naar 'niets' verwijzen. Voor Morita had 'niets' vooral de spirituele betekenis van 'transcenderen'. Voor de Franse kunstenaars Klein en Degottex was de werking van de leegte in hun kunst belangrijk. Voor beiden was de universele en meditatieve uitstraling belangrijk; bij Klein ging het ook om de spirituele werking.

In de onderzochte werken is sprake van twee opvattingen van leegte. In een aantal werken blijkt leegte het meest verwant te zijn met het idee over leegte in Zen als gelijktijdig leeg en vol, en in andere werken bestaat er meer verband met de in *Shō* en *Sumi-e* zichtbare eenheid van figuur en leegte, ofwel 'iets' en 'niets' als elkaars complementen.

Dynamiek

De in dit onderzoek bestudeerde kunstenaars beschouwden kunst als een weerslag van 'het leven als dynamisch proces'. Voor hen bleek de abstracte kunst een geschikt middel om niet-zichtbare dynamiek, ofwel energie, weer te geven. Daisetz T. Suzuki's beschrijving van het streven van Zen om 'het leven in de vlucht te grijpen', verwoordde voor verschillende Westerse kunstenaars een nieuw gevoel met betrekking tot het verbeelden van de werkelijkheid.

Vooral de werken uit de categorie 'levende kunst' tonen de belangrijke rol die dynamiek speelt. Aangezien de traditionele Westerse kunstenaar zich voornamelijk beziggehouden heeft met het bevriezen van beweging, is het niet verwonderlijk dat reeds in 1955 in Japan een groep kunstenaars 'levende kunst' maakte.

In de categorie 'kunst van het lege veld' is dynamiek aanwezig in de vorm van de subtiele 'stille dynamiek' zoals die ook in de Zentuin, het Nō-theater en de thee-ceremonie te vinden is. In de kunst met het kalligrafische gebaar is dynamiek zichtbaar in het karakter van de penseelstreek. Ook de werkwijze van de kunstenaars uit deze categorie kan vanwege het spontane karakter dynamisch genoemd worden. Eigenlijk is de term 'geoefende spontaniteit' toepasselijker, omdat zij jarenlang dezelfde werkwijze herhaalden. Ook de spontaniteit van Zenmeesters is gebaseerd op oefening, maar in hun geval betreft het een strenge training.

Onbepaalde en omgevende ruimte

In de twintigste eeuw werden in de Westerse beeldende kunst nieuwe experimenten gedaan met ruimte-uitbeelding, onder andere met de 'oneindige' en 'ongedefinieerde' ruimte. Bovendien groeide de belangstelling voor de ruimte om en tussen objecten, de ruimte om (in plaats van voor) de kunstenaar en de ruimte tussen het werkstuk en de toeschouwer. De ruimte werd tevens als 'veranderlijk' ervaren. Een aantal Westerse kunstenaars herkende in de visie van Zen en de daarmee verbonden Zenkunsten hun nieuwe visie op ruimte. Zoals de Japanse houtsneden in de negentiende eeuw tegemoet gekomen waren aan de behoefte van Westerse kunstenaars aan een nieuwe uitbeelding van ruimte, zo was dit in de jaren vijftig het geval met de visie en de kunsten van Zen. De voor Westerlingen nieuwe vorm van ruimtesuggestie is in de moderne Japanse kunstwerken daarentegen juist een traditioneel aspect te noemen.

Directe ervaring van het hier en nu

In de visie van Zen wordt *Satori* (verlichting) verkregen door de intense beleving van het hier en nu. Generaliserend kan gesteld worden, dat ook de bestudeerde moderne kunstenaars in hun werk uiting gaven aan een directe ervaring van het zijn. De directe zijnservaring was tevens verbonden met de kunstbeoefening, door een intense concentratie tijdens het werk. Het vervaardigen van kunstwerken kreeg zo het karakter van een ritueel. Dit was een gedisciplineerd ritueel, dat enigszins vergelijkbaar is met de beoefening van de Zenkunsten.

Verschillende kunstenaars meenden dat ook het bewustzijn van de toeschouwer door de beschouwing van hun werken geïntensiveerd kon worden. Het publiek kan de belangstelling van de kunstenaar voor de intense ervaring waarnemen in de expressief geschilderde lijnen, die de sporen van een heftige actie vormen, in de werking van de kleurvelden of in alledaagse handelingen en voorwerpen.

Nondualisme en het universele

Een aantal Westerse kunstenaars hield zich in de jaren vijftig bezig met de vraag hoe de individuele persoonlijkheid overstegen kan worden. Jung had vanuit de psychoanalytische theorie geprobeerd te bewijzen dat het universele (collectieve) een onderdeel van de eigen persoonlijkheid is. Ook de antropologische wetenschap hield zich met de vraag naar het bestaan van iets universeels in de mens bezig. Kennis over Zen bevestigde het geloof in het universele en de mogelijkheid om vanuit het individuele het zelf te kunnen transcenderen naar een meer universeel zelf.

In de 'kunst van het kalligrafische gebaar' werd gemeend dat via het schrift een universele uiting gevonden kon worden. In de 'kunst van het lege veld' werd het egaal geschilderde vlak geacht universele gevoelens op te roepen en in de 'levende kunst' werd het universele in algemeen-menselijke – natuurlijke – handelingen gezocht.

In de verschillende Westerse landen bleek bij een aantal onderzochte kunstenaars iets als een religieus gevoel te bestaan. Uitspraken van deze kunstenaars toonden aan dat zij niet onbekend waren met de Middeleeuwse christenmystici, in het bijzonder Meister Eckhart, en dat zij zich bewust waren van verwantschap met Zen. Bovendien besteedden zowel Suzuki als Jung aandacht aan de verwantschap tussen deze mysticus en Zen.

Het onderzoek toont duidelijk een brede belangstelling voor Zen onder kunstenaars in de jaren vijftig aan. Die belangstelling kan gekarakteriseerd worden als een breed gedragen en pluriforme affiniteit. Er is vooral inzicht gegeven in de complexiteit van het onderwerp van onderzoek. Een onderdeel van die complexiteit is dat begrippen als 'typisch Westers' en 'typisch Oosters' zeer relatief zijn. De vaak 'typisch Oosters' genoemde kenmerken blijken door de eeuwen heen bijna voordurend als een onderstroom in de Westerse wereld aanwezig geweest te zijn. Veel van de genoemde Westerse kunstenaars waren zich hiervan bewust.

Uit het onderzoek blijkt dat causale verbanden niet of nauwelijks aan te tonen zijn. Het ordenen van het onderzoeksmateriaal in categorieën en het uitwerken van een aantal vergelijkingen op basis van enkele karakteristieken van Zen en de Zenkunsten, die aan de boeken van Suzuki ontleend zijn, leidde tot de conclusie, dat de bestudeerde kunst uit de jaren vijftig te benoemen is als *Zen – like art* of, nog beter, als: '*Suzuki-Zen – like art*'.

Acknowledgements

There are several people whom I wish to thank for their contribution in the materialization of this thesis:

The Canon Foundation in Europe for the Visiting Research Fellowship, which enabled me to conduct research abroad for a year; Professor T. Fujieda and his colleagues at the department of Art History of the Musashino Art University in Tokyo for their hospitality and guidance during my stay in Japan; all the artists, art historians and other experts who were interviewed and were kind enough to extend their cooperation; my supervisors prof. dr. W.R. van Gulik and dr. W.L. Stokvis of the Rijksuniversiteit Leiden for their contributions; the translator Wendy van Os for her hard work; and my partner Rob, family and friends for their encouragement and interest in my research.

Initiator: Gemeente Amstelveen

Co-initiators: Philip Morris
Ballast Nedam N.V.
VSB Bank N.V.
Warig Nederland BV
Zwitserleven
MAB Groep B.V.
nv Bouwfonds Nederlandse Gemeenten
KLM Koninklijke Luchtvaartmaatschappij N.V.
The Isaac Alfred Ailion Foundation

Colophon

Publishing: Waanders Publishers, Zwolle
Cobra museum voor moderne kunst, Amstelveen

Design: Gijs Dragt, Zwolle

Printing: Waanders Printers, Zwolle

Translation: Wendy van Os-Thompson

Cover: Yves Klein, *Monogold MG II*, 1961, Kunstsammlung Nordrhein-Westfalen, Düsseldorf

Dissertatie Rijksuniversiteit Leiden, 1996

ISBN 90 400 9892 1
2nd edition, 1997